Modern Art 1851–1929

Oxford History of Art

Dr Richard Brettell has taught at the University of Texas, Northwestern University, and Harvard University and is currently Professor of Aesthetic Studies at the University of Texas at Dallas. Formerly Searle Curator of European Painting at the Art Institute of Chicago and McDermott Director of the Dallas Museum of Art, he has been involved with museum scholarship for more than twenty years, publishing articles and catalogues in the history of modern painting, photography, architecture, and museology. His books include *Pissarro and Pontoise: The Painter and the Landscape* (Yale, 1990) which won the Charles Rufus Morey Award, and, with Caroline B. Brettell, *Painters and Peasants in the 19th Century* (Geneva, 1983). He was also curator and co-author of *A Day in the Country: Impressionism and the French Landscape* (New York, 1984) and *The Art of Paul Gauguin* (New York, 1988).

Oxford History of Art

Modern Art
1851–1929

Capitalism and Representation

Richard R. Brettell

OXFORD
UNIVERSITY PRESS

Oxford University Press, Great Clarendon Street, Oxford OX2 6DP

Oxford New York

Athens Auckland Bangkok Bogota Bombay
Buenos Aires Calcutta Cape Town Dar es Salaam
Delhi Florence Hong Kong Istanbul Karachi
Kuala Lumpur Madras Madrid Melbourne
Mexico City Nairobi Paris Singapore
Taipei Tokyo Toronto Warsaw
and associated companies in Berlin Ibadan

Oxford is a trade mark of Oxford University Press

First published 1999 by Oxford University Press

British Library Cataloguing in Publication Data
Data available

Library of Congress Cataloging in Publication Data
Data available

0–19–284220–X Pbk
0–19–284273–0 Hb

10 9 8 7 6 5 4 3 2 1

Picture Research by Elisabeth Agate
Printed in Hong Kong
on acid-free paper by
C&C Offset Printing Co., Ltd

For George Heard Hamilton and Peter Gay

In memory of David Meyerson

Contents

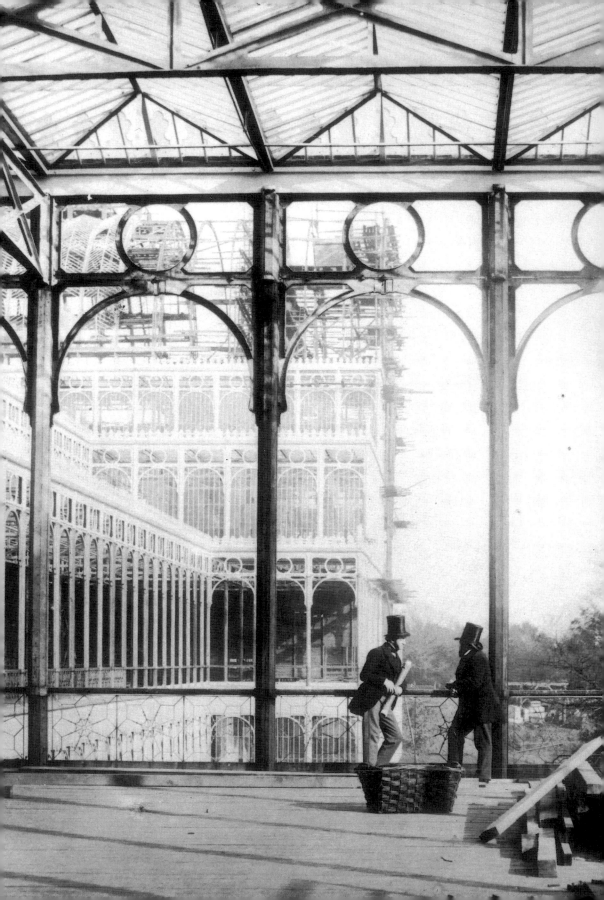

Introduction: The Great Exhibition of 1851, London

The shelves of every general library in the world contain histories of modern art. Since the early years of this century, scholars and critics of virtually every nationality have attempted to explain the extraordinary fluorescence in the art world that started in the mid-nineteenth century in Europe and became global by the turn of the century. The words modern art are often contrasted with academic art or traditional art to indicate the nature of this fluorescence. The notion that underlies most of the books that define modern art is that this art arose in response to the changing political, social, economic, and cultural character of modern life.

This modern life was considered to be urban, industrially based, socially fluid, and defined by the notion of capital or exchangeable wealth. Historians of modern Europe usually begin their investigations in the seventeenth century, a major turning point in the political, social, and economic structure of society. The most recent generation of art historians have included the eighteenth century in their discussions of modern art, with Robert Rosenblum, Michael Fried, Robert L. Herbert, and Thomas Crow all treating eighteenth-century Europe (mostly France) as modern.

This history of modern art is dependent by its very nature on those that preceded it. Julius Meier-Graefe's *Modern Art* (published in German in 1904, and translated into English in 1908)[1] was the first systematic attempt to place the achievements of French painters in a larger art-historical context that includes all of European art. When read in conjunction with Paul Signac's landmark book, *From Delacroix to Neo-Impressionism* (1899), Meier-Graefe's *Modern Art* lays the theoretical and aesthetic groundwork on which most of the principal achievements of modern artists and their commentators rest.[2] As with virtually all the earliest work on modern art, Meier-Graefe stops at 1900, before the achievements of the first three incredibly inventive decades of the twentieth century. Perhaps as a result of this, the nineteenth-century history of modern art has most often been separated from its twentieth-century strands in both academic teaching and its literature.

This book attempts to correct that imbalance by commencing the history of modern art in the mid-nineteenth century and continuing it

through the first quarter of the twentieth century. Its parameters are, by nature, at once arbitrary and symbolic. They do not correspond with the completion of a major work of art or an invention, or an occurrence directly related to the production of art. Rather, they admit that modern art has been, and continues to be, part of an urban spectacle of display, that its exhibition before urban audiences of various scales is essential to its nature, and that a true study of modern art must be grounded as much in its public presentation (which is not to say consumption) as in its private production.

This study commences with the Great Exhibition of 1851, the first of a series of truly international exhibitions of manufactured goods from different countries, held in Joseph Paxton's rapidly constructed and architecturally unprecedented Crystal Palace near London, and concludes with the opening exhibition of the then new Museum of Modern Art in New York in 1929.[3] The fact that both these events were held outside France is not an unimportant factor in their selection as the parentheses of this study. The knowledge that one of them contained works of plastic art as part of a larger exhibition of cultural products (lamps, tractors, ceramics, furniture, machines, etc.) is also essential to an understanding of this book's aims. It must be stressed that there was no art (or design, for that matter) that we would recognize today as modern in the Crystal Palace exhibition. Yet, the sheer modernity of the exhibition itself justifies its position as the point of origin for this book. Its royal co-founder, Prince Albert, spoke at the opening of the exhibition about the 'wonderful period of transition . . . [when] thought is communicated with the rapidity and power of lightning . . . and knowledge becomes the property of the community at large'. This world-without-borders is also the leitmotif of our own digital age, yet we should remember its origins in the middle of the last century, when industrialism and colonialism made all Europeans globally conscious.

This is among the first histories of modern art governed as much by the currently fashionable word 'representation' as by the word art. Here the discovery and subsequent widespread domination of the most modern of media, photography, will be identified as an essential factor in the definition of the primary role of painting in modern representation. The extraordinary importance of photo-mechanical reproduction for the production of art will also be considered. There were few modern intellectuals and artists who failed to argue the merits or otherwise of photography and photo-mechanical reproduction. By 1870 all those living in a modern city anywhere in the world had been affected by the newly developed image world made possible by the industrialization of the reproductive media.

Paris: the capital of modern art

The Euro-global aspect of this history is just as important a factor in the selection of the 1851 exhibition as our starting point. Virtually every history of modern art is dominated by the artistic production of the French capital, Paris. Hence, modern art is in a sense modern French art. This study can do little to reverse that idea, largely because Paris was unequivocally the world art capital throughout the period 1852 to 1929. However, many artists who made critical contributions to modern art were non-French, though based in Paris, and no true history of modern art can exclude the contributions of the many different nationalities such as British, Germans, Russians, Italians, Scandinavians, Czechs, Spaniards, and Americans. Nor can it afford to exclude the achievements of artists working in other major cities. It is largely through the regular practice of the international exhibitions and their artistic offshoots that the Euro-global world of modern art came to be defined. Even nationalism in the arts has its international dimensions; the radically and self-consciously Mexican art produced by Diego Rivera (1886–1957) in the 1920s is inconceivable without his thorough familiarity with French modernism and with the artistic theories of the Frenchman Elie Faure (1873–1937).

With improved communications and new cultural ideas and images from Paris, Vienna, or Berlin, avant-garde groups were disseminated throughout Europe and much of the Americas by the early twentieth century. This created a situation in which central works of art were being made in peripheral places, as Prince Albert seemed to predict in 1851.

New technology

Over half the illustrations for this text are representations made by non-French artists, many of which have never before been included in a general text on modern art. This decision was not made purely for the sake of novelty, but was made possible by the recent availability of information about modern art in the former Soviet bloc and because of renewed enthusiasm for the 'provincial' modern art of Scandinavia, the Americas, and other colonial areas. I begin this book with two representations, both English. They contrast in virtually every way, yet both can be classified as modern. The first, by the artist/photographer Phillip Henry Delamotte (1820–89) is a calotype (a photographic print created from a paper negative, a process developed in England in 1839 by William Henry Fox Talbot (1800–77)). Made during the reconstruction of Paxton's famed Crystal Palace in Sydenham in the years following the close of the 1851 exhibition, *Upper Gallery* (1855), is a pure record of the effect of light on iron and glass [1]. There are no figures, and the receding pictorial space defined by the architecture moves in stately fashion up the left edge of the pictorial format. The asymmetry

of the representation, its glorification of the mechanically made elements of modern architecture, its edge-consciousness, its omission of the human figure, the virtual suspension of its viewer: all these qualities make the representation as modern as its subject. This and the other documentary photographs of the same building made by Delamotte contrast sharply with his simultaneously created watercolours of the English picturesque tradition which would never even be considered for inclusion in a museum of modern art. The message here is familiar to postmodernists who recall the observation of their earliest important theorist, Marshall McLuhan, that 'the medium is the message'. When Delamotte saw and recorded the Crystal Palace through a camera, he was unable to conform to the compositional conventions of the painted representation and was forced to invent new approaches to composition.

The second representation to introduce this text was made not by a machine, but by hand. William Holman Hunt (1827–1910) painted *Valentine Rescuing Sylvia From Proteus* in 1850–1 exactly at the moment

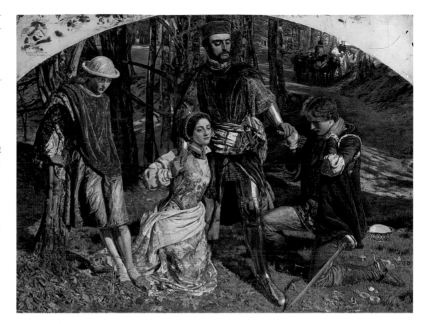

2 William Holman Hunt

Valentine Rescuing Sylvia from Proteus (The Two Gentleman of Verona), 1850–1, oil on canvas

Fine art was intentionally excluded from Prince Albert's 1851 exhibition, and Hunt's painting could be seen at the Royal Academy. This decision was reversed in all subsequent international exhibitions, each of which hosted major global displays of art that raised serious questions about the relationships between art, industry, science, nationalism, and progress.

of the Great Exhibition [**2**]. Its subject, the last scene of the last act of Shakespeare's comedy of love *Two Gentlemen of Verona*, is at once historical and imaginative, inhabiting a cultural time consciously removed from the radically timeless present of Delamotte's photograph. It, too, is modern, but modern in a very different way to the Delamotte image. Hunt's vividly coloured work plays a crucial role in John Gage's recent book, *Colour and Culture*, as an exemplar of mid-nineteenth-century colour and light theory as used by painters.[4] Its obsession with detail and a kind of accumulated visual accuracy owes a profound debt to the sort of hyper-realism that had entered the history of art with the introduction in 1839 of the photographic process called the daguerreotype. Along with the French painter Paul Delaroche (1797–1856), who introduced photography to the French nation in a speech of 1839, Hunt gloried in the almost enamelled details revealed to the human eye by the daguerreotype, a unique photographic print on a silvered copper surface. In Hunt's painting, the last scene of the play is infused with a colour, life, and sheer reality that it could never have had on stage. Its imagery is anything but modern, but its representational vocabulary is absolutely so, to the extent that when it made its first appearance in the Royal Academy exhibition of 1851, it was decried for the garishness and crudity of its colours just as Gauguin's and Matisse's paintings were more than a generation later.[5]

The beginnings of modern art

Before rushing headlong into the body of the text, it is worth exploring some of the other possible starting points for this book. One is surely 1846, when Charles Baudelaire published his landmark review of the

Salon with his call to artists to 'be of their time', to create an artistic world that is continuously involved in an interaction with the present rather than the past. Baudelaire's call to arms was heard by very few artists when he made it, and it was actually his later criticism, particularly his essay 'The Painter of Modern Life', published in 1863, that had the real impact on world art.[6] Another starting date could have been 1848, a year of revolutions throughout much of Europe, and the date used most often in conventional histories of Realism. Yet the 1848 revolution, though of widespread importance in European culture, had too little effect on artistic developments in most nations, England among them, for it to become a touchstone for an international history of art. Another date, used often in histories of painting, is 1855, when Gustave Courbet (1819–77) exhibited his immense painted manifesto, *The Studio of the Painter, A Real Allegory* (see **3**) in a special pavilion constructed outside the second international exposition, held in Paris in that year. Yet, for me, it was the impetus of the Crystal Palace exhibition that caused the conditions for the creation, and exhibition, of Courbet's self-conscious masterpiece.

The fourth and perhaps most compelling alternative to 1851 is, of course, 1863, when Napoleon III was forced to create the epoch-making Salon des Refusés, in which *Déjeuner sur l'herbe* by the French artist Édouard Manet (1833–83) was first exhibited. This exhibition had a profound effect on the definition of modern art by making absolutely clear and central its opposition to any forms of censorship and official control. Yet any representative study of modern art gives ample proof that its aims were not always rebellious or revolutionary. Indeed, many of its greatest practitioners—one thinks immediately of the Frenchmen Paul Cézanne (1839–1906), Odilon Redon (1840–1916), Édouard Vuillard (1868–1940), or the Czech Alphonse Mucha (1860–1939)—became social conservatives, and many of the most persuasive theories of modern art rooted the achievement of those artists in the greatest art of the past. Although there is a strong strand of social and, consequently, aesthetic radicalism in modern art, it is not the sole strand, and, for that reason, a book that begins with an official anti-official exhibition is methodologically hobbled by that decision.

There are troubling problems with 1851 as a starting-point, not the least of which is the fact that many of the keynote characteristics of modernism as defined in this book existed before 1851. Indeed, in approaching the work of two great English painters who died before the Crystal Palace exhibition, John Constable (1776–1837) and J. M. W. Turner (1775–1851), it becomes clear that virtually anything that could be said about the great unmediated French modernists, Courbet or Cézanne or Claude Monet (1840–1926), could also be said about them. And it is also true that virtually all the characteristics of what I will call image/modernism existed in European art before modernism. It was

in England with the Industrial Revolution that the physical, economic, social, and technological conditions of modernism first flowered. For that reason, unmediated modernism first flowered there, before being interpreted visually in France and then translated into every artistic language of the Euro-global world. Hence, our beginning.

But what of 1929? I had at first thought of 1926, the death of Claude Monet, the longest-lived artist among the Impressionists. My rationale was simple: that Monet had lived so far into the twentieth century that he had witnessed the advent of scores of avant-garde movements, many of which defined themselves in opposition to Impressionism. The paradox of an Impressionist living through all the species of anti-Impressionism appealed to me. Yet, in a book that recognizes the socio-political forces as paramount to modernity, the choice of the death of a major artist as an ending point seems ill-advised. A better approach seemed to be to tackle the entire issue of the official recognition of modernism as *the* art of our time by the formation of public museums devoted to modern art. The public opening of the Museum of Modern Art in 1929 institutionalized modernism as the offical mode of representation of the twentieth century. Its nature came increasingly to be defined by museum and university academics. The fact that this occurred only months before the collapse of the stock market and the commencement of the largest depression in the history of capitalism is fortuitous.

This book's aim is to provide a critical introduction to the recent debates and issues surrounding modern art.

Part I

Realism to Surrealism

Modern Art Movements

The history of modern art has generally been written as a loosely chronological sequence of movements, most of which were given their current names as they developed. This history is thus objective because it attempts to repeat the nomenclature and aesthetic language adopted by the artists themselves or their close apologists. In the standard histories, such as the exemplary *Painting and Sculpture in Europe 1880–1940* by George Heard Hamilton, the majority of these movements are defined in the terms set by Parisian art, with nods to the development of artistic groups elsewhere. These movements can be considered in two groups as shown below.

The Italian literary historian Renato Poggioli has written persuasively (and accessibly) about the avant-garde in modern art and literature.[1] By his definition, avant-garde groups are small and have precise

Modern art movements

Firstly there were those that were pervasive, lasted for long periods, and had loosely defined and shifting memberships: Realism, Impressionism, Symbolism, Post-Impressionism, Cubism, Expressionism, and Surrealism. This group tended to be defined and named by critics and art historians rather than by the artists themselves and to cut across national boundaries. One finds Realism throughout Europe and the Americas, as one does Impressionism, Symbolism, Cubism, Expressionism, and Surrealism, and these words have wide currency across linguistic boundaries. Yet most of the definitions of these movements are conceived in terms of a few canonical artists, making it difficult to use them as broadly applicable, historically valid descriptive categories. Secondly there were those that were small, of short duration, and with rigorous, often exclusive membership: the Pre-Raphaelite Brotherhood, Les XX, the Nabis, Suprematism, Futurism, Purism, the various Dadas, Vorticism, and Neo-Plasticism. To these must be added the numerous groups and societies of modern artists in central and eastern Europe which were frequently conceived on French, Austrian, or German models, often around short-lived cultural journals. Certain of these, the Itinerants or Wanderers from Russia, for example, were of long duration because they were devoted to the principle of freely organized exhibitions rather than to a narrow or self-selecting style or theory of representation. The tenets of these movements or groups were defined by the artists themselves, either in collective terms or in those of a powerful leader, giving them the character of small clubs or schools.

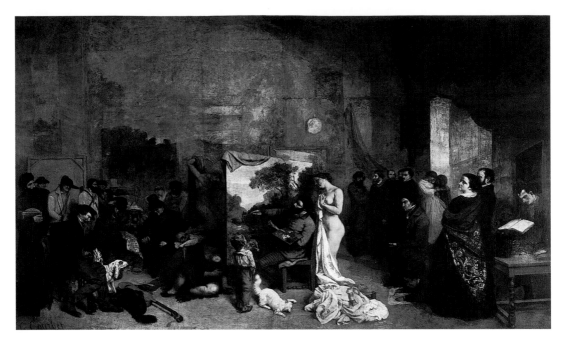

and short-term objectives. Yet, before adopting this positivist and militaristic reading of the avant-garde, it is important to remember that certain modernist groups such as the working-class café societies in 1880s Paris, certain anarchist groups, and Dada, had an almost nihilistic, anti-authoritarian (anti-garde?) character, making it difficult to consider that they were in advance of anything. All the smaller groups, avant-garde and anti-garde, can be contrasted decidedly with the movements whose theoretical positions imply a desire for long-term domination.

Despite attempts to write the history of modern art as an interplay between the avant- or anti-garde groups and the movements that grew out of them, it has proved impossible to live without or replace the categories Realism, Cubism, or Expressionism, or the terms Nabis, Synthetism, or Orphism. Now, as we look back on modernism with a greater critical detachment, we have an opportunity to reassess the utility of these terms and perhaps to consider abandoning them.[2]

Avant- or anti-garde groups or larger movements are so pervasive a feature of modern scholarship that even their detractors use them, often unconsciously, as easily understood categories. As these terms are now common currency amongst students and the general public this summary text will commence with a recounting of the history of modern art defined by these -isms, against which I will build a case for a simpler and more flexible binary system of aesthetic classification to extend the conventional history.

Realism

The canonical artist of Realism is the great French painter, Gustave Courbet, whose *The Studio of the Painter, A Real Allegory Concerning Seven Years of My Artistic Life* has most often been considered the visual manifesto of the movement [**3**]. Exhibited with a large group of other works by Courbet in a specially constructed building, Le Réalisme, outside the international exhibition of 1855, Courbet's immense painting combines the sombre tonalities of Rembrandt and Hals with the sheer scale and epic confidence of Veronese. Its self-consciousness; its acceptance of the urban condition of modern art; its relative roughness and rapidity of execution; and its self-professed Realism, separate it from any nineteenth-century painting made before it and set a standard of ambition for most that succeed it. Yet, when we look at the actual history of European and American Realist painting in the aesthetic terms defined by Courbet's art, the sheer diversity of the movement is evident.[3]

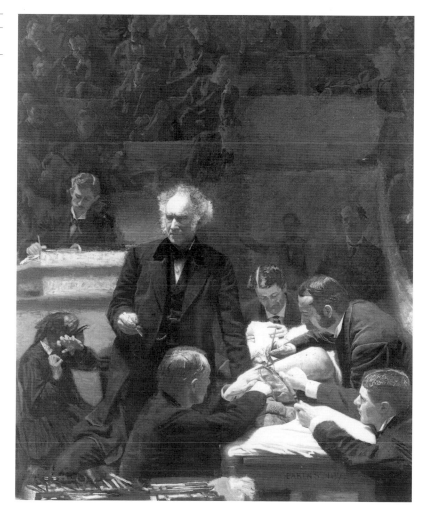

4 Thomas Eakins

The Gross Clinic, 1875, oil on canvas

This is the earliest masterpiece of international Realism in American art and it has been justly published and debated in recent literature. This, like other major Eakins's paintings from the 1870s and early 1880s, stems directly from French practice, following Eakins's extensive apprenticeship with the French painter Jean-Léon Gérôme (1824–1904) and his exposure to all the arts in Paris during the late 1860s.

Realism represented a shift in the subject-matter of art from ancient and medieval history, literature, and religion to what Courbet rightly called 'real allegories': subjects ripe with pictorial, moral, religious, and political significance. Realism can be defined as the first consciously modern artistic movement which produced complex, compelling, and mediated works of art [4]. There are two distinctly different interpretations of Realism. The first, which I shall call Transparent Realism, retained the academic techniques of defining pictorial space and the grouping of figures or forms, but instead of using traditional imagery (from history, religion, or literature) their subject-matter came from modern life. So, in paintings such as *The Railway Station* (1862) by the English artist William Powell Frith (1819–1909), it was the overtly modern subject that created a sense of modernity in their work [5]. With the alternative approach to Realism, Mediated (or self-conscious) Realism, painters conveyed modernity and meaning in their work through the unique use of paint. Courbet and his followers created crusted and heavily-worked pictorial surfaces without a clear linear substructure. Their surfaces often have the character of a stucco wall or a rough fresco. In these works, and the most extreme are the palette-knife paintings of Cézanne and Camille Pissarro (1830–1903) from the late 1860s, the artist's touch is rough and aggressive, and the power of the artist over his subject-matter becomes the true subject of the work. Here the manipulation of the medium is at least as powerful as the subject-matter depicted. This added value is important when we consider the relationship of the newly popularized medium of photography to Realism.

Early photography too had two clearly contrasted techniques, one of which, the daguerreotype or its progeny, glass-plate photography, produced (when perfectly executed) absolutely smooth and insistently linear representations (Transparent Realism, see **46**), while the second,

5 William Powell Frith

The Railway Station, 1862, oil on canvas

Frith's painting is among the earliest works of fine art to deal explicitly with rail travel. It glories in the glass and steel architectural setting for the vast machines, but does so in a style that is in no way different than that used for historical or genre paintings.

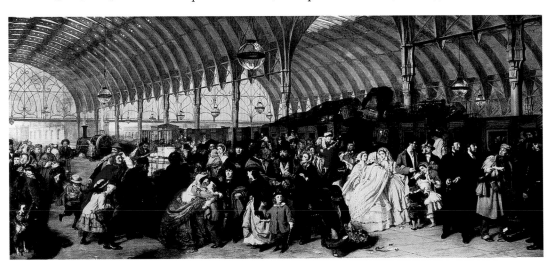

the calotype or paper-negative process, produced rougher images whose tonal masses defined their subjects in terms of value more than outline (Mediated Realism, see **47**).[4]

Impressionism

There is no doubt that Impressionism is the best-known and, paradoxically, the least understood movement in the history of art.[5] It can be defined in two ways. The narrower (and more comfortingly precise) of the two includes the artistic production of the men and women who exhibited as part of the group of artists that first called itself the Anonymous Society of Artists in 1874 and that, in various coalitions, mounted eight group exhibitions in Paris between that year and 1886.[6] The core members of this group were Monet [**6**], Pissarro, Pierre-Auguste Renoir (1841–1919) [**7**], Alfred Sisley (1839–99), Edgar Degas (1834–1917), Berthe Morisot (1841–95), and Gustave Caillebotte (1848–94). Other artists, varying in fame and quality, from Viscomte Ludovic-Napoléon Lepic (1839–90) and the Italian Giuseppe de Nittis (1846–84) to Cézanne, Paul Gauguin (1848–1903), and Georges Seurat (1859–91) were also included. While easy to accept as an historical description, this definition has no aesthetic or stylistic character. The movement itself was not clearly defined, aesthetically it embraced the dexterous and finicky urban realism of de Nittis and the freely brushed suburban Realism of Renoir.

The name itself is unsatisfactory and has always clung to the artists like an unwanted relative. Coined by a critic in response to the title of a painting by Monet (*Impression: Sunrise*, 1873), the name has come to

6 Claude Monet

The Luncheon: Monet's Garden at Argentueil, 1873–6, oil on canvas

This large painting was exhibited initially in the Impressionist Exhibition of 1877, probably as an example of a kind of private decorative panel painting for which Monet hoped to obtain commissions. This view of the painter's own garden has roots in eighteenth-century imagery and excludes any hint of the actual suburban setting of the painter's garden in Argentueil.

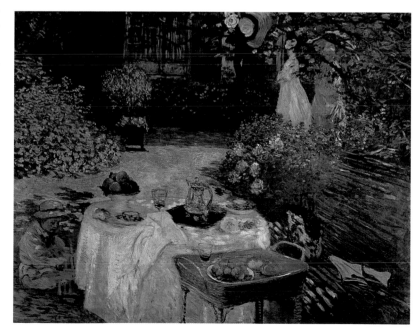

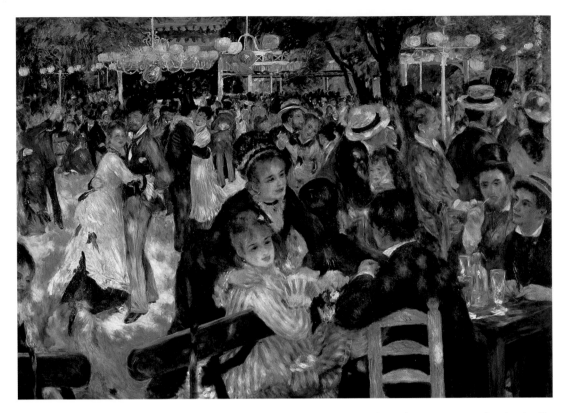

define Impressionism as an offshoot of Realism interested principally in the transcription of visual reality as it affects the retina of the painter within a discrete, and short, period of time. Hence, Monet's paintings are impressions that can, again, be closely linked to the contemporary writing and thinking about photography. This idea is appealingly connected in French theory with the coincident literary movement called naturalism, which, through its principal spokesperson, Émile Zola, defined itself as 'a corner of creation viewed through the temperament of the artist'. The essential difference between Realism and Impressionism is that Impressionism recognized and, in a sense, fetishized the subjectivity of the act of representational transcription. This aesthetic decision was to revolutionize, and define, modern art.

The latter idea is a much more compelling one to contemporary students of the movement, as it can be used to analyse the achievements of diverse artists from Monet to the American artist George Bellows (1882–1925). Yet, in attempting to reconcile it with the more historically-motivated definition, the production of artists like Cézanne, Degas [8], and Caillebotte, who did exhibit with the group, can hardly be called Impressionist, and the elaborate late paintings by Manet, who never exhibited with the Impressionists but worked alongside them, do not conform to the tenets of subjectivity and temporal compression that are essential to its unity.

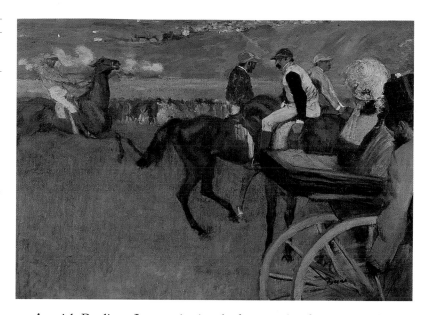

8 Edgar Degas

The Race Track: Amateur Jockeys near a Carriage, 1876–87, oil on canvas

As this racecourse scene demonstrates clearly, Degas was obsessed not only with modern life, but with highly complex compositional strategies. His exaggerated emphasis on the edges of the pictorial format can be linked to his fascination with the pictorial representation of time and motion. His pictorial world was, like that of the other Impressionists, associated with leisure activity, and hence with the sort of free time brought by industrial modernism.

As with Realism, Impressionism had two major divisions within its ranks, and these can be related directly to the two types of Realism already established. The first of these, Transparent Impressionism, includes painters of mostly landscape or urban views, of whom Monet is the canonical figure, who paint what appear to be impressions of visual reality. An example of this might be Monet's early masterpiece *On the Bank of the Seine at Bennecourt* (1868) or, in figure painting, Renoir's *The Promenade* (1870) (see **87, 116**). In this mode of painting, the subject of the painting is the entire visual field in front of the painter rather than clearly separate forms in illusionistic space. It must be emphasized, however, that Transparent Impressionism differs markedly from Transparent Realism in its insistence on the essential subjectivity of art. The viewer of any landscape or figure painting by Monet or Renoir is always aware of the artist as a character in the drama of representation. For the Transparent Impressionist, transparency lies in the temporal compression of representation and in their acceptance of the field of vision rather than a collection of three-dimensional forms in space as the subject of the painter. The eye is fetishized rather than the reality described.

The second type of Impressionism, Mediated Impressionism, is confined mainly to figure painters who, following the lead of either Degas or Renoir, constructed visual realms that stress the contingent and elliptical aspects of realist subject matter in stylistic terms that are mannered and self-consciously elaborate. Perhaps the best example of this is Degas's masterpiece of urban portraiture, *Place de la Concorde* (1874–7) [**9**], but many works by Renoir, Caillebotte, Morisot, and the American artist Mary Cassatt (1844–1926) (see **49**) within the narrow movement and countless European and American painters outside it,

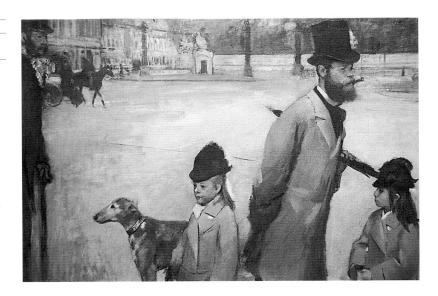

9 Edgar Degas

Place de la Concorde,
1874–7, oil on canvas

This famous painting, long
thought to have been lost in
the Second World War, has
recently emerged in Russia.
It represents a minor aristo-
crat, the Viscount Lepic, with
his two daughters and pedi-
gree dog, in a plaza built by
Louis XV, renamed after the
revolution of 1789, and
rebuilt during the Second
Empire. Thus, issues of class
and urban ownership are
subtly addressed by Degas,
whose family name had also
become falsely aristocratic
and spelled as de Gas before
the painter reclaimed it for
the bourgeoisie.

share its traits. For the Mediated Impressionist, visual reality is con-
ceived not as a vibrant coloured field, but as a social world in which the
figure and its various 'grounds' must be analysed to be understood. Any
student of the group's exhibitions and its internal dissensions knows
that the Impressionists routinely divided into two groups, one around
Monet/Renoir and the other around Degas. For the first, drawing and
composition were less important than colour and surface unity. For the
second, the painter was predominantly a creator of elaborate com-
positions with many elements, all of which related both to each other
and to the edges and proportions of the pictorial format itself. The
contrasting aesthetic aims of these two groups led, in the end, to the
collapse of the group.

I must make several general points about Impressionism before
moving on to the various movements and schools that defined them-
selves in opposition to it. The first is that Impressionist artists were
consciously independent of the state and its controls over artistic taste
and patronage, aligning themselves instead to private dealers and
collectors. In this sense, they were modern in their manner of display
and in the marketing of their art directly to clients on their own terms.
Secondly, the European and American reach of the movement was
immense, as large in many ways as that of the Realists who provided
many of the models to the Impressionists. Virtually every ambitious
artist in the Euro-global world knew of the movement by the mid-
1880s, and its effect on the practice of representation was virtually
global by 1900. Even today, the vast majority of popular or amateur
artists work in ways that have their roots in the practice of the
French Impressionists. Yet this reach has rarely been fully described or
understood by scholars, most of whom resist any serious study of the

assimilation of art practice within the population at large, preferring to concentrate their attentions on the continuously self-selecting avant-garde.

As a term, Impressionism is all but useless and should be gradually dropped from the lexicon of the art and cultural historian. It has proven an even more cumbersome term in the histories of music and literature, most probably because a caricatural definition adapted from art history has been used to describe phenomena in poetry, prose, and music that bear only a coincidental resemblance to Impressionism in visual representation.

Symbolism

The dialectical structure of modern art—indeed of modern civilization—requires a counterbalance to the art of Realism and its offshoot, Impressionism. Since complexity is as much a characteristic of modernity as is simplicity, that counterbalance has several aspects. Of these, the most pervasive and, superficially, the least apparently modern, is the movement called Symbolism. Like Realism and Impressionism/Naturalism, Symbolism was at once a literary and an artistic movement, in which a theory of representation united artists of diverse media, sociopolitical origins, and education. An exploration of the imagination as opposed to visual reality drove Symbolism [10]. For Symbolists the visual was less compelling than the visionary, and their inspiration for image-making came from the powerful content of words, including poetic and dramatic texts, folk tales, mythology, and arcane forms of literature. Yet, in keeping with much literary theory, the relationship between image and text in Symbolist art is often fascinatingly indirect, making it difficult to find in the text the meaning of

10 Oscar Gustave Rejlander
The Two Ways of Life, 1857, print from 32 wet collodion negatives
Rejlander's (1813–75) use of composite negatives to produce compositions with their roots in the history of painting received widespread publicity during his lifetime. Yet most later Symbolist photographers chose to create costumed and posed *tableaux vivants* as the subjects of their photographs rather than to create virtual collages of separate negatives like Rejlander.

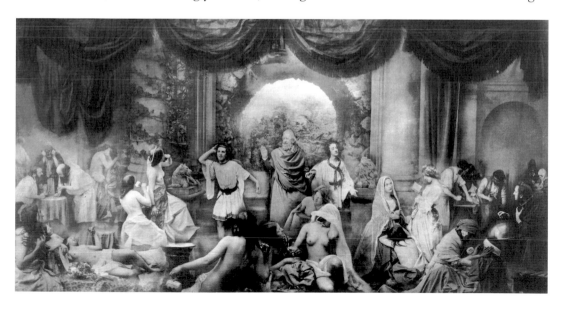

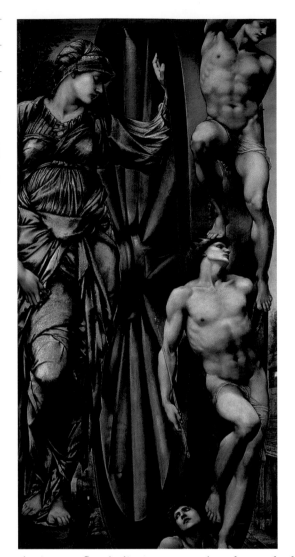

the image. Symbolism assumes the advanced education of its makers and viewers and was made for a self-selecting élite defined largely by education and access to its paraphernalia: books, prints, works of art, and other forms of cultural production.

Of all the major movements of the second half of the nineteenth century in modern art, Symbolism was the most pervasively European and least focused on France.[7] It was also closely tied to regionalist and nationalist cultural and political movements, in which artists attempted through powerful images to create links between modern people and their ancient, medieval, and, to a lesser extent, Renaissance pasts.

Symbolism was prevalent in Europe and America, with the Christian Church, however defined in various countries, being its most powerful patron [11]. This patronage and the effect of this art on audiences of believers have not been fully studied, and specifically

12 Jacek Malczewski

Melancholia, 1894,
oil on canvas

Malczewski has consistently
received international atten-
tion as the master of Polish
Symbolism. This, an early
work, shows evidence of his
fascination both with the
representation of emotional
states and with the complex
history of allegorical painting
in European art. The painting's
most obvious art-historical
precedents can be found in
the immense religious can-
vases of late Renaissance
and Baroque painting.

religious art is the least studied arena in modern art production, mostly because the Church has been viewed by secular scholars as a traditional institution that failed to evolve in a secular or modern world. The fascination of Symbolist artists with religious cults of many sorts and with spiritualism in general was so pervasive and such a major component of various modern movements or groups that the sacred must be placed at the centre, rather than the periphery, of any study of modern representation.

Symbolism was characterized by the same sort of binary structure as Realism and Impressionism. Certain Symbolists adopted the highly impersonal or academic style of Transparent Realists and of certain Mediated Impressionists: a linear style in which compositions are constructed as if in illusory space and imagery is valued more than style. Artists of this type include Fernand Khnopff (Belgian, 1858–1921), Alphonse Mucha (Czech, 1860–1939), János Vaszary (Hungarian, 1867–1939), and others [**12, 13**]. The second type, practised by artists like Gauguin, Redon, Jan Toorop (Dutch, 1858–1928), Ferdinand Hodler (Swiss, 1853–1918), and Edvard Munch (Norwegian, 1863–1944), adopts the modernist attitude towards both surface and composition, in which the artist's presence is always felt by the viewer of the work of art.

Post-Impressionism

Roger Fry coined the term Post-Impressionism in 1906, in an exhibition catalogue, as a consciously bland description of a wide variety of works of art from the last two decades of the nineteenth century.[8] The artists had mostly exhibited with Impressionists and were

predominantly French: Gauguin, Cézanne [14], Seurat, and the Dutch artist Vincent van Gogh (1853–90) [15]. In each case, the works of art were read by Fry in terms set out by the artists themselves as a form of self-conscious departure from the narrowly optical art of Impressionism. Interestingly, two of these artists, Redon [16] and Gauguin, are routinely classified as Symbolists due to their reliance on literary texts. Yet, generally, Post-Impressionists are treated as heirs to Impressionism, even as they depart from its tenets, and are contrasted to Symbolist artists, who are generally viewed as non-modern or heirs to the academy. Impressionism's early embrace of the Post-Impressionists has put them into a kind of genealogy of avant-garde modernism that has been scathingly criticized by feminist historians of art, most fervently by Griselda Pollock.[9]

The stylistic characteristics of Post-Impressionism are strong: a belief in colour as an emotional/aesthetic carrier of meaning, almost independent of form and composition; an acceptance of the artificiality of the picture; and a commitment to the portable easel picture, usually known simply as painting, as the highest mode of artistic achievement. In fact, Fry's Post-Impressionism is an historical synthesis of several discrete artist-defined movements or schools described below. His

14 Paul Cézanne

The Mill on the Couleuvre at Pontoise, 1881, oil on canvas

By the early 1880s the rifts within the Impressionist circle were becoming evident, and a general abandonment of the Impressionist fascination with the ephemeral was widely recognized by the late 1880s. Around 1900 German and British art historians recognized that Cézanne's achievement of a pictorial timelessness, as in this painting, differed markedly from Impressionism. Here, Cézanne represents an old watermill near Pissarro's home in Pontoise in such a way as to remove from the image any signs of industrial or modern time.

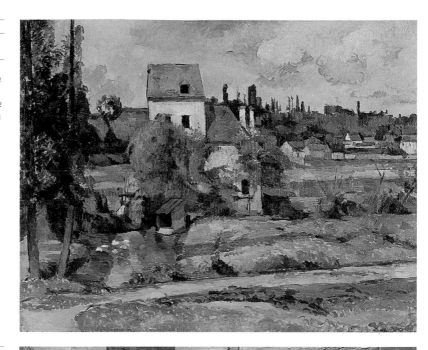

15 Vincent van Gogh

The Night Café, 1888, oil on canvas

The expressive and emotionally charged atmosphere of van Gogh's paintings are exemplified in this canvas, about which the painter himself wrote that he was expressing 'the terrible passions of humanity'. His use of contrasting colour was rooted not in optical theory, like that of his colleague and friend Seurat, but in older European ideas of the symbolic and associative meanings of colour.

Post-Impressionist artists, particularly the Frenchmen Seurat, Cézanne, and Gauguin, were widely exhibited throughout Europe and the Americas in the years between 1890 and 1929 and came to be the canonical formative figures of modern art for the earliest major theorists and writers like Julius Meier-Graefe, Roger Fry, Sheldon Cheney, and Alfred Barr. For these critics, Post-Impressionism was the true beginning of modern art.

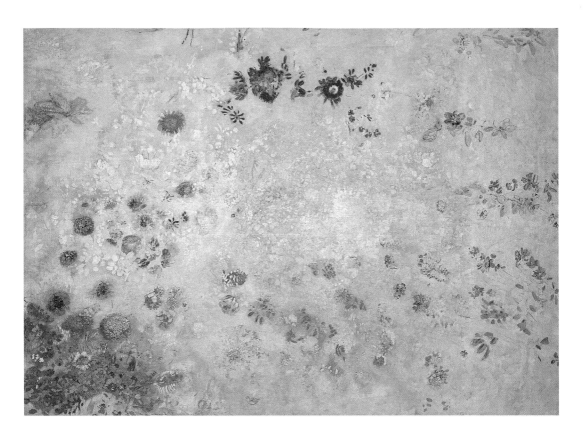

Neo-Impressionism

Two strands of Impressionist practice, light theory and artificial pictorial construction, were coupled to produce the first successfully independent art movement after Impressionism, called Neo-Impressionism or Scientific Impressionism by its practitioners. The master of the movement, Georges Seurat, painted a small number of self-conscious masterpieces before his early death at the age of 32 in 1891. These developed from a seemingly rigorous theory of light and human perception of it, the origins of which can be found in the natural sciences and which were applied imperfectly to visual representation.[10] Yet Seurat's works were so original and so commanding that they themselves created a school of artists led by the Impressionist Camille Pissarro, and by Seurat's most theoretically sophisticated friend, Paul Signac.

The crowning achievement of the movement is always identified as Seurat's *A Summer Sunday on the Island of the Grande Jatte 1884* (1884–6), exhibited at what was to be the final Impressionist exhibition of 1886 (see **96**). The surface of this picture, constructed with discrete touches of paint over which a layer of painted dots has been applied, almost exhausts the viewer with its sheer mechanical orderliness. Although based on a prolonged period of study on the suburban island

of the title, the work was constructed in a small Parisian studio from many oil studies and drawings. Its clear association with the dynastic art of ancient Egypt collides intentionally with the contemporaneity and transitoriness of its Realist subject, and both its large scale and its sheer visual pretension made it difficult for other artists to work easily in its wake. Seurat himself fretted with its successor pictures, each of which was conceived as a carefully calculated move in an aesthetic chess game that ended with his death.

Few could play it as well as Seurat, and Neo-Impressionism has often been portrayed as a short-lived movement by historians of modern art, more important for its theory, as propagated by Signac, than its painting. The falsity of this is clear when we examine the later paintings of its two other great French practitioners, Paul Signac (1863–1935)

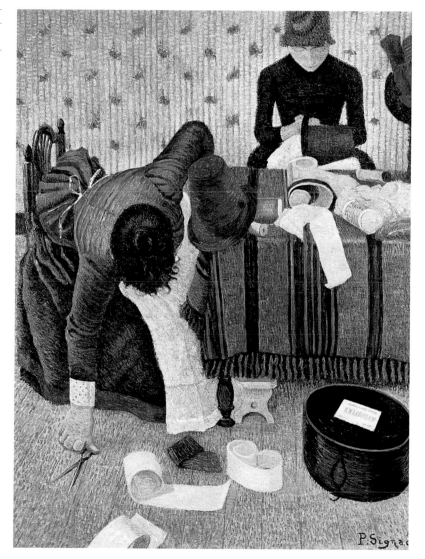

17 Paul Signac

Two Milliners (*Les Modistes*), 1885–6, oil on canvas

Although it is considerably less famous than Seurat's *Grande Jatte* which it hung next to in the final Impressionist Exhibition of 1886, Signac's painting is in some ways a more successful embodiment of both the social and pictorial ideas developed in the mid 1880s by the Neo-Impressionists.

and Henri-Edmond Cross (1856–1910), both of whom had a clear influence on European colour painting of the first two decades of the twentieth century [17]. In fact, it is possible to chart a direct lineage from Impressionism (particularly the work of Monet and Pissarro) to Neo-Impressionism to the Fauves. In addition to this French strand, there were artists throughout Europe who were moved by Seurat's form of hieratic divisionism, the most important of whom were the Italian-Swiss painter Giovanni Segantini (1858–99) and the Italian Divisionists Angelo Morbelli (1853–1919) and Guiseppe Pellizza del Volpeda (1868–1907). The movement had less impact in eastern and northern Europe and comparatively little in the English-speaking world.

Synthetism

Very few movements in the history of art were as grandly conceived, as short-lived, poorly organized, and, paradoxically, as internationally influential as Synthetism. Promoted chiefly by Gauguin, whose theories of art developed from the Impressionism of his teacher Pissarro, the movement was defined by a series of texts written by him and others. The centre for this movement was Brittany, in France, principally the town of Pont-Aven (they are often called the School of Pont-Aven), and the village of Le Pouldu, where Gauguin and his followers worked in the second half of the 1880s.[11] They exhibited only once, in a café inside the grounds of the International Exhibition of 1889.

The tenets of Synthetism are that pictorial art is the result of an aesthetic synthesis among several elements, these being the natural stimulus that prompts the work of art, the training and sensibility of the artist, and the medium at their disposal. Clearly, all this stems directly from Impressionist theory, but Gauguin's practice stressed the artificiality of picture-making and allowed greater freedoms for the artist to alter and exaggerate the formal aspects of representation, line, colour, and value. To achieve an aesthetic synthesis between artist and subject, the Synthetist artist must dominate rather than be submissive to nature. The critical painting of this movement is probably Gauguin's *Vision after the Sermon* (1888), a work that has been considered to be a revolutionary picture since it was rejected as an altarpiece by the small church in Pont-Aven [18]. Its equal engagement with 'vision' and the 'visionary' separate it from most Impressionist or Realist painting (although it is tempting to interpret it as an ironical translation of the Salon success of 1879, *Jean d'Arc écoutant son vision* by the French artist Jules Bastien-Lepage (1848–84)), and its reliance on fields of vibrant colour bounded by artificially exaggerated contours startled young artists, who immediately took it as a model for new works of art.

Oddly, Synthetism, as defined as an avant-garde subset of Symbolism, is among the most pervasive art theories of the late nineteenth

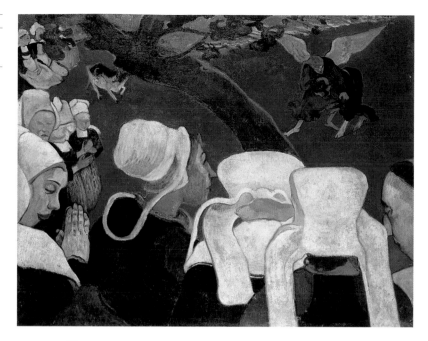

century. This is due completely to the persuasive powers of its prime exponent, Gauguin, and to the fact that the students in Pont-Aven included artists from Switzerland (Cuno Amiet, 1868–1961), Ireland (Roderic O'Connor, 1860–1940), England (Robert Bevan, 1865–1925), Belgium (Meyer de Haan, d. 1894), Hungary (József Rippl-Ronai, 1861–1927), Spain (Paco Durrio, 1868–1940), and Poland (Wladyslaw Slewinski, 1856–1918), in addition to the better-known French members (Émile Bernard (1868–1941), Paul Serusier (1863–1927), and Paul Ranson (1864–1909)). For this reason, Gauguin's idea of Synthetist painting took root in avant-garde circles throughout Europe. The movement is often called Cloissonism, after the pervasive use of black outlines and relatively undifferentiated colour. However, the use of this term is on the same simplistic level of criticism as it is to call Neo-Impressionism Pointillism.

The Nabis

Shortly before the exhibition of Synthetist Artists held in 1889, a small group of young Parisian painters banded together to form a quasi-monastic society and called themselves the Nabis (the Hebrew word for prophet). In a manner familiar to students of the various brotherhoods of Romantic and modern painting (the Nazarenes or the Pre-Raphaelite Brotherhood are the best-known examples), this was a group of very young men, most of whom had known each other at school, and all of whom needed the others in order to achieve a sense of identity as a modern artist.[12] The Nabis membership included the Frenchmen Vuillard, Maurice Denis (1870–1943), Pierre Bonnard

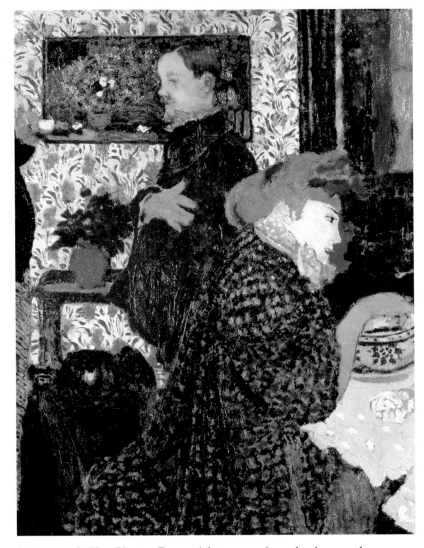

19 Édouard Vuillard

Misia and Vallotton in the Dining Room, 1899, oil on cardboard

This tiny painting represents two of the painter's friends among an international bohemian circle in late nineteenth-century Paris. Misia Natanson was Polish and her friend Félix Vallotton was Swiss, and both were represented as belonging utterly to a cluttered interior represented by a French man.

(1867–1947), Ker-Xavier Roussel (1877–1944), and others and soon expanded to include the Swiss-born artist Félix Vallotton (1865–1925) and the French sculptor Aristide Maillol (1861–1944). Two other major artists were closely associated with the Nabis, Redon, who had exhibited with the Impressionists, and the young French nobleman Henri de Toulouse-Lautrec (1864–1901). The aesthetic theory of these artists was not in any way different to that of Gauguin's Synthetist group, but the Parisian character of the movement, together with Denis's eventual embrace of Catholicism, gave it a distinct character, at once progressive and traditional.

Far from being major inventors or, in their own terms, prophets, the Nabis were artists who refined Gauguin's Synthetist practice and applied it to urban subject-matter retaining its roots in the art of Degas. They were chiefly important in the larger history of art for their close

associations with the Nathanson family, a younger member of which founded the important journal, *La Revue blanche*. These young artists embraced an international Jewish clientele and were thus able to spread certain of the most advanced aesthetic doctrines of Impressionism and Synthetism throughout Europe. Their close association lasted little more than a decade, during which time they exhibited as part of other groups. They used their collective influence to further various short-lived projects, both artistic and literary.

There is no canonical work associated with the Nabis, but surely the greatest individual achievement associated with the movement is that of Vuillard [**19**]. Had Vuillard died in 1900 after just a decade of work, rather than in 1938, he would have a greater reputation today than he currently enjoys. Like the Frenchman Jean-Baptiste-Camille Corot (1796–1875) earlier in the century, his most persuasive and internationally admired work was his earliest. Perhaps the best example of this is the *Large Interior with Six Figures* (1897). Here a domestic interior of extraordinary subtlety and complexity is arranged on a large horizontal canvas, almost as if from puzzle pieces or as elements of a highly complex tapestry (see **120**). There is nothing prophetic about this work; rather, it acts as a brilliant summary of a generation of modern art and its pictorial theories.

The Fauves

The French critic Louis Vauxcelles coined the expression, the Fauves or 'wild ones', to describe the brilliantly, or savagely, coloured landscapes, portraits, and genre scenes by a group of French painters centred around Henri Matisse (1869–1954) in 1905 and 1906.[13] This group included André Derain (1880–1954) and Raoul Dufy (1877–1953), and has its roots in the late painting of the Neo-Impressionists, most notably Cross and Signac. In many ways, the Fauves were a logical development of the painting of two Post-Impressionists, Gauguin and van Gogh, each of whom liberated colour from the restrictive and consciously scientific role that it played in the art of the Neo-Impressionists. Yet, like most observations, this is not strictly the case; after the death of Seurat, Signac and Cross worked in ways that departed dramatically from the purely optical theories exemplified by Seurat. Their colour dots became patches and dabs of larger and larger scale, and their use of colour theory began to stress the independent nature of pictorial construction over the workings of the human eye. Hence, they made room in their art for an idea of the picture as a pictorial surface that communicated certain emotions through the interaction of colour independent either of nature or of our visual perception of it.

Although Matisse was to become the dominating artist of Fauvism, the work of another Frenchman, Maurice de Vlaminck (1876–1958) and Derain in 1904–7 was equally powerful and impressive. An

example of the pictorial force of these comparatively minor artists is surely Vlaminck's *Bougival* (c.1905) [**20**]. Here a strictly Impressionist subject, a site associated with Monet and Renoir in the early years of the movement, is injected with a pictorial energy that owes much more to the painting of van Gogh, featured in a retrospective in Paris in 1904, than it does to the colour constructions of the Impressionists. Yet the full impact of the French movement on the aesthetic autonomy of colour does not come until 1907–8, and one must wait until 1910–11 to find a completely mature and confident mastery over colour. In Matisse's *The Red Studio* (1911), all thoughts of Gauguin and van Gogh vanish [**21**].

Fauve painting had immense global impact, particularly through exhibitions, in the years before the First World War. For that reason, it is possible to identify works that stem directly from this Parisian avant-garde in many different countries from Australia to Czechoslovakia.[14]

Expressionism

Although French art completely dominated both the invention and the propagation of artistic movements and avant-garde groups,

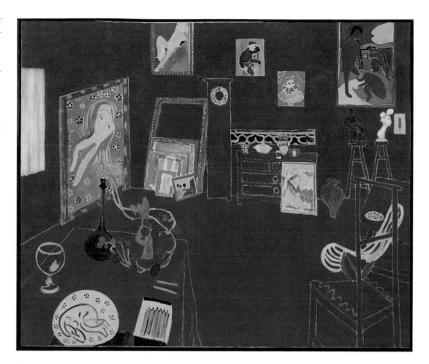

The Red Studio, Issy-les-Moulineaux, 1911, oil on canvas

The chromatic liberation of Fauvism attained its highest level in the painting of Henri Matisse, whose work around 1910 was intended to contrast in every way to the non-chromatic and analytical painting of his friends Picasso and Braque. Here, the colour red so suffuses the composition that it becomes, in essence, the subject of the painting.

German artists played an important role in the propagation of that history. It took the publication of Julius Meier-Graefe's *Modern Art* in 1904 to goad German artists into the action that produced the first authentic avant-garde in that country, known today as Expressionism (and too often as German Expressionism). Because Germany lacked a traditional capital city that could serve to centre, organize, and distribute its cultural energies, its history of modern art has tended more often to be regional and decentralized. It was not until German painters, following the lead of the French, organized themselves around the expressive painting of the elderly Realist, Max Liebermann (1847–1935), and the richly painterly canvases of Lovis Corinth (1858–1925) that they were able to produce an art whose emotional power and raw pictorial surfaces make contemporary French work seem precise and cool.

The art produced by two crucial avant-garde groups dominates the German Expressionist avant-garde: Die Brücke, founded in 1905 in Dresden and dominated by the painting of one of its founders, Ernst Kirchner (1880–1938) [22]; and Der Blaue Reiter, founded in 1911 in Munich as an exhibition society that provided a forum for the work of three great painters, two Germans, Franz Marc (1880–1916) and Gabriele Münter (1877–1962), and one Russian, Wassily Kandinsky (1866–1944), who had lived in Munich since 1896. All these artists produced work that, like that of their French counterparts, the Fauves, was dominated by high-intensity colour and stemmed from the work of van Gogh and Gauguin. For the Expressionists, the emotional strength

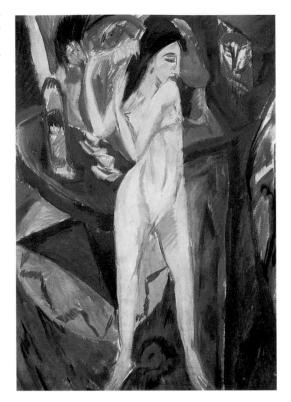

22 Ernst Ludwig Kirchner

Nude Woman Combing her Hair, 1913, oil on canvas

The brothel imagery of Kirchner derived from a long tradition in vanguard painting stemming from Manet, Degas, and Toulouse-Lautrec. In the German work, the subject-matter was given renewed power through the use of expressive formal devices that intensify the picture's tortuous emotional atmosphere. How different this is from the timeless nudes of Cézanne and Renoir.

of their subjects was as important as the colour. Though, like their French colleagues, several of them rooted their imagery in Realist urban culture, their works deal forthrightly with social class, commodified sexuality, the world of animals (both in captivity and in the wild), and finally, in the art of Kandinsky and others, with mythology and folk tales. In many ways, the Expressionists fused Realism and Symbolism with the conscious chromatic excesses of the Fauves. Largely because of the persistence of anti-German ideology throughout the twentieth century in France, Britain, and the United States, the art of the German Expressionists is underplayed in the museums, survey texts, and university courses of those defining countries. However, the European reach of Expressionist art was extraordinary, particularly in Russia and central Europe, where the German language and Germanic or Austro-Hungarian culture vied with that of France for cultural dominance.[15]

Cubism

The first artistic movement to rival Impressionism in its global reach and broad international significance was Cubism. Like Fauvism, the movement was named by Vauxcelles when in 1908 he referred to Braque's contemporary paintings as 'bizarreries cubiques'. Cubism as a movement has been recognized since shortly after its development as the most original invention of twentieth-century pictorial art. Although

rooted in the tightly organized paintings of Cézanne, which were seen by young artists in the immense retrospective in Paris held in 1907, the Cubist breakdown of the object and its relative disdain for expressive colour have always been interpreted as a radically inventive strategy in Western art and compared with such powerful artistic phenomena as the development of one-point perspective in the Renaissance. Indeed, the inventions of the Cubists have been powerfully exaggerated by their apologists, many of whom wanted to see a complete rebirth in the art of painting in the early twentieth century and to endow art with mythic powers in an attempt to redefine the relationship between seeing and representing.

The careers of the canonical Cubist practitioners, the Spaniard Pablo Picasso (1881–1973) and the Frenchman Georges Braque (1882–1963), were so intertwined in the years 1907–14 that many amateur art lovers cannot easily tell their paintings apart.[16] In the definitive exhibition of their work at the Museum of Modern Art in 1989, the competitive edge went to Picasso, whose work was extolled most passionately in the intense and learned pronouncements of Leo Steinberg. Yet, like many avant-garde practitioners, neither Picasso nor Braque were persuasive theorists of art. For that, one must turn to a group of minor artists, often referred to as the Puteaux Cubists after the Parisian suburb in which they worked. Led by the Frenchmen Albert Gleizes (1881–1953) and Jean Metzinger (1885–1941) they defined in clear language the aesthetic tenets of Cubism. The fact that many of their ideas relate imperfectly to the practice of Braque and Picasso is not surprising, given the fact that, in this case, the theory post-dated the practice of the inventors and was not rooted in a close study of their works.

Cubism has a small canon that has been defined by critics and historians to include the work of the Spaniard Juan Gris (1887–1927) and the Frenchmen Fernand Léger (1881–1955) and Robert Delaunay (1885–1941) as major followers of Picasso and Braque and then fans out to include relatively minor French artists such as Henri le Fauconnier (1881–1946), Marcel Duchamp (1887–1968), Roger de la Fresnaye (1885–1925), and others. Indeed, few major artists of the early twentieth century were untouched by Cubism, and even those who wrestled with it and rejected it such as Piet Mondrian (Dutch, 1872–1944), Gino Severini (Italian, 1883–1966), or Kasimir Malevich (Russian, 1878–1935), could not have developed as they did without dealing powerfully with Cubist practice and theory. Cubism was also a good deal more international in its scope than is often recognized in the predominantly French-oriented bibliography and exhibition history. The art of the Russian and early Soviet avant-garde is inconceivable without it, and there were major Cubist practitioners by 1909–10 in New York, Milan, Prague, Bucharest, and Moscow, to name only major centres.

Cubist practice is divided into two major phases, called Analytic and Synthetic respectively. Unlike the simultaneous and intertwined development of the double strands of Realism, Impressionism, and Symbolism, those in Cubist practice were successive. The Analytic phase, here exemplified by Picasso's great *Portrait of Ambroise Vollard* (1909–10) [**23**], tended to be monochromatic and obsessed with the creation of a shifting geometric pictorial image that fills the centre of the composition and radiates out toward the edges of the pictorial format [**24**]. In theory, the artist arrives at the geometric structure by studying the subject over time and analysing its pictorial character. The pictorial vocabulary of short black lines and patches of paint applied in sequences of clustered strokes is so simple that the challenge is to wrest from the subject (a figure, a still-life, or an architectural landscape are the most common) the basic characteristics of contour and value. These, when assembled on the surface of the canvas, create an image that embodies what theorists hoped to be the 'essential' qualities of the pictured subject.

The second phase of Cubist practice, the so-called Synthetic phase [**24**], applies to Cubist practice the same aesthetic shift that took Impressionism from optical description to Synthetism. Yet, for the Cubists, the Synthetic phase is rooted in a particular pictorial practice, collage, in which the image is constructed not only with painted (or drawn) lines and patches, but also with pasted elements from popular

23 Pablo Picasso

Portrait of Ambroise Vollard, 1909–10, oil on canvas

The great art dealer had been painted by both Cézanne and Renoir when he sat for this, the most famous of his many portraits. His immense bald head looms from a veritable network of lines and painted marks that give energy and dynamism to a type of painting that is traditionally associated with stability. The Cubism of Picasso and Braque was achieved through intense collaborative practice and lacked the theoretical dimension of the Cubists Albert Gleizes (1881–1953) and Jean Metzinger (1883–1956) who first wrote about the movement in *Du Cubisme*, published in August 1912.

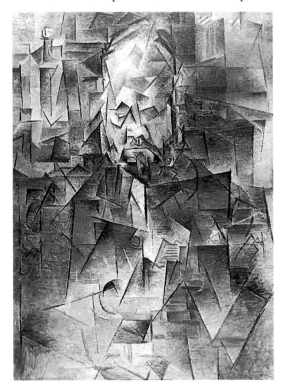

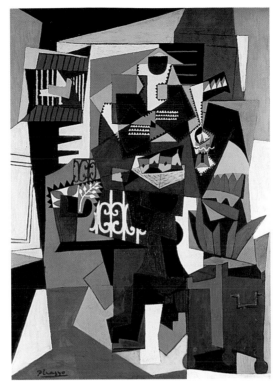

24 Pablo Picasso
The Bird Cage, 1923,
oil on canvas

visual culture: wall-paper, sheet music, posters, newspapers, theatre
tickets, and other flat urban refuse. The idea that the image is a syn-
thesis of pictorial elements, some of which are hand-made and
others of which are borrowed, makes it clear that the representation is
not only artificial, but also essentially flat. The practice also relates the
artist to the urban image maker who works for commercial purposes
and to the world of the urban worker, forging powerful aesthetic and
political links between the Cubists and the art of the early Realists.

Futurism

Modern art in Italy is all too often downplayed in histories of modern
art, particularly the brilliant developments of the Macchiaiolli in the
1850s and 1860s and the real fluorescence of painting around the 1890s
with the Divisionist painters of Milan, Pelizza, Morbelli, and Giovanni
Segantini (1858–99). Yet the first powerful interaction between Italian
and French vanguard artists took place in the second decade of the
twentieth century and involved a group of artists who called them-
selves Futurists. Led by the Italians Severini, Umberto Boccioni (1882–
1916), Giacomo Balla (1871–1958), Carlo Carrà (1881–1966), and Filippo
Tommaso Marinetti (1876–1944), the group moved easily between
northern Italy and Paris, learning fully from the developments of the
Cubists.[17] Yet, unlike the principal Cubists, the Futurists were ob-
sessed primarily with words, and issued various manifestos, essays, and

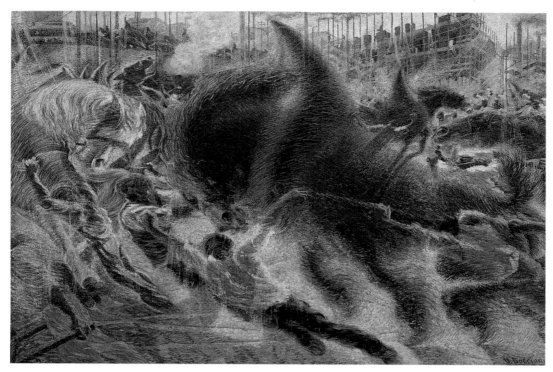

25 Umberto Boccioni

The City Rises, 1910, oil on canvas

Here, Boccioni is primarily concerned with the representation of movement and flux. Rhythmically repeated lines derived from the motion photography of Marey and Muybridge are combined with brilliant colours and an urban subject to create an image of time that is both progressive and utterly modern. Boccioni chose to represent urban construction of a completely pre-modern sort, using horses and manual labour rather than machines and machine-made forms.

even books about their aesthetic theories. Like the Impressionists before them, the Futurists celebrated motion and the simultaneity of unrelated events [**25**]. They took the Impressionist preoccupation with the machine, the railroad, and the industrial transformation of the urban/suburban environment, and combined it with the pictorial inventions of the Cubists to invent a synthetic urban art that is highly rhythmic and infused with the energy of rapidly moving time. While time in Cubist art is generally the time of an observer's study of a static subject, Futurist time is dependent less upon an observer than on a sense of collective experience. The Cubists were visually unprepared for the First World War. For the Futurists, it was not only inevitable, but representable.

Orphism

Orphism was, more or less, a one-person movement, which, with the marriage of its instigator, Robert Delaunay, to Sonia Terk, became a partnership. The name itself was coined by Guillaume Apollinaire to describe the work of a group of artists who liberated colour from any representational function.[18] Delaunay's colour painting [**26**] developed together with a theory of painting that he himself articulated, and both his theory and practice had a profound effect on painting beyond France. In the United States, American painters Stanton McDonald-Wright (1890–1973) and Morgan Russell (1886–1953) developed Delaunay's art to produce a body of work that is

26 Robert Delaunay

Circular Forms: Sun, Moon, Simultane I, 1912–13, oil on canvas

Delaunay was the great pictorial exponent of the theory of simultaneous colour contrast in French art after Seurat. Yet, rather than apply that theory to a fundamentally representational art, Delaunay created a brand of abstraction in which colour itself carries the meaning of the picture. In this work, he makes strong associations with a planetary realm more familiar to students of science than to those of fine art.

27 František Kupka

Vertical Planes III, 1912–13, oil on canvas

Kupka was the first eastern European artist to have a profound effect on the development of French painting. He lived mostly in Paris before the First World War and worked intensively with Delaunay. However, his particular brand of colour modernism was distinctive in eschewing both primary colours and the theory of simultaneous contrast fetishized by his French colleague.

immensely sophisticated and internationally significant. Yet it was in Paris and Prague that the Czech František Kupka (1871–1957) created work that pushed Delaunay's even further. Like most French artists of the modern tradition, Delaunay was hobbled by that tradition, and he seems to have been forced by history to base his colour painting on the earlier theories of Chevreul and Rood, most of which had already been applied to painting by the Neo-Impressionists. In this way, Delaunay and his American followers conceived of colour in the fundamentally optical terms of simultaneous contrast. Kupka's work stems much more fully from Symbolist synesthesia in which colour is related to musical sound. Thus he produced works of startling chromatic originality because his theory was more supple and suggestive [27]. The Orphic Cubists, as they were often called, have been seen as the instigators of abstract painting in France and central Europe.

Vorticism

Since the Pre-Raphaelite Brotherhood, English artists had made few attempts to band together in avant-garde groups. This all changed in the second decade of the twentieth century when the painter Wyndham Lewis (1884–1957) developed a theory of art that he called Vorticism, which concentrated the theories of synthetic Cubism and the Italian Futurists to produce a new art movement. Like many vanguard movements, this one linked the visual arts and literature, with the poet Ezra Pound being as important to Vorticism as Zola was to Impressionism, Mallarmé to Symbolism, and Apollinaire to Cubism. These artists and writers developed a powerful body of work before, during, and just after the First World War. The group unfortunately dissolved in the 1920s, as London lost its vitality as a centre for the

28 David Bomberg

The Mud Bath, 1914, oil on canvas

Although overshadowed by the reputation of his colleague Wyndham Lewis, Bomberg was in some ways the more accomplished painter. By combining the theories of Cubism and Futurism with his own visual speculations, Bomberg created a form of pictorial dynamism more in keeping with the individual achievement of Léger than with the theoretically inclined work of the Puteaux Cubists or the Futurists.

production of modern art. Yet, at their best, Lewis and his colleagues, C. R. W. Nevinson (1889–1946), William Roberts (1895–1980), and David Bomberg (1890–1957) created a body of experimental art as interesting and vital as any in the world [**28**].[19]

Suprematism/Constructivism

If Vorticism is linked almost directly with the experience and repres- entation of war, the most powerful movement in the creation of a com- pletely abstract art in the early twentieth century is inextricably linked with the Russian Revolution. Suprematism and its successor movement Constructivism are inconceivable without the Russian Revolution. Although Kasimir Malevich claimed to have developed a completely abstract art by 1913 and is known to have exhibited non-objective collages in that year, it was not until after the 1917 revolution that his art became an exemplar not only of pure aesthetic research, but also of a new social and economic world order [**29**]. Together with a well-formed and internationally significant group of vanguard artists, Malevich constructed a theory of autonomous, non-representational art that was linked by many early revolutionaries to the kind of

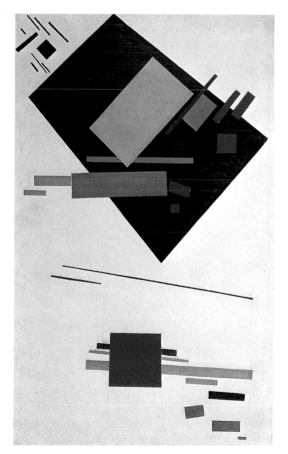

29 Kasimir Malevich

Suprematist Composition: Black Trapezium and Red Square, after 1915, oil on canvas

This work bears the name of the movement that it embodies in its title. Its sense of complete freedom from representation and its relatively impersonal facture are hallmarks of Russian vanguard painting in the years immediately preceding the Revolution.

cataclysmic social forces that were to transform Tsarist Russia. For the first time in European art history, the most advanced art was directly linked to equally advanced social and political theory, and artists worked with architects, writers, musicians, dancers, and actors to transform the visual world. There is no more important social/ aesthetic/political experiment in the history of modern art than Malevich's Suprematism and its general offshoot, Constructivism.[20] Its crushing defeat at the hands of Stalin and its resulting inaccessibility both to Soviets and to the capitalist West is one of the gravest acts of censorship in modern history, an act only partially redeemed today.

For Malevich, human consciousness rather than the visual world was the true, or supreme, subject of art, and he made the radical leap into an art composed of elements with no relationship to the forms of nature. His thinking was largely prompted by the Futurists, whose name he adopted as early as 1913, and whose primary theorist, Marinetti, visited him in St Petersburg in 1914. Yet, the strong tradition of Symbolist art and theory in Russia looms large in Malevich's commitment to the expression of the artist's emotions through abstract elements. Like many avant-garde leaders, Malevich was a dedicated polemicist and had learned from the close ties between Russia and France of the importance of independent exhibitions in propagating aesthetic doctrine to the intelligentsia. Europe's first truly independent artists' group was not French but Russian (first with Artel in 1863 and then with the Association of Travelling Art Exhibits, which transformed Russian artistic consciousness from 1870 until 1923).

Few European nations other than Russia could have produced a population of artists who could create a revolutionary consciousness through images (see **123**). The list of the names of artists associated with what some have called the Great Utopia would fill pages of this book, and, unlike other avant-garde movements, this one became part of the larger society it did so much to define. The failures of that society led to its demise and to the odd marginalization of the only successful vanguard movement in the history of art.

Neo-Plasticism

The Western world is much more familiar with the theories and practice of abstraction as developed by Mondrian and a small group of Dutch artists and architects than they are with the production of the Great Utopia [30]. Mondrian lived and worked in France, England, and the United States as well as his native Holland, and he was accessible to the defining intellectuals of modern art, both French and American. Although he worked closely with followers, encouraged the formation of a group called De Stijl and wrote powerful polemical prose, his art remained curiously hermetic, and he died in virtual isolation in New York.

30 Theo van Doesburg (1883–1931)

Pure Painting, 1920, oil on canvas

Even the title of this painting tells us of its abstract significance. If Purism was to become the name for a later Parisian movement, it also served as a kind of talisman for Dutch painters of the late 1910s and early 1920s, who strove to get beyond painting as a form of personal emotional expression to another kind of art in which the pure interplay between the painting and the viewer was more important to pictorial theory.

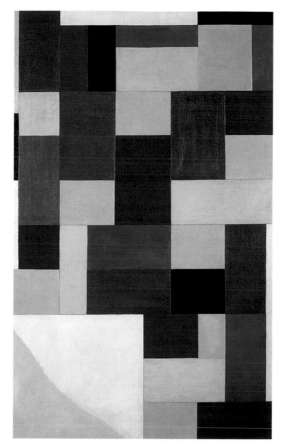

31 Piet Mondrian

Composition with Great Blue Plane, 1921, oil on canvas

Mondrian was the most consistent and important painter/theorist connected with geometric abstraction. In a sense, each of his works represents a step along a path that he set for himself. Though this path was fundamentally linear, his quest took him away from his native Holland to Paris, London, and New York, freeing him from the complex politics of the Dutch de Stijl movement, to which he contributed so powerfully.

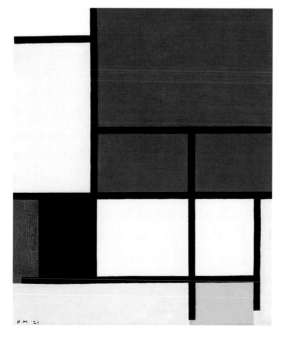

Mondrian's ideas of a new plastic consciousness in which art is completely liberated from representation stem from Symbolist theory, and it is no accident that his own early work is a form of late, rather decorative Symbolism [31]. Yet while living in Paris, where he was directly exposed to the various strands of avant-garde art, he practised a kind of non-referential image making in which linear and geometric elements play roles that have no apparent connection with the visual world. It is not accidental that Mondrian's pure plastic art arose simultaneously with that of Malevich and his colleagues in Russia, but, unlike their boldly dynamic work, Mondrian's art is consciously constrained and, in many senses, classical.[21] Whereas Malevich's constructions celebrate the world of the diagonal, and play visual games with rhythmic forms, Mondrian's work celebrates the restrictions of the easel-picture's rectilinear format, producing a form of modern plasticism that has its roots in the Protestant world in which Mondrian, like his countryman van Gogh, was born.

Dada

If there is an anti-movement in the history of modern art, it is Dada. Its name is nonsensical; its membership was shifting and unpredictable; and its aims had more to do with randomness, total freedom of expression, absurdity, and abandon than with the construction of a new aesthetic system for replication by others. Yet, like most of the other groups already discussed, Dada had various urban centres of operation, was highly theoretical and textually based, and had a cadre of leaders and hangers-on, all giving it the quality of the organized avant-garde it

32 Francis Picabia

Universal Prostitution, 1916–19, ink, tempera, and metallic paint on cardboard

Picabia (1879–1953) and his friend Duchamp were the primary French exponents of Dada. Both in Paris and New York, they produced images like this that have their origins in scientific and technical illustration rather than in art. Their delight in verbal play and in trans-linguistic punning are also hallmarks of a type of art-making associated with the Dada movement. This painting was made in New York during the First World War.

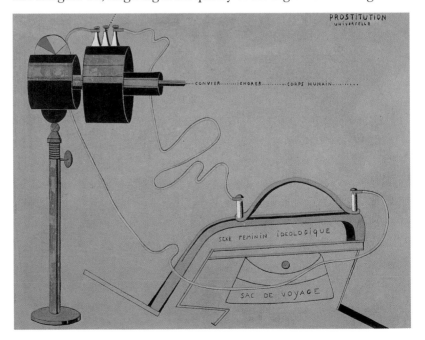

sought to displace.[22] Its major precedents in cultural history were the radical cafés of Paris in the 1880s and 1890s, where all forms of bizarre anti-bourgeois behaviour were encouraged and where works of art were made as part of performances or as instigators of conversation (or contrived argument). The most extreme manifestation of avant-garde café culture was the poet-playwright-philosopher-drunkard Alfred Jarry (1873–1907) whose creation of an anti-order, an anti-doctrinaire doctrine, and, in a sense, an anti-life defined an absurdist strategy that came to be closely associated with Dada.

A list of individual works of art as embodiments of the essential characteristics of Dada would be completely unfair to the tenets of this anti-movement. In fact, a good many of the most characteristic works associated with Dada were impermanent, made, that is, in conjunction with the cabaret culture that was, in itself, the art form of Dada. The Merz constructions of urban refuse created by the German Kurt Schwitters (1887–1948) and the found objects selected and entitled by Duchamp are evidence of the extreme divergence of artistic practice that can be classified as Dada. Schwitters unearthed urban refuse like a truffle sniffer, arranging it with the artificiality of an Escoffier. Duchamp transformed the artist into an intellectual shopper who, in browsing through the shops of a busy city, would suddenly pounce, leaving to his viewers the task of interpreting his selection.

Dada's origins are intertwined with those of the First World War, and it was in the relative neutrality of Zurich and New York that artists of various nationalities formed their cells of inanity in imitation of the larger inanities of their world [32]. Dada had none of the intense idealism of the various abstract movements—all of which saw room for hope in the creation of a world beyond the War. Indeed, the nihilism and individualism of the Dadaists can be contrasted utterly with the idealism and conformism that characterized movements such as Suprematism, Constructivism, and Neo-Plasticism.

Purism

The majority of important avant-garde groups of the second decade of the twentieth century arose in the years around the First World War, and few arose in the decade following it. In fact, the 1920s can be read as a consolidating decade for the avant-garde, and its most important advances were made in the systematic education of modern artists, exemplified by the Bauhaus, and by the attempt on the part of a group of French and Swiss artists to create a new industrial classicism or machine aesthetic. Three French artists, Léger [35], Amédée Ozenfant (1886–1966) [33], and Le Corbusier (1887–1965) banded together in the early and mid 1920s to create a theory of art and architecture in which the basic products of industry became the new standards of a modern order.[23] For these artists, a mass-produced glass, pitcher, plate, or pis-

33 Amédée Ozenfant

33 Amédée Ozenfant

The Jug, 1926, oil on canvas

This enormous painting is perhaps the pictorial manifesto of Purism. In it both architectural elements and ordinary utilitarian objects are distilled to their essential characteristics and arranged in such a way as to demonstrate the theoretically universal qualities of form. The interlinked profiles of a pitcher and a moulding are intended to demonstrate that all beautiful forms share fundamental qualities.

ton was as pure a form as a Greek kouros or a Renaissance bronze, and the analysis of these objects, created for use by new technology, would provide the standards against which all forms should be judged. Nothing was outside the realm of art, and the role of the modern artist was to produce a new visual world, in keeping with industrial technology, in which beauty was to be found in the world of mass production. In many ways, their thinking went way beyond the art of painting. Yet each used painting as a way of communicating these ideals to a sophisticated intelligentsia. Their most profound moment came in 1925 at the Exhibition of Decorative Arts in Paris, in which they collaborated to create new domestic spaces in which painting, sculpture, furniture, decorative arts, and architecture were all equal in their conscious emulation of mass-produced objects. Their utopian world was so pure that it appealed to only a few wealthy clients rather than to the workers and social organizers for whom it was intended.

Surrealism

As the Purists attempted to transcend easel painting and to create a new world order through industrial classicism, another group of artists and writers came to the fore in Paris.[24] It was in 1924 that the writer André Breton (1896–1966) issued the first Surrealist manifesto, not for visual artists, but for writers. He called for a poetics of the unconscious, of the mental world outside the control of reason and social organization. For Breton, the unconscious was as real and as susceptible to representation as the visual world, and he formed a cadre of friends and associates who valued literary and visual representations based on hallucinations, dreams, nightmares, and other manifestations of the unconscious. These men and women developed new strategies for art making that 'revealed' the unconscious, visualizing, in so doing, the secrets of the imagination. That their thinking stems logically from

34 Salvador Dalí

Little Cinders, 1927, oil on panel

Dalí following the suggestive pictorial lead of the Spaniard Miró and the Italian Giorgio de Chirico as well as the theoretical direction of the French theorist André Breton, broke free from both Realism and Cubism to lead a group of artists who used dreams, memories, and fantasies as their pictorial sources. This early Surrealist painting adds a disturbing dream realism to Miró's fields of colour and areas of automatic or unconsciously motivated drawing.

Freud is worth noting, as is the pre-eminence in Surrealist practice given to the word and literature. The effect of Breton's suggestive and ambiguous prose was to inject a new energy and experimentalism into the practice of picture making.

There are two main types of Surrealist practice. The first of these, exemplified by the painting of the Italian Giorgio de Chirico (1888–1978) (who in fact preceded Breton by more than a decade), the Belgians René Magritte (1898–1967) and Paul Delvaux (1897–1994), and the Spaniard Salvador Dalí (1904–1989) [34], accepts as true all the conventional representational strategies of western painting—perspective, shading, shadows, atmospheric perspective, local colour, and a transparent surface. However, these conventions were subverted in the minds of the Surrealists because they were used to give the illusion of reality to the surreal or unconscious. The origins of Surrealist imagery of this sort lie in dreams, in the encounter between the truth of visual conventions and their sheer artificiality, and in the tensions between transparent technique and opaque subject-matter.

The second type of Surrealist practice has no clear representational function but is, rather, the use of materials by artists either during a trance or without a clear representational plan. In this way the work of art is automatic, the direct communication of the unconscious mind. This technique has a long history in spirit photography and other Symbolist attempts to give form to the unconscious imagination. But at no time in the history of art before the Frenchman André Masson (1896–1987) and the Spaniard Joan Miró (1893–1983) were the results of this type of experimentation considered to be art. 'Automatic drawing' became one of the central tropes of Surrealist practice, and its revival in the United States during the late 1930s and early 1940s had a tremendously liberating effect on the history of post-war American abstraction. It is interesting, in this context, to speculate on the connections between the automatic qualities of Transparent Impressionism, with its belief in rapid and largely unconscious visual transcription, and those of the Surrealists, who eschewed any visual armature for the image. Again, the seeds for a branch of the last modern movement covered in this book can be found in an earlier one.

Surrealism was, like Realism, Impressionism, Symbolism, and Cubism, a widespread movement that had a profound, and prolonged, effect on world art. Its global reach was insured by the chaos that resulted from the global depression and increasing warmongering of the 1930s, and cells of Surrealist, along with other, artists and writers settled in the United States, Mexico, Argentina, and Brazil, invigorating the artistic traditions of those provincial centres with doses of modernist theory.

The '-ism' problem

This necessarily brief summary of the conventional movement-based history of modern art makes clear the inherent limitations and even the contradictions of the approach. These problems of definitional clarity are not in themselves insurmountable. Indeed, the idea that the representational arts of a long period in the history of modern culture can be reduced to a few simple formulae would terrify most of us whose aim is to explain that art.

In thinking about the meaning of the visual, the real, and the representation, no one can deny the absolute relevance of photographic theory and the closely intertwined practice. The mechanization of visual reproduction transformed both the distribution and the idea of art in the industrial world, and the almost hermetic development of painting that is the history of modern representation must be read as a reaction against the proliferation of mass-produced representations. It must also be remembered that photography played a very important role in the working process of artists as diverse as Gauguin and the American Man Ray (1890–1976) and that, by the turn of the century, photography was seen as an important modern art form, whose practitioners were major forces in modernism.[25] Indeed, the history of modernism in America is inconceivable without the photographer-theorist-dealer-collector Alfred Stieglitz (1864–1946), and the practice of photography was an essential part of the Bauhaus.[26]

The recent opening-up of Russia and central Europe has coincided with a massive attempt to redescribe modernism in western Europe, the Americas, and Australia. This has resulted in a data-glut of proportions for which all of us are unprepared. Few historians of modern art, trained in the West during the last generation, even know the names of the major figures in eastern European or Latin American modernism, in either the nineteenth or the twentieth century. And the national histories of art kept so faithfully by historians and museum curators in Russia and eastern Europe have not been linked to the truly international and cosmopolitan art history to which they belong. Artists working in Bucharest or Warsaw in the years before and after the First World War were supremely well connected to a network of cultural capitals defined by the media and the railway. No one in modernist Vienna was uninformed about the latest developments in Paris or Berlin, and for us to write the history of modernist art as if it happened only in Paris is as fundamentally wrong as it would be to write the history of the high Renaissance as if it occurred only in Rome, or Greek architecture as it occurred only in Athens. The modern Metropolis, as we will learn, was part of an interlinked and cosmopolitan system of other urban centres. So too modern art.

Part II

The Conditions
for Modern Art

Urban Capitalism

1

In 1919, just as the First World War ended, Fernand Léger painted his largest canvas. Simply by entitling it *The City (La Ville)*, Léger tells us that his immense painting represents the very condition of modern urban life, not a city with a particular name and history [**35**]. In it, we see no historical monuments, no streets or trees, no sky or space. Rather, the city is defined as a coloured construction of flat visual elements, and Léger gives form to the subject that is, in a certain sense, the most pervasive in the history of modern art—the modern city, its suburbs, and their inhabitants.

There is little doubt that the fantastic growth of cities was the most important single achievement of the nineteenth and early twentieth centuries. Most of the great historical cities in Europe were essentially rebuilt and reconfigured in that century, and such is the extent of newly constructed cities that one can scarcely imagine the Euro-global world as it was before the nineteenth century [**36**]. Even the quintessential city of modern art, Paris, would be almost unrecognizable to a twentieth-century viewer if that person were suddenly taken back in time to the Paris of 1800. Many of the most important historical buildings (the Louvre and Notre Dame, to name only the most prominent) were then in fragmentary condition, and not a single one of its defining boulevards had yet been built.[1] When we look at new cities like Glasgow, Manchester, Chicago, New York, Frankfurt, Buenos Aires, or Melbourne the urban growth of the Euro-American world has no precedent in human history.

In the late eighteenth century, France led the world in the shift from high to low birth-rate that social historians have defined as a prime characteristic of modernity, and virtually every Euro-global nation followed suit during the nineteenth century.[2] With that shift and the concomitant movement of peoples from rural to urban areas, the human geography of Europe and America changed more dramatically in the nineteenth and early twentieth century than ever before. The pre-industrial world in which the vast majority of workers were agricultural labourers who lived in the country or in small villages and hamlets gave way with almost alarming rapidity to a world of urban, and eventually suburban, workers, who congregated to secure employment and who

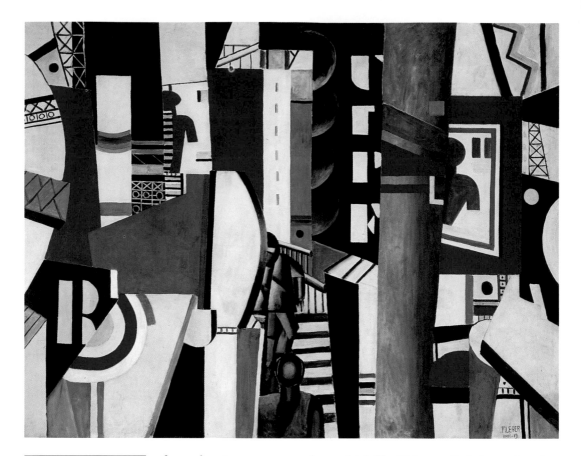

formed an immense new class, which Karl Marx called the proletariat. Another shift came with the enormous rise in the nineteenth century of the previously small class of urban shopkeepers, professionals, small-business owners, and other non-aristocratic property owners called the bourgeoisie who by the twentieth century came to be the dominant class—both economically and socially—throughout Europe and much of the United States of America.

Paris and the birth of the modern city

The paradigmatic city of modern art throughout the period covered by this book was Paris. Although somewhat smaller in population than its rival London, Paris was without question the artistic capital of Europe and America. Its museums, galleries, art academies, art schools, art shops, and art studios were unparalleled anywhere in the world, and artists from every nation flocked there to develop their work.

Many twentieth-century visitors to Paris think of it as an historical city, filled with monuments dedicated to the glory of its historic kings, its powerful bishops, and its wealthy aristocrats. From the Baths of the Romans and the monastic church of St-Germain-des-Prés to the palaces of the Louvre, the Panthéon, and the Arc de Triomphe of

36 James Wallace Black

Boston from the Air, 1860, albumen print

Black's view of the eighteenth- and early nineteenth-century city of Boston is one of many views of Euro-global cities made from the air. In these images, cities seem to spread laterally forever and to command the whole of our visual experience. Black's photograph shows how the traditional urban rhythms of Boston harbour could be made modern by the medium and mode of representation.

Foreign artists in Paris

Americans: Whistler, Eakins, Inness, Hassam, Davis, Sargent, Cassatt, Hopper, Bruce
Austrians: Klimt
Belgians: van Rysselberghe
Canadians: Carr, Morrise, A. Y. Jackson
Czechs: Mucha, Kupka
Danes: Pissarro
Dutch: van Gogh, Mondrian
Germans: Menzel, Liebermann, Pechstein

Hungarians: Rippl-Ronai
Italians: Boldini, de Nittis, Boccioni, Segantini, Severini
Lithuanians: Soutine
Mexicans: Rivera
New Zealanders: Goldie
Norwegians: Thaulow, Munch
Russians: Repin, Benois, Bakst, Chagall, Kandinsky
Spaniards: Picasso, Gris, Miró, Dalí
Swiss: Hodler, Amiet, Vallotton, Giacommetti

Napoleon, Paris is so thoroughly associated with its past that one almost forgets that it is, as a city, as thoroughly modern as Manchester or Chicago. Walter Benjamin, the great German social critic, considered Paris as the capital of the nineteenth century. Benjamin saw the roots of Parisian modernization in the 1820s and 1830s with the construction of a web of commercial arcades in the city, private streets, glazed against inclement weather and lit at night, that serve as models-in-miniature both for the boulevards of Napoleon III and Haussmann and for the extraordinary development of centralized covered markets and department stores.[3] The best portrait of modern Paris is probably the earliest, the multi-volume study of the city *Paris, its Organs and its Functions*, written at the end of the Second Empire by Flaubert's friend, the writer Maxime du Camp.[4] Like the novels of Balzac and Zola, it transformed the actual Paris into a conceptual paradox; a bounded place without boundaries, a human realm unknowable by individual men, or, in certain poetic and fictional terms, a seductive and mysterious woman [**37, 38**].

Paris, to its apologists, had pulled away from the yoke of French aristocratic history and was galloping headlong into the future which it would define for much of the world. Paris was a construction zone for most of its modern history, with its population moving house during the period creating an unstable environment. The sheer instability of the social, economic, and physical reality of nineteenth-century Paris had a profound effect on artists' representations of it.

Paris was scarcely alone. The demolition of slums and traditional quarters in the old cities of Europe continued apace throughout the late nineteenth and early twentieth centuries. Photographers in every

37 Gustave Caillebotte

Paris Street; Rainy Day, 1876–7, oil on canvas

Caillebotte was a wealthy amateur painter brought into the Impressionist fold for financial reasons by Degas. The smooth surfaces and academically controlled spaces of his compositions were at the service of a new urban imagery, and the section of Paris chosen by Caillebotte was almost new when he painted it. The principles of dynamic yet regular urban planning embodied in this flat image were used throughout the Euro-global world. The painting first appeared in the Impressionist Exhibition of 1877.

38 Pierre Bonnard

Morning in Paris, 1911, oil on canvas

This painting, together with its 'pair' representing a Parisian evening, were conceived as immense decorative panels to adorn the walls of a luxurious private house. Each brings the streets of Paris into an interior (both found their ways to the Morosov collection in Russia several years before the Revolution), and each revels in the human population of the modern city rather than its architecture. In the evening painting, Bonnard arranged the canvas into horizontal bands of pavement and street as if playing a visual game with the horizontal panelling and large-scale decorative mouldings of traditional interiors. The flower seller, whose cart enters the painting, is readying herself for the evening market of Parisians buying flowers as tokens of various affections.

39 Charles Marville

*Tearing Down the Avenue de l'Opéra, Paris, c.*1877, albumen print from a collodion glass negative

This is one of hundreds of photographs made of Paris by Marville. He recorded (with grim determination) the destruction of the traditional city as it was being systematically crushed to make way for modern Paris. This image records a section of the city that was almost completely destroyed in the 1870s in order to build the quarter associated most fervently with Impressionism.

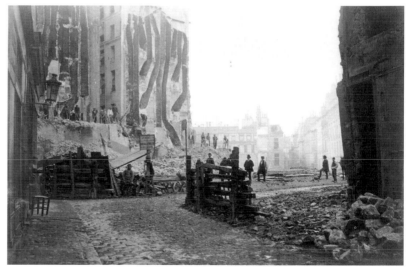

city rushed to record the old buildings before their complete destruction, and many of the greatest urban photographs of the nineteenth century must be considered to be a form of preservation through representation. These are the work of Charles Marville in Paris [**39**], Thomas Annan in Glasgow, the Bools and the Dixons in London, and the photographers who recorded the Jewish quarter in Prague, the old quarters near the walls of Vienna, the crooked streets of old Pest, and the wooden buildings of Moscow. Even the modernist master, Eugène Atget, as we have learned from Molly Nesbitt and others, made photographs of old Paris for historians and antique dealers anxious to find in the endless anonymity of modern Paris some forgotten corner in which time stood still.[5]

It is scarcely possible today to imagine the sheer magnitude of transformation in nineteenth- and early-twentieth-century Europe

and the Americas: human, physical, social, architectural, and techno-
logical. No life, not even that of the wealthiest aristocratic, was left
untouched, and, when one considers the enormous growth of capital
(or expendable wealth) during this period, the effect of all this on the
visual arts becomes clear. Works of art remained, as they had been,
either relatively (and variously) expensive commodities for individuals
with disposable income, or embodiments of state or church patron-
driven values. But the nature of individual, governmental, and institu-
tional wealth was so changed in the nineteenth century that the world
of art changed with it.

Capitalist society

Studies of the urban transformations of traditional cities like Paris and
Vienna have made it possible to interpret the representations of these
cities in sophisticated and specific ways.[6] 'Haussmannization' and the
'Ringstrasse mentality' are now standard ideas in courses on modern
art, and the phenomenal growth of American cities like Chicago and
New York has been well studied. The Haussmannization of cities like
Rio de Janeiro, Mexico City, Cairo, and Philadelphia is well charted, as
is the Viennification of Budapest and Bucharest, and the London- or
Edinburgh-based urbanism of Calcutta, Montreal, and Melbourne.

Yet there is a failure in all this literature to deal with the interlinked,
simultaneous, and global nature of urban capitalism in modern civil-
ization. It is true, of course, that certain of these cities served as models
for others and that greater concentrations of wealth and governmental
power produced more—and less—fully developed urban systems.
However, we should recognize first, that almost every city in the world
grew vastly in the nineteenth and early twentieth centuries, and second
that the simultaneous development of mechanized transport and mail
services linked them in a communications system of increasing com-
plexity. Children in Japan knew more and more about the West, and
the reverse is true for children in Europe and the Americas. And the
sheer volume of global knowledge, of products, and of travel created a
world that was different in fundamental ways from the nationally and
regionally bound worlds of previous eras. No empire of the past—not
even the vast stretches of ancient Rome, or of imperial China—could
compare with the leaderless capitalist empire of modernism. And at no
time in previous human history did economic forces have a larger scope
than those of religion and government in the shaping of civilization.
Capital and its expansion was the story of modernism, and govern-
ment survived only in so far as it could mould itself to the interests of
capital.

This system was most brilliantly analysed by Karl Marx and his fol-
lowers, who became obsessed not only with their study of capital and

its ownership or control, but also with the socio-economic classes of people defined in terms of their access to that capital. The sheer simplicity of Marxist analysis, with its ironclad categories of bourgeois, proletarian, and peasant classes, proved so compelling that Marxist notions affected public policy throughout the Euro-American world for nearly a century, providing the basis for a veritable industry of governmental bureaucracies and university scholarship. The arts were similarly affected, both in practice and in theory, by Marxist systems stressing the fundamentally economic forces that underlie all modern civilization, producing numerous images that present or analyse class relations, family structures, and individual anxieties in the midst of social struggles.

The locus of these forces is the city, where workers and owners co-exist in uneasy harmony; where goods and services flow in seemingly effortless or invisible systems; and where ideas and representations congregate. In these cities, fortunes are made by energetic men and women, and the expenditure of capital on luxury goods and representational images is concentrated. Representational art, both mechanical and hand-made, played a central role in this capitalist system and has always been attached to urban centres. Yet, as the nature of these centres changed in the nineteenth century, so representational art changed with them. Art shops, commercial galleries, exhibition collectives, private homes, and private museums replaced the church and state institutions as the loci of display and exchange. Modern collectors were as often opera singers, factory owners, petty bureaucrats, publishers, restaurateurs, and department store magnates, as aristocrats and powerful government officials. A post office worker, Joachim Gasquet, was as important as a collector for Impressionism as the Marquis de Marigny had been for incipient neo-classicism in the aristocratic age.

The study of these changes has increased during the last two generations, and particular strides have been made in the social history of modern art. Following the lead of Marxist historians of the early and mid-twentieth century, a veritable industry of scholarship has defined significant art as a structured critique of capitalist civilization, while other less ideologically motivated scholars have seen modern representation as embedded in a discourse tied irrevocably to capitalist ideology. Other scholars have been almost aggressively neutral in their charting of the history of modern art as a system tied to the art market, the art exhibition, and the system of criticism that gave verbal definition to these modes of display and exchange. However, few studies of modern art have applied to the description of representational art history the same methods used to study the history of clothing, decorative arts, or other luxury commodities.

The commodification of art

What can be said about art *as* commodity? First, it is clear that art is, and was, marketed in remarkably similar ways to other luxury goods. The markets in fine jewellery, antiques, vintage wines, carpets, or couture fashion are equally arcane, secretive, and dominated by a small number of houses, whose reputations are carefully moulded so as to enhance the value of the desirable commodities in which they trade. The definition of desire on the part of these market manipulators stresses rarity, distinctiveness, and social allure, the importance of the product being very closely tied to the economic and social clout of the client or consumer. The markets for avant-garde art deliberately stress its difficulty and lack of public appeal to give it an air of exclusivity. If one actually liked Monet in the 1870s, Gauguin in the 1890s, Matisse in 1910, or Duchamp in the years after the First World War, one was part of a very small, seemingly self-selecting club similar in structure to that of collectors of other rare commodities. Indeed, avant-garde art was among the very most exclusive of commodities throughout its history, and to be part of the club of artists, dealers, critics, collectors, and hangers-on was to have arrived at a very high cultural plateau.

To be successful as commodity, art must transform itself regularly without losing its value, and in this way modern art has a close relationship to the history of other luxury products. Many historians sceptical of the art world have routinely compared it to the world of women's fashion. Yet few art historians have accepted their ideas as truths because of their view of high fashion's frivolous nature. However, the changes in subjects, surfaces, imagery, texture, compositions, and colour that fill the history of modern art are not so different from those of hems, colours, contours, and length in the fashion industry.

That said, we cannot claim that art dealers created the history of art, as no economic system based on desire can be determined by set rules; an element of unpredictability is important. Another more complex reason why market fomulae have not determined art history involves two factors: first the intrinsically critical (or privileged) nature of art making in modern society; and second the idea central to artistic theory that works of art can transcend time and can assume increasing critical and financial value with time. For art, there is no planned obsolescence.

The art market and contemporary criticism

One of the principal characteristics of modern urban capitalism is the continuous creation of capital and its accumulation in new configurations. The value of capital is determined by the speed of its exchange, so that if exchanges can be maximized, value increases in proportionate ways. The art market is absolutely determined by these rules, although the study of this system is still in its infancy and there has been no

attempt to define the economic system for modern art in a global way. The most systematic work on art markets is Pierre Bourdieu's *Distinction: A Social Critique of the Judgement of Taste*, one of the few books that considers art within a context identical to that of other cultural products.[7]

The most sophisticated, and persistent, study of the relationship between representational art and capitalist society has to do with the reception of works of art by the critics and writers at the moment of their entrance into the discourse about art. This form of art history privileges exhibitions over sales, largely because exhibitions produced the conditions for criticism in the form of published reviews, whereas sales usually produce only bills of sale, shipping documents, and other forms of receipt. The bias of this type of history is partly due to the easy access that modern scholars have to published reviews through large research libraries, as opposed to the largely inaccessible archives of art dealers or collectors.

Early art historical analysis (such as John Rewald's) of critical writing about modern art focused on the struggle of artists to overcome the influential negative opinions of critics. This type of analysis, in which a negative review is a sort of paper tiger, has been largely replaced by a closer and more clearly contextual study of reception in which modern critics read and reread the critical discourse that grew up around painting in modern art.[8] The most serious work has been done in the field of modern French painting, largely because the critical discourse in Paris was so much greater in quantity than that of any other Euro-global city. We learn from students of artists such as Seurat, Picasso, and Matisse just how a certain critic with a measurable socio-political position interpreted a particular work of art at a particular moment, providing critical evidence for modern interpretation. As such, the art historian searching for the significance of a modernist object is much like an archaeologist, for whom the physical (and, thus, temporal) position of an artefact is as important as is the artefact itself.[9]

The problem with these analyses of the initial reception of works of art is that they give critical privilege to contemporary interpreters, who are seen as giving us better access to original meanings, and possibly even artistic intentions, than do later ones. The logical flaws of this theory are obvious, not only because we know well how blind we often are to the systems in which we operate, but also because the published readings of works of art are often written by those with indirect and partial access to the actual socio-economic context of the object. In a way, the theoretical division between atemporal (or modernist, anti-contextualist) criticism and contextual, historically specific criticism has simmered throughout the past two centuries, not only in studies of art, but also in literary theory.

The modern condition

Fascinating connections have been drawn between the physical, psychological, and social conditions of modern urban society and the works of art that seem to represent modern reality in a transparent manner. These links have been made following the lead of Arnold Hauser, whose *Social History of Art* is among the most important Marxist texts in the history of art and whose essays on modern representational art, both on Impressionism and on cinema, have proven durable in the nearly two generations since they were published in 1951.[10] Following Hauser, the consumption of nature by modern urban dwellers of all social classes has been a persistent theme of modern iconography in both the United States and Europe.

This text stresses two major aspects of capitalist modernism that are seen as essential to modern representation: speed and dislocation. The modernist ideas of alienation, dislocation, rapid transformation, and anonymity are essential to these views of artistic representation in capitalist society. The canonical works discussed by art historians of this persuasion abound in iconological and formal difficulties that express these states of consciousness. This view of modern art as a structured critique of capitalism has worked so well for certain objects of art that it has created a whole idea of modern art as *essentially* critical of capitalism.

We must remember, however, that modernism had its admirers as well, both in the academy and among artists and their critics. Indeed, the sheer energy of artistic modernism, with its ability to embody the excitement of the modern city, is a major feature of the art of this period. The shopping genre scenes of Franz Marc and Kirchner; the urban photographs of Stieglitz and the Hungarian Làszlò Moholy-Nagy (1895–1946); the crescendos of construction among the Futurists; the black-and-white punctuation of Vallotton's urban prints; the gritty representations of New York by John Sloan (1871–1951), Joseph Stella

40 Joseph Stella

New York Interpreted (The Voice of the City), 1920–2, oil and tempera on canvas, five panels

The five panels—more than eight feet tall and twenty-two feet long—that formed this immense public mural were painted over two years by the Italian-American artist, Joseph Stella. Although they stem from the wartime paintings of New York by the French Cubist-in-exile, Albert Gleizes, they were given a formal rigour, a precision draughtsmanship, and a scale unknown to the Frenchman. They constituted the most important post-war embodiment of modern urbanism in America, and Stella had hoped that they would be purchased for a prominent public building, but they remained unsold until 1937.

41 Edward J. Steichen
The Flatiron, 1905, gum-bichromate over gelatin-silver
Steichen recorded the most exciting tall building of the turn of the century in New York. Designed by Chicago architect, Daniel Burnham, its shape derived from an irregular intersection in New York. Steichen recorded it in a small, deliberately unfocused image into which the great building bursts with an exaggerated sense of scale. Architecture transcends both the human body and nature, which is reduced to the decorative lines of tree branches.

(1877–1946) [**40**], and Edward Steichen (1879–1973) [**41**]; Degas's brothels, and Toulouse-Lautrec's cafés. The fact that these images use new or anti-traditional representational strategies and that they eschew notions of balance, order, harmony, and internal unity can be viewed as an expression of the essential conditions of modern urban life.

In discussing the modern city as both the locus and the subject of a certain type of representational modernism, we must remember that modern cities varied considerably in the period covered by this volume. The endless grid of Chicago, with its Loop of inter-urban trains defining a skyscape of large privately owned buildings, could not be more different to the sociable boulevard modernism of Paris, with underground inter-urban trains and state-owned symbolic historical monuments as the defining focal points of collective urban experience. Nor can one discount the loosely organized, neighbourhood-centred and fundamentally suburban sprawl of urban London, with its irregular street pattern, tidy places, asymmetrically shaped parks, and seemingly chaotic but user-friendly urban train system. Each of these three cities presents us with a different model of the modern city, and still other models could be discussed. There is the Vienna model, with the late-medieval city surrounded by a modern one with its wall becoming a circular boulevard. And there is the juxtaposition of old city and new city in Budapest, Edinburgh, and, to a lesser extent, Prague, each of which concentrated its traditional urbanism on one side of the river (or,

in the case of Edinburgh, railway) and built a modern reflection on the other [**42, 43**].

Each of these cities represented itself for its citizens, visitors, and rivals in countless works of visual art, and additionally created exhibition spaces for art to define its particular civilization in conjunction with another system of buildings for the performing arts. Indeed, art museums were central monuments to civilization in practically every modern city, no matter how its street system or public rail system worked. The very link between the city and the museum is exemplified by the Metropolitan Museum in New York and its many less obviously named copies throughout the world. For New Yorkers, the sheer fact of their global metropolitanism is most perfectly embodied in their art museum. Conceived as an institution as global and complete as possible, it combines old and new art, fine art and applied art, Western and

43 Charles Sheeler
(1883–1965)

Church Street El, 1920,
oil on canvas

non-Western art, art and archaeology, in a way that defines the city as a global capital.

Thus the urban discourse of modernism was fluid and transformative under a veneer of monumental permanence. One of the great features of the cosmopolitan modern world was greater speed of communications and the fluid movement of multi-lingual populations, creating new professional social interactions that had their only precedent in the small-scale aristocratic world of the *ancien régime*. The proofs of this are so numerous that one scarcely has to strain to find an example. In October 1913 the Russian textile merchant/collector Shchukin wrote to his friend Henri Matisse that, within the previous two weeks, he had received visits in his home in Moscow from numerous individuals including Karl Osthaus from Hagen Germany (twice), Dr Peter Tessen from Berlin, other gentlemen from Nuremberg, Strasbourg, Flensburg, Hamburg, Darmstadt, and Halle, as well as from Jens Thiis of Christiania (Oslo). One wonders what languages they spoke! All these men saw major works by Gauguin, Picasso, Matisse, and others in Moscow.[11] Such was the cosmopolitanism of the modern.

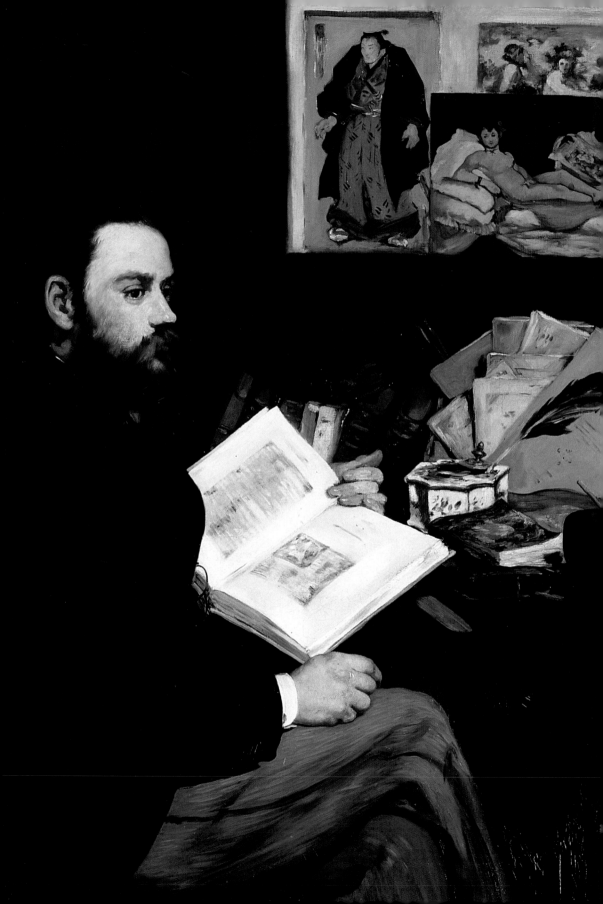

Modernity, Representation, and the Accessible Image

Three potent inventions—the art museum, lithography, and photography, all made before 1851—produced results that profoundly altered the course of the history of art. These created another set of conditions, related to, but different from, those of urban capitalism that determined many of the characteristics of representational modernism. Although the art museum and lithography are associated with the late eighteenth century, their roots lie deeper in western civilization. The thoroughly modern medium of photography harnessed image production to the machine and so could have been invented only in the nineteenth century. Its invention, announced by the painter Paul Delaroche to the French Chamber of Deputies in 1839 and deeply contested throughout the nineteenth century, is among the handful of such inventions in the human history whose results have proven so far-reaching that they have yet to be fully understood. All three of these innovations had profound effects on the history of Western ideas of art and, thus, on the limits within which artists worked. All were perceived in two ways: both as powerfully positive, and as equally powerfully repressive forces. There are no important modern artists whose careers were not affected by them.

Early in 1868, Édouard Manet completed his greatest portrait to date, a formal exhibition portrait of the newly successful young writer, Émile Zola [44]. By situating his friend and defender in a book-and-art-filled corner of a dark room, Manet immersed this young naturalist not in the real world but in a world of representations. Interestingly, he included not a single European painting. Rather, Zola sits as a bourgeois in a comfortable chair placed in front of a fashionable Japanese screen, which runs along the left edge of Manet's canvas, and a delightful image bank consisting of a Japanese wood-block print, an eighteenth-century French engraving by Nanteuil after a painting by Velázquez (the original of which had been seen by Manet in Madrid the year before), and finally either a photograph or reproductive print of Manet's own painting, *Olympia*, completed in 1863 and included in

44 Édouard Manet

Portrait of Émile Zola, 1868,
oil on canvas

This formal portrait represented the rising novelist and critic Zola a year after the publication of his first successful novel, *Thérèse Raquin*. It is visual proof of the dominance of reproductions and exotic works of art in the capitalist world. It was first shown in the Salon of 1868, after Manet's complete rejection from the Salon the previous year.

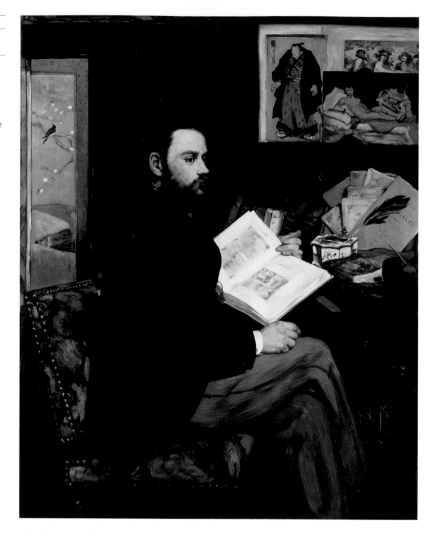

the Salon of 1865 [**82**]. All these images are virtual rather than actual works of art, only two of which, the Japanese screen and possibly the Japanese print, were produced by (or under the supervision of) the same artist who conceived of the image itself. In this way Manet represents Zola as a completely modern man, able to evaluate and interpret works of art in a polyvalent world of reproductions, photographic and otherwise. If André Malraux had not yet begun to conceive his imaginary museum of reproductions, Manet certainly had.[1] The remainder of Zola's desk is filled with books and pamphlets, certain of which are illustrated, including the most popular and bestselling French art book of the mid-nineteenth century, Charles Blanc's *Histoires des Peintures*, and Zola's own pamphlet promoting the work of Manet to an urban public. For Manet, and for Zola, the world of the visual and literary artist was altered and enriched by their access to reproductions, pamphlets, magazines, and books. Their modernism

was a highly mediated affair, enmeshed in both urban capitalism and its cultural products.

The art museum

The art museum is so deeply rooted in modern urban culture that it seems at once as ubiquitous and as eternal as the art it protects. Too few museum visitors recognize the sheer modernity of the institutions in which they see works of art preserved for all time. The apparent transparency of the museum, and its position outside ideology, has been powerfully denied by postmodern scholars and critics of culture.

Although art museums existed during the Renaissance, and many of the great treasure homes of Europe were open to visitors (of the right social class) on a virtually regular basis before the late eighteenth century, we must look to the political revolutions of modern civilization for the origins of public art museums, whose mission is to make art from all eras and civilizations accessible to any citizen. The initial idea of the revolutionary Louvre museum is quite simple: that the treasures of art owned and housed in palaces by the King and French aristocrats

45 Eugène Delacroix
The Triumph of Apollo, 1850–1, oil on canvas (mounted on the ceiling of the Salle d'Apollon, Palais du Louvre)

This immense canvas was painted to fit into a ceiling designed in the late seventeenth century by the architect Le Veaux for the Louvre. It was a modern work for an *ancien régime* setting that had itself been transformed from a palace to a public art museum. Delacroix's art historical debts, particularly to Veronese and Rubens, are clear, and the museum visitor could measure them by walking to the large-scale paintings by those hallowed artists in the Louvre itself.

were actually the property of the citizenry, who must preserve these works for posterity as part of its own national heritage. Museums became embodiments of public pride of ownership and are tied to notions of national power.

After the opening of the Louvre to great acclaim in 1793, the pressure effectively to nationalize royal collections was immense, leading to the development of new public museums all over Europe during the nineteenth century [45]. England had its own quirky way of dealing with this by creating a sort of private–public museum, the British Museum, outside the Royal Collection. If Catherine the Great built her Hermitage for 'myself and the mice' in the later eighteenth century, her successors had no such delusions of power. Her great-grandson, Nicolas I, hired the important German museum architect Otto von Klenze to design an immense public museum, constructed between 1842 and 1851 adjacent to the palace itself.[2]

Perhaps because the works of art that these museums celebrate were not modern, we forget that the museums themselves were modern creations, developed for political rather than aesthetic reasons, and that they essentially determined the Euro-global idea of great art in the nineteenth and twentieth centuries. Men and women like Sergei Shchukin, Albert Barnes, Leo and Gertrude Stein, Samuel Courtauld, Ilya Arensberg, and others have as great a presence in the literature of art as a result of their collecting. In the nineteenth century the capitalist collector replaced the ruler, who had obtained his works of art by economic and military force. The notion that whoever owns art confers on it his importance just as art confers its importance on him, is central to modern ideas of art.

A list of major art museum buildings opened in Europe and the Americas during the period covered by this book would fill pages. It would include virtually every great museum in the world, excepting only the Louvre, the Prado, the National Gallery of Art in London, the Altes Museum in Berlin, and most of the museums of Italy. In fact art museums are, in many ways, as modern as department stores and railway stations, and their history can easily be integrated into the larger history of display and public culture that has been written so interestingly by historians who have chronicled the rise of bourgeois civilization.

It was visits to art museums by artists, and the rise of the museum art school in many European and American cities, that moulded the artistic values of generations of modern artists such as Manet, Picasso, and Léger. Historians of modern art know well the effect of schools like the Art Institute of Chicago on canonical modern artists like the American Georgia O'Keeffe (1887–1986) (the effect was, of course, negative), and visits to museums were as major a part of the travels of modern artists as they were of any modern tourists. To read the attend-

ance figures for the major art exhibitions held in the late nineteenth and early twentieth centuries reminds us of a time when these institutions were the mass-culture venues, before the onset of public access to sporting venues, films, television, and the world-wide web. Over 150,000 people paid to see an exhibition of the contemporary Spanish painter Joaquin Sorolla y Bastida (1863–1923) at the Hispanic Society in New York in 1909, and more than 20,000 of them bought catalogues. Similar statistics could be presented for museum exhibitions throughout the period covered by this book. Even the ever anti-traditional painter/teacher Camille Pissarro, who reportedly wanted to burn down the Louvre early in his career, painted this pre-eminent museum building more than seventy times in the last five years of his life.

What did the art museum as an institution do for artists? Firstly and most important, it placed works of art on the pedestal of civilization, as the most significant and valuable of man's creations. This showed young artists with little or no hope of being collected by a museum during their own lives that the activity of art making had immense cultural value in itself. Museums also encouraged artists with an idea fashionable among Romantics, that artists, if they are truly important, must wait until after death to be fully recognized. This sense of museums as being the eternal repositories of the greatness of the past was encouraged because very few museums actually purchased art for high prices during the late nineteenth and early twentieth centuries. Hence, they were not intimately involved with the art market. Indeed, their independence from it was carefully sought by the museum administrators, who encouraged collection growth through gift or, more frequently, state seizure rather than museum purchase, thereby separating the museum from the tainted world of money. This idea still persists today in France, Italy, much of eastern Europe, and Russia.

Museums were among the few places of display in modern culture apparently free from the pressures of commodity markets, and this very status gave them immense power. One can measure, for example, the incredible effect on contemporary French art of the gift in 1869 of the La Caze bequest to the Louvre. The wonderful group of paintings by Chardin assembled by La Caze literally caused the production of major works by painters such as Manet, Cézanne, Degas, and Morisot. Without the Louvre, this impetus from the eighteenth century might never have occurred, and it was the Salle La Caze that Vuillard chose as his quintessential painting gallery in 1921 when he devoted a series of four large decorations to the reopening of the museum after the First World War.

One of the most persistent myths about museums and modern art is that artists learned from museums principally by copying works of art in them at an early point in their careers. There is little doubt that most modern artists did in fact copy in great museums. This type of activity

probably represents a distinct minority of their total use of the art museum. The cases of Cézanne or Pissarro will serve us here, but I am sure that a careful study of artists from any European capital would reveal similar patterns. We know that both Cézanne and Pissarro visited the Louvre throughout their lives although Pissarro seems never even to have taken a sketch-pad, and there are no surviving copies or drawings after works in the Louvre in his considerable *œuvre*. Yet his letters make it clear that he would observe the compositional decisions in Poussin's work, study the palettes of Turner and Veronese, or learn about paint handling from Rembrandt or Chardin. Indeed, a quick visit to a well-haunted corner of the Louvre could have helped him solve a particularly nagging problem by providing him with an immediate and time-tested precedent. Cézanne used the Louvre with the same persistence, but, perhaps because he spent most of his working life away from Paris, he felt compelled to take a sketch-pad with him so as to study the rippling muscles in Hellenistic sculpture, the inter-play between volume and void in the paintings of Chardin, and the relationship between facial features and curling hair in a portrait by Rigaud.

The Louvre was emptied twice in the twentieth century, for each of the two great wars. The first time led to the longest closure of the museum in its history, a period of nearly five years in which its collections were inaccessible to the public. When the Louvre reopened in 1921 artists and the public flocked to it in extraordinary numbers. Indeed, the absence of great art from the contemporary world had proved as devastating in certain ways as the war itself, and artists responded to the reopened Louvre by creating works that responded powerfully to the past it enshrined and protected for moderns. The so-called *rappel à l'ordre*, the conservatisizing tendency of 1920s representational modernism, may have had as much to with the new availability of the past at the Louvre as it did with anti-modernist ideology. One form of modernism replaced another.[3]

The sheer simultaneity of various historical times in virtually any modern art museum made it decidedly modern in the sense that history itself was pluralistic and simultaneously available to the modern viewer. No great modern artist before Picasso lived to see their work represented in a major encyclopaedic museum, and none expected to do so.

Temporary exhibitions

Exhibitions had a key role to play in the creation of the modern idea of art. Although there had been Salon exhibitions in France since the later seventeenth century, and many other countries developed versions of this practice, it can truly be said that the nineteenth and twentieth centuries are the great age of public display.[4] Whether the

increasingly common industrial exhibitions, which most often included representations or images produced by modern technologies; world's fairs as major commercial vehicles for governments and the private sector; or private exhibitions produced by individuals, dealers, or co-operatives of artists, the opportunities to display original works of art or printed reproductions increased dramatically in the second half of the nineteenth century. Attitudes towards display changed just as rapidly as did the contents of the displays. We all know about salon-style hanging, with bilaterally symmetrical rows of paintings of increasing size as one's gaze ascends the wall. We also know that many dealers and artist-groups changed these norms by hanging works in single rows, by allowing the wall itself to show around the pictures, by introducing new forms of artificial lighting, by developing skylit technology, by developing new colours for gallery walls, by changing framing and matting customs, and by grouping works in various new combinations. Thus the mode of display became as important in the art world as it did in the commercial world, where major developments in display technology were sweeping Europe and America.

It is no accident that the best early essay about commercial window display as an art form was written by Fernand Léger, and that Marcel Duchamp and many other important modern artists were involved in commercial window design.[5] And we know that the modern idea of picture display, with works hung at eye level separated by a good deal of space, with minimal framing, and on neutral walls, developed out of the Impressionist exhibitions in the late 1870s and early 1880s. There are literally thousands of photographs that document not just works of modern art, but also the exhibitions that housed them. In fact, these became increasingly common as photography entered the amateur realm and as the exhibitions themselves became more elaborate, artificial, and bizarre. The exhibitions of the Russian Constructivists were for many years better known than the paintings themselves, and those of the Dada artists too came to have greater importance than anything they contained. Any reader of the prolific correspondence of Monet and Pissarro or of the journals and private communications of Gauguin and Vuillard will learn that they were all but obsessed with issues involving the display of their representations, and this obsession can be extended to modernist photographers as well.

The first generation of *catalogues raisonnés* of the works of canonical modern artists lists numerous temporary exhibitions in which these works appeared during the first generation of their lives. These lists include cities as far flung as Melbourne and Johannesburg and as culturally diverse as Moscow and Barcelona. In fact, it is astounding to cautious modern conservators who safeguard these works of art today that they were transported so far and so often, without greater damage; a geographical map of early exhibitions by Monet or Gauguin would

be extraordinary. The works of many modernists created such a stir in provincial cities that artists immediately reacted to them in ways little different than those of traditional artists who confronted a new work of art for the first time. The wonderful painting of 1913 by Stanley Cursiter *The Sensation of Crossing the Street—West End, Edinburgh*, was painted just after the Scottish painter had seen Severini's *Boulevard* (1912) in an exhibition curated by Roger Fry, shown in the city that was considered the bastion of aesthetic conservatism in Scotland. The most thorough study of the particular effect of a French artist on a far-away place is Alberty Kostenevitz's recent work on the reception (and transformation) of Cézanne in Moscow and St Petersburg.

Lithography

If museums were immense libraries of visual representations that could be easily used (or, as was often the case, plundered or even misused) by modern artists, it was the countless reproductions of works of art in the print media that transformed modern art history to an even greater degree. Few modern artists, even those who lived in remote cities, went through life without visiting at least one great museum. But even fewer artists were untouched by the virtual barrage of reproductions that forever changed the relationship between the work of art and the individual viewer in the nineteenth and twentieth centuries.[6] Modern intellectuals from Albert Barnes to Walter Benjamin have decried the pernicious effect that easily available reproductions of works of art have on our experience of the original art object. More numerous, however, are the optimists, most of whom follow the ever-eloquent lead of André Malraux. Using the phrase, *musée imaginaire* or, awkwardly in English, 'museum without walls', Malraux spoke and wrote about a peculiarly modern condition of art: that most modern people see more reproductions in their lifetimes than they do original works of art. For Malraux, the liberating potential of this condition was even more important than its obvious limitations.

The importance of reproductions for the history of art has often been considered, yet too few systematic attempts have been made to measure the effect of reproductions on the history of art itself. The photographic technology that has made the modern discipline of the history of art viable across the globe has also brought works of art into the household, the studio, and the larger visual experience of the artist. Many of the greatest modern artists such as Degas, Picasso, and Dalí made active use of reproductions, photographic and otherwise, in their working process, allowing them a kind of conceptual freedom or apparent boundlessness that is distinctly modern.

It is tempting to think that this practice is simply an extension of

the standard artistic method codified in the academies, in which prints of works of art were used as an active part of the process of artistic training. The difference between the historical use of reproductions and the modern practice is in both degree and kind. Whereas, for the academically trained artist, reproductions played a principal role in the training of the artist and in the dissemination of work to an urban élite, modern artists have used reproductions throughout their working lives, as inspiration as well as an *aide-mémoire*. The visual field of the modern artist is so much larger, more complex, and more easily available than it had been in previous centuries that it provided visual stimuli that threatened in many cases to overwhelm the actual visual world of the artist. If the seventeenth- or eighteenth-century artist was confined to expensive reproductions produced in relatively small editions, the modern artist is literally inundated with mass-produced reproductions in many media, including photographic.

One of the earliest processes of reproduction was developed in Germany in 1798. The technique of lithography was the first reproductive technique in the history of art that had no limits on the number of reproductions that could be made from an original drawing. The method of lithography involves a smoothly sanded surface of fine-grained limestone, on which an image is placed with an oil-based crayon or a grease-based solution with a brush or pen. The resulting image accepts ink, while the stone itself does not, and after printing it can be re-inked and printed virtually an infinite number of times without any perceptible decline in the quality of the print. After the printing is completed, the stone is ground down to remove the drawing and is prepared for another. A single lithographic stone can receive as many as a thousand drawings and produce literally millions of prints. Although this technical discussion might appear to be irrelevant to the larger aims of this book, it helps us to understand the fact that, for the first time in human history, one could print thousands of identical prints from one original. Whether it was drawn by a major artist like Goya or a professional print-maker like Senefelder or Lemercier, the image itself could have a mass audience. The industrialization of image-making and the creation of a market for these mass-produced objects formed a set of particular conditions for the modern artist.

Access to visual information was at its height in large cities and also widely available in provincial areas. These virtual works of art so numerically overwhelmed actual works of art that in many important senses they defined the art world for the majority of people who lived in modern cities. Whether related to travel, religion, literature, science, art, or any other subject-matter, images saturated Europe, her colonies, and the parts of the world dependent on her for trade and prosperity. The image trade involved literally thousands of artists, in both the production and the consumption of images, and the history of

modern art is intricately linked with that of popular imagery, of which reproductions of works of art constituted an enormous part.[7]

Yet, it was not principally its role in the multiplication of images that set lithography apart from earlier graphic media. Rather, it was the directness with which an artist's gesture could be recorded and replicated using the medium. With the oil-based crayon or the small pots of greasy ink, artists made lithographic paintings and drawings that could be infinitely repeated. This gestural aspect of the medium, the directness of the relationship between the artist's hand and its replication created conditions that assured the connection between art as handmade and art as industrially replicated. This conundrum created one of the greatest traditions in modern mass-produced print-making. Even the ever-reticent Cézanne, whose early experiments with print-making were confined to small-edition etchings, was convinced by his dealer Vollard to create lithographic drawings. There was a major revival of fine art lithography in the 1890s through the simple recognition that lithographs could be both directly related to the artist's working process and capable of sustaining much larger editions than intaglio or relief techniques. The careers of modern artists such as Toulouse-Lautrec, Bonnard, Mucha, and others are inconceivable without lithography.[8]

The names of the industrial printers of Europe are little known today. Lemercier, the first large-scale printer in France, and a host of competitors in Europe and America produced hundreds of millions of inexpensive printed images that one could buy world-wide.[9] Hence modern iconography must contend for the first time with mass visual culture. Indeed, the recognition of the importance of so-called popular or mass-produced visual culture for modernist imagery and technique has been one of the principal trends in recent studies of modern art.

Photography

If lithography and other industrialized representational media transformed the history of modern art, photography had an even greater effect. Its invention was announced in 1839 in both England and France, with competing claims to priority being made by various individuals and nations during the 1840s. By 1850, when albumen-coated paper was introduced and glass-plate negatives began to replace waxed-paper negatives, photography began to exert a powerful force on the history of representation. It produced a distinguished body of criticism in the 1850s and 1860s as its adherents and detractors struggled to define its relationships with traditional media from painting to the graphic arts. Its most passionate advocates came to recognize that the separate media that make up photography possess their own character.[10]

All histories of photography tell about its simultaneous development in France and England. A wealthy landowner and amateur,

Chimney-sweeps Walking, 1851, salted paper print from a paper negative

The pulpy texture of the paper on which the negative for this photograph was made give this calotype a virtual quality. Nègre, like most calotype photographers, created a positive aesthetic value with what was viewed by others as a technical limitation of the first negative process.

William Henry Fox Talbot, perfected a technique of paper photography with help from many friends, a technique that he came to call the calotype or beautiful print. His method involved fixing a value-reversed image on sensitized paper, which was then waxed so as to become the negative for the production of a paper positive produced by placing the negative on top of another sensitized sheet and exposing both to sunlight [**46**]. As a result of this, Fox Talbot's process was actually the first photographic print medium, and, with his considerable resources, he actually set up in Reading the first major photographic printing establishment to produce images and small-edition books illustrated with photographs for sale.

The French development, called the daguerreotype after its inventor or publicist Louis Jacques-Mandé Daguerre, was announced in Paris before Fox Talbot had made his process publicly known. Unlike the English process, the daguerreotype was a unique and unreproducible photographic image made in the camera on a sensitized silvered metal plate. Whereas the calotype possessed both indirectness and the graininess of its paper negative, the shiny daguerreotype was like a mirror (the technique was called 'the mirror of nature'). Daguerreotypes were appreciated immediately for their almost surreal level of detail, for their entrapment of more visual information than the eye could perceive. Thus the medium took over the market for portrait images; its modernity, its permanent metal medium, its uniqueness, and its likeness to a mirror transforming forever the idea of the portrait.

Photography and modern art

Because of its newness and the fascinating rivalry between England and France, photography took the modern art world by storm. Photographs were exhibited at every major international exhibition. Societies and publications were formed throughout the world. Most

major critics and intellectuals gave their opinions on the merits and problems with the medium. And virtually every middle-class urbanite in the world owned photographs by the middle of the 1870s. There was inevitably much anxious commentary about the relationship between painting and photography, and between mechanical and non-mechanical image production [**47**]. Lady Eastlake, wife of the director of the National Gallery of Art in London, declared in 1850 that 'From today painting is dead', and writers from Baudelaire to Ruskin first praised and, eventually, decried the new medium. Many of the most important art galleries commissioned and sold photographs; others scorned photography as a science rather than an art. Yet professional artists were among the hundreds of men and women who turned to the medium at mid-century, and artists used photographs with increasing ease and familiarity.

The idea that photographs were completely accurate and faithful to visual reality was part of the earliest promotional criticism associated with the medium. All of the most intelligent early writers about the medium recognized its artificiality, its conventions, and its limitations, while they praised its advances. The contrivances of the portrait photographer to avoid blur-making movements in their sitters created an almost comic stiffness in early photographic portraits, a stiffness aped jokingly by painters and print-makers. The long exposure times necessary for a full range of tonal value in the print created conditions in which any movement was recorded as a blur or even rendered the mover invisible, and most skies bleached to an absolutely spaceless white because so much light emanated from them. To combat these problems, early landscape and architectural photographers contrived to banish their skies to the corners, edges, and tops of their pictures, and they used hundreds of devices to minimize movement within their field of vision. Their attempts were consistent enough that photographs began to take on certain formal characteristics, many of which appeared to flatten the representation. Architectural photographers tended to place themselves so that the buildings they recorded were strictly parallel to the picture plane. Photographers of cities or landscapes often adopted high vantage points, looking down on their subjects, both to remove what would be a blurred foreground from their compositions (due to limited depth of field in early lenses) and to minimize the white expanse of the sky. It was the very limitations of the medium of photography that created the conditions for the 'photographic', and blurring, flattening, and planar arrangements of form soon became so common in the visual repertory of photographic representation that they appeared—both consciously and not—in other representational media.

Yet, of all the problems associated with photography, the most interesting and aesthetically challenging was the problem of the edge.

We all know that any representational artist who conceives of their subject in a certain way can arrange that subject so that it absolutely dominates the composition. For photographers working out of doors, the edges of the picture presented real problems. In cities and land-scapes, unwanted forms that could simply be banished from the representation by a painter or draughtsman were stolidly present in the photograph, sometimes creating subjects that were unphotographable. Often the photographer struggled to omit them by moving so that they occupied the periphery of the pictorial field. Indeed, the extraneous aspects of visual reality paradoxically became the real concern of the photographer, and their removal or the diminution of their presence was of paramount importance in conceiving of a successful photograph. This very situation lead to the gradual development in which the accidents of nature that deformed photographs came to become aesthetic virtues. The limitations of the medium took on positive characteristics, particularly in photographs by painters who used the medium as part of their practice.

Among the many other limitations of the medium of photography was movement. It was felt that painters or draughtsmen had the freedom to represent movement because they were not encumbered with the long exposure time of a theoretically instantaneous medium. It was actually photographers who were the first to represent the movement of bodies in a complete way and these scientific photographs, some of which were made by the modernist American artist Thomas Eakins (1844–1916), had profound effects on non-mechanical representation into the early twentieth century. The notion of these photographs is that the machine can see more accurately than the human eye, making possible the accurate representation of rapid motion that is invisible or

unanalysable to the human eye. Fascination with movement was so pervasive in this period that artists of such varying aesthetic proclivities as the Frenchmen Duchamp and Ernest Meissonier (1815–91) were united by their absorption with its accurate representation.

The true conquest of the public consciousness by photography came with the development by Kodak of the easily portable hand-held camera. The word Kodak was among the first international brand names to permeate industrial and colonial society. It became a word in virtually every language (including the ever-resistant French), and by the late 1890s few middle-class citizens of the capitalist world had not themselves made a photograph or seen one made by a friend or family member. This was a truly revolutionary and modern development. With the Kodak, anyone could represent their own world and experiences, thus potentially further limiting the professional artist's representational function. The most common needs for images, at births, weddings, deaths, confirmations, and bar mitzvahs, came increasingly to be the arena of the amateur. In response the professional artist came more and more to develop a higher idea of representation.

Conclusion

One of the principal conditions of modernity in representation is universal access to images, both in the original and in reproduction. Although the ownership of works of art remained privileged, any member of modern society who desired to study diverse representations had both the right and ability to do so. In spite of widespread press censorship in certain European cities, the 'graphic traffic', as it has come to be known, was largely unregulated in the nineteenth and early twentieth centuries, allowing individuals to create their own libraries of representations, both in the mind and in fact. The proliferation of museums, fairs, temporary exhibitions, exhibition societies, and commercial galleries made access to originals possible in most Euro-global cities with populations over 250,000. Artists used this access to reproductions and originals in immensely varied ways. Yet no study of modernism would be complete without a sense that modern artists from Symbolists to Surrealists created a kind of modernism we shall call image/modernism.

Part III

The Artist's Response

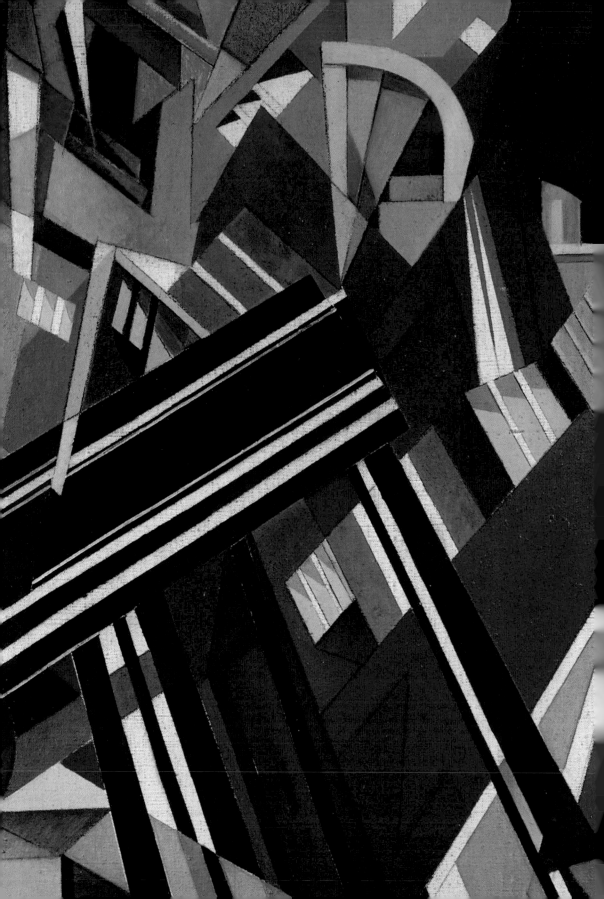

Representation, Vision, and 'Reality': the Art of Seeing

'I get all my inspiration from the real world, so I'm much more involved in just walking down the street... and finding out what's going on in the world, than to look at another person's interpretation.'

Jeff Koons, *Flash Art* (Summer 1997), 105

In 1930 the Canadian painter Emily Carr gave a lecture in her native Victoria entitled 'Fresh Seeing'.[1] She might have called it 'French Seeing', because many of the ideas in her lecture had their roots in her own powerful experiences of French art and theory in the first decade of the twentieth century. Her message was that successful art is not so much a mode of representation as it is a mode of seeing, and that in making important representations artists present the viewer not simply with an internally consistent and successful image, but with an entire way of seeing the world. This idea is not, of course, unique to modernism, but it is so powerful a part of modernist theory that it deserves to be canonized as one of the two principal ways of thinking about art that has prompted modernism.

The desire to see afresh was a crucial part of the modern artist's practice. Constable, we are told, wished that he had been born blind and suddenly regained his sight. Cézanne wanted to make a painting as if in the state of mind of someone who had never before seen a painting. Vuillard and Bonnard saw through the eyes of their nephews and nieces, as if somehow to recreate the visual world anew. Picasso reported that he could draw like Raphael when he was twelve, and needed to unlearn that facile skill in order to draw like a child. Mondrian was convinced that only through supreme effort could one erase the history of art from one's mind in order to make timeless or essential art. Kandinsky and the Swiss artist Paul Klee (1879–1940) used the drawings of children to release themselves from the constraints of conventionalized ways of seeing.[2] A list of neo-naïve theories of art would reveal a virtual obsession of modernism, an obsession that cannot be found in anywhere near the same strength in earlier theories of art.

The French landscape painter Charles-François Daubigny (1817–79) coined perhaps the best expression for this idea—*savoir-voir*.[3] All of us, even in the English-speaking world, know its cognate, *savoir-faire*,

to know how to make or to do. The elegant gentleman who knows how to have the best table in an expensive restaurant ready when he arrives; who, seemingly instinctively, orders the right wine, who knows, in short, how to make the world work as if for him, this is *savoir-faire*. *Savoir-voir* is another matter. How, we ask, can one know how to see? Yet the most powerful weapon of the artist, in a capitalist society that needs constantly to redefine its utility, is the artist's command of the visual. If seeing is believing, then representing is to have ultimate control of the seen world.

To illustrate this point we could look at Manet's *The Balcony* (1868–9) which is, just that, a full-scale representation of a balcony in modern Paris [48]. The bottom of the painting is the lower/forward edge of the balcony; the top is that of the glazed aperture that permits intercourse between inside and outside; the picture's actual frame must have served both to protect the picture and to stand in for the architectural moulding of the window. We see three life-size figures (with a fourth, a shadowy servant), all of whom are occupied in looking out of the picture at something or someone. The dark-haired seated woman (the model was the painter Berthe Morisot) looks laterally, presumably at the world-in-the-streets. The woman with the flower-hat looks at us, the viewer, and the sole gentleman looks at her. There is a hierarchy of gazes, all of which deal with some sort of desire. Yet the ultimate mystery of the painting is that, when we imagine it hung high on the wall of the Salon exhibition in 1868, it almost becomes an actual balcony and we, as viewers of the Salon, are transformed into the human traffic of the boulevard. One of them gazes abstractly, refusing to meet the gaze of others. The second looks directly into the eyes of the viewer, threading the needle of urban consciousness, connecting the synapse of sentiment. How much more modern can one be?

Viewers have long been accustomed to portrait figures with their eyes staring at us as we move around a room. And we learn from countless gallery talks and country-house visits that virtually every peripheral figure in the history of figure painting who makes eye contact with the viewer is actually a self-portrait of an artist. We have also learned from critics of eighteenth-century art of the two modes of representation that Michael Fried has termed absorption and theatricality.[4] Absorption literally blots out our consciousness as viewers, forcing us to give ourselves to the person or persons portrayed because they are absolutely unconscious of us as viewers. The other side of the equation, theatricality, involves the heightened consciousness of viewing, in which we have brokered an agreement with the figure(s) in the painting, and each of us seems to acknowledge the existence of the other. Manet, not being an eighteenth-century painter, had it both ways.

In *The Balcony*, Manet painted an image about viewing: the sexuality, anonymity, and hierarchy of viewing. As such, the subject of his

painting is contemporary urban visual culture. His painting also places the viewer of the painting in the position of being viewed by the figures in the painting, so that the traditional function of the painting, as a world viewed and consciously represented, is reversed. It is precisely Manet's consciousness of the representational efficacy of viewing that characterizes his particular modernism. *The Balcony* makes clear that, in modern art, the viewer is as important as the viewed, that seeing or perception is itself now the subject of art. The viewer is temporary, the painting is permanent.

The human eye

The history of modern representation developed alongside new ideas about seeing itself. The very way the eye sees or perceives was the subject of intense research in the nineteenth and twentieth century, and the implication of all this research is that perception itself is conventional rather than natural, bounded by the physiognomy of the human eye and by the emotional and psychological state of the mind that receives those sensations. It is no accident that the first important scientist who addressed the Academy of Fine Arts in Paris was Michel-Eugène Chevreul (in 1839) and that he taught the students about mixtures of colour in terms of the developing knowledge of the physiology of the human eye. The greatest theoreticians of this period were convinced that the answers to questions about the nature of light and reality could best be found by studying the eye. Alexandre-Edmond Becquerel, the Nobel Prize-winning physicist, published his great study of light (*La Lumière, ses causes et ses effets*) in 1867 and1868, just as the young Impressionists were making their first truly confident outdoor pictures and the year before two simultaneous (and premature) announcements of the development of colour photography. The eye was, for scientists and for artists, an organ to be analysed as the most sophisticated instrument known to record visual sensation.[5]

We know from the writings of Jules Laforgue in 1883 about the physiological origins of Impressionism, and that the Impressionists were vitally concerned with these developing scientific notions of perception, the nature of light, and colour theory.

Even if one remains only fifteen minutes before a landscape, [he tells us] one's work will never be the real equivalent of the fugitive reality, but rather the record of the response of a certain unique sensibility to a moment which can never be reproduced exactly for the individual, under the excitement of the landscape at a certain moment of its luminous life that can never be duplicated Subject and object are then irretrievably in motion, inapprehensible and unapprehending. In the flashes of identity between subject and object lies the nature of genius. And any attempt to codify such flashes is but an academic exercise.[6]

In 1869 Pissarro inscribed a drawing with the tantalizing phrase 'a land-scape seen through a completely transparent vapour, the colours mixed one into the other and trembling'. Not a mention of Louveciennes, of modern subject-matter, of the suburbanization of nature, or any of the other aspects of Impressionist subject-matter written about so extensively by scholars of the last generation.[7] And, when thinking about Impressionist practice in these terms, one can easily move to its rigorous synthesis in the practice of Seurat and Neo-Impressionism and to its fluorescence in the tantalizing later writing of Monet, who considered the subject of his paintings to be an 'envelope of light' rather than specific forms.

The struggle to achieve what Laforgue called a flash of identity between subject and object was almost universally accepted as the duty of the modern artist. The pictorial or stylistic manifestations of this general idea are so diverse that they resist easy classification. Even within the realm of French landscape painting, if one were to place well-chosen examples of Realist, Neo-Impressionist, Fauve, and Cubist landscapes or cityscapes in one gallery, it would be difficult to imagine that they were all painted, partially, if not completely, in front of an actual landscape against which the painter measured the success or failure of his representation. This very idea makes it clear that who painted the landscape and when the landscape was painted is as important as the landscape motif or view itself, and this condition remains true throughout the history of modern painting. In this way, many of the highly complex attempts at modern iconography that confine themselves to an analysis of the artist's representational subject per se (a bridge, river, tree, or haystack) are doomed to failure.

If modern reality is in constant flux and if the materials, techniques, and concepts that underlie that representational strategy are also changing, there is a built-in instability in the system of modern representation to which artists must respond. It is also clear that their ways of doing this varied widely.

Transparency and unmediated modernism

The most obvious way to represent modern reality is to choose as one's subjects those aspects of the visual world unavailable or not invented in the past. In this way, the modern painter could paint a railway station like Francis Frith [5]; the Eiffel Tower like countless artists; a fashionable sea-crossing like the French artist James Tissot (1836–1902); an absolutely new café like Manet; or a zoo like Marc. This subject-oriented representational strategy cannot be undervalued simply because it is so obvious. Yet, in many cases, artists who chose this strategy were less interested in the means of representation, in the subjective aspect of the modernist flash evoked by Laforgue, than they were in the sheer modernity of the represented subject. Works of this

49 Mary Cassatt

Little Girl in a Blue Armchair,
1878, oil on canvas

The young American painter,
Mary Cassatt, was brought into
the Impressionist circle in the
late 1870s by Degas, who had
relatives in the United States
and had visited the country in
1872. This canvas, painted for
inclusion in the art exhibition
of the 1878 International
Exhibition in Paris, has often
been called a collaborative
effort between Degas and
Cassatt. The American
remained in France through-
out her working life, joining
Whistler and Sargent as
American expatriates abroad.

sort could be painted in a wide variety of modernist styles or in careful replications of academic practice, but their chief value to their artists and clients was in the skilful, and clearly recognizable, representation of a modern subject [**49**].

Another strategy in the aesthetic of modern representation involved the artist in the technological advances in seeing that came about due to microscopes, X-rays, motion-photography, and various filtered-light modes of photography. The vast popularity of microscopic images, and the fascination with the recording of planets and the solar system with telescopes, had a real impact on the makers of painted representations, particularly in the first three decades of the twentieth century. Linda Henderson has described the use made by artists of mechanical representations of the world that describe visual realms inaccessible to the human eye except through magnification or mechanical modes of representation.[8] Although different in certain crucial ways from other forms of modern visual analysis, both their visuality and their modernity must be stressed. The cellular and prismatic abstractions of Czech vanguard painters like Kupka, the light representations of Delaunay, and other types of abstraction are based quite concretely in the realm of the visual, not just the visual of the unaided human eye.

One of the most persistent aesthetic notions associated with this strand of modernism concerns the technique of the artist. Unlike Transparent Realist and Impressionist painters who call little attention to their mode(s) of representation, most artists who described the modern visual world were obsessed with how they represented as with what they represented [**50**]. A good deal of the forced banality of much modern iconography, portraits, still lifes, simple genre scenes, and

landscapes, is intended to force the viewer away from the subject itself as the locus of artistic interpretation. Instead, the manner of the representation becomes in this sense the subject, and no serious study of modern art can deny the truth of this thoroughly traditional modernist notion. From Impressionist views of perfectly ordinary scenes to the generally uninspired subject-matter of Cubist and Fauvist painters, modern artists have been deeply committed to the fact that modern seeing or, to return to Emily Carr, fresh seeing can be applied to anything from a tree to a brothel. In this way of thinking, the more ordinary the subject, the more the viewer can appreciate the 'fresh seeing' of the artist.

Surface fetishism and unmediated modernism

Among the many concerns of the painter at mid-century was the increasing popularity of photography. Both daguerreotypes and albumen prints from glass negatives are completely focused, possessing a high degree of surface detail, similar to the neo-classical academic finish of artists such as the Frenchman Louis-Léopold Boilly (1761–1845) and Jean-Auguste-Dominique Ingres (1780–1867), throughout the visual field. Perhaps as a result of the perceived competition from photography, painters from Courbet to Picasso developed a painting style as a coloured relief in which the spatial and material nature of paint itself was vital to the meaning of the painting. The painter strove to involve the viewer in the process of artistic creation by fetishizing their major material, paint.

This overt representational materialism makes clear to the painting's viewer that the painted representation at which they are gazing is

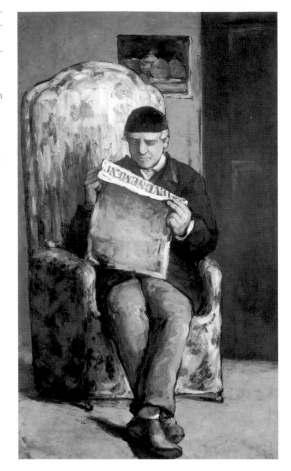

51 Paul Cézanne

The Artist's Father, 1866,
oil on canvas

This painting and a small
group of other canvases by
Cézanne and Pissarro took
Courbet's palette-knife realism
to new heights, making overt
stylistic links between easel
painting and plastering,
trowelling, and other types of
physical labour. The complete
crudity of this work's facture
contrasts strongly with the
haut-bourgeois imagery
of the portrait.

handmade, that its making is part of its meaning, and that a good deal of the signature qualities of a painting stem directly from the painter's personal manner of manipulating paint and surface texture. As we have seen, the most extreme cases of this are the palette-knife paintings of Cézanne made in the late 1860s [**51**], but this painting is different in degree rather than in kind from the modernist paintings of the Macchiolli or even of the painterly society portraitists like those by the American Sargent, the Swede Zorn [**52**], the Italian Boldini, or the Russian Arkhipov. When we consider within this materialist strategy the paintings of artists such as van Gogh, the Fauves, the Ashcan School in New York, and the heavily worked surfaces of Patrick Henry Bruce, Delaunay (1881–1936) and Léger, we can see the sheer range of apparent styles within a single aesthetic system.[9]

For all these artists, the sheer physical reality of paint, its viscosity, translucency, and colour, when brought together with a variety of tools, brushes, knives, and spatulas, presented the painter with the opportunity to be a virtuoso very much like a great pianist or singer. Thus crudity of execution became a virtue, and modern artists worked hard

not to disguise their working methods by refusing to bring their works to a conventionally acceptable level of finish.

Indeed, the processes of conceiving and making a representation were so interlinked in modernist theory that a true modernist painter could not finish a picture because, if he did, the conception of the painting must have existed at the onset of the process, making the process itself irrelevant. Thus, when we see the multiple scrapings of the Frenchmen Degas and Pierre-Auguste Renoir (1841–1919) and the clusters of barely visible and rejected lines in Picasso we see direct evidence of the artist's work, making it impossible for us to interpret the representation as purely an image, but as a process of unique creative interaction among artist, subject, and material.

A particularly succinct embodiment of this notion can be found in Edgar Degas's painting, *The Millinery Shop* from the mid-1880s. His young milliner makes her hat as Degas makes his painting, and her unfinished hat is also the least conventionally finished portion of the painting. Indeed, the section of the painting containing that hat was scraped and reworked by Degas, who refused to disguise his process both because it is central to the aesthetic of modernism and because it was part of a complex representational strategy in which subject and process were directly linked. An analogous claim can be made for Cézanne's canonical, and persistently puzzling, *Still-Life with Plaster Cupid* (c.1895). In this curious painting on paper (unique in his *œuvre*) Cézanne allowed his paper support to show through in the interstices between his painted marks, building up a self-consciously worked surface that linked all the conceptual realms of his painting: actual

53 Unknown photographer

A London Slum, 1889, gelatin-silver print

Many photographers were involved in the pictorial documentation of urban life, and this anonymous work from the 1880s serves as visual proof of the horrible conditions of urban life in the British capital. Certain of these works were used by advocates of social justice to make visible parts of the actual urban world experienced by few people of wealth and power. This vast documentary project continues to this day, has no coherent plan, and is backed by no institution or government.

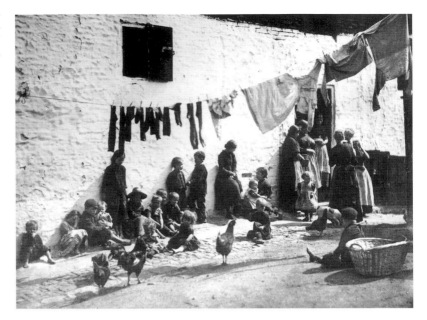

54 Jacob A. Riis

Flashlight Photograph of One of Four Peddlers who Slept in a Cellar, c.1890, gelatin-silver print

In the generation of Henry James, Edith Wharton, and John Singer Sargent, Riis represented the seething slums in which the new immigrants to America lived in New York. The directness of his photographs, and the fact that they are fundamentally a collaboration between photographer and subject, makes them particularly important. Unlike most representations of urban slums made on the streets or in public places, Riis actually entered apartments and other makeshift dwellings to show a side of urban life unseen by prosperous New Yorkers.

sculpture and painted sculpture; actual still-life and painted still-life; child and adult; painting and drawing. Both Degas and Cézanne are involved in painting visual manifestos about the very nature of painting, but, in both cases, they raise rather than answer questions about the new form of representation.

Photography and unmediated modernism

Histories of modern art have always found it difficult to find links between the nineteenth-century preoccupation with the relationship

between reality and representation (or subject and object), and
twentieth-century notions of the autonomy of the picture that lead
inevitably to abstraction.

The fascinatingly intertwined history of painting and photography
in the nineteenth and twentieth century has not been explored fully in
the history of either medium. Indeed, one of the basic tenets of mod-
ernism, that every medium has its unique properties and is involved in
a ceaseless conversation with itself, has prevented historians from deal-
ing seriously with basic issues common to all modern representational
media.

Whether of historic buildings, sections of the landscape, or studies
of the criminally insane, photographs were meant to be analysed in
groups and studied for particular purposes, only some of which could
be known to the photographers themselves [**53**, **54**]. In this sense,
photography and print-making participated in a process of visual cata-
loguing with its roots in the Enlightenment, but with considerably
wider audiences and distribution thanks to the image explosion of the
modern capitalist world [**55**, **56**]. Yet this idea of a document and of the
representation as part of a process of research and analysis was never far
from painting. Indeed, painters of this period tended to restrict their
imagery and to make multiple representations of the same or similar
subjects, such as the study of prostitution by Toulouse-Lautrec, so
that their work came to have a sense of collective order and rigour
of conception analogous to photographic documentation. This aspect
of modern art also affected the practice of serial painters like the
late Impressionists, specifically Monet [**57**], who so standardized his

56 Margaret Bourke-White

High-Level Bridge, Cleveland,
1929, gelatin-silver print

This is one of literally thousands of modernist photographs to represent industrial technology in the new city. Cast-iron and steel construction, a novelty in the mid-nineteenth century came to be increasingly common in the late nineteenth and early twentieth centuries. Photographers vied to compose images that lent a vertiginous vitality to these structures and thus to create emblems of modernity. Bourke-White's photograph is late in the tradition, but manages to sustain its power.

working procedures that he painted in a regular manner similar to the way a photographer created and printed photographs.

What is particularly fascinating about the documentary and artistic development of photography in the nineteenth century is that it can be compared directly with that of modern painting. From the early uses of multiple negatives by Gustav le Gray to the complex pictorial constructions of Robinson and Rejlander in England during the 1870s and 1880s, an entire strand of art photography borrowed notions of compositional order and finish, treating photographic prints as if they were highly mediated and self-consciousless constructed works of art. Their very acceptance of photography as a conventional medium capable of modification must be seen as a part of a fascination with experimental process that is also a part of modern painting [**58**].

Even at its onset, photographic practice was divided into two completely different techniques, daguerrotype and calotype, the results of which were aesthetically opposed despite their equal reliance on the camera. A careful study of modern photography shows an obsession with technical invention that goes hand in hand with an ever-widening imagery and an ever-changing visual character. Photographers and their viewers learned very quickly that photographs were only partially true to the visual character of their subjects. And it was the conventionality of the medium of photography with which photographers struggled. Perhaps the most important of these struggles in modern photography was that of P. H. Emerson, the brilliant English photo-

57 Claude Monet

Weeping Willow, 1919, oil on canvas

Recent studies of the painting technique of Monet have stressed the layered, highly complex surfaces on which he laboured for weeks, even months, before completing the painting. The thick, crusty surface of this late master-piece, completed at the end of the First World War, makes the tree trunk, the foliage, and the light itself equally palpable. Monet is reputed to have signed and dated this picture on Armistice Day, when War officially ended.

grapher who, after creating a distinguished body of work that he called 'naturalistic photography', actually renounced the medium, declaring with a dramatic finality that photography was not an art.[10]

The very struggle of photographers to define themselves and to be defined by the critical world as artists can be read as a reversal of the strategy of modern painters, who defined themselves in opposition to conventional notions of art. For photographers, notions of focus were as important as notions of finish were to painters, and each struggled with compositional strategies, forever balancing their motifs or subjects with the field of vision that contained them. And in all this there was intense questioning of the very idea, and function, of art in a capitalist or consumer-oriented society.

Beyond the oil sketch

We are accustomed to thinking of the oil sketch as being the purvey of the Impressionist, for whom the act of representation was theoretically linked to the direct experience of the motif by the painting throughout the act of representation [**59**]. While Monet often completed his works

58 John Dudley Johnston

Liverpool an Impression, 1908, gum-bichromate print
If ever a photograph was a translation of painterly pictorial values, it is this superb pictorialist photograph of industrial Liverpool. Taking his cues from paintings (and prints) by Whistler, Johnston conveyed a misty, indefinite image of an almost deserted urban realm, intentionally poetic and socially unproblematic. The photographic obsession with mist, steam, fog, and other spatially positive atmospheric effects was a result, in part, of their desire to remove unnecessary visual incidence from their images, giving them the status of fine art.

59 Sandor Galimberti

View of a Street in Nagybánya, 1907, oil on canvas
Nagybánya, an attractive village in present-day Romania, was the Barbizon of the Hungarian avant-garde in the late nineteenth and early twentieth centuries. Here, artists who worked everywhere from Paris to Bucharest would gather for the summer season to paint modern pictures of traditional village life. Galimberti's (1883–1915) vertiginous view of a street imposes an urban aesthetic onto a village.

in the studio, far away from the motif itself, this process allowed him to adjust colours and surfaces to the conditions of exhibition lighting and to create harmonies among pictures so that they hang well together.[11] This practice was surely also maintained by Renoir, Sisley, Pissarro, Degas, and others.

Many of the most artificial of canvases were, in fact, painted in front of the motif; virtually all the oil sketches of Seurat, Signac, and others represent direct responses to their subjects, and we know that the most famous of the artificial landscapes of the 1880s, the *Talisman* by the French artist Paul Sérusier (1863–1927), was painted out of doors during a short period of time, just as Monet painted his Impressionist landscapes.[12] Gauguin instructed Sérusier to exaggerate all his colours in creating the *Talisman* so that the resulting representation, small as it was, attained the same force as the motif through compression and chromatic intensification.

More often than not, artists who accepted the theory of unmediated modernism practised their beliefs as simply as possible. After a period of subject selection and preparation, they stood in front of their motif and worked to transcribe it as they saw it, hoping that their representations would capture that magical synaptic link between the consciousness of the artist and his inspiration from nature [**60**]. For them, other works of art, whether in the original or reproduction, were a hindrance, polluting the purity of their quest for authentic individual experience as it could be represented.

Cubism

The biggest break from this strand of painting seems to have occurred in Paris at the end of the first decade of the twentieth century. In 1909

61 Per Krohg

Female Nude, 1919, oil on canvas

Although scarcely known outside his native Norway, Krohg (1852–1925) was an artist who was familiar with Parisian Cubism in both theory and practice. This 1919 painting was made from a model in ways no different procedurally than those used by Manet, Renoir, and Degas in the 1860s and 1870s. One can relate his work more easily to the practice of the Puteaux Cubists Gleizes and Metzinger than to the canonical Cubism of Braque and Picasso.

and 1910 Picasso and Braque began, under the distinct influence of the late work of Cézanne, to construct pictures by building up forms and figures from hundreds of short strokes of paint, many of which were linear. These paintings, dubbed Cubist, have often been considered to be the decisive moment in early twentieth-century art, after which the creation of an utterly non-objective painting was possible. Yet in looking at analytic Cubist paintings and in reading the early sources one is struck over and over again that Cubist painters worked *en face du motif* just like Impressionist and many Post-Impressionist artists. They also give us manifold clues in the picture that enable us to decipher the subject of the painting. Indeed, Cubists attempted to see anew by representing anew, and the claims made for their syncopated canvases were often rooted in actual sight. One of the most persistent of these has the Cubist painter moving around a static subject, compressing the many silhouettes and contours they observe into a single canvas. In this way, the portraits of Daniel-Henri Kahnweiler or Vollard become a view of either man through time; in a simplistic sense, a four-dimensional representation.

In spite of all the early criticism that situates Cubism as the antithesis of the then fashionable Impressionism, a good deal of the theory of Cubism flows easily from that of the earlier artists. The Impressionists, several of whom (Monet, Degas, and Renoir) were alive when Picasso and Braque carried out their revolutionary experiments, were equally fascinated both with time and with a motion-filled idea of

the world. The sense of Impressionism as being a representation of momentary time or short durations is transformed by the Cubists into an idea of painting as a compressed series of observations made over a comparatively long duration. In each theory, the particular character of the representer is integral to the representation, the artist's receptivity to the motif as well as the preparation that equips them to represent. Yet, where Impressionists immersed themselves in the larger world out of doors, eschewing, at least in theory, the studios of academic artists, the Cubists followed studio artists to a certain extent, in their patient observations of static forms in interiors, where seated subjects sat immobile and still-life elements were arranged for patient observation [**61**].

When we read the favourable criticism written about the Cubists during their breakthrough years, particularly the writing of Roger

62 Moriz Melzer

Bridge–City, 1921–3, oil on canvas

The sheer formal exuberance of this urban representation suggests the progressive urban politics of advanced painters after the First World War and before the final financial and cultural débâcle of Weimar culture.

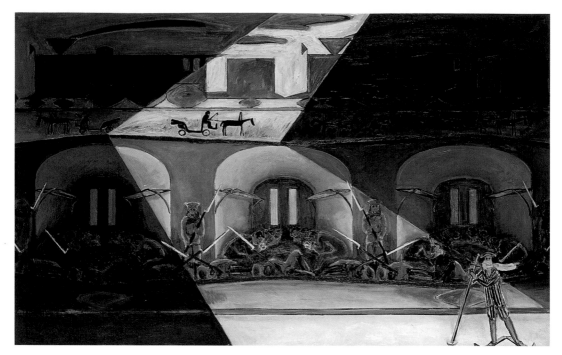

Allard, we are thrust into a critical system that thought of Cubism
as being anti-Impressionist, just as the Synthetists and the Neo-
Impressionists had before them.[13] Perhaps, Allard was unable to see
the extraordinary links between Cubist theory and that of the artists he
repudiated because so much of the most persuasive criticism about
Impressionism was long out of print and because, by 1910, the staunch
defenders of Impressionism were the grand old men of French letters.
Impressionism was now to Cubism what academic painting had been
to Impressionism.

The works of Cubists and Futurists created a visual vocabulary that
had a more revolutionary effect on conventional modes of painting
than had those of the Realists, Impressionists, or the various Post-
Impressionists that preceded them. Indeed, their fascination with a
rapidly shifting urban environment as being the subject of an equally
rapidly shifting modern painting proves that there is more that con-
nects them as moderns than divides them as representers [**62**].
Tolerance of diversity of style among the Impressionists was so great
that virtually every nineteenth-century movement that followed had
its roots in their membership.

Representation, time, and the city in Futurism and Cubism
The artists who, in a certain sense, gave new impetus to the modern
fascination with light and urban reality were the Orphists and the
Futurists. In the paintings of Delaunay, Severini, and others, the mod-
ern city takes on a transformative energy that is only barely hinted at in

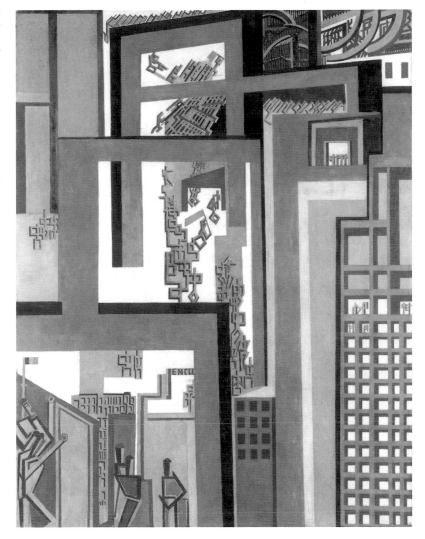

the urban paintings of Impressionist and Realist artists [**63**]. For the later artists, the city is subsumed into a pictorial energy field in which aspects of its visual character are seized, summarized, and scattered across the pictorial surface. Hence the surface is no longer a field of vision, but a field of action or compressed observation [**64, 65**]. In a sense, though, Baudelaire's *flaneur*, the lonely urban connoisseur who walks through the city, observing it from a detached perspective, re-mains the persona of these twentieth-century urban artists.

The metaphor of the window, through which Manet's figures move to enter the upper spaces of the boulevard in *The Balcony*, remains for many modern painters the distancing device that it had been for Realists and Impressionists (see **48**). The fluttering figures at the edge of Monet's *Boulevard des Capucines* (1873) define the viewer's vantage point as a windowed balcony, just as the insistent grill in *View through*

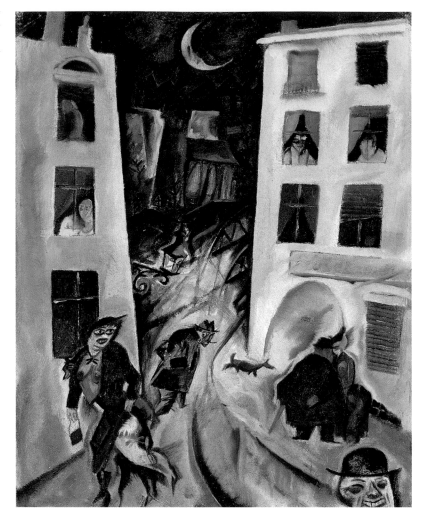

a Balcony Grill by the French painter Gustave Caillebotte (1848–94) locates us in the modern city. Yet for Delaunay, whose window series is among the highest achievements of modern urban painting, the window is fetishized, becoming itself the subject of the picture, its pulled-back curtains becoming the contours of the Eiffel Tower, its mullions dividing the picture field into geometric zones. And Delaunay's absolute fascination with prismatic colour too has its roots in the theories of perception and light that are central to the Impressionist achievement. The convergence of the outside and the inside in many post-Cubist urban views is remarkable.

There were few young modern artists anywhere in the world who had not read, seen, or heard about Paul Signac's great book of 1899, *From Delacroix to Neo-Impressionism*. Signac and his highly articulate colleague and friend Maurice Denis were among a group of artist-writers who defined modern art for artists and whose texts created a

66 Gösta Adrian-Nilsson

The City by the Sea, 1919, oil on canvas

This elegant small painting proves that the Cubo-Futurists' theories of urban representation reached the farthest edges of Europe and the Americas by 1920. Indeed, for all its horrors, the First World War brought to many Europeans and Americans a greater sense of international awareness. In looking at a provincial city by the sea, Adrian-Nilsson created a cosmopolitan image.

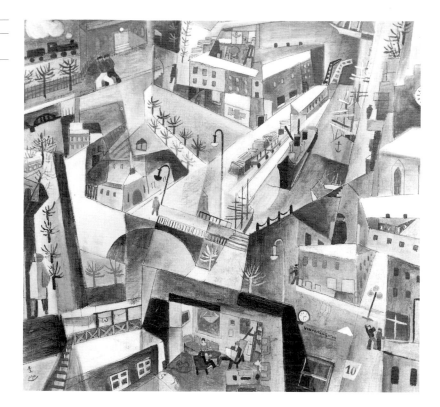

sense of the artist's contribution to a very young and vital history. The fact that, in most of these texts, Impressionism was viewed as a sort of tiny step in the evolution of modern art cannot in any sense undercut its prescriptive importance. This has been recognized most clearly by Richard Shiff, who located in Impressionism not only the seeds of its own death, but also the possibilities that were to be systematically explored by painters for several generations following them [66].[14] Indeed by 1900 the historicity of modernism, the sense of its tradition, had become as strong within modern representation as the rebellious anti-traditional discourse of the 1850s, 1860s, and 1870s.

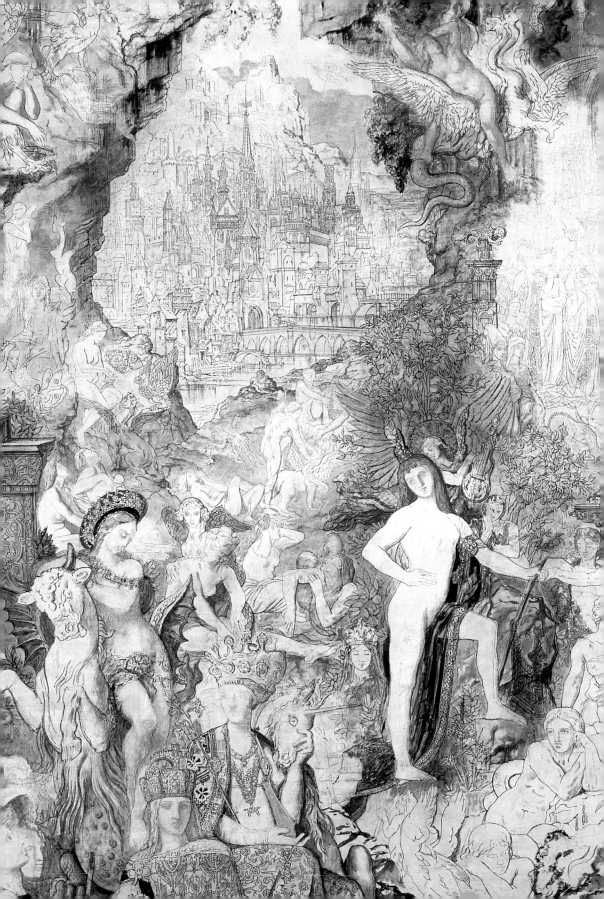

Image/Modernism and the Graphic Traffic

4

'The Pop artists did images that people walking down Broadway could recognize in a split second—comics, picnic tables, men's trousers, celebrities, shower curtains, refrigerators, Coke bottles—all the great modern things that the Abstract Expressionists tried so hard not to notice at all.'

Andy Warhol, *POPism* (New York, 1980), 3.

When Paul Gauguin finally gave up on Paris, turning to a cheaper life and a search for a possible paradise on the remote island of Tahiti in 1891, he took a large collection of photographs with him. Today, unfortunately, these are lost, as are many artists' collections of useful photographs that are crucial to an understanding of modern art. However, we know from a good many of his borrowings and from a few bits of concrete evidence what some of them were. He had purchased pornographic photographs on the way in Port Said; photographs of paintings like Manet's *Olympia*, Pierre Puvis de Chavannes's *L'Espérance*, *Women of Algiers* by the French painter Ferdinand-Victor-Eugène Delacroix (1798–1863); photographs of the great Buddhist temple at Borabadour in Java; and a large group of reproductions. He also had a collection of Japanese prints and printed papers.[1]

His cannibalizing of this collection was once decried as a form of plagiarism. He borrowed Cranach (a reclining Diana) and Manet in making what one critic called his Black Olympia in 1896, and his well-thumbed copy of the sale catalogue for the collection of his guardian Gustav Arosa gave him access to paintings by Delacroix and Courbet among others. Perhaps the academics among us despise this unaccredited borrowing, preferring the tidier world of footnoted quotations. But Gauguin would have laughed at such pedantry, declaring his absolute freedom to plunder the past just as the Impressionists plundered the visual world of the present.[2]

Pissarro wrote scathing letters to his sons about Gauguin's religious paintings and about the younger artist's search for art within art (and spirituality).[3] When we step back from the smoke emanating from this artistic feud, we see that artists who spent their lives borrowing from other sources, cobbling together pictures from fragments of

Detail of 71

other pictures, were as embedded in the capitalist world as were their moralistic counterparts who linked art and vision so insistently.

With accessible museums throughout Europe, easily available reproductions, and the new obsession with temporary exhibitions in large urban centres, the image bank of the artist increased so greatly that one could be modern simply by taking a new look at traditional imagery. It was, indeed, the sheer multiplicity and non-hierarchical variety of sources for works of art that constituted a major strand in capitalist modernism. There have been few detailed studies of this phenomenon. We have learned about the sources of Manet, Gauguin, Cézanne, Seurat, and many other canonical artists of modernism, but these studies have not been systematized. Indeed, the reliance of such analysis on the traditional strategies of the iconographer has meant that, in many cases, sources are identified as part of a type of analysis that locates the meaning of a work of art in these sources. It would be more profitable to study the graphic traffic as a system, in the ways that Estelle Jussim and Beatrice Farwell have begun, following the model of William Ivins, whose *Prints and Visual Communications* made such an impact on the study of popular culture.[4] We know that many of the most important artistic plunderers in the history of modern art were not highly principled about their sources. Manet used major masterpieces of Western easel painting, anonymous photographs, and mass-produced prints with equal ease, borrowing compositions and figures with little apparent regard for the artistic status of the source. And just think of Cézanne in the Louvre: his surviving sketchbooks make it clear that he was absolutely catholic in his taste in painting and sculpture, borrowing figures from sublime paintings by artists such as Rubens and Boucher and more straightforward works by Claude LeFèvre (1632–75), Claude-Joseph Vernet (1714–89), and others.[5] There were many senses of hierarchy of images that operated simultaneously in culture, creating a relationship between images and people that had no precedent in human history.

The system controlling the production, dissemination, and consumption of images is the modern visual condition. In fact, modern men and women operate in a world of images, many of which impinge constantly on their relationship with the real world. Although a principal strand of modernism eschewed, even battled, this system, the second strand either embraced or subverted it, engaging actively in the world of virtual images with indirect relationships to visual reality.

This was a type of modernism that persisted throughout the period studied in this book, from Symbolist easel-painting, prints, and photographs and a good deal of Neo-Impressionism to Surrealism. Image/modernism is a tradition of art in which the encounter between artist and motif, or between artist and canvas, which is important as a direct relationship for the unmediated modernist, is subjugated to that

between the artist and the world of images they cannibalize. This image/ modernist makes representations not from the world, but from other representations, creating works in an endless flow of art production that has its own internal mechanisms. The art of Gauguin, Toroop, Dante Gabriel Rossetti (English, 1828–82), Aubrey Beardsley (English, 1872–98), Gustav Klimt (Austrian, 1862–1918), Max Ernst (German, 1891–1976), and countless others can be placed in this tradition. Many of the artists whose work has been discussed in the chapter on unmediated modernism made major forays into image/ modernism. Courbet and Renoir, great sensualists, made canvases that vie in every way with earlier museum masterpieces by Rubens and Rembrandt and many others; artists often had to feign rather than to practise naïvete.

Again, the styles used by these artists range from the old-master precision and the closely related dream photography of Magritte to the

67 Stanislaw Wyspiański

Głowka Helenki, 1900, pastel on cardboard

Wyspiański was the most varied and accomplished artist of the young Polish modernists. Trained in Paris, he returned to Cracow to commence a lifelong representational project that included architecture, set decoration, painting, illustration, stained glass window design, furniture, and writing. The most important Realist writer for the theatre in Polish, Wyspiański also turned his talents towards portraiture, representing his friends and family in paintings and pastels of an astounding variety. This is one of the many representations of his daughter, whom he studied throughout her childhood.

smeared and gesturally defined images of Moreau. There were the thinned, watery surfaces of Munch, where the texture of the canvas unifies the image like paper unifies a watercolour or becomes light in a lithograph, and the crusty pastels of Redon and the Polish artist Stanislaw Wyspiański (1869–1907), whose surfaces are as visually assertive as is the imagery they embody [**67**]. Perhaps because of this stylistic range, studies of image/modernism have been obsessed with iconography or the explanation of the meaning of the image represented. This has produced fascinating studies of such themes as: chimera, homoerotic idealization of the male nude, and occult Christian themes. Few scholars have confronted the possibility that the meaninglessness or deliberate iconological imprecision of these images may be more important than their attachment to particular meanings. This issue becomes more problematic when one confronts the fact that a good deal of collage and, particularly montage, can be considered a form of image/modernism.

When an artist was at play in a world of images, the possibilities were so great by the middle and later nineteenth century that one could easily claim that there was more 'territory' for the artist in the image world than in the actual world. Artists confined to the confrontational strategy of unmediated modernism were hampered to a considerably greater degree than artists who combed guidebooks, illustrated histories of art, exhibitions, scientific illustrations, X-rays, posters, popular prints, and the like for inspiration. In fact, a good many artists who contributed to image/modernism felt that the imagination was the single most liberating arena available to modern man.

The logical flaws in this position, though obvious, did little to undercut the fervour with which image/modernism was practised. In fact, the real world was expanding at a comparable rate to that of the image world. Trains, rapid mail, improved shipping, lighting technology, and so forth conquered larger and larger domains of the physical world. Night became as visually accessible as day, and scientists and writers like Jules Verne and H. G. Wells took modern people on voyages greater than any colonial imagination could grasp. Education became a cheaper and cheaper commodity as the nineteenth and twentieth century continued. The education of middle-class artists like Rossetti, Vuillard, Duchamp, and others was their liberation from class-bound professions and their introduction to the image world.

It is tempting, of course, to consider image/modernism as simply an extension of the traditional Western art world, in which artists made art from a system of images and techniques that were learned through apprenticeship and the academy. In this system, innovation was encouraged within the boundaries of that image production system, and the openness of the systems to innovation varied from the extreme strictures of the production of icons for the Eastern church to the

relatively loose world controlled equally by the academy and the art market in eighteenth-century France. If one contrasts the territories of Ferdinand Hodler and the Frenchman Jacques-Louis David (1748–1825), examples of allegorical figure painters who both worked in the interstices between two succeeding centuries, that of Hodler is far greater in range [**68**]. David, though a painter of greater power and art historical importance, worked within a considerably narrower idea of the picture, narrower because the state remained, for him, the greatest patron and the salon the most important exhibition venue. To put matters in a sharper perspective, the availability of visual source material for David was so much less than it was for Hodler that one can safely say that the two artists operated in different systems. Even though David lived and worked in Paris with access to the greatest collection of works of art and images then accessible to the artist (or, at least, the powerful artist), his visual library was tiny compared to that available to the multi-lingual Hodler, who travelled outside southern Switzerland to Italy, France, Germany, and Austria, and who had access to an image resource—in books, reproductions, museums, art galleries—that would have amazed David. It is clear from this contrast that many modern artists were intimidated rather than liberated by the capitalist image world. When one contrasts Puvis de Chavannes and Moreau (Parisian artists who embraced it), with Pissarro and Monet (who fled its clutches), the moralism of the latters' consciously unmediated modernism becomes clear.

The possibilities for the image/modernist were virtually limitless, and the variety of styles, of source mechanisms, and of recombinant imagery in image/modernism is extraordinary. The aim of the remainder of this chapter will be to present and analyse the practice of successive generations of artists from the Pre-Raphaelites through to the Surrealists as they manipulated existing images in an almost frantic attempt to produce new ones of authority and originality.

The Pre-Raphaelite Brotherhood

When we think of the Pre-Raphaelites, with historicity built into their very name, it is impossible to conceive of their existence before the art museum, the concept of the history of art, easy travel, reproductions, and art criticism. Indeed, their very consciousness of history, of connecting to a time in art before the High Renaissance, is a modern notion. Although there have been various revivals in the history of art (the Hellenic revival in ancient Roman art, the Renaissance itself, and, of course, Neo-classicism), the main difference here was that the artists were aiming for a kind of corrective revivalism [69]. Pre-Raphaelite theory grew out of the Gothic revival led by Augustus Pugin, which was such an important part of British taste in the first half of the nineteenth century, culminating in the historical criticism of John Ruskin. Whereas the moralism of the Gothic revival had overt political dimensions, the Pre-Raphaelites attempted a less burdened revival, and one that, following the lead of Ruskin, accepts Italian art of the trecento and quattrocento as a touchstone.

At the start of the Pre-Raphaelite movement around the mid-century, the spread of lithographic and photographic reproductions was great, and their project of 'revival' was precisely in sync with that of the independent Arundel Society, a group who promoted Italian religious art of the early and high Renaissance by commissioning elaborate chromolithographic reproductions of works for schools, churches, and suitably pious members of the public. Charles Eastlake, director of the National Gallery in London, directed his purchasing powers towards the same period in the history of painting, and by the 1870s the British national collections of Italian Renaissance painting were superior to those of any European country except Italy itself, many works being accessible to artists in the original. At the same time, London supplanted Paris as the centre for the old master market, with dealers and auction houses increasingly selling major works of Italian art, many of which were thus accessible to the artists, albeit temporarily. In 1857, less than a decade after the creation of the Brotherhood, the largest and most important temporary exhibition of old master painting ever held in Europe was mounted in Manchester, and British and European artists flocked to see it.[6]

It is clear that the system of image exchange and transfer did little to promote intimate relationships between modern artists and specific works of past art. In fact, the partial, temporary, and fragmentary nature of modern knowledge of the past is a large part of its nature. Artists suffered more from the effects of image glut than from powerful encounters with a single work that left them feeling helpless. For that reason, the modern scholar has a great deal of difficulty in analysing the sources of Pre-Raphaelite art, not simply because the artists disguised their sources, but because there were so many of them

69 Stanley Spencer

Christ's Entry into Jerusalem,
c.1920, oil on canvas

Spencer (1891–1959) made every effort to disavow abstraction and to reconnect modern painting to its European traditions, as did the painters of the new realism in Germany, the muralists in Mexico, and many members of the School in Paris. Here, a major Christian religious event is reinvented by Spencer and situated in an English village from an indeterminate age. Spencer forms part of a long tradition of Christian art in which the central drama of the life of Christ is reinvented, re-costumed, and re-presented in modern terms. Spencer's Christ is a modern Englishman just as van der Weyden's St Luke is a Flemish painter.

both visual and literary, and so few of these are clearly traceable. For that reason, a good deal of writing about art-historical sources during the late nineteenth and early twentieth century used the loose term influence rather than the precise term source. Modern university-trained art historians who want rigour and measurable standards in their work often dismiss the concept of influence.

Puvis de Chavannes and Gustave Moreau: image/modernism outside the avant-garde

Two of the greatest French painters of the second half of the nine-teenth century were image/modernists, and a familiarity with the work of both is essential to an understanding of modern art. Pierre Puvis de Chavannes (1824–98) and Gustave Moreau (1826–98) were thoroughly and completely academic artists who worked within the terms of the academy, the official Salon, and state patronage. Yet, unlike many other artists who embraced official culture, the work of each man played a vital role in the history of avant-garde art for two reasons: the first hinges on their extraordinary stylistic achievements, respected by and influential to younger artists; and the second on their free adaptations of old masters in ways similar to the transformations of such sources by Cézanne, Seurat, and Gauguin.

Both Puvis de Chavannes and Moreau were born in the 1820s and came to artistic maturity in the 1860s. Each was convinced that his art was formed by a personal aesthetic quest that ended only with death, and the very individuality of their missions appealed to avant-garde artists. Unlike Manet, who liked to quote from earlier art so as to

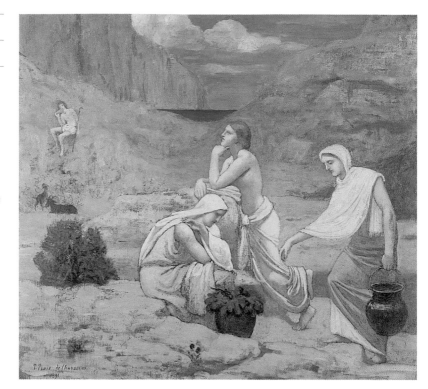

provoke specific comparison, Puvis strove to internalize and transform his sources and, hence, to make them modern. In his immense decorative mural, *The Shepherd's Song* (1891), Puvis treats the water and its lawn-covered banks as undifferentiated planes of colour, on which individually posed figures, from disguised sources, are arranged almost as if they were cut out and pasted into place [**70**]. Occasionally, he would ask a model to adopt a sourced pose and then draw the model. The possibilities for transformation here are great; a female model could be posed in a way that has its source in a male figure; the angle of representation could be slightly shifted; drapery in a source could be removed or added; a small or peripheral figure in a source could be transformed into a near-to-centre figure; and the converse of several of these conditions is also possible.

The same can be said for the even more influential Moreau, who was, with the aesthetically opposed Pissarro, the greatest teacher in the modern French tradition. Moreau created a school for painters, the students from which included Matisse, Georges Rouault (1871–1958), Henri Manquin (1874–1949), and Charles Camoin (1879–1965), in addition to less-well-known late Symbolist masters like Georges Desvallières (1861–1950). According to Matisse, Moreau was virtually unique among art teachers in late-nineteenth-century Paris for insisting that his students copy frequently in the Louvre: 'It was almost a revolutionary step for him to show us the way to the museum, at a

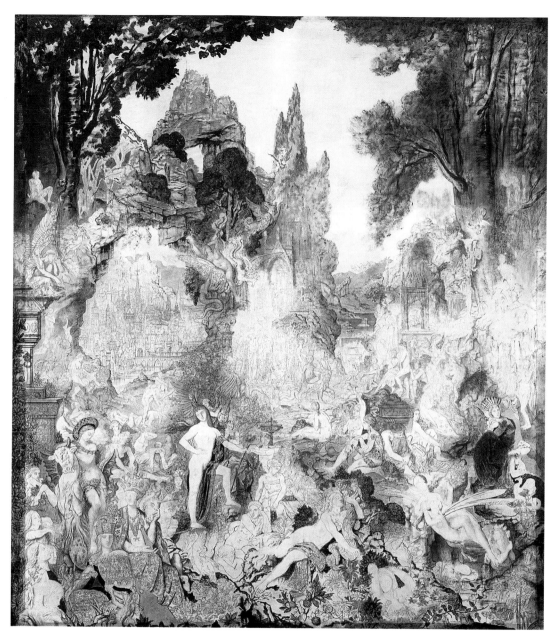

moment when [both] official . . . and living art . . . seemed to unite to keep us away from it.'7 Yet, for Moreau, a copy was an attempt to translate the essence of a work of art rather than faithfully to transcribe its details, and, as if in recognition of this, it is as difficult to find the source for a figure or composition in Moreau's work as it is for Cézanne. One immense painted drawing of 1884, *The Chimeras*, is almost an encyclopaedia of plundered figures, wrested from their original contexts and recombined in a dizzying apotheosis to the human figure [71].

Image/modernism outside France

This freely adaptive transformation of high-art sources was not confined to Paris, and virtually every European capital with a great museum produced artists that mined these treasure troves like truffle-hunters, attempting to baffle and delight their viewers with the obscurity of their sources [**72**].

Several of the greatest of these artists were central to the idea of modernism promulgated by its earliest German exponent, Meier-Graefe, but have been virtually excised from that history in the past generation due to the anti-German sentiment so prevalent in post-war art history. Perhaps the most interesting and enigmatic of these is Hans von Marées (1837–87), for whom the bibliography in any language other than German is paltry. Few visitors to the Neue Pinakothek in Munich can forget the room devoted to the late allegorical compositions of this German master. Nude figures of both sexes and various ages populate von Marées's hauntingly constructed forested landscapes. They are simply present together, challenging the viewer to accept them and to leave the world of the modern city and enter into their mysterious world. In *Golden Age II* from the early 1880s the eight

72 Witold Wojtkiewicz

Baśń Zimowa, 1908, oil on canvas

Wojtkiewicz (1879–1909), in his tragically short life, produced the most bizarre and enchanting Symbolist paintings of Poland. Trained almost exclusively in Warsaw (he had made a short trip to St Petersburg), he was widely read and therefore a textually orientated artist, whose series of works on childhood fantasies and stories must be compared with the early regressive work of Kandinsky. Here, two frigid children stare fixedly at the viewer of the painting, while clowns mounted on rearing rabbits do battle in the snow. Anyone wishing to see these paintings must make a trip to Poland where they are held.

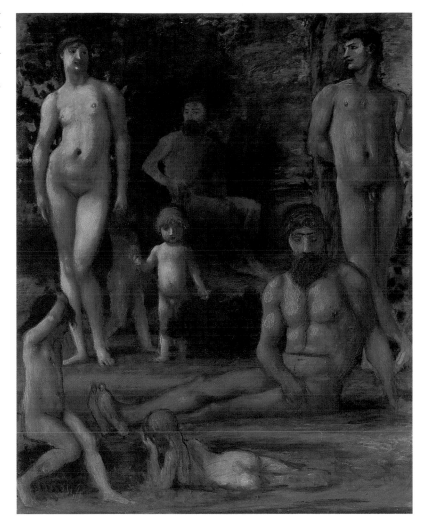

figures present themselves to the viewer in a way at once contrived and unselfconscious, as if begging for an interpretation [**73**]. Only two, the most distant male figure and possibly the child in front of him, seem to meet our gaze, beckoning us into the languid yet oddly unsensual realm of the picture. What were von Marées's sources? The body types suggest everything from classical sculpture to the High Renaissance, but, again, it is clear that von Marées has himself drawn each figure from a posed model, transforming or even obliterating the source by making it actual.

We know that von Marées copied old master paintings and that his sources have as broad and wide a character as did the great collections of Munich and the Italian cities in which he lived. Titian, Rembrandt, Velázquez, Perugino, Raphael, Rubens, and Palma Vecchio have been identified by the careful students of his career. When the great majority of von Marées's mature works entered the public collections of Munich

The Scream, 1893, tempera
and oil pastel on cardboard

This painting has become one
of the principal popular icons
of modernism. Certain writers
have suggested that the
screaming figure represents
the artist himself. Yet the
genderless and featureless
figure is surely generic,
encouraging us to identify
this moment of supreme
modernist angst as universal.

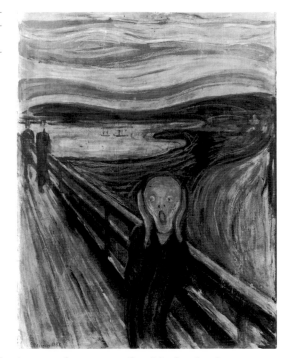

75 Paul Gauguin

Ancestors of Tehamana,
1893, oil on canvas

This portrait-like represen-
tation of Gauguin's Polynesian
common-law wife addresses
fundamental questions of
colonialism and exploitation.
She is dressed in a modest
missionary dress and placed
as if she were a European
woman sitting for a conven-
tional portrait. Yet she is
juxtaposed against a back-
ground of ancestral images—
linguistic and religious—
that were, and are, equally
unintelligible to Gauguin,
to her, and to us. Gauguin's
adoption of a Tahitian-
language title (roughly
translated here) lent further
unintelligibility to the image.

in 1891, four years after his death, they set a standard for young artists
for two generations. One cannot imagine the career of the young
Norwegian, Edvard Munch, without them [**74**].

Image/modernism combined a relentless search for inspiration in
past art with a rigorous studio practice, based both on figure drawing
and on technical experimentation with the materials of the painter.
Certain artists who followed the academic image/modernists (Puvis
and von Marées) made room for themselves as masters by playing
down the museum- and reproduction-based aesthetic search and play-
ing up the experience of painting from life. Among the most important
of these are Munch, Hodler, and Poland's Jacek Malczewski (1859–
1929). Each of these artists was steeped in the image world, but
each brought that world to bear directly on personal experience and
natural transcription, creating a unique directness. It is worth pointing
out that they were provincial painters, for whom the encyclopaedic
museum was to be visited occasionally, but not daily, and for
whom reproductions and memories of works of art constituted their
image bank.

Exhibitions of the avant-garde

Most of the canonical modernist artists of the late nineteenth century
died either in that century (Manet, Seurat, and van Gogh) or in the
early years of the twentieth century (Gauguin and Cézanne). Their
deaths created the conditions for the posthumous display of their
work, and the paintings of most of these artists actually produced a

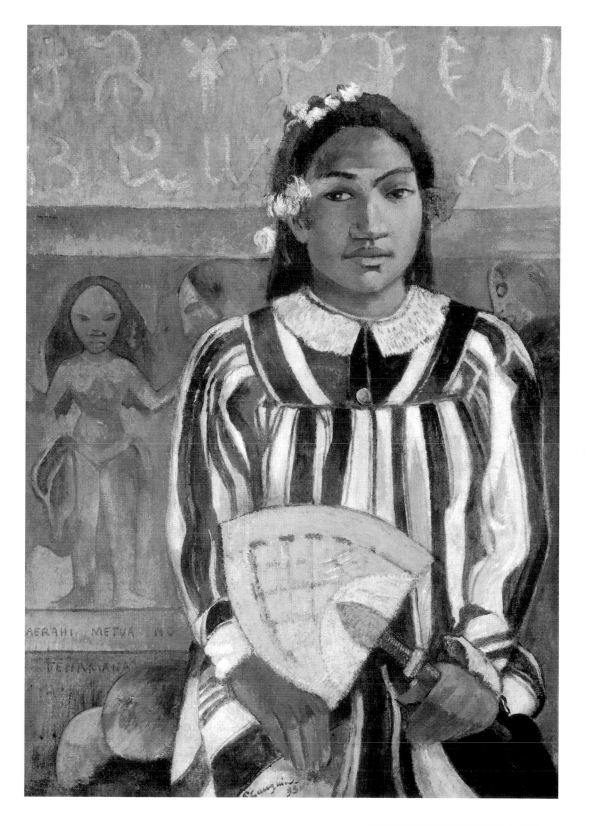

76 Paul Cézanne

Old Woman with a Rosary, 1896, oil on canvas

This late painting by Cézanne is one of a handful of works in his career that deals with old age. In this case Cézanne, who had himself returned to the traditional religious beliefs of France, examines the repetitive ritual of an old woman, who fingers her rosary while repeating endlessly the words of penitent devotion. Suggesting both late Rembrandt and Chardin, the painting is a modern meditation on art, old age, and religion.

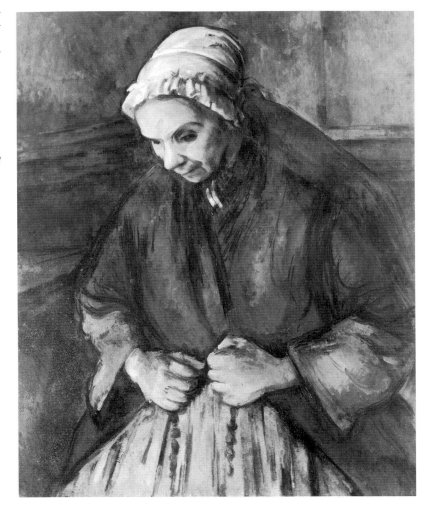

77 Hans Christian Andersen

Wandschirm, 1873–4, collage on linen

Throughout the Euro-global world, men and women of leisure made scrapbooks for amusement and as recorders of their lives. This collage by the famous scholar-writer is one among thousands of similar photographic collages made in the nineteenth century, well before the idea of collage was codified as a prime medium of modernism. Although it has long been known, this project awaits serious study. Only two of the eight panels from this series of photocollage are reproduced here: *Germany* (left) and *France* (right).

greater effect on European modernism of the first three decades of the twentieth century than it did within their own lifetimes. Studies of Cubism have made it clear that it was the study of precise paintings by Cézanne that compelled Braque and Picasso to create their studio paintings of the years 1906–10, and precisely the same relationships can be made between the work of Fauve painters and large-scale Parisian exhibitions of the works of Gauguin and van Gogh in the first decade of the century. One simply cannot imagine the paintings of Matisse, Vlaminck, or the French artist André Derain (1880–1954) without their having studied particular paintings by van Gogh and Gauguin, deriving loaded impasto from one and chromatic exaggeration from them both, and these same works were seen by foreign artists as well [**75**].

In this way, it was as much the experience of works of art as it was the studio or natural experience that caused the production of colour abstraction throughout the world. In a certain sense, this can be classified as image/modernism only in a very guarded way. What

Derain and Matisse learned from van Gogh was not what to paint but how to paint, and they derived little from the imagery of these artists. They did learn compositional strategies, chromatic systems, ideas about surface disruption, and the like, and they applied these lessons both to similar and to different motifs. In this case, their lessons were technical and could not have been learned clearly from contemporary reproductions of the same works. This experience of original works of

78 George Grosz and John Heartfield

Life and Activity in Universal City at 12:05 Midday, 1920, photomontage

Here is the archetypical summation of image/modernism, the photo-collage. The reality conjured here is at once cinematic (even before the creation of Universal Studios!) and static, and we, as viewers, are expected to participate with the artists in the formation of a visual synthesis. The discourse of abundance and choice, central to capitalist marketing, plays a powerful role in this photomontage.

79 Paul Citroën

Metropolis, 1923, collage of photographs, prints, and postcards

If there is a single image of the Metropolis—or ultimate city of the imagination—it is this collage. Here, the metropolis is everywhere and nowhere, participating in the consciousness of travel, imaginative and actual, that is such an important part of modern life. Citroën was a member of an active group of artists who used photomontage to describe the city. His colleagues were Hausmann, Höch, and Heartfield.

art and the convoluted interconnectedness of works of art across generations has yet to be clearly studied. The recent monographic exhibitions of van Gogh, Gauguin, and Seurat have clarified just which paintings by those artists were exhibited during the decades following their deaths, but the study of the reception of this work is at an early stage. This is precisely because historians of modernist art have always believed in the fundamentally antithetical relationship of their artists to tradition and have preferred to minimize their influences and sources. Conversely, iconographers and students of sources have preferred to deal with non-art or reproductive sources rather than the accurate charting of precise visual relationships among specific paintings, drawings, prints, and photographs. The same can be said for the study of the Impressionists, who were treated to great exhibitions of Corot, Courbet, Manet, and the French painter Jean-François Millet (1814– 75) in the years following the deaths of those precursive masters, and these exhibitions produced results analogous to the posthumous exhibitions of Gauguin, Seurat, van Gogh, and Cézanne in the first decade of the twentieth century [**76**].

Fragmentation, dislocation, and recombination

Perhaps the most fascinating forms of image/modernism involve collage and montage [**77, 78**]. If the image world consists of billions of representations of different sizes, types, relationships to visual reality, and media, this very commonness allowed artists not only to collect images, but also to alter them by cutting, arranging, pasting,

and rearranging. Braque, Gris, Severini, the German artist Kurt Schwitters (1887–1948), and many others used newspapers, advertisements, theatre tickets, handbills, labels, wallpaper, or other flat urban ephemera as other artists used paint and brushes [**79**]. Although modern artists like Cézanne and Pissarro had long had a fascination with forms of proletarian labour like wall-plastering, collagists took on the equally proletarian alter-ego of a paper-hanger, either of wallpaper or of printed advertisements and posters. And what fun they had! The power of scissors and paste, long known to parents of small children, was a kind of regressive liberation for artists. They literally controlled images and printed ephemera in ways unknown to the copyist or collectors of museum reproductions.

Most study of the collage has devoted itself to artists' use of verbal messages, whether newspaper articles by Picasso and Braque or word fragments in what might be termed the visual poetry of Schwitters. Less well studied is the longer tradition of photographic and image-oriented collage and montage like that practised as early as the 1850s in

80 Stuart Davis

Lucky Strike, 1921, oil on canvas

Davis (1894–1964) and Gerald Murphy (1888–1968), both American modernists of the 1920s, were perhaps the first important artists who took the world of advertising as a source of imagery for bourgeois easel painting. Here, in a painting made before his famous trip to Paris, Davis applies the rules of advertising—instant legibility, easy reproduction, and brand recognition through repetition—to painting. His lead was followed in Paris by Murphy and Léger.

81 Victor Brauner

*Composition, c.*1929, oil on canvas

As a leader in the Paris-orientated avant-garde in his native Bucharest, Brauner had dabbled in the various '-isms' associated with modernism. By the late 1920s he had firmly entered the Surrealist camp, and in this picture of a marauding dragon he combines imagery from various sources to trap a nightmare with almost clinical realism. Romanian art historians have been anxious to see images like this as reactions to the world-wide depression that descended upon the country in 1930, but it is actually more convincingly linked to a pre-depression aesthetic trend in Paris.

the photographic albums of amateurs and turned into a sort of high art by Max Ernst and the German artist Hannah Höch (1889–1978) and others in the 1920s [80]. This trend recombines dissociated fragmentary images, each with a separate spacio-temporal matrix, to form a new whole. The improbability of these constructed images is part of their essence, and viewers of the sophisticated twentieth-century versions are asked to be anonymous players in what must have been an amateur parlour game in the nineteenth century. What does 'it' mean?

The sheer force of the image/modernist tradition cannot be underestimated, in spite of the varieties of its practice. Although rooted in the traditional artistic education of academies, the force of the capitalist image expansion and its potential for adaptive reuse created possibilities for the conception and construction of new images that were dazzlingly realized by artists. From disguised borrowings to conscious plunderings of existing images, image/modernists vary from playful to savage [81] and their work can be contrasted in virtually every way with the products of their equally modern cousins, the unmediated modernists.

Part IV

Iconology

Introduction

Historians of modern art working during the past generation have focused almost entirely on recovering the meanings of works of modern art. These obsessions follow from, and seek to correct, the two preoccupations of their teachers, the first generation of professional historians of modern art: the first with recording the heroic conquest of the art world by modernism, and the second with describing the history of modern art in terms of the formal qualities of the easel picture. Few current art historians and critics can forget the dramatic narrative of formalism: a narrative that stressed the gradual acceptance by canonical modernists of the essential flatness of the painting and of its independent, and utterly non-verbal expressive domains, colour and the painted mark. For most early historians and critics of formalist modernism, the roots of these great pictorial achievements were to be found in the art of Manet and the Impressionists, which was treated as a prelude to the expansion of modernism in the seemingly contentless abstract art developed by Kandinsky, the Suprematists, and the Neo-Plasticists in the second and third decades of the twentieth century.

It is the sheer determinism of this history to which the second and third generation of art historians and critics have reacted. 'Wait,' their writing has told us, 'these works of art are more complex than we have allowed, more embedded in their own particular times and in the ambiguities of modernist culture.' They are not empty vessels to be filled simply with a pictorial meaning independent of language, as we were taught by so many early historians and critics of modernism, but are actually representations with highly mediated and complex interactive relations to the worlds in which the artist worked. The art historians who found everything from bodies to waterfalls in the abstract paintings of Kandinsky were flying in the face of an entire generation of scholarship, emanating from Kandinsky himself, a scholarship that effectively denied the importance—and occasionally the existence—of these hidden forms.[1] As Kandinsky's pictorial world was being recovered, students of collage began to study the sources of the texts in the work of Picasso, Braque, Severini, and Schwitters, creating plays between verbal and visual content in collages that had earlier been explained in terms of flatness, conscious banality, and lack of content.[2]

There has been, of course, a recent backlash against all this content

Detail of 134

analysis, but the most sophisticated iconological writers about modern art have contributed enormously to our understanding of pictorial modernism. For the purposes of this survey, the four basic areas in which content analysis has been foregrounded in the literature will be treated individually. There will be a distinct bias in this discussion towards French art of the period 1860–1915, not only because it was so much the dominant tradition, but also because its bibliography is both international and infinitely richer than those describing the art of other national traditions. We must wait at least another generation before the abundant material (both artistic and documentary) that awaits publication and analysis in Russia and eastern Europe, as well as the vast and increasingly sophisticated literature on colonial art or on American, Australian, and Canadian art, are integrated into the larger history of modernism and before the various national schools that still seem to obsess us can die a painless death.

The topics for these four iconological sections have been selected not only because they have been richly explored by historians during the last generation, but because so much more remains to be done in each of them. Each section will contain a discussion of major works of art that have been reinterpreted during the last generation, including criticism of this work and speculation about new areas for research following the suggestive leads of recent scholars.

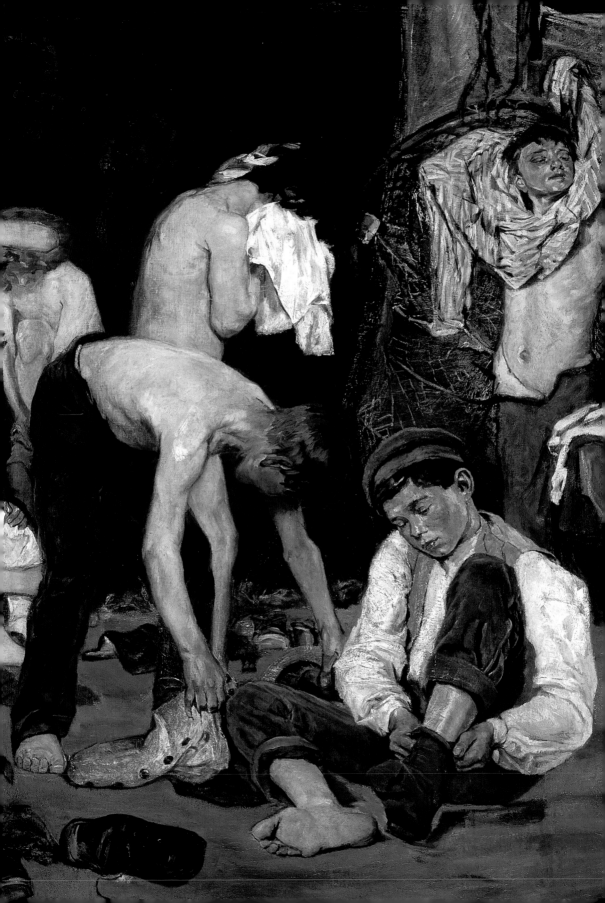

Sexuality and the Body

That the most persistent and problematic subject in the history of human art is the human body, is almost a truism. Our various gods, whether Apollo, Christ, Buddha, Muhammad, or Vishnu, have had their bodies represented in two- and three-dimensional human form throughout the history of art. Yet the modern age has been profoundly secular, with religion placed in a subsidiary position as a right to be practised privately (or not) rather than as the organizing principle of life. This, together with a diminution in the apparent power of the hereditary aristocracy, removed immense areas of picturable subjects and patrons for representation and forced modern painters to find subjects that could command our attention in the relative absence of religion and social hierarchy.

Now the central drama of civilization became the life cycle, and specifically the role of sexuality and gender politics within it. The world of visual representation has been mined as part of the new interpretive strategies created by Freudian, feminist, gender, and gay or queer studies scholars. Indeed, the very meaning of the word body has been significantly expanded during the last generation, and central to this has been the fascinating development of body studies in the visual arts.[1]

Manet's bodies

One of the first ways in which modern artists entered the realm of public consciousness was to engage in a challenge to the conventions of body representation. This was done most forcefully through an effort to take the nude figure from the realm of allegory, religious or otherwise, and place that nude into actual or clearly contemporary visual contexts. Courbet's nude model, who stands as a viewer at the centre of *The Studio of the Painter* (1855), is among the most decorous of the early examples (see **3**). Her position and demeanour signify modesty, and she implicitly acknowledges by her gaze that it is the painter Courbet (who is painting a landscape in this crowded human setting!), not herself, who serves as the subject of the painting. We all know that Manet raised the level of discourse about the contemporary nude with the most potency in 1863 and again in 1865. *Déjeuner sur l'herbe* was rejected

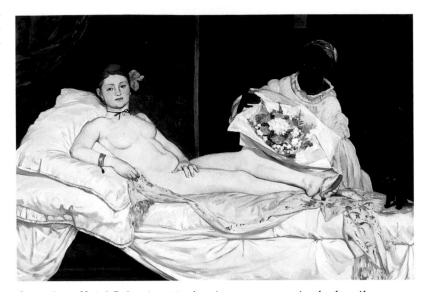

82 Édouard Manet

Olympia, 1863, oil on canvas

Manet completed *Olympia* in 1863 and withheld the painting from the Salon until 1865. There it created a second scandal only slightly less virulent than the earlier reception of the same painter's *Déjeuner sur l'herbe* in 1863. Manet's manipulation of public expectations, his courting of scandal, and his fundamental belief in art as part of social discourse all derive from the practice of Courbet.

from the official Salon in 1863, but its appearance in the hastily organized Salon des Refusés ensured that its notoriety was even greater because of this refusal. Studies of the significance of this move on Manet's part are legion.[2] Virtually every line of contemporary criticism has been uncovered and scrutinized for clues about early interpretations of the painting, and we learn that more critics were affected by the contemporaneity of the subject, particularly by the nudity of the principal female figure against the clothed young men, than they were by the flatness of Manet's treatment of the main figure. The relative absence of modelling in Manet's treatment of the nude and his decision to suppress the space-suggesting illusionism of the model's left leg by draping it, and hence flattening the foot into the plane of the body, were noted in the reviews of certain critics. Yet, these formal oddities were linked with the 'dirty' or improper subject: loose women, probably prostitutes, out in the country (the Bois de Boulogne?) with wealthy Parisian men.

Few of the early critics picked up on the source for the painting, and it was too cleverly obscure and fragmentary to be easily recognized. In fact, the source was the river god and his attendants on the right side of the reproductive engraving by Marc Antonio Raimondi after a fresco representing the *Judgement of Paris* by Raphael. Clearly, Manet wanted the composition to suggest a source in high art, but was less interested in the recognition of that source. Had he been interested in public recognition, he would have chosen a more readily available source and would have transformed it a little less.

No, it was scarcely the source that made the picture shocking, it was the fact of 'pictured nudity', to use Kermit Champa's useful phrase, and a nudity that affected contemporary discourse.[3] One must remember that the *Déjeuner* was exhibited only six years after Flaubert's trial for

Madame Bovary and in an arena, the public art exhibition, much less known for its assaults on public morals than the theatre or the novel, both of which could be consumed in semi-public or totally private settings.

In virtually every lecture course on Modernism, lecturers immediately skip two years and introduce Manet's next volley to the astonished students. *Olympia* was finished by Manet in 1863, but withheld by him from the Salon of that year, and the next [**82**].[4] The implication of all this is that Manet actually was a gamester with his flat, and naked, playing-cards. Yet, in all the years I have heard lectures and read articles or books about this delightfully deliberate act, I have never seen Manet's *Olympia* shown next to his other canvas painted for the 1865 Salon, *The Mocking of Christ* (or *Jesus Insulted by the Soldiers*, as Manet himself called it) [**83**]. Here, two nudes, one with a discreet loin-cloth, one male, the other female; one vertical, the other horizontal; one seated, the other reclining; one historic, the other contemporary; one sacred, the other secular; one a real God and the other a false goddess. Both *Olympia* and *Christ* raised questions of the consumable body, and, for that reason, the body itself, as a site of communication and interpretation, was the subject of both paintings. In many ways, this juxtaposition raises more questions about the body, tradition, modernity, and sexuality than were raised at any earlier moment in the history of Western art. This was not because a painter had never addressed these issues before (think of Titian, Michelangelo, or Rembrandt), but

83 Édouard Manet

The Mocking of Christ, 1865, oil on canvas

The second of Manet's two secular representations of Christian religious themes, *The Mocking of Christ* represents the moment of Christ's sham coronation before his final trial. An image burdened with both theological and pictorial precedents, its conscious confrontation of modern anxieties about religion has rarely been understood in the fundamentally secular literature on modernism.

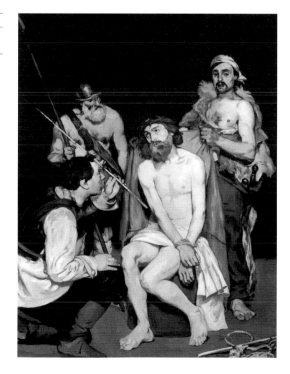

because no painter had ever sent two such extreme (and convergent) pictures to the same highly public exhibition.

In many ways, Manet's gambit, to borrow that wonderfully useful word from Griselda Pollock, was too strong to be comprehended, and not a single study of his *œuvre* has attempted a simultaneous understanding of these two works. Interestingly, the female nude has always been seen as the success, as the truly modern picture, while both Manet's immense religious paintings have been relegated to the sidelines of his enormous bibliography and to the equally enormous bibliography of body studies.[5] Writers such as Linda Nochlin, T. J. Clark, Abigail Solomon-Godeau have looked long and, in a critical sense, lovingly at *Olympia* and all but ignored the equally nude and equally challenging body of *Christ* shown at the same Salon.[6] It is the intention of this chapter to assert that it was not merely the female body, not the prostitute, that was the locus of concern in modernist art, but the human body itself.

The female body has been for the past generation the site of feminist studies of modernist imagery. The subject of the canonical works of the modernist tradition from Manet's *Déjeuner sur l'herbe* to Duchamp's *The Large Glass* (see **94**), is more often than not the female body, either alone or more titillatingly in groups. This very observation forces us to confront the essential sexism of artists, the art world, and modern society, reminding us of the exploitation of the female body and of its status as the preferred site for what has come to be called the male gaze. When we look at *Olympia*, or at most of the reclining nudes made directly in response to her, we have no choice but to assume a male identity, and, further, we have no choice but to be customer-admirers. Thus we are involved in a kind of complicitous moral secret simply by looking at the painting. If we, the viewers, had sent the gift of flowers being presented to Olympia by the black servant, as we must infer from her gaze, then there is someone we can't tell about our assignation: our wife, our fiancée, our mother, our aunt, our grandmother. Not only are we a male viewer, but a clandestine one, and, to borrow the parlance of gay activism, Manet has effectively outed our affair by having it take place in a public gallery.

Again, Manet makes this rendezvous more shocking by quoting Titian's famous *Venus of Urbino* (which, in turn, represents a Venetian courtesan of Titian's lifetime, but as Venus) and by entitling the picture ironically, *Olympia*; a feminized 'mountain of the Gods'. No *au courant* Parisian would have missed the sly allusion to the popular novel and play, *La Marriage d'Olympe*, by Alexandre Dumas fils, in which a courtesan manages to entrap and actually marry a young aristocrat.[7] With Manet's Olympus, one feels that conventional morality, class hierarchy, and pictorial values have been eroded. Hence, the painting, like the French novels of immorality so common in the eighteenth and

nineteenth centuries, seems to be exposing the ills of society through the act of representation. What is chilling about Manet's picture is the sheer force of Olympia's gaze, her self-possession, her complete lack of illusion. She is, we suspect, ultimately the realist, utterly in command of both her beauty and her body.

What were Manet's female viewers to do? Did he paint the *Mocking of Christ* for them? Or, as writers have suggested, is this great religious painting related to contemporary anxieties about religion, anxieties exacerbated by the appearance in 1864 of Ernest Renan's book *La Vie de Jésus*? The clarity of Renan's book was remarkable, but its qualities went unnoticed in the furore of public response to it. By omitting all references to Christ's resurrection, his reappearance on earth, and other manifestations of his divinity, Renan's book appeared to suggest that Christ was not divine. Manet's knowledge of the raging controversy around the book is assured by the sheer prominence it had in Parisian discourse. The year before, he had sent to the Salon another religious painting, *The Dead Christ with Angels*. In his 1865 canvas, Jesus is alive, being falsely worshipped by his tormentors, and is represented as he looks heavenward for solace. His body is anything but beautiful, and his pallid complexion, gnarled knees, and enlarged feet give him the air of a worker. Our gaze is met not by Christ himself, but by a swarthy young man with well-muscled arms, a hairy chest, and immense feet who wears a brilliant orange kerchief-turban, a wrap of long fur, heavy trousers, and a sword. Why does he meet our gaze? Is he drawing us into the circle of false worshippers of Christ? Are we to pick up the rope and rod conveniently placed in the lower right corner of Manet's canvas so that we can join in this gruesome act? Again, as with *Olympia*, Manet renders the viewer vulnerable, but, in this case, the viewer is made to feel cruel rather than guilty, and the nude is an actual God rather than a false goddess. Once more Manet cloaked his representation in allusions to major works by other artists, about which scholars have been arguing throughout the past generation.

Both these nudes are representations that link the history of High Renaissance easel painting, both secular and sacred, with purely contemporary concerns and that place the viewer in the unflattering and morally problematic roles of both a customer and a mocking torturer. In each picture, the nudity is essential to the meaning of the work: Olympia's brazen shamelessness, her acceptance of her body and its use, is contrasted with Christ's vulnerability just before he is to be covered by the young man who meets our gaze. In both cases, we are asked by Manet to recoil from the act of gazing. As viewers, we are ashamed.

What strikes most commentators about the sexual (and religious) politics of Manet is that the artist banked not simply on the picture to carry his messages, but on the picture in the specific context of a temporary public exhibition. Their size, their restricted palettes, their

strong and clearly readable compositions, the gazes of their figures, and relationships with past art and contemporary literature, all this was calculated by Manet for maximum shock value and effect. Their allusions are part of the cultural discourse of mid-1860s Paris, and would simply not be understood by a provincial unaware of Parisian literature and intellectual life. They are, in every sense, part of capital culture.

Before departing forever from the male nude in the context of religion, one must turn to the first painting submitted to the Parisian Salon by the American artist Thomas Eakins (1844–1916). *The Crucifixion* was painted in Philadelphia during 1879 and accepted into the Paris Salon of 1880.[8] As a representation of the male nude, it is among the strongest and most shocking in the history of art, but not for reasons of sexuality. Eakins is reported to have posed his model, John Laurie Wallace, in a skimpy loin-cloth outside on the roof of a Philadelphia building so that he, Eakins, could paint the crucifixion from life. The reality of Christ's body, together with the fact that the representation focuses on Christ's hands as they seem to struggle to free themselves from the nails, gave the representation a force essentially unknown in earlier art. The frequent comparisons in the literature to the famous *Crucifixion* by the French artist Léon Bonnat (1833–1922) from the Salon of 1874 (it should be pointed out that Eakins never saw this painting) favour the Eakins crucifixion. Bonnat reportedly painted his Realist nude from a cadaver in a manner well known to Romantic artists. Eakins, by contrast, emphasized the struggling life in Christ as he writhes in the blinding light of the day shortly before the temporary night that descended on the earth at the moment of Christ's death. How different it is from the slender, androgynous crucifixion, *The Yellow Christ*, painted by Gauguin in 1889, and how easily we know that Gauguin's model was not life, but art.

Modern art and pornography

The nude, and specifically the female nude, continued to dominate the politics and practice of modernist painting throughout this period. Typical subjects would include: bathers out of doors, bathers in the interior, prostitutes alone or in groups, or women of uncertain social standing at their toilette. These works seem to constitute an internal tradition within modernism, a formal and iconographical tradition of the female nude, stronger in modernism than in any other period of the history of painting with the possible exception of the Baroque.

Fascinatingly, this tradition was absolutely co-equal with the rise and mass dissemination of photographic pornography, which played a suppressed but strong role within that medium from the 1850s onward. All the photographic media made contributions to pornography, in particular stereophotography, the most titillating of mediums, with its delightful 3-D effects. We know that artists collected pornographic

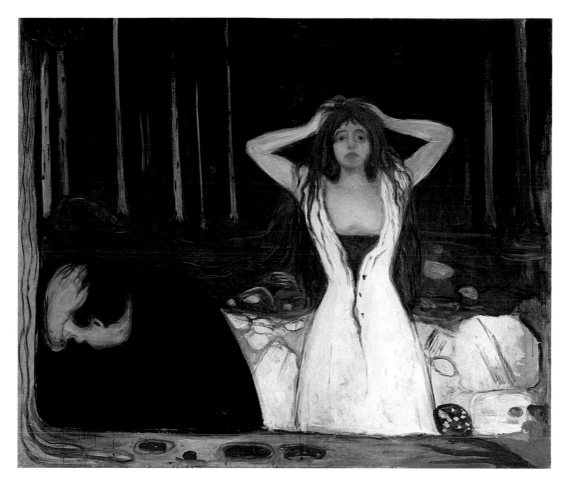

84 Edvard Munch

Ashes, 1894, oil and tempera on canvas

Munch's project to paint a vast multi-canvas series called 'The Frieze of Life' is one of the most ambitious in the history of modernism. Virtually Wagnerian in scope, although the series was, in fact, never completed, it was exhibited in several forms in Germany, France, and Scandinavia. This life-cycle analysis, like that of Freud, was centred on male-female sexual relationships and their rumblings through the life of the individual. Themes of guilt, shame, wanton lust, betrayal, and impotence dominate the series.

photographs, probably for two reasons: first as pornography and, in certain cases, as part of their critique of conventional sexual mores and, secondly, as models or easily accessible sources of actual nude figures. Gauguin purchased a group of pornographic photographs (probably of the colonialist or multi-racial variety) in Port Said and we know that he kept them in his bedroom in the South Seas. We also suspect that the poses of many nudes in modernist painting have their origins in pornography, which was, in turn, a kind of kitsch mimicking of high art.

This contribution of an unofficial and unregulated type of popular imagery to the visual discourse must be remembered when we look at painted representations of the female nude. Some, like the nudes of Manet and Gauguin, have fascinatingly direct relationships with the photographs. Manet even seems to have been interested in the flatness of the strongly lit photographed nude, which is such an important formal component of his painted nudes. Others, like Degas and Toulouse-Lautrec, invented naturalistic compositions and scenes that have little precedent in the contrived and posed scenes in photographic pornography. Indeed, their two great series of pornographic prints,

Degas's untitled brothel monotypes of the late 1870s and early 1880s and Toulouse-Lautrec's lithographic series Elles, depart radically from the stereophotographs and pornographic narratives being produced in late nineteenth-century Europe.

The nude and the modernist cycle of life

If one were to write a history of modernist body imagery, one could easily find representations of bodies throughout the life-cycle of the individual [84]. One can easily begin with images of childhood pre-sexual nudity which, though rare, range from the quasi-pornographic photographs of little girls by Lewis Carroll (1832–98) to the well-nourished babies of Mary Cassatt.

In the case of Carroll, the visual availability of the girls contrasts with their remoteness (for both compositional and moral reasons) from actual touch, and this can be contrasted with the completely transparent and guiltless sensuality of Cassatt's investigation of the tactility of infants and of inter-generational touching. In fact, no artist in the history of Western art has treated this subject with such subtlety and probity outside the confines of the holy relationship between the Virgin Mary and her infant son Christ. That there are erotic aspects to this relationship was surely not entirely absent from Cassatt's conscious mind, and Gauguin's gently erotic representation of his own sleeping child raises this type of voyeurism to a more disturbing, and clearly conscious, level.

85 Magnus Enckell

The Awakening, 1894, oil on canvas

There is no more powerful representation of male adolescent sexuality in the history of modern art than Enckell's haunting painting. Like many northern European artists, the Finnish Enckell was trained in Paris, where this painting was conceived and made in a tradition that included Puvis de Chavannes, Toulouse-Lautrec, and Munch.

One of the most fascinating visual obsessions in modern art is with adolescent sexuality. From the investigations of male pre-pubescent preening and wrestling by Gauguin to the single most terrifying image of male adolescent transition, *The Awakening* [**85**], by the great, and little-known, Finnish artist Magnus Enckell (1870–1925) artists dealt as frankly with the developing eroticism of the adolescent as did Freud or his followers. And, lest we think Enckell's painting peripheral to our investigation because of its provincial origins, we must not forget that it was painted in Paris during Enckell's three-year stay there, and that it was sent to the largest international exhibition of contemporary art ever held, in Paris in 1900.

Picasso too had an extraordinary sensitivity to the adolescent and young adult of both sexes. His work from the first decade of the twentieth century seems all but obsessed with lost innocence and desolation, and, although many of his family subjects can be traced to the images of popular entertainers by the French artist Honoré Daumier (1810–79) (whose work was undergoing a modest revival in the early twentieth century), Picasso injected an air of psychological poignancy into scenes that were, for Daumier, more political in significance [**86**]. As many scholars have pointed out, it was Picasso's reaction to the early suicide of his friend, the young Spanish painter Carlos Casagemas (1881–1901), that produced some of his most powerful images of the passage into manhood culminating in *La Vie* (1903). This was painted a

decade later than Enckell's masterpiece, and is presided over by a brooding young man (Casagemas), nude but for a bit of drapery to hide his genitalia, clinging to a young nude woman. They confront an older woman, fully draped, who holds a sleeping child. Picasso's young man, dark, troubled, and doubtful, reaches out in Michelangelesque grandeur towards the mother as if in recognition of the ultimate responsibilities that must be taken in human life.

Picasso's famous investigation of the passage from adolescence to manhood has so many relationships to earlier and contemporary painting that they can only be summarized here. One thinks of Eakins's adolescent and male *Arcadia* (1883), Cézanne's great visual poem about the introspection and vulnerability of adolescence, *Le Grand Baigneur* (1885), and Hodler's *View into the Infinity* (1902–3), and the list could be considerably longer. Not since the Mannerists had artists dealt so frankly and so ambiguously with adolescent sexuality. Again, there are numerous parallels in photography, both the kitsch homoerotic

pornography of the infamous Baron van Gloeden or the blurred male bodies of John Holland Day. The concept that there is a paradoxically powerful innocence in the young male nude figure runs throughout the history of modern art, countering the avant-garde preoccupation with prostitution and the reclining female nude that has been such a dominant part of modernist discourse and its feminist critique [**87**].

In fact, there is a counter-investigation of developing female sexuality through girlhood and adolescence in modernist paintings. Interestingly, the most fascinating of these are outside the French tradition, in which the male gaze is so dominant. One thinks of the female equivalent of Enckell's boy, Edvard Munch's *Puberty*, a haunting image of a female at the edge of womanhood conceived by a male artist, a work made very close in time to Gauguin's father-to-daughter book, *Cahier pour Aline*. Hodler and Munch both painted multi-canvas life-cycles of both males and females. Munch's cycle was entitled *The Frieze of Life* and exhibited in various forms and versions throughout his mature life.[9] In all of these, nudity is central to the enterprise. Hodler's *Communion with Infinity* (1892) and his *Woman at a Mountain Stream* (1903) placed the female nude alone in a landscape in poses with no connection to bathing, giving them an elemental force by denying any specific genre narrative. Because we cannot explain them as actual women doing something out of doors, they become 'woman', for whom age and gender are more essential than class or social status. Also, the sheer fact of their solitude gives them a viability as humans apart from men, against whom they are at least partially defined in most images in the modernist tradition.

The single work that sums up the life-cycle is Gauguin's *Where Do We Come From? What Are We? Where Are We Going?* (1897). In this work the viewer is treated to a mythic frieze of life from infancy to death which takes place in a temporally and physically remote paradise [**88**]. The androgynous male fruit-picker at the centre of the composition alludes, of course, to the fall of man, but in an oddly ironic way. Why, we ask, does a lone male pick fruit in Paradise? Why are there so many women in Paradise? Why is there ageing and even death in Paradise? What God presides over Paradise? The questions pile up as the viewer comes slowly to terms with the visual and iconological issues in this frieze of life, questions that one is forced to ask because the title of the painting itself is a series of questions, and it is clear that those questions have no precise answers.

The bathing nude

The vast majority of images of the nude exist in the context of bathing, a subject rife with sexual and social associations that are currently being analysed by Linda Nochlin and others.[10] For most representational artists, however, the subject of the bather renders nudity transparent by

making it seem guiltless and thus acceptable to the viewer. Bathers are
nude because they have to be; they are engaged in a cleansing ritual
which, even when collective, is most often unconnected to the sexual
act. In contrast to the internally voyeuristic tradition in bather imagery
(Suzannah and the Elders), modern bathers, both male and female,
place the viewer in the place of voyeur, but generally deny them access
to the pictured realm via the gaze of one of its figures. Renoir's and
Cézanne's bathers do not look back at us, and even the sexually active
bathers of Degas (women bathing alone or, at most, with a servant, as if
after or before sex) do not acknowledge the viewer's presence.

This is also true for the fascinating tradition of male bathers that
plays an important and little-recognized role in modern body imagery.
In France, we have the male bathers of Caillebotte, Cézanne, and the
French artist Frédéric Bazille (1841–70)—a tradition which all but dies
in French art of the first three decades of the twentieth century, when
the female nude completely dominates body discourse [**89**]. Yet, there
are major contributions to this tradition by painters such as Eakins,
Max Liebermann (1847–1935), and Munch [**90**, **91**]. Few of these
images engage in any overt way with sexuality, treating the body as

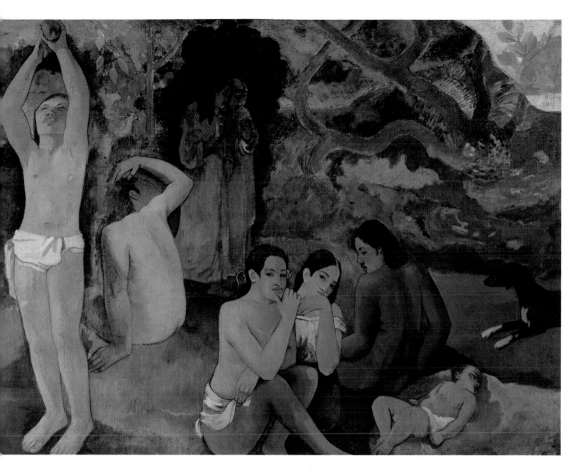

innocent when it swims far from the prying eyes of others. By representing this subject repeatedly, painters did bring into the realm of the public gaze a private subject, again allowing a form of voyeurism into art, but a form that does not in any direct sense assault what might be called conventional bourgeois morality.

We all know, of course, that bathing does not always occur outside and that many of the most important modern representations of bathing deal with the new bourgeois obsession with bodily cleanliness by focusing on the bather indoors. The male examples of this genre are extremely rare, and only one important example hangs in a public museum, Caillebotte's *Man at His Bath* (1884) [**92**]. This painting defies easy explanation. Its subject is a completely nude middle-aged bourgeois man, shown from the back while drying himself in a large modern bathroom. What, may we ask, is picturable about this? The man is too old to be an ideal or even a beautiful youth. He is shown in a completely private act during which he is visually inaccessible to anyone else (except possibly an invisible male servant who has handed him the towel). We are even permitted a discreet view of his scrotum, just visible between his legs in a way that shocks viewers to this day. His

89 Jean Frédéric Bazille

Summer Scene, 1869,
oil on canvas

This painting was accepted at
the Salon of 1870, just before
its young painter volunteered
for service in the French
military and was killed. It is the
first large-scale representation
of the modern male nude in
the Salon shown in the new
light-filled style achieved by
Monet, Bazille, and Renoir in
the late 1860s. Its homosocial
discourse has become
fashionable in current
literature.

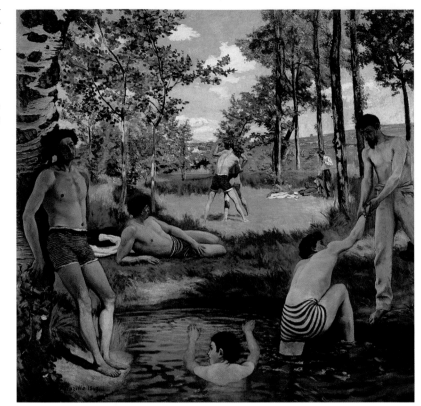

90 Max Liebermann

In the Bathhouse, 1875–8,
oil on canvas

This early painting by the great
German—and Jewish—
Impressionist serves as proof
of the internationalism of
vanguard modernism by the
1870s. Begun in Amsterdam,
where Liebermann is reputed
to have observed the repres-
ented scene, the work was
largely painted in Paris, where
he visited Manet and was
exposed to Impressionism.
It was kept by the artist
throughout his life, and the
fluid landscape behind the
figure on the right (a clothed
version of the famous classical
sculpture of the *Thorn Picker*)
was completed in Germany
shortly before the painter's
death.

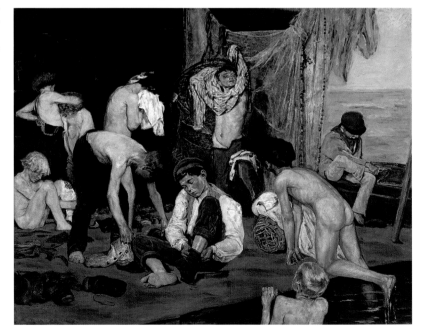

91 Thomas Eakins

Swimming, 1885, oil on canvas

This work was painted as part of a private commission from one of Eakins's admirers. Its frank representation of the male nude and the fact that its models included the painter himself as well as several of his students at the Pennsylvania Academy were so scandalous that Eakins actually lost his teaching position as a result of the painting.

wet feet have made glistening marks on the wooden floor. In terms of its represented subject, Caillebotte's painting is absolutely without precedent, and, when he sent it to the 1884 exhibition of the vanguard group Les XX in Belgium, the outcry was such that it was moved to a locked room.

When we contrast this bather with the group of women bathing indoors represented by Degas in the 1880s and 1890s, its flagrant denial of pictorial decorum becomes even clearer. Yet Degas's representations have been subjected to literally thousands of pages of criticism in the past two decades, while Caillebotte's picture has languished in critical obscurity. There are two probable reasons for this. One concerns the canonical status of Degas as a professional modernist, compared to the critical view of Caillebotte as an occasionally inspired amateur who also sailed, swam, and played cards. The other concerns the fact that the vast majority of the most intelligent and passionate body/criticism of the past decade is the product of feminists who have focused on the problem of male artists representing (and hence dominating) the nude female body. Whether these scholars focus on the discourses of bodily cleanliness, prostitution, and sexual morality or simply on the act of male fantasist voyeurism through representation, their writings have relentlessly probed the male artist's, dealer's, and collector's constructions and receptions of desire through representational domination.

The comparatively rare representations of the male nude by male artists have not been relevant to this endeavour. Indeed, these latter images seem now to be the territory of the growing subdiscipline of gay or queer studies, with its focus on homoeroticism or, less stridently, homosocial pictorial codes.

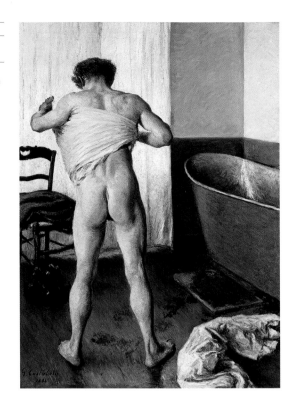

92 Gustave Caillebotte

Man at his Bath, 1884, oil on canvas

This painting, perhaps the most shocking representation of the male nude in nineteenth-century art, was exhibited in a closet when it was sent to the Belgian vanguard exhibition of Les XX in 1884. Although, like Eakins's *Swimming*, it was conventionally painted, its imagery was hardly acceptable within the idealizing context of easel painting. Caillebotte kept the painting throughout his life, and it was not among those selected after his death in 1894 as part of his monumental gift of Impressionism to the French nation.

The allegorical or non-sexual nude

In thinking about body representation in its fullest sense, one cannot omit the nude within the context of allegorical and historical painting. Whether Degas's *Young Spartan Girls Provoking the Boys* or the comparatively chaste work of Gauguin or Matisse, works representing the nude figure in a kind of timeless pictorial realm are common in the history of modern art. In few of these cases are the figures actually erotic. Rather, nudity remains tied to an unspecified, and usually classical, timelessness. Yet, in certain images, particularly those by Malczewski and Hodler, the allegories take on the air of actuality; the figures approach the pictorial surface and the intense colours give them a directness and clarity at odds with the idea of a remote, ageless past. Their works might even be called aggressive allegories, in that they possess the viewer's visual realm so completely that there is little room for escape or passive contemplation such as that we might muster for Puvis de Chavannes or von Marées.

These works set an odd but definite precedent for the urgently powerful representations of rather placid bather themes that shook French art in the first decade of the twentieth century. It is not the imagery or even the compositions of Cézanne's large *Bather* compositions of the late 1890s and early years of the twentieth century that make them modern, it is the way in which these strong and virile female

nudes were drawn as large and misshapened figures. They are not the elegant androgynes that populate so much modernist art, nor are they voluptuous pillows of flesh such as those favoured by Rubens and the French artist François Boucher (1703–70) and reinvigorated by Renoir, nor even are they the concoctions of curves that fill the history of French art after Jean-Auguste-Dominique Ingres (1780–1867). None of this applies to Cézanne's amazons, whose eroticism, should we find it, is contained within the picture and has nothing to do with the world of the viewer. They are essentially representations of power and movement rather than sensual beauty, and they exist not because of us, but in spite of us.[11]

These great creations have no relationship to the discourse about class and sexuality that seems to have preoccupied Manet and his numerous followers. They are also absolutely glacial in their lack of interest in the viewer. Cézanne's large *Bathers* were not available to members of the Parisian vanguard until the autumn of 1907, when at least two of them were exhibited in the Salon d'Automne. By that time Picasso had already painted, and repainted, *Les Demoiselles d'Avignon* and Matisse had completed his boldest bather yet, the so-called *Blue Nude*. This demonstrates more strongly than any other example I could use the inter-generational and collective nature of modernist art. Indeed, the elderly Cézanne was responding to the same ideas of representation that were inflaming the young French artists Braque and Matisse and the younger Picasso. It was not so much a question of influence as of a collective sense of pictorial investigation that, in these cases, flourished both in the comparative freedom that Cézanne had created through his distance from Paris and in the hothouse of anonymity and youth created by the others in Paris.

Colonialism and the nude: the troubled case of Gauguin

One of the other major subsets of body imagery has to do with the immense cultural discourse around colonialism. From the gigantic and controversial ruminations of Edward Said to the equally strident, but more confined, protestations of Abigail Solomon-Godeau and Stephen Eisenman, the current critical obsession with what might be called the colonial body is among the strongest corrective veins in postmodernist discourse. The principal victim of this writing is the ur-colonialist painter, Paul Gauguin, whose lamentable inability to speak any other language than French restricted his choice of paradise to the French colonies. Initially he tried to live among francophones working in Panama; then he visited Martinique, subsequently returning to France and considering Madagascar and the Ile de la Réunion, before receiving a government subvention to go to Tahiti. He died of an overdose of morphine on another island, Hiva Oa, this too part of the French colonial administration. Few artists tried harder to leave

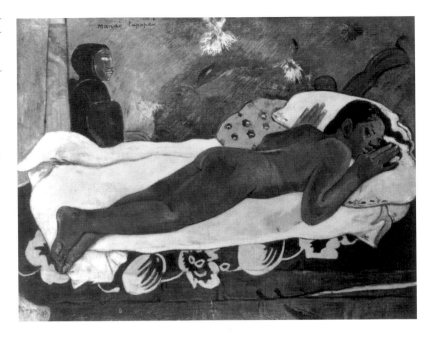

Europe and modernist urban culture behind, and few failed more miserably in their attempts. His last collective work of art, the house which he decorated and called the *Maison du jouir* or House of Pleasure, had a modern sewing-machine, lots of good wine, machine-made furniture (along with work of Gauguin's own making), machine-produced books, an entire collection of photographs and prints, machine-printed textiles, and the like. The world of the native that he aped was really a sort of hand-made veneer over an utterly European, and modern, substructure.

These facts are pointed out over and over in the diatribes against Gauguin that fill the politically correct literature of the past decade.[12] Yet, when we read Gauguin's own texts and think through his highly complex and polyvalent images, it becomes clear both that he was utterly aware of his modernism and that he himself knew from the onset that his search for a paradise on earth would not succeed in any literal way.

What about his bodies? They are mostly brown, mostly Polynesian, mostly female, young, and available. Every commentator who lashes into Gauguin's colonialist sexism in analysing *Manau tupapau*, the most famous anti-Olympia of the fin de siècle, does so without regard for Gauguin's own sardonic irony. Indeed, any reader of his voluminous late prose knows that he is often his own greatest victim and that his attitude towards the world is that of a wizened jokester who projects such disdain for the world that even his delusions become comic. Gauguin's several versions of the story behind *Manau tupapau* (*Spirit of the Dead Watching*) were all written after the painting had been

completed [**93**]. They deal with two aspects of body imagery, the first personal and the second mythic. What Gauguin learns when he sees his frightened mistress gaze up at him in the middle of the night is that her feelings of guilt or fear are not easily accessible to him and that, although he can speculate on their causes, he cannot ultimately know her mind because he is a European man. The entire construction of the painting around the trope of Olympia tells us that Gauguin is dealing with his incomprehension within his terms, not hers. Where Olympia reveals herself to us because we have paid for her, Gauguin's mistress, Tehura, lies on her stomach as if recoiling in fear, presided over by a fully clothed figure of indeterminate sex who seems as much to haunt as to protect her. Is she frightened of the painter/viewer or, as the painting suggests, are her fears rooted in her culture and its mysterious, and inaccessible, belief systems? If Manet made his viewer feel like a male customer out in public, Gauguin created a situation in which his European male viewers (the painting was first sent for exhibition in Copenhagen) feel as if they have frightened this beautiful young girl and, furthermore, that they don't understand quite why. This work is anything but a simple act of male colonialist domination, because it tries so very hard to force the viewer to confront that domination and to question it. The easy sexuality of the native, so much part of the myth of colonial culture, is here exploded in an image of the fear of 'the other' and our incomprehension at that fear.

It was, in fact, the sins of the European world related to the religious and cultural history of Europe and the Middle East that were the greatest subjects of Gauguin. His late nudes derive their poses from Buddhist sculpture, but their meanings are rooted in the various images of the fall of man or the expulsion from paradise that populate the history of Western art. The system of colonialism allowed Gauguin to search beyond Europe, but Europe was always with him. His bodies are so various and complex that they cannot be reduced to the sexist charge that his art was totally determined by the male gaze. The muscular standing Eve, whose body derives from Buddhist sculpture at Borabadur, in *Nave Nave Fenua* (*The Delightful Land*), is not a likely candidate for visual rape, and several writers have remarked on the odd androgyny of several other figures, particularly the fruit-picker (surely a male) in Gauguin's *Where Do We Come From? What Are We? Where Are We Going?* [**88**]. The water-drinker in *Pape Moe* (*Mysterious Waters*) relates to a distinctly homoerotic scene in his novelistic text, *Noa Noa*, that is often quoted in gay studies courses and flies in the face of his equally often quoted comment, 'I like my women ugly, fat, and vicious' (surely an example of Gauguin's extremely sardonic humour).

The shame of a raped woman is clearly the subject of *The Nightmare*, a transfer drawing from the penultimate year of Gauguin's life, and the nudes in what we might call Gauguin's philosophical brothel,

the cover of his manuscript 'L'Esprit Moderne et le Catholicisme', take part in rites of display and denial the roots of which lie in Christian and pre-Christian dogma. For Gauguin, as for many of the most powerful body modernists, the represented body was the seat of desires that, unless temporarily sated, prey upon the psyche. The body was also a container of ageing and despair, the vessel of the failure as well as the triumph of humans. At few periods in the history of Western art has the body been more powerfully expressive than in the years covered in this book, the years before modernism became hegemonic.

The bride stripped bare

The idea of the nude as a machine has deep roots in the sciences and scientific illustration. From Leonardo's anatomical drawings, through to the obsessive recording of the human body in the eighteenth and nineteenth centuries, the interior of the body has been a subject of a type of representation that lies outside art. In the twentieth century, the workings of the body entered the exhibition hall and, eventually, the museum. The artist most persistently associated with this is Marcel Duchamp, who 'tore to tatters' his sisters in a painted representation of 1911 and then went on to construct a machined bride that was to populate his representations until the incompletion (it broke) of his *The Large Glass* in 1923. The bride in question has no flesh or covering for her mechanism. She also has no head or arms (no mind and no feeling). She is a series of tubes and organs, the functions of which are reproductive, and she is juxtaposed in *The Large Glass* with a group of bachelors (the nine malic moulds) that are precisely the opposite of her. Where she, the machine revealed, has no covering, they have no interiors; they are moulds to receive melted liquids that will solidify and be unmoulded before they are once again filled with warm liquid.

Duchamp's witty and terrifying dialectic of woman/man, inside/outside, machine/mould, parts/whole, etc. and his industrialization of sexuality has many precedents in the history of Western art, but none of them either predict or explain Duchamp's nude, which is as many have pointed out, his move in an artistic chess game of manoeuvres that started in antiquity and gained in strategic intensity with modern art. The philosophical brothel of Picasso's *Les Demoiselles d'Avignon*, the most famous nude representation of the first decade of the twentieth century, demanded a counter nude, and Duchamp created her over a period of years.

There are few works in the history of art that are more complex, more essential to subsequent artistic developments, and more deliberately enigmatic than Duchamp's penultimate (but not ultimate) move, *The Large Glass* or *The Bride Stripped Bare by her Bachelors, Even* (his title) [94]. Among its many achievements is its oddly modern internationalism. *The Large Glass* was made by a Frenchman in New

94 Marcel Duchamp

The Bride Stripped Bare by her Bachelors, Even (also *The Large Glass*), 1915–23, oil and lead wire on glass
Duchamp had begun to conceive of this visual manifesto at least two years before he began the arduous process of its creation, and a thorough knowledge of his intellectual preparation is as important to an understanding of the work as is an examination of *The Large Glass* itself. Like many works of modernism, Duchamp confronts the impossibility of sexual union by separating the realm of the bride and the bachelors completely and by insuring, through formal and linguistic means, that there will never be physical contact. This is the most complex representation of sexual frustration in the history of art.

York and has never crossed the Atlantic. It has resided since 1953 in the Philadelphia Museum of Art, where it takes its place in a virtually definitive collection of works by Duchamp, who, as its installation suggests, preferred his own company to that of others and who wanted himself to be in charge of the reception and interpretation of his own works. Because *The Large Glass* is so large and so intentionally breakable it cannot, and will not, be moved, forcing the modern connoisseur (or voyeur) to make the journey to Philadelphia to look through the glass.

Body parts and fragments

All the nudes discussed so far in this essay are complete. We assume in looking at them that the entire human body of the model was known to and represented by the artist. Yet there is an entire species of modern body representations, including photographs, that divide the whole body into parts and revel in discontinuities and the fragmentary. The most obvious of these are what might be called Cubist bodies, in which the wholeness of the body is undercut. In Braque's *Ma Jolie*, we are unable to imagine ourselves caressing the thighs or fondling the breasts of this prostitute's body. No, she is all parts, bundles of lines that intersect and dissolve to create a palpitating image in flux. Braque's 'my pretty'

sits rather than reclines, receiving our gaze, but not as herself. Rather she is a representation by Braque, who makes a work about seeing and transcribing a seated nude. He, not she, is the subject. Yet to call her fragmentary is wrong. She is not made of parts. Rather, the lines and patches of paint from which her body is assembled represent themselves, not portions or aspects of her body. We are not called upon to imagine that she looked like Braque's representation of her. Rather, we are asked to interpret Braque's session with her in the terms of the painted marks made by him on the canvas. She was whole, but Braque cannot represent her as whole because he is so concerned with fetishizing or analysing his process of representation. Hence, Braque's nude is less about the nude even than Duchamp's mechanical bride, who is, by contrast, a traditional representation, because it is the bride who is being represented.

It is to Léger and to a larger group of artists who mechanized the nude that we must turn in our search for body fragments. Léger's nudes are assembled from parts as if they were constructed in a factory. The jointed fingers and arms are like prosthetic devices that literally represent parts of the body, and for this reason they are considerably simpler as body representations than what we might call Braque's and Picasso's non-representational bodies of 1910–11. This notion of the machine body is a persistent sub-theme in modernist body representations and, given the increasing industrialization of Europe and America, this is scarcely surprising. Indeed, mechanized body representations annex the representational to the industrial in a surprisingly literal and unimaginative way.

One must turn to Dada and Surrealism, with their wilful scalar and chromatic distortions, their employment of montage, and their often violent fragmentations, for the real revolution in body representation. The so-called 'exquisite corpse' of the late 1920s is the ultimate violated body, for, in these collaborative works, the whole body is made up of three parts, each the product of the fantasy of one artist, each of whom is, in turn, unaware of those of the other two when making his contribution to the whole body. Hence, the body is whole only at the end of production, and no one artist can claim the representation. This division of the body is essentially unprecedented in Western art, unless one counts the collaged body as a form of precedent. In this latter tradition, practised by amateur and professional artists since the mid-nineteenth century, the represented body is composed of several separate elements that are combined to become a single body. These collaged bodies often combine male/female, human/animal, young/old, and other apparent oppositions to question the very inviolability of the body itself. Certain of these images function as visual equivalents to verbal puns or metaphors, making suggestive links among unlike forms. Others are wittily subversive jokes, whose point is not clear. In

95 Hannah Höch

The Sweet One (Die Süsse)
'From an Ethnographic
Museum', *c.*1926, photo-
montage with watercolours
Höch's photomontages are
part of a vanguard project
rampant in the 1920s
involving the dismemberment
and recombination of the
human body. Whether using
surrogates like the dolls of
Hans Bellmer or pages taken
from scientific and socio-
logical manuals like Höch,
artists violated the integrity
of the body and created new
bodies through art. Here, the
body parts belong to others,
human bodies catalogued
for research by ethnographic
museums. Höch seems to
question the entire enterprise
of body collecting by creating
this recombinant body.

all these cases, the wholeness of the body is jettisoned, exploded, and even denied in images that are among the most disturbing in the history of art. Whether the terrifying dolls of the Polish artist Hans Bellmer (1902–75), the witty combinative insect-human bodies of Max Ernst, or the fabulous body contraptions of Hannah Höch [**95**], these plays on image/modernism were made to thumb their noses at traditional representation and to declare arenas of representational freedom that many early viewers took to be prescriptions for socio-sexual freedoms. For this, the images can be interpreted as anti-bourgeois contrivances made for the delectation of the bourgeois intelligentsia whose mores they satirize or subvert.

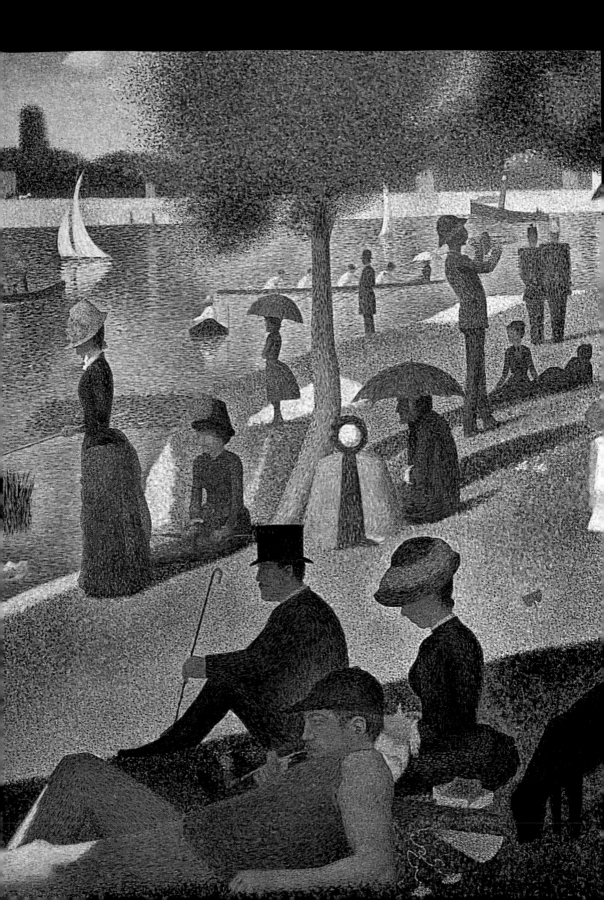

Social Class and Class Consciousness

The social history of art has been the most active and confident branch of the larger history of art for more than a generation, and no period in the history of art has been more systematically rewritten using socio-historical methods than the history of modern art. There is little to surprise us in this, as modern culture saw the creation of an immense new bourgeoisie and an urban working class, whose relationship with the traditional peasants or rural workers of Europe was complex and difficult. The Marxist class-structure defined at the beginning of modernist Europe was very much part of the life of Europeans. Indeed, the overlay of modern classes on traditional ones: the tiny aristocracy, the slightly less tiny mercantile bourgeoisie, and the rural worker, created strains in society that affected everyone. The proper or intrinsic attributes of class were defined throughout the modern period, and the psychic and social tensions of inter-class relations are recorded in countless nineteenth- and twentieth-century memoirs, biographies, and novels.

Whether we read of the fictional lives of Balzac's heroes and heroines or the memoirs or letters of Disraeli, Zola, Toulouse-Lautrec, or Kafka, the issue of class is of paramount importance. Americans, we are often told, have a difficult time understanding this, because they are taught from a young age that there are no rigid social classes in America and that one can be what one wants. Yet, actual experience has taught us differently, and American modernism, particular that of its photographers, the painters of the Ashcan School, and other urban Realists, has had highly developed interests in social class in most of its representations.

Seurat and *A Summer Sunday on the Island of the Grande Jatte, 1884*

Seurat split the Impressionists apart with the sheer force of his embodied pictorial theory in 1886. His large painting *A Summer Sunday on the Island of the Grande Jatte, 1884* was the talk of Paris [**96**]. Its surface, covered with thousands of tiny strokes of paint, some in the shape of dots, caused painters to split into camps of converts or enemies. Its painter, a 27-year-old classically trained artist, had never before

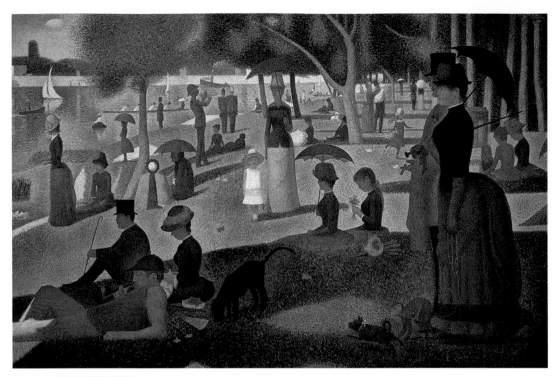

exhibited with this vanguard group, but the criticism and conversational discourse that surrounded this painting were as intense and prolonged as any aesthetic argument in the history of modern art. For proponents of what Seurat himself called Neo-Impressionism, the work was nothing less than revolutionary, putting forward a set of standards and rules against which representations could be measured.

Curiously, a good deal of the most interesting recent literature about this painting has very little to do with this stylistic controversy or with the painting's technique, but is concerned with its imagery.[1] According to T. J. Clark, who writes passionately about its meanings, the painting's most revolutionary feature was not intimately tied to its colour theory and dotted facture (which are merely ciphers for modernity), but rather its relationship to the class-based social discourse of Third Republic France. For Clark, the actual subject of the picture is its entitled subject: a specific weekend day, Sunday, at a specific place, the island of La Grande Jatte, between Neuilly and Asnières to the west of Paris, in a definite year, 1884 (two years before the initial exhibition of the painting). In his now famous passages about the painting, Clark is fascinated by the positions, sizes, costumes, sex, age, and interactions of the painting's many figures, all of which are, to him and many others who work in his manner, part of a sustained meditation by Seurat on the subject of social class. Hence, for Clark, the subject of the picture is embodied in a particular style of representation, but it is not about that style, as many students of modern painting have long been taught.

97 Georges-Pierre Seurat

Bathers at Asnières, 1883–4,
oil on canvas

This, the first self-conscious
masterpiece by Seurat, rep-
resents male working-class
leisure in a hieratic way
derived from sources as
diverse as Egyptian sculpture,
Piero della Francesca, and
Puvis de Chavannes. Like the
later *Grande Jatte*, the image
is organized within a struc-
tured series of planes in which
the figures are trapped almost
like insects in amber. Across
the Seine, we see the island
of the Grande Jatte and the
completion of a boat-race that
also enlivens the left side of
the *Grande Jatte*.

What makes this immense machine, as it would be called if it were a
Salon painting, about social class? The answer is complex and lies in its
relationship to another painting by Seurat, completed in 1884 (the year
of the illusionistic *Grande Jatte*), the *Bathers at Asnières* [**97**]. Before
Seurat's later addition of the stippled, integral frame to the sides of the
Grande Jatte, the two works were of identical dimension. Each rep-
resents figures out of doors in two distinct, but visually shared, land-
scapes. In fact, the figures in the *Bathers* all look to the right (east)
across to the Grande Jatte, and all contemporary commentators on
Seurat's paintings have noticed that there is a boat race in both paint-
ings, thus suggesting an actual link. The earlier painting confronts
urban poverty and, perhaps, unemployment. All its figures are male;
none is wearing the well-cut clothing of the bourgeoisie, nor the
equally elaborate costumes used by that class for outdoor leisure. One
figure, an adolescent youth, seems to call out across the Seine to the
unseen inhabitants of the Grande Jatte. All the figures dominate a set-
ting defined by industrial technology, with railway bridges and factory
chimneys structuring the landscape. The painting is composed as if it
were a great mythological tableau, and many writers have pointed out
its affinities with works by conventional painters like Puvis de
Chavannes (whose Salon painting of 1882, *Pays Doux*, has fascinating
affinities with it). Its component of radicalism has less to do with its
style or chromatic structure, than with its class-laden, and thus con-
ventionally inappropriate subject. The classicizing rules of composi-
tion and pictorial structure used by Seurat were considered perfectly
appropriate to elevated subjects from mythology and history, but not to
a banal and literally lower-class subject like Seurat's working men and
boys on the Seine.

It seems clear that Seurat initially conceived of the *Grande Jatte* as a

98 Lukian Popov

Mobilized, 1904, oil on canvas
One of the primary places of systematic class mixing was—and remains—the military, and Popov confronted the social gulf between officers and soldiers in this powerful painting about social control and government-sanctioned slavery. His contribution to military painting was unusual within that official sub-genre of modern art because of its overtly questioning—even critical—stance.

99 Adolph Menzel

Supper at the Ball, 1878, oil on canvas

Menzel was among the supreme masters of modern painting in Europe. This work plays a role in the international avant-garde because it was exhibited in Paris in 1878 and admired (and copied) there by Degas. It represents a huge official ball like those that were the definers of social life in Euro-global capital cities. Its co-mingling of government officials, aristocrats, and members of the haute-bourgeoisie in a tapestry of light, costumes, and movement was so successfully achieved by Menzel that he seems almost to have been a pictorial apologist for the official culture he represented.

pendant to the *Bathers* in order to present a world that is in every sense opposed to his earlier painting, in ways familiar to historians of nineteenth-century art.[2] Yet, rather than pairing day and night or ancient and modern, Seurat paired workers with bourgeoisie, creating a situation in which the modern artist focused his attention on utterly contemporary issues of social class and its visual legibility. In reading the current literature about the two paintings, we quickly confront the slippery nature of social class in modern society. In fact, most commentators on the *Grande Jatte*, which is a considerably more complex picture than *Bathers*, stress the inclusion within this seemingly respectable bourgeois world of workers masquerading as bourgeoisie. It seems, from this commentary, that Seurat gave visual embodiment to the relative impermeability of the working class (after all, nobody wanted to be part of the working class) and the disturbing permeability of the bourgeoisie.

If, as many think, the placid Sunday afternoon on the Grande Jatte is polluted with prostitutes and noise-makers, most of whom appear as members of the bourgeoisie in disguise, then the entire social order so elegantly constructed by Seurat is more tenuous than his rigid composition at first suggests. The fisherwoman and the woman with the pet monkey have been identified as prostitutes by their attributes; and the prim but unchaperoned woman reading a novel in the foreground, sharing the shade with a rower and a dandy, might solicit or simply receive the interest of one or the other of these men before the afternoon is over.[3] And the fact that all this covert activity takes place during a holy day in the presence of respectable women and children makes it all the more alarming (and potentially subversive). Seurat seems to chart a course for women in the *Grande Jatte*, and we see that gender represented throughout life. There is a baby (and perhaps another in a baby

carriage), a little girl walking with her mother, a young girl running to another, two adolescents (in different states of readiness for the battle of life), many young women, married or attached women, and one old woman with her nurse. By contrast, the men are mere chess pieces (like Duchamp's malic moulds) whose costumes and poses give them significance in terms of the women. Within the context of this seemingly respectable place, women have been and will be corrupted by men (or will corrupt men), and innocence will be kept, or lost.

Class issues in modernist culture

If the intricacies of urban social interaction, both sexual and class-based, were Seurat's subject in his first two self-conscious masterpieces, he was not alone [**98**]. Indeed, the entire history of the most modern literary form, the novel, is engaged with class stabilization and class rise, the latter adversely affecting the former. Readers of Jane Austen, Charles Dickens, Gustave Flaubert, F. Scott Fitzgerald, and countless others can recite a series of plots in which aristocrats, professionals, shopkeepers, and workers dance delicately through the transitions of life from birth to death, transitions in which the rules seem

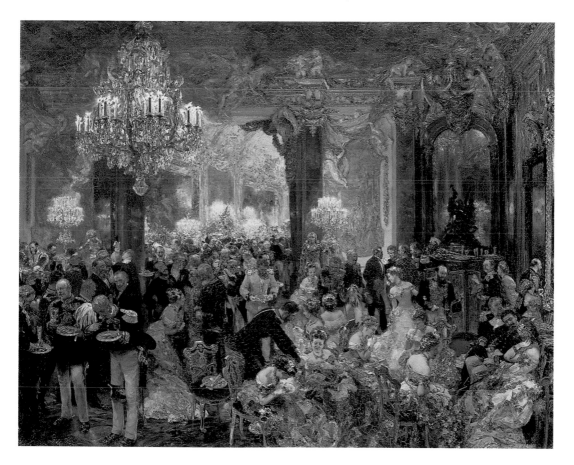

made to be broken again and again, but most often to the detriment of the rule-breakers. The death of the good courtesan, who gives herself over to her true love after years of sin, is a regular feature of popular fiction, theatre, and opera. Why should painters be any less interested in this drama than were their friends, the writers?

The social geography of Europe plays across the surface of modern painting [**99**]. We marvel at the levels of the social prison of Tsarist Russia as it was represented by the greatest masterpieces of Russian Realism, *Religious Procession in the Province of Kursk* [**100**], painted by Ilya Repin (1844–1930) at precisely the same moment as Seurat's social diptych. All the orders of Russian society swarm through Repin's denuded landscape, moving relentlessly, and collectively, towards an unseen goal. In this immense canvas, Repin's aims tend more towards the totalizing ambitions of his countryman Tolstoy than towards the subtler, and more carefully coded, social drama in Seurat's seemingly mono-class realm. For Repin, the question of class as a defining, and constraining, force in society was to be dealt with all at once, and in this single mythic image he compressed thousands of years of class development. His painting places the future of each class in the hands of each other class, creating in a single image a portrait of Russia known to no one individual, yet accessible to everyone.

One can see why historians who delve into the intricacies of class ambivalence and disguise are more fascinated by Seurat than by Repin. Seurat's women strain at the edges of bourgeois respectability, some with more success than others. Reading his painting in ways that

100 Ilya Repin

Religious Procession in the Province of Kursk, 1880–3, oil on canvas

Repin was the most famous modern artist of late Tsarist Russia. He painted larger-scale canvases representing important scenes from Russian history and was also pressed into the service of the state when he was commissioned to paint government officials towards the end of his life. Here, he created a sort of *summa* of Russian society, diverse members of which move uneasily but relentlessly together down a dusty path through a naked landscape towards a future that cannot be seen even by the painter.

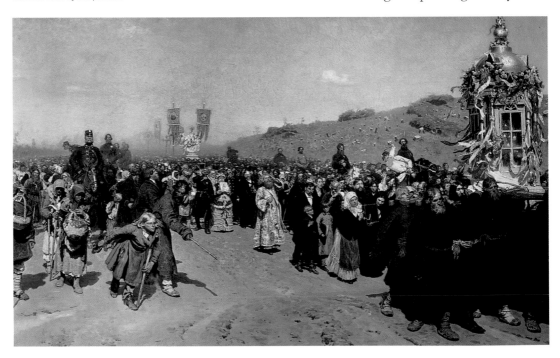

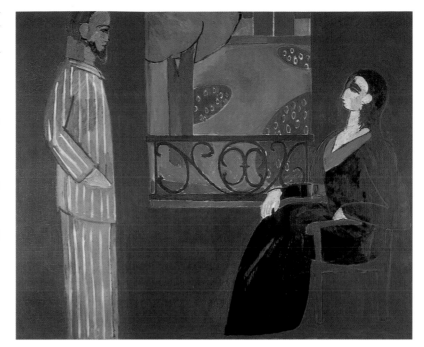

101 Henri Matisse

The Conversation, 1909, oil on canvas

Among the great modernist masters of the twentieth century, Matisse was the ultimate bourgeois. His commitment to family life and to maintaining the traditions of the paterfamilias are notable, and even the apparently unabashed sensuality of his paintings was proper. Here, in an image of family discord rare in his *œuvre*, we see the artist and his wife in what he wryly calls a conversation. Freud could scarcely have conceived of a more layered encounter between husband and wife, father and mother.

Richard Thomson and T. J. Clark insist it must be read requires formidable research skills and a delight in social nuance that is often elusive to contemporary viewers. Whether their readings, and the subsequent brilliant summary texts of Michael Zimmermann, are those of Seurat himself is difficult to know. Yet this arcane research demonstrates that there were contemporaries of Seurat who could read the painting in terms of subversive class-crossing. The danger in this type of activity is apparent only to those of us who live in societies that value class stability, and, when all is said and done, few moderns actually do. More of us applaud than decry the exceptional chambermaid who marries the count and becomes a successful countess. More of us wince than cheer when a merchant who has worked hard all his life is trounced by the unprincipled speculator who ruins his carefully tended market. Makers of representations were in all likelihood more interested in the permeable than the fixed elements of class, as virtually all Impressionist images suggest.

Certain social historians of art have dwelt on the bourgeois aspects of modern iconography. We learn from various writers about the class-bound, and anti-aristocratic, aspects of Impressionist imagery, and students of the bourgeois family could find ample material for discussion in those of artists like Cassatt, Picasso, and Mondrian. Indeed, few important representations of the modern world now in public collections in Europe or the Americas fail to represent social class in some way [101]. Whether kitchen still lifes, river-bank suburban landscapes, tourist mountain scenes, or urban genre scenes,

virtually every representation carries class signifiers, either of the represented class or for its intended bourgeois audience.

Artists and class

There are also the dramatic stories of class rise through art, and various examples include the lives of two contemporaries, the Impressionist Renoir, whose family was solidly working class, and the French academic painter Jules Bastien-Lepage (1848–84), whose parents were well-off peasants. Both these artists flirted with and finally entered the highest levels of society in the terms of the haute-bourgeoisie.[4] Renoir retreated to a farmhouse in the south of France, while Bastien-Lepage alternated restful periods at home in the country with urban escapades with Sarah Bernhardt and the *beau monde*, only to die at a very young age. Each of them dealt with various levels of society in their representations, although neither adapted his style to the class of his subjects. Bastien-Lepage made a career as a painter of peasants and the pluckiest members of the working class, while Renoir became a great painter of (and for) the nouveaux riches, as his numerous society portraits attest. Although neither of them belonged through birth to the urban bourgeoisie, neither can be placed in any other class.

This little digression into the social origins and ambitions of two French artists is intended to demonstrate that artists themselves were in many fundamental senses socially ambiguous throughout the period covered by this volume. Very few artists were produced by the aristocracy; one can think effortlessly only of Tolstoy and Toulouse-Lautrec, among important artists. Most came from the educated middle classes, some from the professional class (like Manet), and others from the mercantile bourgeoisie (like Caillebotte and Cézanne). Interestingly, there are very few good biographies of modern artists. The monograph or exhibition catalogue with a biographical essay or chronology all give us the impression that artists' lives are of secondary importance to their works, and with the exceptions of van Gogh, Gauguin, Toulouse-Lautrec, Picasso, and Dalí, very few lives of the artists are part of the general cultural discourse. A recent biography of Manet and modern biographies of Toulouse-Lautrec and Gauguin locate all these French artists in families of real accomplishment.[5] The artist, in each case, was not the only interesting and important person in his family.

In this way, artists occupied an almost classless or class-avoiding place in modern society, and most biographies of artists insist that, when their artists' families were from the respectable bourgeoisie, there were difficulties in gaining parental approval for a profession that was anything but secure. In spite of the widespread belief in the financial and social insecurity of artists, most important modern artists were successful in reaping financial awards from their production. As with many members of the new bourgeoisie, there were the years of struggle,

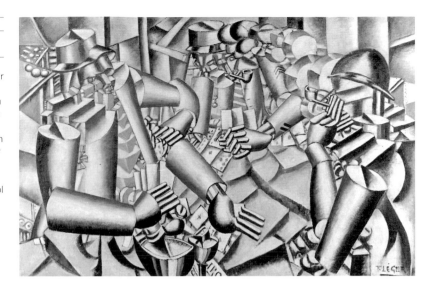

but, with real effort and with the help of dealers and other middlemen, most artists whose work is reproduced in this book enjoyed comfortable lives, at least by their late middle age.

Portraiture

Whom did modern artists portray and how did they portray them? Until recently, the art of portraiture has assumed a tertiary role in the vast bibliography of modern art. When portraits are central to the career of an important modern artist (as they were for Cézanne, for example), they have often been treated as figure studies in which issues of likeness, class, and age are less significant than they are for ordinary portraits. When one comes to ordinary portraits, most historians of modern art almost dislike them because they were made for money. However, as many recent exhibitions and studies have made clear, portraiture is among the principal strands of modern art. Indeed, social historians, historians of the family, psychologists, and many others have a wealth of material in the vast body of modern portraits, both photographic and hand-made.

Certain artists conceived of their *œuvre* as a vast collective portrait of their societies. One cannot imagine arriving at a complete understanding of the modern European family or of the individual in modern society without the portraits of Manet, Eakins, and countless others. When these are placed in the context of contemporary portrait photography, they present the interpreter of the modern individual with an almost overwhelming body of evidence about modern anxieties, triumphs, and social pressures [102].

The analysis of the Philadelphia professional and business intelligentsia by Eakins uncovers tormented, deeply cultured, and melancholic men and women who inhabit a world of shadows. Degas, surely

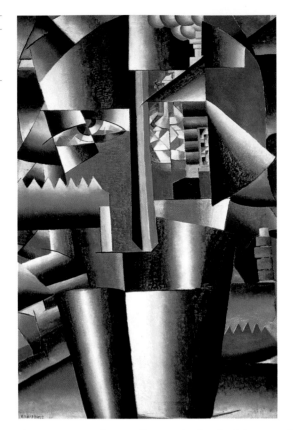

the greatest painter of portraits in the history of modern art, investigated the subtle tensions and dependencies in marriage, sibling rivalry, loneliness, impotence, and same-sex friendship as well as the complexities of anonymous public encounters in the modern city. And how the American John Singer Sargent (1856–1925) worked hard to make his portraits of the wealthiest bourgeoisie and their aristocratic friends look the same, further eroding a class boundary that had been the most apparently secure in traditional society. His vast family portrait of the ninth Duke and Duchess of Marlborough, painted to rival Reynolds's famous family portrait of the fourth Duke, recorded an alliance between a distinguished English aristocratic family in decline and a wealthy nouveau-riche American family, the Vanderbilts. The marriage didn't last very long: enough to produce children and to spruce up Blenheim Palace and its gardens, enough to give Consuela Vanderbilt a title she didn't really need; but the painting survives at Blenheim as proof of the social compromises families make for the sake of class rise or class maintenance. It speaks volumes about both Sargent and the Marlborough family as one walks through Blenheim.

Yet, when thinking about modern portraiture as a phenomenon, what becomes clear is that it was almost completely a bourgeois art form. Modern portraiture represented the comforts and anxieties of

the urban-based class, who used their minds, their charm, their languages, and their money, but rarely their bodies (except through marriage), to secure and maintain their social positions. There are numerous aristocratic portraits in the history of art, but they are, in the main, virtually indistinguishable as representations from those of the bourgeoisie [**103, 104**]. The clothes, furniture, and poses were not in any important way different in a portrait of a countess or of an actress. In this way, class itself was not the ostensible subject of modern portraiture. The class status of the individual portrayed was, more often than not, assumed by the sheer fact that most such representations were commissioned.[6] For that reason, the painter's role was to give

104 Raoul Hausmann

Tatlin at Home, 1920, collage of pasted papers and gouache Hausmann (1886–1971) and his wife, Hannah Höch, were the German masters of photomontage. In this picture Hausmann creates a portrait of the great Soviet architect Tatlin not from life, but from a photograph to which he adds disembodied images that link the head of Tatlin to a 'home' of machines, animal anatomy, travel, industry, and poverty. For Hausmann the portrait represents his meditation on Tatlin rather than Tatlin himself.

representational substance to the individuality rather than the class origin (or class aspiration) of the subject. It was the particular way in which a woman sat, wore her clothes, or posed, as well as the particular characteristics of her features, that made a society portrait successful as a representation. We must understand, in recognizing this, that portraits function to define collective class membership, as they also reveal the individual's unique traits of physiognomy, taste in dress, gesture, and physical setting. For a woman of substance in Paris or Boston there were quite rigid class rules of dress, conduct, decorum, and gesture that, if not followed, would prompt expulsion or social stigma. Portraits, more often than not, accepted and represented those rules, treating the individual as an exemplar of their social group or class [**105, 106**].

Modern portraits were very often exhibited in public settings like the Salon or the various Secession exhibitions in Munich and Vienna, but without identifying their sitters precisely. The most famous case was, of course, Sargent's portrait of Madame X, shown in the Salon of 1884 to great effect. In fact, the urban game of identifying the subject of exhibited portraits reached a real peak in modern art, when an increasingly international high society began to compete for public attention in the arena of the exhibition, using and being used by artists. The complete scandal of Madame X's black velvet evening dress, which revealed a scandalously large portion of powdered skin and which she

105 Arthur G. Dove

Grandmother, 1925, collage
The American abstract modernist, Dove (1880–1946) began making collage in 1924 and used this Dada technique only during 1926. Here he invokes a nameless American grandmother, perhaps his own, but with no hint as to her appearance. Rather, her combination of modesty, piety, hard work, and devotion to her garden are evoked. We suspect that she has died and that this recreation of her was produced from objects found after her death rather than during her lifetime or as recalled by her child.

106 Katherine Dreier

Psychological Abstract Portrait of Ted Shawn, August 1929, oil on canvas

Dreier (1887–1952) was among the most important forces in post-First World War American collecting and marketing of European modernism. Here, she represents a friend in terms not of his likeness, but of his psychological essence, probing the depths of the intellectual bourgeoisie of which she was a member.

wore in public at the Salon, gained instant notoriety both for the subject (whom certain Parisians instantly knew as the creole wife of the banker Pierre Gautreau) and for its young American painter. As a representation, Sargent's portrait is as modern as any portrait by Manet or Degas. Also like their portraits, it stands in a clear, and knowing, relationship to the history of painted portraiture, particularly, in Sargent's case, to Flemish and English portraiture. As such, it is a work that is modern because it seeks publicity amidst the spectacle of the modern city. If the representation is traditional in that it succeeds within a limit of painted marks, poses, and formats already set in the history of art, its application of those principles to a modern person without social justification for these connections is remarkable.

Many of the most famous modern portraits seem critical both of their class and of the social strictures of class representation. Degas's only commissioned portrait outside the painter's own extended family was refused by its subject, Mme Dietz-Monin, a Parisian society hostess, a relative of whom arranged the commission when the artist was suffering financial reversals. It was, however, listed in the catalogue of the Impressionist exhibition of 1879 as *Portrait after a Costume Ball* and as part of a series of portraits dealing with the urban bourgeoisie by Degas, Cassatt, and Caillebotte. The idea that the modern urban class, the bourgeoisie, was the most important subject for the modern painter was a common one in the discourse surrounding the creation of Euro-global modernism. The 'New Painting', as Edmond Duranty called it in 1876, was dedicated to the careful and discreet representation of the modern urban citizen at home, at work, at play, in daytime

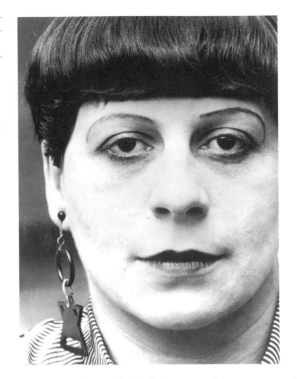

107 Lucia Moholy
Florence Henri, 1926–7, gelatin-silver print
This utterly direct portrait allows the sitter's face literally to fill the pictorial format. As such, the sitter is at once unavoidable and oddly inaccessible. Only her earring and her make-up are indicators of gender and class, and we learn nothing about her surroundings, little about her costume, and less about her body.

and at night, and Caillebotte and Degas were his heroes. We know now that they were far from alone, and that artists throughout the world rushed to represent the new money of modern capitalism as well as the men and women of accomplishment in the arts, politics, letters, and professions.

The history of modern art is filled with painted portraits of people from different areas of life, from doctors to bankers, café owners to art dealers, and countless men and women of leisure with the time and the means to be represented. All in all, this astoundingly rich painted portrait of modern capitalist society has yet to be deeply mined by either social historians or historians of art, all of whom have relinquished this job to historians of photography.[7] The veritable mania for photographic portraiture started in earnest in the late 1850s and produced vast quasi-industrial shops with equally vast fortunes reaped by their organizers. Throughout the world, there was a developing market for portraits in which the purchaser was lured not only to commission portraits of himself and his family, but to join a kind of photographic pantheon of worthy men and women. In virtually every capital city, portraits of High Society or great achievers in culture or business were grouped and sold by subscription. This mania resulted in the propagation of the English, Irish, Scottish, and American national portrait galleries. No such institution existed before the nineteenth century, and most have survived the twentieth century as relics of the lost industrial world. These collections of portraits in all media are, in the

end, about as interesting to modern viewers as the photographic portrait galleries of the capitalist city—ephemeral, of course, but catering to a dated notion of celebrity.

Scholars of photographic portraiture have taught us the ways in which photographers simply adapted representational strategies and props from painted portraiture to make their images both credible and legible. We can learn many of the same lessons from a study of modern painted portraits. Swirling drapery, flower-filled urns, distant vistas with cloud-filled skies, and poses deriving from Graeco-Roman sculpture—all these are equally common in painted and photographic portraiture in the modern age [**107, 108**]. Yet, in both media, scholars have identified the most significant modern portraits as subversive of these elevating devices. Whether in the photographic portraits of Hill and Adamson, Julia Margaret Cameron, or Nadar, or the painted portraits of Degas, Eakins, or Vuillard, the subversive or transgressive character of the image is a constant theme in recent scholarship about this work. The artist is perceived as being critical or even contemptuous of traditional portraiture, which is viewed as socially consistent, elevating, and, in large measure, banal. This critique of the recipes of portraiture is often interpreted as a critique of class-based society itself. Tradition in portraiture is not at all monolithic, if one considers the work of Titian, Rubens, Rembrandt, Velázquez, Hals, and Goya, where the expressive range within the genre is great enough to act as precedent (or example) for virtually any modern portrait, avant-garde or otherwise.

The history of art in general has avoided precisely the kind of statistical and quantitative methods that have been so fruitful for social

historians, historians of technology, and population historians. It is now time to correct this imbalance and to train art historians in quantitative methods so as to recover from the immense body of artistic representations a good deal of their lost documentary significance. Social historians have set an agenda, and certain art historians have followed this up, especially in the area of children and the family, but art historians' excessive focus on reading and rereading the individual works of a handful of great artists has prevented them from grappling with larger questions and from using the visual evidence they are best equipped to gather and interpret.

Images of peasantry

Although the bourgeoisie can claim numerical superiority in representation, they are certainly not alone. Artists often address social classes separately, preferring to construct visual realms that are closed or class-specific. We have seen this in the case of Seurat, and it is also true of Vanessa Bell in her picture of working people at the beach [109]. The oldest class on earth, the peasantry, deriving from the earliest human agricultural societies, plays a very large role in modern representation. There is, in fact, no style of modern art devoid of peasant imagery.[8] Even the most advanced and urban of art styles, Cubism and related Futurism, allow the rural worker into their visual fields, and even the almost exclusively bourgeois Impressionists painted peasants. There is a small but vital literature devoted to peasant images, most of which stresses the usefulness of these representations to certain cultural myths fostered in industrial cities: myths of origin or of the pastoral simplicity of rural society when viewed from a corrupt urban perspective. We have learned from many writers about the ways in which peasant images were designed to function in an urban artistic context to which the peasant had no admission, and hence about their evident artificiality. This is particularly compelling in the analysis of the erotic function of many peasant images, a function that was already recognized by urbanites in the seventeenth and eighteenth centuries. In the hands of certain scholars, the truism of the bourgeois function of peasant images has become a means of discrediting peasant images by making them part of a complicitous and co-optive representational strategy, not so different from colonialism. In this way the modern representation of the peasantry is filled with hegemonic political meanings that enable the modern scholar to claim moral superiority and, thus, to discredit the representation and its maker.

In the face of the wide range of peasant images by male and female artists, this categorical view is untenable. Following the lead of the internationally famous Millet, whose origins among the peasantry itself is well known, artists throughout Europe and the Americas painted

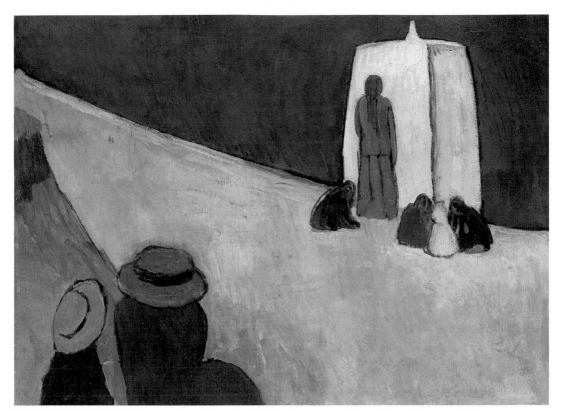

109 Vanessa Bell

Studland Beach, c.1912, oil on canvas

This sophisticated and haunting modernist painting borrows freely from Gauguin and Matisse, applying their formal ideas to a scene observed in Bell's native England. The title places us firmly outside France, and the imagery of huddled figures, standing figures with their backs to the viewer, and figures wearing hats confined to the edges of the picture, transforms this place into a part of the international scene.

rural workers in fields, homes, and markets. Some of these peasants work to produce food for themselves, but the market economy is not really so far from most nineteenth-century peasant images. While many of the images stress the mind-numbing physicality of peasant life (in this, following the earlier tradition of the peasant as a human beast), others confront peasant leisure and even education among the rural classes [**109**]. The images have such a variety of styles that no attempt to link the peasantry with a particular mode of representation is possible. What is clear is that, as part of the general artistic project to understand the world through the representation of it, the peasant occupied an important niche. In fact, the galleries of the Salon, the Royal Academy, or any of the major exhibitions in Germany, Austria, and Russia were better socially integrated in representation than they were in audience. Peasants harvested grain, tended their animals, churned butter, sewed by candlelight, ate frugally, and even posed for their representers in galleries full of royalty, dandies, and generals, all of whom looked out from gilded frames. Peasant images were neither larger nor smaller, more or less avant-garde, than those of the bourgeoisie. That they were made for the bourgeoisie is undeniable; they were, after all, modern commodities.

It has long been thought that the peasant image can be tied more or less exclusively to the visual project of Realism, and the peasants of

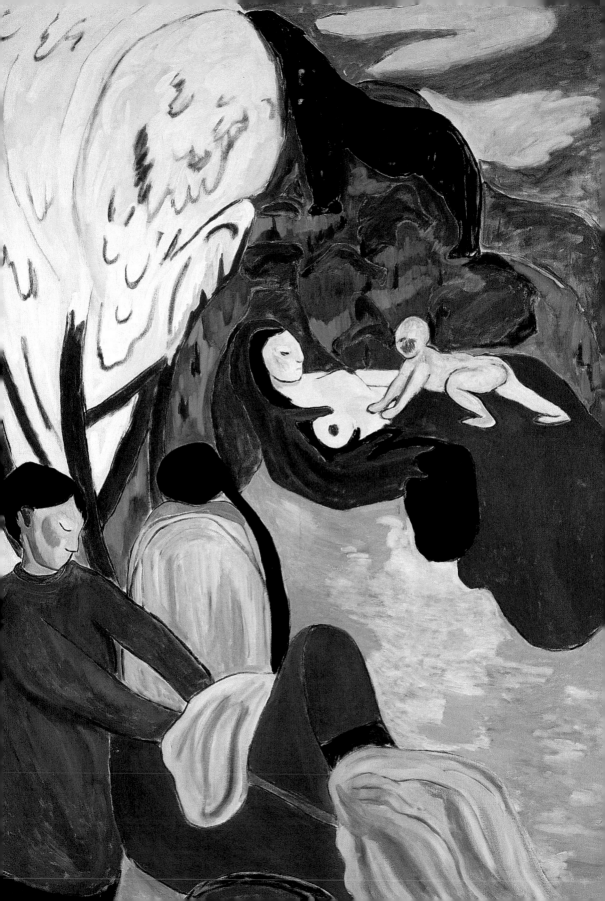

110 Rudolph Thygesen

Barbarians, 1914, oil on canvas

In this brilliant, if provincial, painting one sees just how quickly the linearity and colour intensification of Matisse's brand of Fauvist modernism permeated Europe and America. The decorative arabesques of Thygesen's composition unfold in leisurely rhythms that are given pictorial punch by his brilliant, contrast-filled palette. His 'barbarians' are surely the 'fauves' or 'wild beasts' that animated Parisian exhibitions from 1905 to 1908.

artists such as Courbet, Millet, and Paul Adolphe Dagnan-Bouveret (1852–1929) are often grouped and studied. Yet a simple list of peasant images in what has become mainstream avant-garde art would be very long, varying from the Impressionist and Neo-Impressionist peasants of Pissarro and the French artist Maximilian Luce (1858–1941) through those of Gauguin, van Gogh, and Cézanne to the noble peasants of Gosol in the work of Picasso. While Pissarro and Luce created their images as part of a specifically anarchist political project and as part of a representational embodiment of a modern 'agro-industrial' world, those of Gauguin, van Gogh, Cézanne and Picasso can be interpreted as part of an elemental humanism, in which the class-bound fashion trends of cities are removed from the viewer's consideration so that the art functions on a generally human plane. To this predominantly French image, we must add the extraordinary fascination with the peasant in Russian, Swiss, Italian, and Central European modernism [110]. And on the eve of the Russian Revolution the overtly politicized representation of serfs as noble rural workers was common in Russian modernism. In Russia and, subsequently, the Soviet Union, the rights and individuality of rural workers were being expressed in artistic representations as modern and as urban as any in the history of art.

In 1886, Pissarro completed *The Apple Pickers* after a four- or even five-year period of intermittent work on the canvas [111]. It hung next to Seurat's *Grande Jatte* at the final Impressionist exhibition of 1886. In it, a group of three female rural workers (can we actually call them peasants?) work in a carefully tended garden. One loosens ripe apples from the tree with a stick; another picks them up from the ground; a third tastes the sweet fruit, while putting the apples in a basket, most probably for sale. There is, hence, a sort of visual diagram of the steps involved in the harvesting and presentation of apples. None of the young women makes any form of contact with the viewer, and Pissarro's adoption of a very high horizon line and a square format makes it difficult for us to relate in any direct bodily way to the figures. Rather we are asked to think about them in the context of a contrived and decoratively complex representation. Oddly, given the usually sexist urges in the representation of young peasant women in modern painting, these figures were not intended to provoke thoughts of lust, in spite of the obvious links between apple picking and Christian sexual discourse. We do, it must be admitted, look down on them, but Pissarro seems more anxious to deny our presence than to use the poses and horizon line to embody a class superiority that we know he did not feel. What, then, is the class significance of this work?

Surely we can say something about this issue by considering it as an exhibition picture in the context of two other works, both of which were shown in its presence in 1886: Seurat's *Grande Jatte* and Signac's *Two Milliners* (1886). One room contained a collective class portrait of

111 Camille Pissarro

The Apple Pickers, 1884–6, oil on canvas

Pissarro was one of several committed modernist painters who represented traditional rural life using the stylistic advances created for urban art. Like many members of the left (Pissarro was an anarchist), Pissarro valued human work of all kinds. He confined his analysis of work to rural labour, leaving the representation of industrial labour to his younger colleague, Maximillian Luce. Here, we see a virtual dance of rural labour in a work that Pissarro painted and re-painted several times before exhibiting it next to Seurat's *Grande Jatte* at the final Impressionist Exhibition of 1886.

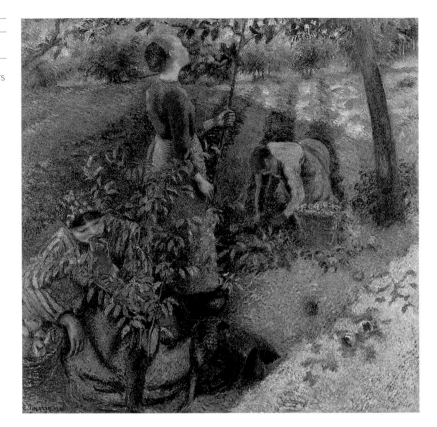

three levels of French society, rural workers, urban workers, and urban bourgeoisie, in three paintings of a similar style. Both Signac and Pissarro were committed anarchists, for whom the class divisions in modern society were like shackles that prevented individuals having full and free self-expression. Yet, in this exhibition, three class-specific representations were juxtaposed so as to raise profound questions about class, questions without easy answers. The realm of representation was, thus, socially varied without being socially mixed, or in the case of the Seurat, apparently so. And the same can be said about the official Salons.

The worker and modern art

Perhaps it was because the peasantry was associated with a distant rural world that its image tended more towards elegy and pastoral than did the images of the immense and modern proletariat or working class. Concerns over the working conditions and spiritual life of the urban working class were an important component of modern thinking throughout the second half of the nineteenth century, as communication and representation made the lives of the working class more accessible to the economically dominant bourgeoisie. In fact, images of the working class were rare by comparison with the peasant image, most

112 Nikolai Yaroshenko

The Stoker, 1878, oil on canvas

Yaroshenko's contribution to Russian art was defined by the Association of Travelling Exhibitions or 'The Wanderers', of which he was an early member. This was the first well-organized vanguard movement in Europe, and its aim, to take art directly to the Russian people through privately organized exhibitions, was later adopted by the Impressionists. Here, Yaroshenko permits a terrifying guide to take us into the 'hell' of industry.

113 Abrham Arkhipov

Laundresses, 1901, oil on canvas

This brilliant study of urban work revels in the heat and comparative darkness of a crowded laundry. Arkhipov, along with the portrait painter Serov, should be considered among the handful of Euroglobal masters of the loaded brush. Like Zorn, Sorolla, and Mancini, Arkhipov applied the same technique to workers and peasants as Sargent and Boldini did to aristocrats and members of the hautebourgeoisie.

probably because of their predominantly negative and critical character. Although most recent writing about working-class imagery has been directed at the urban workers of Manet, Degas,[9] and the Impressionists, I have chosen two Russian examples of proletariat imagery: the famous *The Stoker* (1878) [**112**] by Nikolai Yaroshenko (1846–98) and Abrham Arhkipov's (1862–1930) later and more lyrical *Laundresses* (1901) [**113**]. Both works were exhibited in the privately financed exhibitions of 'The Itinerants', a group of advanced artists who sought to bring art directly to urban audiences throughout Russia in an unsanctioned manner. In each case, the viewer is asked to confront the grim realities of urban work: in Yaroshenko's case that of an individual male industrial worker and in Ashkipov's urban laundresses toiling on the ground floor of a vast building. Their representational strategies differ: Yaroshenko elected to suppress his own involvement with the subject and to establish a seemingly direct confrontation between the urban bourgeoisie who view exhibitions and a particular middle-aged worker who cannot be ignored. Arhkipov, by contrast, evoked the straining, sweating bodies of his workers with the sort of sensual strokes of thick paint used by Sargent, Boldini, and the Swedish artist Anders Zorn (1860–1920) to represent aristocrats and members of the haute bourgeoisie. Hence the style of representation can in neither case be associated with the class of the represented subject, and one again confronts a situation in which the difficulties of class-based research are clear.

In spite of the immensity of the social history of art during the last generation, studies of class representation in modern art are at a very early stage. Most analyses are confined to a single country, thereby

114 Károly Ferency

Boys on the Danube, 1890, oil on canvas

Ferency was among the most distinctive and original modernist painters in late-nineteenth-century Budapest. Here, he seems almost to be competing with Seurat, whose *Bathers at Asnières* was completed just six years earlier. Although it shares with Seurat's masterpiece a sort of timelessness, Ferency's painting is as monochromatic as a photograph and has dynamic, asymmetrical spatial structure. Its subject is young boys with time on their hands —neither working nor in school, and its view of their future is unclear.

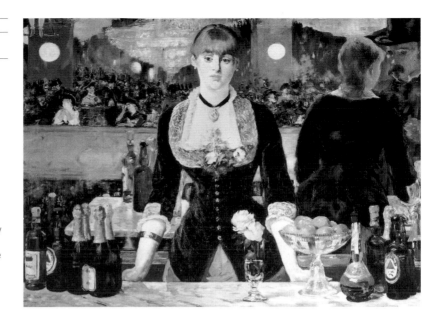

making it difficult to make conclusions about represented class itself.
Studies of the modern representation of industrial workers are also
rare, and bourgeois Marxist scholars have preferred to hound the bour-
geoisie in representation rather than to analyse images of that, or any
other, class in quantity and depth [**114**]. Exceptions to this rule tend to
be in the area of entertainment workers, particularly popular singers,
service workers, and prostitutes. This may be because their image is
perhaps more common and because it involves class confrontation. A
waiter or waitress, a dance-hall performer or cabaret singer, all these
entertainment workers are defined by their relationship to a customer
or an audience, often, though not always, bourgeois. This condition
provides the representer with occasion for study of class interaction, a
subject more difficult to represent in the case of industrial workers and
their families, who lived and worked in relatively class-confined areas.

Many of the most compelling and morally problematic readings of
modern art concern such class interactions. Perhaps the most canon-
ical work of art to read in this way is Manet's *A Bar at the Folies-Bergère*
(1882). The single figure in the painting is a waitress, who stands
alone behind a bar laden with the goods that she sells, beer, liqueurs,
champagne, and fruit [**115**]. Behind her is a mirror, the reflection in
which has caused more speculation than any depicted mirror in the
history of Western art (including the convex mirror in Parmigianino's
Self Portrait, the mirror in van Eyck's *Arnolfini Wedding Portrait*, or the
mirror in Velázquez's *Las Meninas*). Manet's mirror is troubling both
because it does not reflect the reality in the picture (and beyond it) in a
comprehensible way and because it contains a reflection of a presumed
costumer, who leans forward to interact with the waitress herself, but is

not present in the 'real' realm defined by Manet. The countless discussions of the mirrored and the actual realms of the painting have dealt with the ontology of painting itself, with the representation of desire, and with the unbridgeable social gap between the urban working class and the bourgeois customer or viewer. All these readings are fascinating, many are eloquent, and all hinge on social class as a major component of the representation's various meanings. Thus, during the last generation, the painting has gone from being an examination of flatness and complex pictorial illusionism and has become a representational examination of many of the class and gender issues raised in an expanding urban capitalist society. Both views are, of course, correct, but the class-based reading depends on a thorough knowledge of entertainment workers, their access to capital, and the milieu in which they interacted with the urban bourgeoisie.

The future of scholarship that deals with the historical representation of class is great. As public collections of modern images become digitized and widely accessible, the tendency to read (one might say over-read) a small number of works of art will become less compelling than new research into modern portraiture and genre painting of all sorts. The importance of this project to human scholarship is, I think, great. Artists making representations of particular individuals or classes of individuals in modern society produced a collective portrait of that society as compelling as those created by novelists and playwrights, psychologists or anthropologists, or writers of memoirs and publishable letters. The realm of visual representation they defined is filled with secrets, with ideas, and with potential for expanding human discourse.

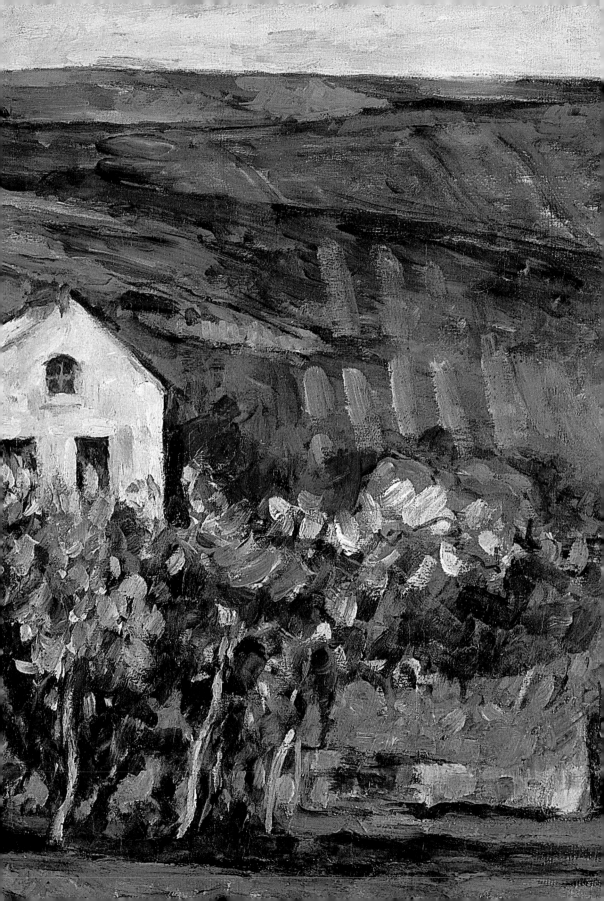

Anti-Iconography: Art Without 'Subject'

7

How, in a section of a book devoted to the iconography of modern art can one have a chapter that deals with the artist's attempts to defy meaning? The risks are great, and they are perhaps greatest if the thesis that certain artists attempted to avoid meaning is interpreted as a return to the formalism of earlier modernist criticism. We have seen in these pages that representational artists used their arsenals of pictorial skills to give visual form to modern sexual anxieties, class tensions, and national myths. We have also seen ways in which certain notions associated with religion, philosophy, the occult, and even science that are perhaps best expressed in words were given pictorial form by artists who worked both in image/modernism and abstraction. Yet it must be remembered, in looking at many works of canonical modern art, that the ascription of verbal meaning to them was made difficult by the artists themselves. How?

The first method was the most obvious, to create representations from completely banal or, in this sense, unrepresentable subjects. In this, modern artists followed the lead of the major bourgeois masters of Dutch seventeenth-century art (before modern scholars began to teach us about all the hidden moral meanings in those seemingly contentless paintings). Even among canonical French artists, this deliberate cultivation of the banal is remarkably prevalent. The dull suburban streetscapes of Sisley and Maurice Utrillo (1883–1955); the seemingly random stretches of the Seine by artists from Monet to Vlaminck; the portraits of anonymous gardeners and servants by Cézanne or Picasso; the corner market apples and pears by Cézanne, Matisse, and others; the provincial market scenes by Pissarro; the list could continue easily for pages. So many of the subjects of avant-garde Realists defy our attempts to explain just why they were selected to be pictured.

Landscape painting

Monet's *On the Bank of the Seine at Bennecourt* (1868) has been discussed enormously because of its almost universal visual availability since its acquisition by the Art Institute of Chicago in 1922 [**116**]. It is, in certain senses, among the first truly Impressionist landscapes. We know from its title where it was painted (in a village west of Paris along the

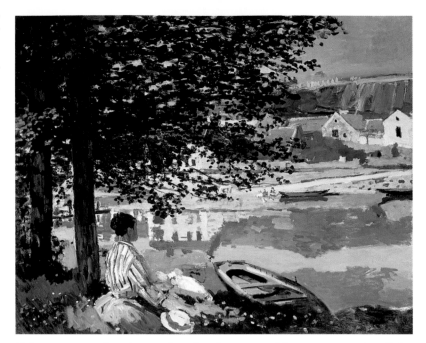

Seine, soon to be the setting for the powerful prose portrait of the modern artist by Zola in *L'œuvre*), but what, really, does it represent? The *repoussoir* trees are neither interesting nor beautiful (nor do they make space very well, as such trees are supposed to do). The female figure (there were two earlier, but Monet has removed one rather crudely, so as to let the viewer know) is faceless and psychologically illegible. The reflection of Bennecourt in the Seine cannot face scrutiny: it is improbably schematic when we can see the village and rather more precise when Monet chooses to screen the village behind the trees. We see, for example, the full reflection of a hidden house just to the left of centre, while there are no painted reflections of the visible houses on the right of the composition. Only the weather, gloriously sunny and, from the evidence of the figure's dress and of her being seated in the shade, wonderfully warm, is picturable. In this sense, Monet encourages us to join him in this evocation of a summer day. Yet, again we must ask the question, why this stretch of the river? Why these buildings? Why only one empty boat and one figure, but two trees (one of which was obviously added after the composition was largely achieved)?

Clearly, in painting *The Seine at Bennecourt*, Monet made many changes which, in attempting to decode the picture, have no effect on the subject of the picture and little on its meanings. There are no pages of prose or poetry that Monet elected to evoke in this painting. There are no other works of art to which it has anything other than the most generic of relations. There are not even works of art made by Monet himself that, taken with this picture, enable us to ascribe

further meaning to the work. We are, in the end, stumped if we try to interpret the picture in any way that would be familiar to the iconographer. What, in this situation, have art historians and critics done to develop verbal equivalents for this work?

They have turned to two major sources: early Realist literature, particularly the novels of Zola, with whom Monet was living in one of the houses in the painting at the time it was painted, and the voluminous travel literature produced to render the environs of Paris accessible to the tourist.[1] Both of these sources create a sort of verbal context in which Monet's representation can easily be set, but do these contexts in any real sense explain it? The answer is surely no. The same texts work as well for many other representations, most of which are different from Monet's in virtually every sense. The illustrations in guidebooks do not look like his painting, indeed they are most often crowded with figures (we do see a group of rowdy boaters in the middle-ground of Monet's composition, but only after careful looking), regattas, swimmers, and detailed evocations of buildings and trees. And, although one could easily find certain passages in Zola's *Thérèse Raquin* (published in 1867) that parallel the painting in words, the reading of them does nothing to affect our interpretation of Monet's representation. Zola's prose passages are, because of their positions within a dramatic narrative, suffused with meanings that relate to a human drama (in this case a murder). His words do not form independent pictures like that of Monet's representation.

The point of all of this is that, in many ways, Monet clearly intended to avoid any literary or visual associations that would limit or determine the meanings of his representation. Indeed, the most persuasive way to interpret the picture is as an image about painting as representation. By painting both reality and reflection, Monet addressed a central mimetic function of visual art, but, oddly, seems to propose no solution or assert no theory. In constructing the work with such aggressive strokes of paint, Monet was at pains to reveal himself as the producer of the work. We see not only his boldly black signature and date (both probably added later), but also his painted marks on the canvas. We are asked, in this sense, to interpret the work as a construction in paint that uses a particular scene as its organizational scaffolding. Thus, the houses are not important as houses, nor the trees as trees. The subject of the picture, the Seine at Bennecourt, is at once banal and, in its banality, accessible. Any Parisian could get there in less than an hour from the capital with the expenditure of a small amount of money. So why did Monet paint it?

The answer is made even more difficult when we compare it to a photograph of a remarkably similar motif, Eugène Atget's *The Marne at Varenne* [117], made about the time of Monet's death in 1926. Of all media, photography seems more than any other to be about the

photographed subject, in this case some abandoned leisure boats on the banks of the Marne river east of Paris, along a stretch that Pissarro had favoured in the 1860s. Atget has no recourse to rearrangement (unless he moved the boats until they were in the right relationship both to each other and to the river's surface that they define), and his *contre-jour* effect of light, rather like that of Monet, presents considerably greater representational challenges in the photographic medium than in painting. The resulting image is a good deal moodier, quieter, and more contemplative than Monet's painting, in spite of the fact that Atget probably spent less actual time making it. When analysing the Atget, we are fascinated by the artificiality and contrivance of the representation—by his particular decisions regarding the horizon line, the hazy space at centre left, and the barely revealed contours of the forms on the river bank that fill the lower left corner of the composition. Atget evokes a psychologically satisfying pictorial space; a space of light and dream that we fill with our fantasies, while Monet gives you an in-your-face representation in which the brilliant colour and evidently warm weather are the only attractive components.

Another consciously meaningless landscape representation is Cézanne's *Houses near Auvers-sur-l'Oise* (1873–4) in the Fogg Museum at Harvard [**118**]. This landscape was among the distinguished group of works by Cézanne owned by Joachim Gasquet, the most important French collector of avant-garde painting in the 1870s. It also was exhibited at the 1904 Salon d'Automne in Paris, and in Roger Fry's famous exhibition held at the Grafton Galleries in London in 1910.[2] For those reasons alone, its effect on modern representation has been

118 Paul Cézanne

Houses near Auvers-sur-l'Oise, 1873–4, oil on canvas

This small painting, together with others by Pissarro and Victor Vignon, represents a farm along the Oise river near Pontoise. For Cézanne, the powerful spatial interplay of the axially contrasting buildings is emphasized as is the chromatic tension between the grey-beige buildings and their intensely green setting. Yet it is the group of grey-painted diagonal marks to the right of the buildings that makes this small landscape painting revolutionary.

considerable. Painted a little more than five years after Monet's representation, Cézanne's picture was made during the period of the painter's intensive artistic interaction with Pissarro. He chose a pair of houses used by rural workers that sat along the small road that ran along the Oise river between the village of Auvers, where he lived, and the hamlet of l'Hermitage, where Pissarro lived [**119**]. They stood against a steep hillside and looked down on an alluvial agricultural plane that bordered the Oise river. In a sense, Cézanne's subject was almost identical to that of Monet, but Cézanne chose to concentrate on the houses themselves and to omit the river and, hence, the picturable reflections that it would afford. Like Monet, Cézanne also virtually omitted the sky, squeezing it into a band at the very top of the picture and refusing to grace it with space-giving clouds. Why, one must ask, would Cézanne, or anyone, choose to paint this motif? It has no architectural interest, no figures for human interest, no old trees, no harvest scene—in short, nothing that makes it interesting as a landscape motif.

Clearly, Cézanne chose his motif precisely because it was so banal and, in making such a successful representation of it, he posed himself a challenge all the greater because of the very banality of his subject. Like Monet, he signed the picture (its first owner, Joachim Gasquet, seems to have insisted) and, also like Monet, he constructed

it with consciously applied facture. In fact, many of his strokes of paint function more powerfully as strokes of paint than they do as representational forms within the landscape he chose to define. Yet there is, along the right side of the landscape, a group of parallel strokes of greyish green paint, arranged in almost martial diagonal lines that are very difficult to interpret in terms of the traditions of representational painting. No matter how hard we try, it is simply impossible to read these strokes as either agricultural fields, shrubs, or buildings. In fact, they represent nothing more than pictorial gestures and have, for that reason alone, an extraordinary status in the history of Western representational painting. They are, perhaps, the first strokes of paint in a finished work of art made for exhibition that have no representational function. Their status as painted marks is in no way different than that of the non-representational beige paint strokes in Picasso's analytic Cubist pictures of 1910–11. For Monet, and in a stronger sense Cézanne, representational painting was conceived in terms that border on abstractness or non-representionality. This idea thunders through the next hundred years of painting.

One could easily chose a photograph by Atget or even by a contemporary of Cézanne's (like Achille Quinet) to make the point more strongly, but it is wise to skip a few years and move to the next canonical French landscape representation, this one a tiny painting by a minor French artist, Paul Sérusier (1863–1927), made on the advice of a major one, Gauguin. Called with an intentional mystery *The Talisman*, this small panel painting represents a small pond near the Brittany town of Pont-Aven in the autumn of 1888. Again, the subject itself is unremarkable, but in this case we know just what Gauguin told Sérusier to do in painting it. 'When you see a red, chose the reddest red on your palette. When you see a green, the greenest green.'[3] Thus the representation is a concentrated chromatic intensification of actual

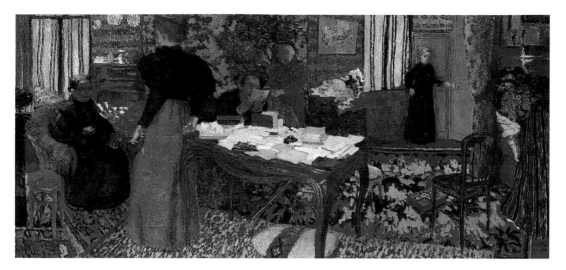

120 Édouard Vuillard

Large Interior with Six Figures,
1897, oil on canvas

The Nabis tended to work on
either a very large or a very
small scale in painting. This
work has the scale of a Salon
painting made for official
exhibition. It is, however,
among the most complex
compositions by Vuillard
from the 1890s. Its painted
patterns interact with the
puzzle-like composition of
figures and furniture to form
a chromatic tapestry of urban
bourgeois life. Although
Vuillard used his family,
friends, and even himself as
models, his decision to embed
the figures in a complex
setting suggests that their
identity had no real interest
to him.

sight, an intensification that tells us more, perhaps, about the available materials of the artist than about the scene represented. Here, as with Monet, the basic subject of the panel is the interplay between actual and reflected landscapes. Yet, like Monet, Sérusier renders the difference representationally irrelevant.

Vuillard's *Large Interior with Six Figures* has a title that courts banality even more effectively than does the representation itself [120]. In fact, when we know that Vuillard represents merely an interior with six figures, we are struck by its fabulous pictorial richness. Almost because it has no iconographic richness, the sheer multiplicity of the chromatic, spatial, and organizational delights he provides is all the more pleasurable. By referring to the actors in his interior drama simply as figures, Vuillard removes any precise psychological dimension from the painting. Yet in spite of these efforts, we persist in attempting to decode them. Why six? Why is it easy to find five of them and difficult to find the sixth? Why one male and five females? What are they doing? Yet, for all that we ask these questions, Vuillard gives us no clues to the answers, and we return, after a wonderfully pleasurable period with the painting, to its title, *Large Interior with Six Figures*, as an adequate description of its subject precisely because it becomes clear to us that the painting is not about its subject but about the act of representation.

Text and image

This gambit of enforced meaninglessness is such an important component of unmediated modernism that its methods deserve careful analysis. Unfortunately, iconography, even of the complex postmodernist sort practised today, does not help. In looking again at the Vuillard, one is tempted to go rushing to the theatre, or to read the plays by Ibsen and Strindberg that Vuillard read and saw and for which he created various designs. Yet, as Belinda Thomson and others have pointed out,

121 August Strindberg

The Wave VIII, 1892, oil on cardboard

Strindberg is known primarily as a writer, but his paintings are among the most original and important in the history of Swedish modernism. He rejected the image/ modernism of Gauguin, whom he knew, for a more bracing form of modernism that derived from the palette-knife paintings of Courbet and his followers. Here, water and air are literally equivalent to paint.

this practice, while fascinating, enriching, and educational, gets us no nearer to a solution to the iconological puzzle of *Large Interior with Six Figures* than we were before. Indeed, the representation itself has a good deal more pictorial suggestiveness than comparable scenes in contemporary theatre and, just as with Odilon Redon's deliberately irrelevant illustrations of the poetry of Mallarmé, seeing and reading go together, but do not reinforce each other with any degree of ease.

Indeed, as we learned from the writings of artists from the Impressionists from Gauguin and Sérusier to Matisse, verbally based iconography or iconology does not apply to the theory of modern painting. The very cult of the visual and the non-verbal nature even of representational painting is stressed over and over by artists and their most intelligent critics. In our current obsession with both indirect and direct readings of modernist paintings, most of which are textually based, we must remember this fact. At no earlier time in the history of Western art did the visual gain greater autonomy from words than in the period covered by this book.

Among the most fascinating painters to address this issue squarely was, ironically enough, a great writer. Not since the death of Victor Hugo had a major European writer been drawn to the practice of visual representation (though many great writers wrote about painting, photography, or print-making). Yet in the 1890s, as he was writing his greatest plays, the Swedish writer August Strindberg (1849–1912)

painted a series of fascinating visual representations that are profoundly visual, obsessed with the material of the painter, and non-literary. One of the most interesting of these is *The Wave VIII* (1892) [**121**]. This remarkable painting has been related to Strindberg's interest in the paintings of Turner that he had seen in London. Courbet's stormy seas are closer in the intensity of their painted surface and in their almost complete absence of legible pictorial space. Neither Turner nor Courbet can explain this canvas, (whose vertical format makes it a distinct rarity among seascapes), and the absence of any scale-giving form or any sense of land gives the representation an added terror for the viewer. That there is a very strong and literary-charged subject here, the crashing sea, is undeniable. Yet Strindberg conveyed that subject in ways that have little to do with standard illusionism, and removed any sense of internal narrative from the canvas. There is no way in or out of this seascape and, in looking at it, the viewer is at his own representational peril. One must wait for the late landscapes of Mark Rothko for anything comparable.

Wave VIII proves that, by denying a very potent natural motif its narrative and illusionist trappings, the artist can in fact intensify the very subject that he denies. Yet most anti-iconographers represented banal subjects; banal either because they were unremarkable in life or because they had been represented so many times as to have become banal. (We must remember that even Andy Warhol claimed that *The Last Supper* had lost all representational interest.) This sense of banality reached new heights in the first decade of the twentieth century with both Cubist and Fauve painters. Although Derain and Matisse continued the landscape imagery of the Impressionists, they avoided the great tourist sites of the Mediterranean, preferring the

122 Laura Gilpin

Basket of Peaches, 1912
This early colour photograph has become justly famous. Although assuredly 'real', its very subject and composition have their roots in European still-life painting, and we think of Chardin, Manet, and Renoir still-lifes more than we do of actual fruit when we look at this photograph.

most ordinary of fishing ports and rocky cliffs. Vlaminck risked almost complete iconological banality by choosing to represent precisely the same landscapes painted by the Impressionists, Chatou and Bougival. His contribution was to inject a chromatic, facturial, and compositional vitality into these banal scenes, most of which could easily have been painted by Renoir, Sisley, or Monet more than a generation earlier. As with the Fauve views of the dreary port of Antwerp by Braque or the tutti-frutti façades of Mornau by Kandinsky and the German artist Gabriele Munter (1877–1962), the mode of representation contrasted utterly with the represented subjects.[4]

Abstraction

Few artists made smaller demands on iconography than the Cubists, who insisted on representing the most accessible figures and still lifes they could find. There were no searches for subjects, no long periods of doubt in deciding between apples or oranges, a female or a male sitter, a portrait or a genre scene. Rather, all the excitement in their representations came from the particular modes of painting they developed while staring at their simple subjects. We return again to the cultivation of meaninglessness. Are there other points in the history of Western art when such iconographic obfuscation occurs? The mind wanders first to Dutch seventeenth-century Realism, to the rural peoples of the Le Nain brothers, to Annibale Carracci's butchers, or to the plums and kitchen-maids of Chardin. Yet these all are concerned with problems of illusionism, and the apparent accessibility of their subjects is part of a gambit to get one to focus on the extraordinary mimetic likeness achieved by the artist. The same is true for the French artist Louis-Léopold Boilly (1761–1845) and other European painters of genre from the first third of the nineteenth century. In fact, even in the realm of landscape painting, there are no periods or groups of artist who created finished paintings that strain the interpretative strategies of the viewers more persistently than those just discussed.

When we look at the aggressively ordinary subjects of abstract-realist painters like the American Georgia O'Keeffe (1887–1986), the strategy continues (see **133**). There is nothing inherently interesting about a particular flower or an apple or a barn, but when O'Keeffe elected to contemplate these banal subjects for long periods and to transform these contemplative acts into works of representational art, the representation became the subject. The viewer has no desire to pluck or buy a similar flower or to find the barn in upstate New York. Rather, the sheer pictorial concentration evinced in her act of representation becomes in itself interesting. To make the point more strongly, if we look at a several photographs of simple everyday subjects made by Laura Gilpin [**122**], Paul Strand, or Margrethe Mather, we confront O'Keeffe's essentially photographic aesthetic. In every case,

123 Lazar El Lissitzky

Proun 12 E, 1923, oil on canvas

Lissitzky's career is particularly important for European art and theory because he spent a good deal of his working life outside Russia and had a profound effect on German and Dutch modernism. As a Jew, Lissitzky participated in the interconnected and profoundly modern culture of the diaspora and was among the most important individuals in international modernism.

124 Kasimir Malevich

Suprematist Composition: White on White, 1918, oil on canvas

Malevich's abstractions of the late teens are among the most reductive in the history of art. Conceived as both independent and interdependent, the separate easel pictures were positioned in simple spaces by the artist in ways that approximate later installation art and that deny them their integrity. In museums today, they are generally enshrined by being hung as illusionist easel pictures at eye level and lit by designated spotlights. This—and their continued publication as plates in art books—removes them from the highly experimental, noncommodity worlds for which they were conceived.

125 Mikhail Matiushin

Movement in Space, 1917–18, oil on canvas
Russian artists in both St Petersburg and Moscow were aware of the latest in French— and European—art and theory and when their own revolution completely transformed the social and intellectual structure of the state many young artists annexed revolutionary art to revolutionary action. Matiushin was among the artists fascinated by the aesthetics of flux and temporary instability, which had been an essential part of Euro-global vanguard art since Impressionism.

126 Hans Mattis-Teutsch

Composition in Yellow from 'Flowers of the soul series', 1916–24, oil on canvas

Claimed by both Romania and Hungary, Mattis-Teutsch was of German origin and lived in a part of the world that has been both Hungary and Romania. His personal brand of colour abstraction can be linked with that of Kupka in Prague, Kandinsky in Munich, and Delaunay in Paris.

the viewer is asked to perform an almost Zen-like act of concentration and to direct that act to something of no particular interest, forcing us back on ourselves or, with O'Keeffe, on the artist as a more compelling subject than the ostensible one of the work of art.

This aestheticizing strategy runs throughout the history of modern art. Artists who represent the everyday do so with a message, that the picture itself is art and thereby contains its own plastic values and

127 Bertram Brooker

Sounds Assembling, 1928, oil on canvas

Brooker was one among a small group of Canadian and American artists who embraced transcendentalism and applied its principles to painting. Many of them fled urban areas and formed an artistic colony in the hills and mountains of northern New Mexico. Here they created universal abstractions designed to go beyond all political and ideological boundaries.

its own non-verbal associations. This notion runs so strongly through the history of modern painting that it should come as no surprise to anyone who reads painter-theorists like Gauguin or Signac that art without iconography or representational subject already existed before the development of abstraction or non-representational painting around 1910. Whether based on the principles of abstraction from representational forms like the paintings of van de Velde, or whether the work of art represents concepts, ideas, or values not visible in nature, like fully mature Mondrian and the painting of the Russian artists Kasimir Malevich (1878–1935) and El Lissitzky (1890–1941), the concept of the picture as an autonomous pictorial object without necessary relationship to the act of representation is intrinsic to a certain type of modernism [**123, 124**].

Interestingly, this notion of the painting as expressive in its own terms does not apply to the pictorial theory of the first legitimate abstract painter, Kandinsky, for whom painted abstractions are so full

of associations from memory, images, and/or visualized emotions that his pictures are as dependent on notions of the world as are Gauguin's late Polynesian fantasies or Cézanne's bathers. The elision of concepts of decorative painting, in which the work of art functions as a surface of organized colours and forms that remain in the middle ground of the imagination, with abstraction is also remarkable and relatively unexplored in the literature of modern art [**125**, **126**, **127**]. Each of these modern traditions has its roots in the kind of painting discussed at the beginning of this chapter, a kind of representational art in which the representational meanings of the work are minimized by the artist. Although there is an immense leap in appearance between Monet's *Luncheon* (*Argentueil*) (1873–6) and Kupka's *Vertical Planes* (1912–13), the paintings have equally uninteresting subjects (see **6** and **27**). Monet's functions not as a representation of a luncheon, but as a representation per se, and Kupka, though he represents nothing in particular, does so in a clearly organized and emotionally resonant manner. These works could hang in a room together.

Nationalism and Internationalism in Modern Art

National identity

On entering the National Museum of Poland in Warsaw, one walks through galleries of foreign art before entering a vast suite of skylit rooms that chart the national history of Polish painting. Any non-Polish visitor feels that the national character of Polish painting is difficult to define, and that it is actually the imagery rather than the representational strategies employed by the painters that makes their work Polish. But, on entering the largest gallery devoted to nine-teenth-century painting, one confronts a truly epic canvas by Jan Matejko (1838–93) called *The Battle of Grunewald* (1878). Matejko's masterpiece defies description [**128**]: it is too large and bombastic to fit into the avant-garde; it is too absorbed with the past to be truly Realist; it is too finished to be associated with any of the forms of action paint-ing that litter the history of modern art. Indeed, no great nineteenth-century nation produced any truly comparable painting. Instead, it was the new nations, such as Switzerland and Hungary, often with com-plex and politically unstable pasts, that specialized in vast representa-tional epics. They produced the nationalist icons that continue to this day to exercise powerful authority in their own countries.

Let us return to Matejko, the beloved patriarch of self-consciously Polish painting. A native of the earliest capital of Poland, Cracow, Matejko learned German, the language common to educated Poles of that city, and travelled as a young artist to Munich and Vienna. When he returned to Poland, he became consumed with the nationalist fervour of that troubled country and worked in Cracow. His national museum in Warsaw had been closed for two years when his *Grunewald* painting was exhibited, and exhibition facilities in Cracow were not of international standard. Matejko flew in the face of all odds by painting a canvas of dimensions so epic that few rooms in the world could receive it. He therefore sent it to Paris, where it was first shown as *the* Polish painting at the International Exhibition in the art capital of the world.[1]

What Matejko did was to seize a moment in the troubled history of Poland, a battle that took place in 1410, and to represent it in such a way that the viewer seems literally immersed in history. One feels sweat,

Detail of 128

128 Jan Matejko

The Battle of Grunewald, 1878, oil on canvas

The Battle of Grunewald is the visual manifesto of Polish Nationalist culture in the nineteenth century. Although created in a part of Poland then controlled by Germany, it re-enacts on a huge scale a battle in which the Poles secured their immense national territory from the German Teutonic Knights who ruled a good deal of Lithuania north of Poland. In this way, the painting used history for present-day political ends and cloaked a fierce but frustrated nationalism under the mantle of history painting. The sheer pictorial energy of the canvas is unprecedented in nineteenth-century painting.

blood, and raw aggression in ways that are simply unexplainable in words. Few pages of prose in any language (maybe only Caesar's *Gallic Wars*) have its breadth and majesty. Even today, as Poland attains another independence, schoolchildren sit in front of it for hours, their teachers identifying the figures and explaining the historical significance of the moment evoked by Matejko.

How can one call *The Battle of Grunewald* modern? Its historicism is marked, and its style makes one think of artists from Altdorfer to Delacroix. Yet its sheer vastness and the urgency with which its nationalism is expressed is modern. It was not commanded by a king or general; nor was it a state commission, designed to be an emblem of the glory of the nation for official use. Instead, it was made privately for public exhibition in the hope that its lessons of the struggle of the Poles and their neighbours against foreign oppression would provide an example for young rebels and nationalists. Matejko bet on the survival and continued strength of Poland as a nation, that its national museum would become home to the glory of Polish painting, and that *The Battle of Grunewald* would occupy a place of pride in it. Few painters from other nations had such vast dreams for painting, and none of them attempted anything so magnificent and defiant.

Yet, when thinking about this canvas-spectacle conceived on such a grand scale, one struggles to find anything quite comparable, and it might be best at this juncture to contrast it with another battle painting, this one painted in 1911 by a Russian painter living and working in Munich. Kandinsky's *White Cross* is everywhere and in every way the opposite of Matejko's self-conscious manifesto/masterpiece [129]. Although large by the standards of the modernist easel picture, Kandinsky's canvas is minuscule when compared to that by Matejko. With its slashing black lines, hints of spears, mountains, castles, and battle clashes, it evokes rather than describes war. Yet its brilliant scattering of colour and its title make one think more readily of musical

129 Wassily Kandinsky

White Cross, January–June 1922, oil on canvas

This large canvas is a virtual catalogue of elements Kandinsky had both observed and invented during his years in Russia from 1914 to 1921. Although he had developed his early abstract style in Germany and published his important book, *Concerning the Spiritual in Art*, in 1912, he had returned to Russia to work with Klyun, Rodchenko, Malevich, and many other members of The Great Utopia. When the terrible problems of the Revolution became apparent, Kandinsky left for Berlin, where this powerful canvas was painted just before he was appointed a professor at the Bauhaus.

recitals than historic battles. We all recognize rushing soldiers, boats with rowers, and landscape elements, yet none of these helps us to place this battle either geographically or temporally. When we search for clues in the life of the painter, we learn that this painted representation of a battle (the single subject type most readily associated with national history) was made by a man from one country, living and working in another, speaking a language foreign to him, and, most revealingly, working for a completely international group of collectors and clientele. This, we have long been taught, is modern.[2]

Why is the cosmopolitan tradition in modern art coequal with modern itself? We have already learned that a good deal of modern art associates more readily with the present than with the past, and that it is all but obsessed with the manner of representation, or what we might call technique. Yet it must be said that nationalism is among the most powerful forces in modern society, that it has been at the root of most cataclysmic political events, and that, in spite of cosmopolitanism, the history of modern art remains a sequence of largely national histories written in national languages by historians who view art as the embodiment of national values. The histories of every eastern European country's art, as well as that of Russia, are not easily accessible to the West, and even the histories of other nations' modern art are written largely for a national audience. The minority of painters who worked in the modern world are treated as part of their national heritage, both in

130 Leon Wyczółkowski

U Wrót Chałubińskiego, 1905,
pastel on cardboard

This pastel view of the mountains of Poland represents a portion of the national landscape then controlled by Germany. Its emptiness and sublimity created an aesthetic condition in which it could be reconquered by each Polish viewer, thus contributing to the fundamentally cultural politics of the 'Young Poland' movement.

university courses and, even more pervasively, in the collections of national and regional museums, and this follows from the earliest arrangements of works of art into national and regional schools arranged by geographical area [**130**]. The histories of Florentine, Venetian, and Roman painting are treated in most Euro-American art museums as part of the history of painting in Italy, in spite of the fact that Italy didn't exist as a political unit until the nineteenth century; the same can be said for German art.

Time and place

Every modern art museum teaches us that place is as important to art as time, and the primary mode of organization in art museums of both painting and sculpture is by nation and region, through which time is allowed to flow. Hence, in every major European museum of European art, we see works produced in the same geopolitical place at different times in a single area of the museum, but almost never works produced at the same time in different places. And, as if this restrictive geographical organization in art museums were not sufficient, it extended also to most of the great temporary exhibitions of art held in international exhibitions and other sorts of fairs. For modern institutions in the nineteenth and twentieth centuries, art was presented as a product of nations, not of the *Zeitgeist* or of individual people. Many modern artists accepted this condition as true, and, for some, such as Mucha in the Slav Epic and Hodler in the Zürich Landesmuseum, their greatest efforts as artists were directed toward vast nationalist works with many vast canvases covering acres of wall.[3]

It goes without saying that none of these works is included in a museum of modern art anywhere in the world. Indeed, these

institutions have conceived of themselves as modern in a way that is fundamentally dissociated from nationalism (hence the almost universal distrust of museums of modern art by nationalists in the United States, the Soviet Union, England, Scotland, etc.). The theorists of modern art would contend that place is more important than time in traditional culture (when communications were more difficult and travel unusual). The modern condition, for them, produced a culture in which time replaced place as the signifying variable in classifying works of art. To put it simply, the fact that a work of modern art was made in 1890 or 1925 is more important than that it was made in Munich or Oslo. Baudelaire's dictum literally became the rallying cry for modernism—that the modern artist be of his own time.

A good deal of the cosmopolitanism of modern art has to do with the urban art system created in the nineteenth century, a multi-centred system of urban communication nodes surrounding a central city, Paris, and a small number of subsidiary capitals, Vienna, Berlin, London, St Petersburg, and New York. For that reason, an artist who worked in a place like Melbourne or Bucharest was focused on one major centre, about which artists, critics, dealers, and patrons knew a great deal more than they did about other peripheral places. It is important to remember that travelling exhibitions of provincial modern art were organized to be shown in large geographic areas. One need only think of the exhibitions organized in Melbourne, San Francisco, Pittsburgh, Chicago, Buenos Aires, and Copenhagen during the late nineteenth and early twentieth centuries to recognize just how cosmopolitan the system actually was.

Life in the capital city was very much organized around colonies of foreigners, artists and otherwise. It would not be difficult to read the art criticism of any great nation as a partial attempt to define the character of the national school of art, particularly since some of the most intensely reviewed exhibitions of the nineteenth century contained the work of foreign artists or, in the cases of the huge exhibitions held in conjunction with the World's Fairs, attempted global coverage in national terms. Even the venerated Paris Salon came increasingly to be an international affair, as artists from most parts of Europe and America attempted to place their works at the epicentre of world art.

The ability to succeed in a multi-lingual artistic society was seemingly essential for success as a modern artist, and those who were able to cross boundaries were often more successful in explicating their art than were artists who remained at home. The lists of men and women who 'passed' for 'French' or 'British' when they were Americans or Romanians are legion. Although most of them eventually returned home, it was their ability to bring back ideas and stimuli from abroad that in many ways validated them and gave them important aesthetic currency. In this way, we have learned from recent studies of Jewish

contributions to vanguard culture that the Diaspora encouraged Jewish artists, collectors, critics, and intellectuals to cross national and linguistic borders, making them, as a group, considerably more modern in the sense of international and cosmopolitan culture than others.

It is surely no accident, given this cosmopolitanism, that one of the most powerful strands in modern art was anti-nationalist. For every work made to be Polish or Russian, there were others made not to be classifiable in national terms. We have already noted that Kandinsky wrote the first full-scale manifesto of international abstraction, *Concerning the Spiritual in Art*, in 1911. It is not so far from there to the Czech Kupka, developing transnational colour abstraction in Paris or to the Dutchman Mondrian, refining Neo-Plasticism in the same city. There is plenty of evidence to assert that the inventors of Suprematism actually believed that they were charting a new aesthetic course for all humanity as part of the particular revolutionary struggles of the Russian people. What would American modernism have been without the presence of Duchamp and Francis Picabia (1879–1953) (among others) in New York during and just after the First World War or without the critical presences of the Steins or Patrick Henry Bruce in Paris in the first three decades of the twentieth century? And the travels of Segantini are crucial for the development of transnational modernism throughout Europe.

Abstract art, spiritualism, and internationalism

In the context of nationalism, abstraction plays a very small role. Indeed, the aims and achievements of most abstract painters were, at the very least, transnational and, at most, cosmic and universal [**131**]. Again, one can return to our two battle paintings by Matejko and Kandinsky. In the earlier, and clearly nationalist endeavour, it is necessary to know Polish history, to know the names of the factions in the battle, and to decode a good deal of information from the armour, costumes, and heraldic devices in the painting. None of these areas of knowledge applies to Kandinsky's cosmic war, which seems more to come from memories of childhood tales in which heroic knights stormed turreted castles in countries with no real existence. The same kind of comparison can be made between the modernist representations of Amsterdam made in both photography and paint by the Dutchman George Breitner (1857–1923), and the façades of his countryman Mondrian that present architecture freed from place.

It has long been known that a good deal of the theory of abstraction in northern Europe and the Americas developed from forms of transnational mysticism, many of which were textually based.[4] Rendering visible sounds, spirits, cosmic forces, and other invisible forms was a principal task of a particularly vital form of cosmopolitan modernism in the first two decades of the twentieth century. Although these

Geometric Composition,
1922, paper and watercolour
Bortnyik, like many cosmo-
politan modernists, refused to
be constrained by what he saw
as the narrow boundaries of
national art. For that reason,
he composed works of art
that attempted to transcend
language and national history
and to replace it with a uni-
versal or, at least, trans-
national language of form.

advances in pictorial practice were heralded as completely revolution-
ary in the years following their appearance, recent scholarship
and museological practice have taught us that abstraction grew out of
many ideas powerfully associated with Symbolism and other forms
of occult image/modernism. The representation of unseeable forms
has been a challenge to artists since the beginning of human history,
and representational solutions have tended towards abstraction long
before the development of the various strands of abstract art. The
representation of a chimera, of innocence or of any idea, deity, or
force involved levels of abstraction. Curiously, most of these non-
representable ideas transcend nations and national languages and are
more closely involved with borderless institutions such as religions.

It is not a great leap to assert that well-travelled, multi-lingual cos-
mopolitan capitalists tended toward such forms of mysticism more
than did their opposite. It is for that reason that many of the greatest
figures in nineteenth- and early twentieth-century mysticism were
voyagers for whom the mundane necessities of daily life were provided

132 John Covert

Time, 1919, oil and carpet tacks on canvas

Covert's Dada constructions are rare, but they show both the sophistication and the cosmopolitanism that was possible in urban America in the late nineteenth and early twentieth centuries. The subject of this work is time, which is visually unrepresentable in a static image, but which Covert succeeded in representing with the use of unorthodox materials. There are simply no national indicators in this work of art, which succeeds in transcending place while it embodies time.

by others (or, at least, by the fruits of working capital). Whether they gathered in Sweden, rural England, northern New Mexico, or the forests of Transylvania, the men and women who created various Euro-global spiritual revolutions between 1880 and 1930 did so without feeling great material need. They also did so with a good many books, diagrams, and representations to explain and embody their visions. The association of artists with these colonies of seekers has long been known, and the anti-national aspiration of most of these groups is an important component of their thinking [**132**].

With the proliferation of public libraries and easily accessible shops for illustrated books, an entire range of occult and scientific literature became available to artists. Whether a *Manual of Zen Buddhism*, *The Book of Occult Philosophy*, or *The Principles of Light and Colour*, illustrated books had an entire range of visual information documenting, diagramming, or describing the unseeable, and we know from the last generation of scholars just how assiduous artists were in their use of these sources. Kandinsky's familiarity with popular illustrations to the *Book of Revelations* has been documented by Carol Washton Long; Linda Henderson has proved that Duchamp used scientific and

pseudo-scientific illustrations with all the subtlety of a connoisseur; and John Boult has identified connections between the Esoteric Movement in Russia and both Symbolist and abstract art in that vast nation.[5] Indeed, scholars have combed libraries and archives to identify precise sources in the image world for forms that were previously thought to have had no such attachment to iconography. The search was for a utopia beyond nationalism where artists would be viewed as both inevitable and necessary parts of society rather than as image-workers for the dominant bourgeoisie.

While it is tempting to consider the various forms of abstraction developed in Europe and America between 1900 and 1920 as completely cosmopolitan or international in character, that conclusion would be wrong in at least one case—that of Georgia O'Keeffe. O'Keeffe developed a mode of abstract painting that combined the mysticism of the American Arthur Wesley Dow (1857–1922) and Kandinsky and that seems to have been formed as part of a search, misguided as it seems now, for a legitimately American art.[6] Through her association with the American-born and German-educated Stieglitz, she had access to the Cubism of Braque and Picasso as well as to the English text of Kandinsky's *Concerning the Spiritual in Art*. Although she rejected Cubism as European, she felt liberated by the ideas of Kandinsky and attempted to create a kind of abstraction rooted in her own experiences. As she had never been outside the United States, and because of her stubborn independence, O'Keeffe seems to have believed that her abstractions of the late 1910s and early 1920s sprang from herself and from American soil, although it is much easier to find

133 Georgia O'Keeffe

Blue and Green Music, 1919, oil on canvas

O'Keeffe sent a series of abstract drawings to New York in 1915, and when they were shown to her future husband Alfred Stieglitz, they were immediately requested for exhibition. From these bio-morphic abstractions in charcoal and ink, O'Keeffe proceeded to develop a painterly abstraction in which colour played a dominant role. Like many early abstraction-ists, she explained her sub-jects by analogy to the equally abstract language of music. This form of biomorphic or nature-based abstraction runs counter to geometric abstraction throughout the 1910s and 1920s.

precedents for her work in the theories of European modernists. In fact, a comparison between a small work on paper by the Belgian artist Henri van de Velde (1863–1957) entitled *Abstraction*, made in 1893, and O'Keeffe's *Blue and Green Music* (1919), shows that the similarities of form and, most likely, intention, are greater than the differences [**133**]. Van de Velde abstracts from vegetal forms, the origins of which are pretty clear to the viewer, while O'Keeffe's title tells us that she is making a representation of music. In each case, the artist is anxious that we read the sources of the abstraction and, thus, guides us on an aesthetic journey. Granted, both works were produced by individuals in different countries for different audiences. Yet O'Keeffe's is no more American than van de Velde's is Belgian.

Nationalist landscape painting

Many of the most compelling efforts to create viable American, Russian, or many other national artistic identities had to do with modernist view painting. The entrapment of the national scene using the advances in colour perception and painting techniques developed on the international stage is one of the unifying elements in national art history. Each one of the great national collections proves that international art was produced by national artists using native scenery as their raw material. In this way, Tom Thomson (1877–1917) or Lawren Harris (1885–1970) created a bold international image of Canada that linked the pictorial achievements of avant-garde Europeans with the

134 Tom Thomson

In the Northland, 1915, oil on canvas

Thomson (1877–1917) was the most important painter of the national landscape in Canada in the first two decades of this century. His work is fundamentally Fauvist in the intensity of its colour and its fascination with patterns. Scarcely known today outside his native Canada, his work was exhibited widely in the 1920s in England, France, and the United States.

135 Lawren Harris

From the North Shore, Lake Superior, 1923, oil on canvas
The three great land-based nations of the modern world are Canada, the United States of America, and Russia, and each produced a kind of landscape painting that made national icons of her landscapes. Harris was the master of this tradition in Canada, and his many representations of mountains and lakes in his vast native country can be found in museums, galleries, and homes throughout that nation. For him, the landscape was less particular than elemental, and he removed most of the particularizing features of a view in order to create a vast synthetic whole.

most isolated national scenery of their country [**134, 135**].[7] Not only were these paintings emblems of pride in Canada, they were routinely exported to the nations that mattered most for Canada: Britain, France, and the United States, for exhibitions of Canadian art. Yet it was precisely their modernity (and, by implication, foreignness) that led many Canadian writers and critics to decry them.

We feel the very same forces throughout Europe and the United States. A selection of modernist landscape paintings that represent national scenery using international techniques would be very large and would contain many of the best-loved images in their respective countries. Whether O'Keeffe, or the American painter John Marin (1870–1953) evoking the mythic, pre-United States landscapes of New Mexico, or Tivardar Csontvary Kosztka creating vast 'Hungarian' panoramas centred on impressive Greek and Roman ruins like those at Taormina (Sicily) in 1904–5 [**136**], modernist painters served the nationalist rhetoric of much of the capitalist world through powerful images that could be reproduced and sent throughout the nation and abroad for exhibition. This aspect of modernism is rarely stressed in the most theoretically sophisticated texts and exhibitions devoted to the movement. It was pervasive throughout the period covered by this volume. Recent scholars of American, French, indeed any national painting, have carefully analysed the construction of national imagery by modernist painters, a process of construction which was almost never related to government commissions or other less obvious forms of intervention, but was, rather, part of a general cultural climate that preferred artists to identify with their own place of birth.

The fact that many of the greatest modern emblems of America were created by immigrants or foreigners (Bierstadt, Bodmer, Steichen, Kertesz) has never troubled students of American art, perhaps because the immigrant experience is so central to the American experience.

There is no doubt that one could select a very large exhibition of modern landscape paintings from the international world. These landscapes, when shown together, would demonstrate just how global the modes of representation actually were. The national landscapes produced by the Swiss painter Alexandre Calame (1810–64) in Switzerland or Bierstadt in California are in no way different as representations. Even the vast, land-rich Russia was awash in images of the national forests, lakes, and villages that stretch almost forever from Europe to Asia, and certain images, like the Russian Nicolai Dubovskoy's (1859–1918) *Calm before the Storm* (1890), were produced in many versions to satisfy the national demand for images of Russia. Even the anti-national regionalism of Brittany in France produced a sort of avant-garde or modernist imagery intended to erode the conservative nationalism that was at the core of much political culture in the modern world. It is scarcely an accident that Ireland's first important modernist painter, Roderic O'Conor (1860–1940), lived virtually his entire life in Paris, but that he was attracted to the non-French imagery of Brittany as a kind of analogue to his own non-English Ireland. Again, modernism was both politically elastic and capable of giving powerful expression to ideas that are non-cosmopolitan.

We must remember, however, that all these images, from Matejko's *Battle of Grunewald* with which we began this essay, to the Finnish Akseli Gallen-Kallela's (1865–1931) *Lemminkainen's Mother* [**137**], with which we end it, were made for public exhibition both within and outside the national boundaries.[8] They were thus national images created to permeate the boundaries of the nation and to bring world-class techniques and visual ideas to the service of local stories. Gallen-Kallela had conceived his great nationalist project while a student in Paris and had extended and refined his mission on another extended visit to Berlin (where he was impressed by the painting of the Norwegian Edvard Munch, also an exemplar of his own country in the international arena). From this melting-pot of sources and ideas, he created a visual vocabulary that allowed him to construct representational re-enactments of his national myths with a power that can be felt to this day.

Afterword:
The Private
Institutionalization
of 'Modern Art'

The opening of the Museum of Modern Art in New York could not have happened at a worse time, just ten days after the stock market crash that, within a year, had spun out of control to create the first truly global capitalist depression. No one knew how to deal with the situation. The age of managed capitalist economies in which we now live had not yet begun, and all the richest capitalists and their politicians had neither the connections, the data, nor the organizational skills to combat an economic phenomenon that had little to do with the one skill they all had, the accumulation of private wealth. Capitalism had faltered long enough to allow other alternative systems, at least briefly, to flourish. But what of its modern art?

The idea of modern art as evoked in these pages is linked irreducibly to urban capitalism and to the loosely structured and decentralized markets that fostered the sorts of freedoms it needed to flourish [**138**]. Without independent and personally controlled wealth there could be no small independent dealers, no real occasion for the exhibitions they fostered, and, therefore, no impetus for the art criticism that has been the fodder of most recent art-historical interpretation of modern art. Yet the depression was only a temporary setback for capitalism and the informal privately sponsored art system it created. Indeed, the Museum of Modern Art (MOMA), as it decided to call itself after a consideration of alternatives that included such unlikely candidates as 'The Modern Gallery of Art', was to become within five years the defining institution of modernism precisely because it was privately owned and run, reflecting the tastes and ideas of its board and the staff with whom they elected to work. Names like Rockefeller, Clark, and Goodyear were not there by accident.[1]

Modern art has always been a private (meaning independent and capitalist) affair. Its most important patrons were self-made industrialists of virtually every nationality, more alike in their socio-economic ideologies than they were different in their geographical origins. Their names are legion, and we have come to admire them more than any of

the government bureaucrats who created the European museums on which their art was, fundamentally, based. By the mid-1920s there was no major city in the capitalist world without examples of modern art in major private collections, and the story of that decade is the story of the creation of public-private institutions like MOMA that would perpetuate modern art.

There was almost universal agreement among these rich patrons about the nature of modern art. Most of them followed the intellectual lead of either Julius Meier-Graefe or Roger Fry in thinking that modern art had begun with Manet, that the Impressionists had invigorated and collectivized it (even if Renoir was the only artist with enough ambition to have triumphed over what seemed to them the limitations of the movement), but that it lacked masters until the next generation of artists, Seurat, Gauguin, van Gogh, and Cézanne. From these four artists, virtually all Euro-global modernism seemed to them to have sprung, and their work dominated exhibitions of modern art, before its ultimate triumph in the painting of Picasso and Matisse. Notice that this idea of modern art stopped short of abstraction, virtually omitting Kandinsky, Mondrian, and the Suprematists.

This metaphor of modernism is a French, or Parisian, phenomenon (to which van Gogh and Picasso gained honorary admission) and is dominated by ambitious figure-painters with roots in an equally modern reappraisal of old master painting. Whereas the pre-modern view of old master painting had been a complex system of artists grouped in

Americans: Horace Havemeyer, Bertha Potter Palmer, Albert Barnes, Arthur Jerome Eddy, John Quinn, Leo and Gertrude Stein, Martin Ryerson, Frederick K. Bartlett, Katherine Dreier, Duncan Phillips, Galatin, Ilya Arensberg
British: Samuel Courtauld, Gwendoline and Margaret Davies, Sir William Burrell, Sir Hugh Lane
Czechs: Vincenc Kramar
Danes: Alfred Brandes

Dutch: Helene Kroeller-Mueller
French: Jean-Baptiste Faure, Henri Rouart, Victor Chocquet, Ernest Hoschedé, André Fontainas, August Pellerin, Jacques Doucet, Raoul la Roche
Germans: Karl Osthaus, Gerstein
Russians: Pavel Tretyakov, Ivan Morosov, Sergei Shchukin
Swiss: Joseph Mueller, Oscar Reinhardt, Buehrle

national and regional schools to which they variously contributed, the new old-master art, as rewritten by critics like Meier-Graefe and embodied in collections like those of Duncan Phillips, Albert Barnes, and Oscar Reinhardt, consisted of a handful of individual geniuses who stood outside the dominating trends of their times and made, therefore, timeless and fundamentally personal contributions to the history of art. It was this modernism that created the nineteenth- and twentieth-century reputations of Masaccio, Velázquez, El Greco, Rembrandt, Vermeer, Hals, Watteau, Hogarth, and Goya, all of whom are perceived as brilliant eccentrics with the talent and the determination to buck the restrictive aesthetic forces embodied in the scientifically arranged collections of the nineteenth-century art museum.

It is not accidental that modernism, being a product of the museum age, seems to have become the first period in the history of Western art that annexed the museum idea to its own project of definition and promotion. One can scarcely imagine the friends and patrons of, say, Rembrandt or Boucher or Goya getting together to start a museum that would present their work, and its conscious antecedents, in a seemingly independent way to what we call the general public. But that is exactly what Tretyakov, Shchukin, Lane, Barnes, Phillips, Courtauld, Bartlett, Kroeller-Mueller, Osthaus, Dreier, and the small group of people who started MOMA succeeded in doing. These men and women perceived themselves as the selfless and generous proponents of neglected geniuses whose work deserved to be given the highest possible respect. In order to give it that respect, the art museum, with its ideas of political power or personal memorial, stretched itself to include the promotion of the taste and ideas of men and women with the means and the leisure to make the best judgements about contemporary works of art. All this is not to say that the public has not benefited enormously from this enterprise. Rather, it is to point out the fundamentally private, and hence limited, nature of the vision put forward by these worthy figures.

139 Kasimir Malevich

Girls in a Field, 1928–30, oil on canvas

Malevich's career is usually interpreted as a long free-fall from the dizzying heights of inventiveness he achieved in the years just before and after the Bolshevik Revolution. In many ways, however, his desire to mould his art to the service of the society in which he lived was both sincere and important, as this later work makes clear. The purely non-representational anti-imagery of the 1910s gave way to a new form of monumental human-ism in which the body itself carries revolutionary messages and proletarian athletes become the heroes and heroines of modern life.

140 Walker Evans

Brooklyn Bridge, New York, 1929, gelatin-silver print

Evans was America's greatest 'direct' photographer. This beautifully composed repre-sentation of the architectural icon of New York's modernism takes a form that had been painted, photographed, and printed literally hundreds of thousands of times and re-presents it with a new inevitability and clarity. For Evans, as for Atget, the photo-grapher was a silent witness who rendered sense and order from the very same chaotic world in which we are all immersed.

Yet, before either deifying or crucifying these very individual institutions, we must recognize that they were not the first public places for the display of modern art. In fact, there were almost countless places, official and unofficial, where interested members of the urban public could see and, hence, judge modern art. Perhaps the most important of these institutions was the one experienced by the most people, the Musée de Luxembourg in Paris. Created in the second decade of the nineteenth century as a state collection of the work of living artists, it became well organized after the Revolution of 1848 and opened its doors to the work of living artists, mostly French, whose work was thought important enough for long-term public display. It was the comparative neglect of the most progressive trends in modernism that made this museum seem increasingly irrelevant as the powerful global collectors of modern art came to form their own galleries and museums. Many were in the homes of the patrons themselves. The Russians took the initiative with the creation of private museums financed by merchant princes as early as 1872, culminating in the 1909 opening to the public of Shchukin's great collection in the Trubetskoy Palace [**139**].

Even MOMA itself opened first in galleries on the twelfth floor of a private office building, before moving to the Rockefeller town house, and finally to its own building constructed on the site of the latter. Its creation resulted from no public hearings, no government commissions, no debates about the efficacy or morality of this kind versus that kind of art, no public involvement at all (although the lawyers for the Museum made sure that private contributions to it would be deductible from that horrible new phenomenon, income tax). Indeed, its organization was more like a private club with public days than it was like any truly public (governmentally run) museum. Yet, because MOMA followed the British/American civic model in that it was formed by a group of people, none of whose names appear in that of the institution, and because it hired a Harvard-trained intellectual as a director, it took on the semblance of institutional balance lacking in other more personal projects, such as those of Barnes, Phillips, and Osthaus.

For that reason, MOMA took the world by storm. It embraced architecture, industrial arts, furniture, graphic design, and photography in addition to the fine arts of painting, sculpture, and the graphic arts preferred by the other private museums of modern art [**140**]. Its geographical reach was completely global, and its curators and advisers felt as comfortable in Berlin, Mexico City, or Moscow as they did in Paris or London. Within two years of its founding one of its first trustees, Lilly Bliss, died, leaving MOMA a collection of works by Cézanne, Gauguin, Picasso, Matisse, and other canonical artists that it could scarcely then afford to buy. Its first decade was at once triumphant and full of discord, and the exhibitions and

publications it generated have become fodder for the art historical mill to this day. Alfred Barr's famous genealogical diagram of the history of abstraction, designed in 1936 as a sort of aide-memoire for a neo-phyte public, has been reproduced countless times in recent years and roundly criticized for its narrowness, male-centrism, and anti-contextualism.

Even now, in its full mid-life crisis, MOMA is forcing all of us to ask questions about the very nature of modern. Its 'modern' still begins in the 1880s with the Post-Impressionist masters, Cézanne, Gauguin, Seurat, and van Gogh. It has its spine in Parisian easel painting, but feels comfortable with Russia, Germany, Italy, the Netherlands, and the United States. Its early forays into Latin American painting have not continued apace, and its holdings of Romanian, Czech, Hungarian, Polish, and Scandinavian modern art are tiny and mostly in storage. The collections of photography, industrial design, graphic design, and applied arts are also shown with a few select examples in residual galleries, allowing the 'great' paintings so defined by a generation of collectors and scholars to be canonically modern.

In Paris, the situation is even stranger, with two immense institutions, one devoted to the second half of the nineteenth century and the other to the twentieth century, dominating the Parisian representation of the modern art to which the city was a manipulative muse. The best part of both institutions is that they fear nothing: all the arts and industries are included in a way that would have made the originators of the Crystal Palace exhibition proud. This generous modernism allows academic art into the fold, because it too was created for the modern city and in ways that are fundamentally different than academic paintings of the seventeenth and eighteenth centuries. Many foreigners are a little uncomfortable with this decision, largely because our very idea of modern art has been determined more by MOMA than it has by the more recent Parisian institutions, the Musée d'Orsay and Centre Pompidou. New modern museums have cropped up all over the globe, with France, Germany, Japan, and the United States leading the way, but with important contributions by other countries.

It goes without saying that the modern art both protected and represented by these museums is not the same modern art. The geographical and temporary ranges of each institution have their own character. Yet the general public who visits these museums know that modern art is global, urban, and cosmopolitan, and that, from the very beginning in the mid-nineteenth century, it has forayed into areas of human production not limited by the concept of fine art. That one of modern art's principal tasks has been representational has never been denied, even in the presence of abstraction, and its fundamental attachment to a shared global culture is still accepted. Its regionalisms are still debated; there are particular brands of Czech modernism or

American regionalism. But all these institutions make it clear that modern art is unified in its acceptance of both geographical and aesthetic variety.

The list of exhibitions of modern art created by MOMA in its first decade is a sort of prescription for the concept of modern art that survives to this day. Many of the principal characteristics of postmodernism, anti-modernism, and neo-modernism can be identified in modernism itself. The study of modern art in the year after 1929 is a study of the interplay between institutions, commercial galleries, critics, collectors, and artists, an interplay in which the first of these players has a starring role for the first time in the history of modernism. For that reason, the history of modern art after 1929 needs to be written differently. The two principal strands of modernism, unmediated modernism and image/modernism, persist, as do many of the iconological preoccupations defined in this volume. A good many of the preoccupations of modernism after 1929 are nationalist rather than cosmopolitan and international as they were before. Mary Cassatt, John Singer Sargent, or Patrick Henry Bruce, despite their American names, were uninterested in making American art, as were thousands of other cosmopolitan modernists of the first three generations of Euro-global modernism. Yet critics and commentators of modernism in the years following the great depression and the Second World War tended to focus on the issue of national achievements and of the national characteristics of this or that type of modernism.

Too many scholars have followed their lead, forgetting the integrating principles of the capitalist city, its markets, and its systems of interchange, the conditions for an international modernism. Nationalism in modern art has often been used as a sales tool, as a way of making art palatable to people who conceive of themselves as Polish, Russian, French, or American. In looking both at the representational art produced in the modern world and at the values of the people who bought it, we can see that the commonalities are more important than the national or regional differences we are often at such pains to identify. It is precisely the openness, the interpenetrability, and the exchangeability of modern representations that make them modern, not their particular formal or iconological characteristics or even the values that underlie them. This brand of modernism applies as well to the human past, which has been, for all of us, made accessible through public museums, universities, and the publishing industry. We can find precedents for our actions, our thoughts, and our representations in the various human pasts opened to us through the institutions of our capitalist cities. These institutions are the accessible diagrams of a terrifyingly vast human realm in which we can play, which we define, and through which we become ourselves.

Notes

Introduction

1. The first English edition was entitled *Modern Art: Being a Contribution to a New System of Aesthetics* (London and New York, 1908). Julius Meier-Graefe was the son of a Jewish industrialist from Czechoslovakia (then part of the Austro-Hungarian Empire) and was the first major cosmopolitan scholar of modernist art.

2. For a modern reprint of the first complete English translation (by Willa Silverman) of Signac's *d'Eugène Delacroix au Neo-Impressionisme*, see Floyd Ratliff's *Paul Signac and Color in Neo-Impressionism* (New York, 1992), 193–287. Because of its origins in France, Signac's important text became canonical in the formation of modern aesthetics before the more complex and subtle book of Meier-Graefe.

3. There are numerous studies of the Crystal Palace. While most of them are primarily concerned with Paxton's buildings, Patrick Beaver deals with the display itself and with the numerous texts (primarily English) that form a verbal critique of its nature. See Patrick Beaver, *The Crystal Palace (1851–1936): A Portrait of Victorian Enterprise* (London, 1970). Art historians have neglected the Crystal Palace exhibition largely because it neglected 'art', concentrating on the applied arts and sculpture. However, it set a pattern for subsequent exhibitions in Paris, Philadelphia, Vienna, Chicago, and numerous other cities in which art played a large role.

4. See John Gage, *Colour and Culture: Practice and Meaning from Antiquity to Abstraction* (London, 1993), 295, fig. 177, n. 51.

5. See the Tate Gallery, *The Pre-Raphaelites* (London, 1984), 90–2. The entry was written by Malcolm Warner.

6. The most accessible English edition of this and other texts by Baudelaire is *The Painter of Modern Life, and Other Essays* (London, 1964).

Part I: Realism to Surrealism

1. Seemingly unread today, Renato Poggioli's *The Theory of the Avant-Garde* (New York, 1971) was written for literary historians, but is, in fact, an indispensable structural analysis of the phenomenon of avant-garde.

2. Among the most valuable rehearsals of modernist theory is Johanna Drucker's *Theorizing Modernity: Visual Art and The Critical Tradition* (New York, 1994). Drucker's work considers three 'modernist' tropes— its preoccupation with 'space', its sense of 'objectivity', and its courting of particular forms of subjectivity. Its brevity and lack of jargon make it an ideal introductory text on modernist art theory.

3. There is still no good integrated history of photography, painting, and print-making in the nineteenth and early twentieth centuries. The old chestnut is Aaron Scharf's mistitled *Art and Photography* (London, 1968), along with Van Deren Coke's *The Painter and the Photograph from Delacroix to Warhol* (Albuquerque, N. Mex., 1964). For a discussion of the aesthetic character of calotype as opposed to photography see Richard Brettell et al., *Paper and Light: The Calotype in France and Great Britain* (Boston, 1984).

4. The bibliography on Realism is vast, but there is one general book that is a must for every beginner. Linda Nochlin's *Realism* (London and New York, 1971) is a book of almost unmatched intellectual generosity. Rather than focus on canonical figures and on the defining moments of the movement in France, Nochlin cuts a wide swath, including in her survey photography and academic painting as well as the work of major figures in England, Germany, Spain, and the United States. Her weakness is Russia and eastern Europe, and the date of publication explains why.

5. Oddly, there is no good general book on French Impressionism, although several

scholars and critics are writing at present. Phoebe Poole's intelligent survey, *Impressionism* (Oxford, 1967), is at once dated and dull, and one feels more comfortable with the big book by Maria and Godfrey Blunden, *Impressionists and Impressionism* (Geneva, 1976). A well-intentioned and largely accurate two-volume survey edited by Inco F. Walther and published in 1993 deals with both French and International Impressionism. Its English edition is *Impressionist Art, 1860–1920*, vol. I, *Impressionism in France* (New York, 1993) by Peter H. Feist, and vol. II, *Impressionism in Europe and North America* (New York, 1993), prepared by a host of German scholars. Another impressive global study of the movement is Nora Broude (ed.), *World Impressionism: The International Movement, 1860–1920* (New York, 1990), although this is hampered by the fact that this supposedly international movement is treated separately by nation!

6. The best recent publication that deals with this narrow definition is Charles Moffett et al., *The New Painting: Impressionism, 1874–1886* (San Francisco, 1986). A two-volume edition of the complete criticism collected for the eight Impressionist exhibitions has recently been published. The casual reader should be warned that, although the introductory material and the scholarly apparatus are in English, the texts themselves are printed in the original French. This can be found (inconveniently) under an almost identical title, *The New Painting: Impressionism 1874–1886, Documentation* (San Francisco and Seattle, 1996).

7. The best recent presentation of the Euro-global and multi-media aspects of Symbolism is an immense exhibition catalogue conceived and edited by Jean Clair, *Lost Paradise: Symbolist Europe* (Montreal, 1995). Interestingly, the American contribution to Symbolism is dealt with in both the catalogue and the exhibition, but not in the title.

8. See Jacqueline V. Falkenheim, *Roger Fry and the Beginnings of Formalist Art Criticism* (Ann Arbor, Mich., 1980).

9. See Griselda Pollock, *Avant-Garde Gambits, 1888–1893, Gender and the Colour of Art History* (New York and London, 1993).

10. The best and most sweepingly conceived monograph on Seurat is Michael Zimmerman's *Georges Seurat and the Art Theory of his Time* (Antwerp, 1991). For the movement at large, see Jean Sutter (ed.), *The Neo-Impressionists* (Greenwich, NY, 1970).

11. The Gauguin literature is vast and is best summarized in Richard Brettell et al., *The Art of Paul Gauguin* (New York, 1987). There are many discussions of the 'School of Pont-Aven', and most of these stress its multi-national and multi-generational aspects. The most accessible is Henri Dorra's 'Gauguin's Unsympathetic Observers', *Gazette des Beaux Arts* 6/76 (December 1970), 357–72.

12. The best-illustrated and most evocative recent study of the Nabis is Claire Freches-Thory and Antoine Terrasse's *The Nabis: Bonnard, Vuillard, and their Circle* (New York, 1990).

13. The classic book in English on the Fauve movement is, not surprisingly, an exhibition catalogue produced for the Museum of Modern Art in 1976. This has been reprinted as *The 'Wild Beasts': Fauvism and Its Affinities* (Oxford, 1987) by John Elderfield. A more recent and more critically sophisticated treatment of the subject is Jody Freeman et al., *The Fauve Landscape* (New York, 1989).

14. The international spread of Fauve painting has been as little studied as has that of Cubism. Perhaps because of the Fauve painters' attachment to traditional subjects of representation, their modes of painting appealed strongly to provincial artists who were unfamiliar with the pictorial theories being developed around Parisian modernism in the years around 1910.

15. The most durable survey of Expressionist painting is Peter Selz's *German Expressionist Painting* (Berkeley, Calif., 1957). Another useful general book is R. Samuel and R. H. Thomas, *Expressionism in German Life, Literature, and the Theater (1910–24)* (Cambridge, 1924). A more recent survey is Barry Herbert's *German Expressionism: Die Bruecke und die Balue Reiter* (London, 1983). A more critically sophisticated book is Joan Weinstein's *The End of Expressionism: Art and The November Revolution in Germany, 1918–1919* (Chicago, 1990).

16. See Douglas Cooper and Gary Tinterow, *The Essential Cubism: Braque, Picasso, and Their Friends* (New York and London, 1984). For a brilliantly concise and non-judgemental study of the aesthetic dance between the two protagonists, see William Rubin, *Picasso and Braque: Pioneering Cubism* (New York, 1989).

17. See Anne Coffin Hanson's *The Futurist Imagination, Word + Image* (New Haven, 1983).

18. The most accessible sources in English are S. A. Buckberrough, *Robert Delaunay: The Discovery of Simultaneity* (Ann Arbor, Mich., 1982) and A. A. Cohen's edition, *The New*

Art of Color: The Writings of Robert and Sonia Delaunay (New York, 1978).

19. See Richard Cork, *Vorticism and Abstract Art in the First Machine Age* (London, 1976), 2 vols.

20. The literature on Constructivism is beginning to emerge from a period in which its sheer isolation from other vanguard movements was exaggerated. See C. Lodder, *Russian Constructivism* (New Haven and London, 1983) and *The Great Utopia* (New York, 1993).

21. The term Neo-Plasticism was developed by Mondrian in 1920 as a way out of the constrictions of De Stijl: it is best expressed in his own writings, *Plastic Art and Pure Plastic Art* (New York, 1937) and *Other Essays* (New York, 1941–3). Also see *The Collected Writings of Mondrian* (London, 1987).

22. The classic description of Dada can be found in William Rubin's exhibition catalogue, *Dada, Surrealism, and their Heritage* (New York, 1968). More recent work on the movement by D. Ades and Francis Nauman have deepened our understanding of Dada and made clear the connections between it and other vanguard movements, particularly in literature and performance. A major study of performance art (and of the strand of anti-object-image making connected with verbal discourse) throughout the history of modern art remains to be written. From the absurdist cafés of 1880s Paris through Fluxus and the California performance cults, there is a strand of 'engaged' art that is precisely disengaged from the art world.

23. Perhaps because of its apparent conservatism, the movement of Purism has also failed to attract much contemporary attention, and there is no book about the movement written in this generation. It emerged from a manifesto written by Amédée Ozenfant and Charles-Edouard Jeanneret (Le Corbusier) published in 1924 and called 'La Peinture Moderne'. Readers should consult the writings of both men, both of which have been published in translation.

24. See André Breton, *What is Surrealism?: Selected Writings* (New York, 1978); H. N. Finkelstein, *Surrealism and the Crisis of the Object* (Ann Arbor, 1979); J. H. Matthews, *The Surrealist Mind* (London and Toronto, 1991); F. Rosemont, *André Breton and the First Principles of Surrealism* (London, 1978); and William Rubin's *Dada and Surrealist Art* (London, 1968).

25. Not surprisingly, the history of photography is written either as a sweeping whole from its origins in the 1830s to the present or as two separate histories—one nineteenth-century and originary and the second twentieth-century and vanguard. With the exception of the writings of Aaron Scharf, Peter Galassi, Kirk Varnedoe, and a handful of other scholars, photography is completely omitted from the history of modern art particularly as it was written as a history of movements. In fact, photography played a considerable role in Impressionism, Nabis, Symbolism, Cubism, Dada, and Surrealism, moving hand-in-hand with painting and the graphic arts.

26. The most accessible study of Alfred Stieglitz and his role as a promoter of vanguard European and American art is William Innes Homer's *Alfred Stieglitz and the American Avant-Garde* (Boston, 1977). A definitive analysis of Stieglitz as a collector-dealer will have to await a planned exhibition of the Stieglitz Collection by the Metropolitan Museum, The Philadelphia Museum, and The Art Institute of Chicago in 2000.

Part II: The Conditions for Modern Art
Chapter 1. Urban Capitalism

1. There are many studies of Parisian urban development in the nineteenth century. The classic book is David Pinkney's *Napoleon III and The Reconstruction of Paris* (Princeton, 1972). Readers should also consult the extensive bibliography in Robert L. Herbert's *Impressionism, Art, Leisure, and Parisian Society* (New Haven and London, 1988).

2. See John Caldwell, *Theory of Fertility Decline* (New York, 1982).

3. See Walter Benjamin, 'Paris—The Capital of the Nineteenth Century', *New Left Review* 48 (March–April 1968), 77–88.

4. See Maxime du Camp, *Paris, ses Organes et ses Fonctions* (Paris, 1869–75), 6 vols.

5. See Molly Nesbit's weirdly written yet evocative, *Atget's Seven Albums* (New Haven and London, 1992).

6. For an early recognition of 'Haussmannization', see Henri Clouzot's essay 'L'Haussmannization de Paris', *Gazette des Beaux Arts* 4/4 (1910), 348–66. No one is better on the 'ringstrasse' mentality than Carl Schorske in *Fin-de-Siècle Vienna: Politics and Culture* (New York, 1979). My favourite, widely accessible book that deals with Euro-American urbanism in clear jargon-free terms is F. Roy Willis, *Western Civilization, An Urban Perspective: Vol. III From 1815 to the*

Contemporary Age (New York, 1973).

7. This point is clearly made in Pierre Bourdieu's great book, *Distinction: A Social Critique of the Judgement of Taste* (Cambridge, Mass., 1984). However, Bourdieu is not particularly revealing in his remarks about works of art, largely because, for him, they are nothing but parts of a class-driven system of cultural signs.

8. John Rewald's contribution to modernist studies, though much discredited today, is of great historical importance. The various editions of his histories of Impressionism and Post-Impressionism, initially published by the Museum of Modern Art, have defined modernist studies.

9. 'Reception Art History' of modern art is so much *the* social history of modern art that one can scarcely summarize it in a note. The essential writer is T. J. Clark, whose precise and nuanced reading of contemporary texts as evidence of meaning has given rise to the work of numerous followers including Martha Ward, Hollis Clayson, and others.

10. Arnold Hauser, 'Impressionism' and 'The Film Age' in *The Social History of Art* (London, 1951), 869–979. To me, Hauser's essay on Impressionism is unsurpassed.

11. See B. W. Kean's chatty but essential *All The Empty Palaces: The Merchant Patrons of Modern Art in Pre-Revolutionary Russia* (New York, 1983), 241–3.

Chapter 2. Modernity, Representation, and the Accessible Image

1. André Malraux's conception of the image world is little remembered today, but it deserves reconsideration. Malraux was actually the first museum director who understood the pressures against museums from reproductions and who attempted to understand and, therefore, control them. See André Malraux, *The Voices of Silence* (New York, 1953) (inexplicably, the translation of *Le Musée Imaginaire de la Sculpture Mondiale* (Paris, 1952)). Wonderfully enough, Malraux called the history of art 'The History of What can be Photographed', *Voices of Silence* (New York, 1953), 645.

2. See Andrew McClellan, *Inventing the Louvre: Art, Politics, and The Origins of the Modern Museum in Eighteenth-Century Paris* (Cambridge and New York, 1994). The most accessible general studies of the art museum are Germain Bazin's *The Museum Age* (New York, 1967) (of which only three chapters are devoted to the modern museum and in which

there is no bibliography), and Nathanial Burt's *Palaces for the People: A Social History of The American Art Museum* (Boston, 1977).

3. This tendency is discussed in two exemplary recent books, Christopher Green's *Cubism and its Enemies: Movements and Reactions in French Art, 1916–1918* (New Haven and London, 1987) and, more aptly, Romy Golan's *Modernity and Nostalgia: Art and Politics in France between the Wars* (New Haven and London, 1995).

4. For an intelligent study limited to two international expositions in France, see Patricia Mainardi's *Art and Politics of the Second Empire: The Universal Expositions of 1855 and 1867* (New Haven, 1987). Perhaps the most magisterial achievement in publishing with regard to modern exhibitions is *Modern Art in Paris, 1855–1900: Two Hundred Catalogues of Major Exhibitions, Reproduced in Facsimile in Forty-Seven Volumes* (New York and London, 1981), selected and organized by Theodore Reff. With a similar project for London, Vienna, Munich, Berlin, and St Petersburg, and with an extension well into the twentieth century, the quality of art historical research would increase dramatically.

5. See Fernand Léger, 'The Street, Objects, Spectacles', *Functions of Painting* (London and New York, 1973), 78–80, translated by E. F. Fry.

6. See Domenico Porzio (ed.), *Lithography: 200 Years of History and Technique* (New York, 1984); Wilhelm Weber, *A History of Lithography* (London, 1966); and Michael Twyman, *Lithography 1800–1850* (Oxford, 1970).

7. Perhaps the best modern study of this phenomenon is Peter Marzio's *A Democratic Art: An Exhibition on the History of Chromolithography in America* (Fort Worth, Tex., 1979).

8. The tide is changing, but mostly in the study of the relationship between photography and painting. With major studies devoted to Gauguin, Mucha, Picasso, Bonnard, and Vuillard, we know a good deal more about the complex uses to which artists put photographs (or memories of photographs). An analogous study of pre-photographic reproductions remains to be written.

9. See Phillip Dennis Cate, *The Color Revolutions: Color Lithography in France, 1890–1900* (Santa Barbara, Calif., 1978).

10. See Estelle Jussim's ground-breaking book, *Visual Communications and the Graphic Arts: Photographic Technologies in the 19th Century* (New York, 1983) and, for the United

States, Michael L. Carlebach's *The Origins of Photojournalism in America* (Washington, 1992).

Part III: The Artist's Response
Chapter 3. Representation, Vision, and 'Reality': the Art of Seeing

1. See Doris Shadbolt, *The Art of Emily Carr* (Seattle, Wash., 1979), 36. The lecture was given to the Victoria Women's Canadian Club and under the title *Fresh Seeing* was published in book form (with another lecture) in Toronto, 1972.

2. See Jonathan Fineberg, *The Innocent Eye: Children's Art and The Modern Artist* (Princeton, 1997).

3. This most theoretically interesting notion occurs only in Frederic Henriet's memoirs of 1891, *Les campagnes d'un paysagiste* (Paris, 1891), 69ff.

4. See Michael Fried, *Absorption and Theatricality: Painting and Beholder in the Age of Diderot* (Berkeley, Calif., 1980). This is without doubt the most stimulating and useful of Fried's many brilliant essays and books, and its concepts have held considerable sway over students of modernism, many of whom have been all but obsessed with the 'beholder' and the 'gaze' for the past decade.

5. These notions are summarized in English in Richard Brettell's 'Pissarro in Louveciennes: An Inscription and Three Paintings', *Apollo* (November 1992), 315–19.

6. See Charles Cros' fragmentary essay (his lover reputedly burned the original, and it is only known from manuscript fragments) 'La Mécanique Cérébrale', *Oeuvre Complete* (Paris, 1970), which to my knowledge has never been translated, and Jules Laforgue's well-translated, 'Impressionism' in Linda Nochlin's *Sources and Documents in The History of Art: Impressionism and Post Impressionism, 1874–1904* (Englewood Cliffs, NJ, 1966), 14–21.

7. Ibid. p. 18.

8. See Linda Dalrymple Henderson, *The Fourth Dimension and non-Euclidean Geometry in Modern Art* (Princeton, 1983). Also, much of the literature related to Neo-Impressionism as well as to the connections between Cubists and such thinkers as Poincaré and Bergson makes similar points.

9. Many have talked about doing the obvious book and/or exhibition that links these seemingly disparate artists (most of whom knew each other), but it has not yet happened.

10. See Peter Henry Emerson's *Naturalistic Photography for Students of Art* and *The Death of Naturalistic Photography* (New York, 1973; repr.

from the 1891 edn). No one seriously interested in modern art can neglect this text.

11. See Robert L. Herbert, 'Method and Meaning in Monet', *Art in America* 67/5 (September 1979), 90–108, and John House, *Claude Monet: Nature into Art* (New Haven and London, 1986).

12. For the most accessible discussion of this famous picture, see Claire Freche-Tory and Antoine Terrasse, *The Nabis: Bonnard, Vuillard, and Their Circle* (New York, 1991), 12–13. 'What colour do you see the tree?' Gauguin reputedly asked Sérusier. 'Is it green? Then use green, the finest green on your palette. And the shadow? It's blue, if anything? Don't be afraid to paint it as blue as you possibly can'.

13. The most accessible summary with quotations of Allard's criticism in English can be found in Lynn Gamwell's *Cubist Criticism* (Ann Arbor, Mich., 1981). The following will do: 'To react with violence against instantaneous notation, insidious anecdote, and all the substitutes for impressionism …' (p. 28).

14. Richard Shiff's *Cézanne and the End of Impressionism* (Chicago, 1984), derives from a brilliant essay that Shiff had published earlier for the Metropolitan Museum. In all his work, Shiff recognizes the roots of most modernist representational strategies in Impressionism. He is, among contemporary theorists of modernism, almost unique in this recognition.

Chapter 4. Image/Modernism and the Graphic Traffic

1. Information about these borrowings is scattered through the vast Gauguin bibliography, which is summarized in Richard Brettell et al., *The Art of Paul Gauguin* (New York, 1988).

2. I am reminded of a maxim currently fashionable among university students: 'To steal ideas from one source is plagiarism, while to steal from many is research'.

3. See *Camille Pissarro, Letters to his Son Lucien* (New York, 1972, 3rd edn), 164–5, edited and translated by John Rewald with assistance from Lucien Pissarro.

4. The most exciting discussion of this phenomenon is William Ivins', *Prints and Visual Communications* (Cambridge, Mass., 1953). See also Beatrice Farwell's *French Popular Lithographic Imagery, 1815–1870* (Chicago, 1981–97), 12 vols.

5. For an exemplary discussion of Cézanne's plundering of the Louvre, see Theodore Reff and Innis Howe Shoemaker, *Paul Cézanne: Two Sketchbooks* (Philadelphia, 1989).

6. Manchester Exhibition of 1857

7. See Gaston Diehl, *Henri Matisse* (Paris, 1925), 11.

Part IV: Iconology
Introduction

1. The scholarship that unpacked the early abstractions of Kandinsky has been particularly interesting in this regard. See Rose-Carol Washton Long's *Kandinsky, The Development of an Abstract Style* (Oxford and New York, 1980).

2. This research is summarized and, in part, synthesized in Christine Poggi's *In Defiance of Painting: Cubism, Futurism, and The Invention of Collage* (New Haven and London, 1992). For Schwitters, see Dorothea Dietrich's dutiful book, *The Collages of Kurt Schwitters: Tradition and Innovation* (Cambridge and New York, 1993). An alternative and deeply contextual view of these same works can be found in Annegreth Nill's 'Rethinking Kurt Schwitters, Part One: An Interpretation of "Hansi" ' and 'Rethinking Kurt Schwitters, Part Two: An Interpretation of "Grunfleck" ' *Arts Magazine* 55/5 (January 1981), 112–25.

Chapter 5. Sexuality and the Body

1. This bibliography would itself be as long as the present book. Here are some relatively accessible sources for the beginner: Linda Nead, *The Female Nude: Art, Obscenity, and Sexuality* (London, 1992); Kathleen Adler and Marcia Pointon (eds), *The Body Imaged: The Human Form and Visual Culture Since the Renaissance* (Cambridge and New York, 1993); *The Female Body in Western Culture: Contemporary Perspectives* (Cambridge, Mass., 1986). There is also an oddly excellent book with an even odder title, Bram Dijkstra's *Idols of Perversity: Fantasies of Feminine Evil in Fin-de-Siecle Culture* (Oxford, 1986).

2. Few individual paintings in the history of art have a bibliography that can match in quantity that devoted to Manet's *Déjeuner sur l'herbe* and its successor, *Olympia*. Most of these have been summarized in Françoise Cachin's concise and well-conceived catalogue entries in the great Paris/New York Manet catalogue of 1984, *Manet, 1832–1883* (New York, 1983), 165–91. The most influential and debated recent discussion of the paintings can be found in T. J. Clark's *The Painting of Modern Life: Paris in the Art of Manet and his Followers* (New York, 1985).

3. This phrase can be found in Champa's brilliant review of the Chicago Bazille exhibition,

4. The most intelligent and accessible book on Manet's *Olympia* is Theodore Reff's *Manet, Olympia: Art In Context* (New York, 1976).

5. The most easily accessible treatment of Manet's religious paintings can be found in Michael Driskel's *Representing Belief, Religion, Art, and Society in Nineteenth Century France* (University Park, Pa., 1992), 188–93.

6. See Peter Brooks, *Body Work: Objects of Desire in Modern Narrative* (Cambridge, Mass., 1993); Abigail Solomon-Godeau, 'Going Native' *Art in America* (July 1989); Hollis Clayson, *Painted Love: Prostitution in French Art of the Impressionist Era* (New Haven, 1991); Eunice Lipton, *Alias Olympia: A Woman's Search for Manet's Notorious Model and Her own Desire* (New York, 1992); and James H. Rubin, *Manet's Silence and the Poetics of Bouquets* (Cambridge, Mass., 1994).

7. See Alexandre Dumas fils, *Theatre complet* (Paris, 1870–99), 8 vols.

8. See Theodor Siegl's *The Thomas Eakins Collection* (Philadelphia, 1978), 88–90.

9. See Reinholdt Heller's *Munch: His Life and Work* (Chicago, 1984).

10. Linda Nochlin has been the most persistent student of bathing and its modernist iconographies, but has yet to publish her work in any complete way. For Eakins, the recent publication entitled *Thomas Eakins and The Swimming Picture* (Fort Worth, Tex., 1996), summarizes the literature and includes discussion of male bathers in European art.

11. See Mary Louise Krumrine, *Paul Cézanne: The Bathers* (New York, 1990).

12. The most virulent critics of Gauguin as both a sexist and colonialist are Abigail Solomon-Godeau and Griselda Pollock in *Avant-Garde Gambits, 1888–1893: Gender and the Colour of Art History* (New York and London, 1993).

Chapter 6. Social Class and Class Consciousness

1. The social readings of the Grande Jatte by Clark are summarized and discussed in Robert L. Herbert's thoughtful essay on the painting in *Georges Seurat, 1859–1891* (New York, 1991), 170–9; see particularly 179, n. 16.

2. This view, put forward by John House in 'Reading the Grande Jatte', *Museum Studies* 14/2 (Chicago, 1989), 115–31, is disputed by Robert Herbert in the essay cited above. Herbert's view is that the paintings don't actually function visually as pendants and that such a view is forced. However, there is much evidence to suggest that the second painting

was begun as the pendant of the first and then assumed a life quite independent of it.

3. These identifications have been made most strongly by Richard Thomson both in his amusing public lectures and in his excellent monograph *Seurat* (Oxford, 1985).

4. Perhaps because his life was largely spent painting, Renoir's biography has yet to be written. His famous son, Jean Renoir, tried (*Renoir: My Father* (London, 1962)), but he was born too late to be of much use in the early or formative part of the artist's life. Barbara Ehrlich White's *Renoir: His Life, Art, and Letters* (New York, 1984), is the best modern source. Colin Bailey, in his highly detailed new study *Renoir Portraits: Impressions of an Age* (New Haven, 1997) is very subtle in his discussion of class issues. For Bastien-Lepage the reader needs a very good library. Perhaps the best early biographies in English are André Theuriet's *Jules Bastien-Lepage and his Art* (London, 1892) and Julia Cartwright's *Jules Bastien-Lepage* (London, 1894).

5. The best of these are Beth Archer Brombert, *Edouard Manet: Rebel in a Frock Coat* (Boston, 1996); David Sweetman, *Paul Gauguin: A Complete Life* (London, 1995); and Julia Bloch Frey, *Toulouse-Lautrec: A Life* (London, 1994). These, together with the competing biographies of Picasso and Georgia O'Keeffe, are all that modern art has contributed to modern biography.

6. And, when they were not, as in the case of Sargent's infamous *Madame X* or Renoir's *Riding in the Bois de Boulogne*, they appeared to be.

7. The exemplary book in this arena is Elizabeth Ann McCauley's *A. A. E. Disderi and the Carte de Visite Portrait Photograph* (New Haven, 1985).

8. A thorough survey of representations of peasants in all media is Richard and Caroline Brettell's *Painters and Peasants in the 19th Century* (Geneva, 1983).

9. Again, this literature is largely confined to the study of French art and, more specifically, to the images of Manet and Degas. The literature for the latter is staggering in its size. The most accessible are Richard Kendall's and Griselda Pollock's collection of essays by British scholars (and Linda Nochlin and Hollis Clayson) entitled *Dealing with Degas: Representations of Women and The Politics of Vision* (New York, 1992). Also important is Carol Armstrong's *Odd Man Out: Reading of the Work and Reputation of Edgar Degas* (Chicago, 1991).

Chapter 7. Anti-Iconography: Art without 'Subject'

1. These connections can be found in several recent studies: Richard Brettell, Scott Schaefer, and Sylvie Patin, *A Day in The Country, Impressionism and The French Landscape* (Los Angeles, 1984); Paul Hayes Tucker, *Monet at Argenteuil* (New Haven, 1982); Robert L. Herbert, *Impressionism: Art, Leisure, and Parisian Society* (New Haven, 1988); and Charles S. Moffett et al., *Impressionists on the Seine* (Washington, DC, 1996).

2. See John Rewald, *Cézanne: A Catalogue Raisonné* (New York, 1997), and Richard R. Brettell, 'Cézanne/Pissarro, Élève/Élève', *Coloque Cézanne* (Paris, 1997).

3. Discussions of this tiny painting abound. Perhaps the most accessible to an anglophone is Claire Freches-Thory and Antoine Terrasse, *The Nabis: Bonnard, Vuillard, and their Circle* (New York, 1990), 12–13, where this translation of the Gauguin text is to be found.

4. For highly politically motivated reading of Fauve landscape subjects, see James D. Herbert, *Fauve Painting: The Making of Cultural Politics* (New Haven and London, 1992).

Chapter 8. Nationalism and Internationalism in Modern Art

1. Studies of Polish nineteenth-century painting are not widely accessible outside Poland, and the bibliography in English is very small. There is a brief discussion of Matejko's historical painting in Agnieszka Morawinska's *Symbolism in Polish Painting, 1890–1914* (Detroit, 1984), 16–20. One should also find T. Drobokowlski's *Polish Painting from the Enlightenment to Recent Times* (Warsaw-Cracow, 1981) as well as the English language publication, *The National Museum in Warsaw, Painting* (Warsaw, 1994).

2. One of the most powerful studies of nationalism as a modernist idea is Benedict Anderson's *Imagined Communities: Reflections on the Origins and Spread of Nationalism* (London, 1983). See also Ernest Gellner, *Nations and Nationalism* (Ithica, 1983).

3. The most persistent and informed student of Hodler's Swiss subject-matter is the American art historian Sharon L. Hirsch. Her most easily accessible study is her monograph, *Ferdinand Hodler* (New York, 1982). Mucha's career has been well served by his son Jiri Mucha, who has a well-documented chapter on the Slav Epic in *Alphonse Maris Mucha: His Life and Art* (New York, 1989), 240–67.

4. The single best and most accessible intro-duction to these ideas is Maurice Tuchman et al., *The Spiritual in Art: Abstract Painting, 1890–1925* (Los Angeles, 1987).

5. All these discussions can be found summarized in Tuchman et al., ibid., 165–84, 201–18, and 219–38.

6. Dow's teaching is summarized in Arthur Wesley Dow, *Composition: A Series of Exercises in Art Structure for the use of Students and Teachers* (New York, 1920; first edn, 1899).

7. See Charles S. Hill, *The Group of Seven: Art for a Nation* (Ottawa, 1995).

8. The most accessible English language study of Finnish painting and of the career of Akseli Gallen-Kallela is *Dreams of A Summer Night: Scandinavian Painting at the Turn of the Century* (London, 1986), 104–21.

Afterword: The Private Institutionalization of Modern Art

1. There is, to my knowledge, no single critical history of the Museum of Modern Art. There are, however, several insider studies that contain a wealth of information. These are Alice Goldfarb Marquis, *Alfred H. Barr Jr: Missionary for the Modern* (New York and Chicago, 1989); Russell Lynes, *Good Old Modern: An Intimate Portrait of the Museum of Modern Art* (New York, 1973); and Sam Hunter, et. al, *The Museum of Modern Art, New York: the History and the Collection* (New York, 1984). The latter focuses more on the collections than on the institutional history.

List of Illustrations

The Publisher would like to thank the following individuals and institutions who have kindly given permission to reproduce the illustrations listed below.

p. x Phillip Henry Delamotte: *Rebuilding the Crystal Palace at Sydenham*, 1853. Gernsheim Collection, Harry Ransom Humanitites Research Center, The University of Texas at Austin. Detail.

1. Phillip Henry Delamotte: *Upper Gallery of the Crystal Palace*, 1855. Albumen print mounted on card. 28.2 × 22.8 cm. Gernsheim Collection, Harry Ransom Humanities Research Center, The University of Texas at Austin.

2. William Holman Hunt: *Valentine Rescuing Sylvia from Proteus (Two Gentlemen of Verona)*, 1850–1. Oil on canvas. 98.5 × 133.3 cm. Birmingham Museums & Art Gallery.

3. Gustave Courbet: *The Studio of the Painter, A Real Allegory*, 1854–5. Oil on canvas. 361 × 598 cm. Musée d'Orsay, Paris/© Réunion des Musées Nationaux.

4. Thomas Eakins: *The Gross Clinic*, 1875. Oil on canvas. 243.8 × 198.1 cm. Jefferson Medical College of Thomas Jefferson University, Philadelphia, PA.

5. William Powell Frith: *The Railway Station*, 1862. Oil on canvas. 116.7 × 256.4 cm. Royal Holloway and Bedford New College, Surrey/photo Bridgeman Art Library, London.

6. Claude Monet: *The Luncheon: Monet's Garden at Argenteuil*, 1873–6. Oil on canvas. 162 × 203 cm. Musée d'Orsay, Paris/photo Bridgeman Art Library, London.

7. Pierre-Auguste Renoir: *Ball at the Moulin de la Galette*, 1876. Oil on canvas. 130.8 × 175.3 cm. Musée d'Orsay, Paris/photo Bridgeman Art Library, London.

8. Edgar Degas: *The Race Track: Amateur Jockeys near a Carriage*, 1876–87. Oil on canvas. 66 × 81 cm. Musée d'Orsay, Paris/© Réunion des Musées Nationaux/photo Gérard Blot.

9. Edgar Degas: *Place de la Concorde*, 1874–7. Oil on canvas. 79 × 118 cm. Hermitage Museum, St Petersburg/photo Novosti (London).

10. Oscar Gustave Rejlander: *The Two Ways of Life*, 1857. Composite photograph from 32 negatives. The Royal Photographic Society, Bath.

11. Sir Edward Coley Burne-Jones: *The Wheel of Fortune*, 1870. Oil on canvas. 200 × 100 cm. Musée d'Orsay, Paris/© Réunion des Musées Nationaux.

12. Jacek Malczewski: *Melancholia*, 1894. Oil on canvas. 139 × 240 cm. National Museum of Poland, Poznan.

13. Józef Mehoffer: *Strange Garden (Dziwny Ogród)*, 1903. Oil on canvas. 217 × 208 cm. National Museum of Poland, Warsaw.

14. Paul Cézanne: *The Mill on the Couleuvre at Pontoise*, 1881. Oil on canvas. 72.4 × 92.1 cm. National Gallery, Berlin/photo Bildarchiv Preussischer Kulturbesitz.

15. Vincent van Gogh: *The Night Café*, 1888. Oil on canvas. 72.4 × 92.1 cm. Yale University Art Gallery, New Haven, CT. Bequest of Stephen Carlton Clark, BA, 1903.

16. Odilon Redon: *Decorative Panel*, c.1902. Tempera and oil on canvas. 183.8 × 254 cm. Rijksmuseum Twenthe, Enschede.

17. Paul Signac: *Two Milliners (The Modistes)*, 1885–6. Oil on canvas. 116 × 89 cm. The Foundation E. G. Bührle Collection, Zurich. © ADAGP, Paris and DACS, London 1999.

18. Paul Gauguin: *Vision after the Sermon: Jacob Wrestling with the Angel*, 1888. Oil on canvas. 72 × 92 cm. National Gallery of Scotland, Edinburgh.

19. Édouard Vuillard: *Misia and Vallotton in the Dining Room*, 1899. Oil on cardboard. 70.5 × 50.8 cm. Collection William Kelly Simpson, New York. © ADAGP, Paris and DACS, London 1999.

20. Maurice Vlaminck: *Bougival*, c.1905. Oil on canvas. 82.6 × 100.6 cm. Dallas Museum of Art, The Wendy and Emery Reves Collection. © ADAGP, Paris and DACS, London 1999.

21. Henri Matisse: *The Red Studio, Issy-les-*

Moulineaux, 1911. Oil on canvas. 181 × 219.1 cm. The Museum of Modern Art, New York, Mrs Simon Guggenheim Fund/photo © 1999 The Museum of Modern Art, New York. © Succession H. Matisse/DACS 1999

22. Ernst Ludwig Kirchner: *Nude Woman Combing her Hair*, 1913. Oil on canvas. 125 × 90 cm. Brücke-Museum, Berlin. Courtesy Dr Wolfgang Henze.

23. Pablo Picasso: *Portrait of Ambroise Vollard*, 1909–10. Oil on canvas. 92 × 64.9 cm. Pushkin Museum, Moscow/photo Novosti (London). © Succession Picasso/DACS 1999.

24. Pablo Picasso: *The Bird Cage*, 1923. Oil on canvas. 201 × 140 cm. Private collection © Succession Picasso/DACS 1999.

25. Umberto Boccioni: *The City Rises*, 1910. Oil on canvas. 199.3 × 301 cm. The Museum of Modern Art, New York, Mrs Simon Guggenheim Fund/photo © 1999 The Museum of Modern Art, New York.

26. Robert Delaunay: *Circular Forms: Sun, Moon, Simultane I*, 1912–13. Oil on canvas. 65 × 100 cm. Stedelijk Museum, Amsterdam. Courtesy Jean-Louis Delaunay. © L & M Services BV Amsterdam 98095.

27. František Kupka: *Vertical Planes III*, 1912–13. Oil on canvas. 220 × 118 cm. The National Gallery (Collection of Modern and Contemporary Art), Prague. © ADAGP, Paris and DACS, London 1999.

28. David Bomberg: *The Mud Bath*, 1914. Oil on canvas. 152.4 × 224.2 cm. Tate Gallery, London.

29. Kasimir Malevich: *Suprematist Composition: Black Trapezium and Red Square*, after 1915. Oil on canvas. 101 × 61.9 cm. Stedelijk Museum, Amsterdam/photo Bridgeman Art Library, London.

30. Theo van Doesburg: *Pure Painting*, 1920. Oil on canvas. 135.8 × 86.5 cm. Musée Nationale d'Art Moderne, Centre Georges Pompidou, Paris. © DACS 1999

31. Piet Mondrian: *Composition with Large Blue Plane, Red, Black, Yellow and Gray*, 1921. Oil on canvas. 60.5 × 50 cm. Dallas Museum of Art, Foundation for the Arts Collection, Gift of Mrs James H. Clark. © Mondrian/Holtzman Trust, c/o Beeldrecht Amsterdam, Holland and DACS, London 1999.

32. Francis Picabia: *Universal Prostitution*, 1916–19. Ink, tempera, and metallic paint on cardboard. 74.5 × 94.2 cm. Yale University Art Gallery, New Haven, CT. Gift of Collection Société Anonyme. © DACS 1999.

33. Amédée Ozenfant: *The Jug*, 1926. Oil on canvas. 304.2 × 148.6 cm. Museum of Art, Rhode Island School of Design. Gift of Mrs Houghton P. Metcalf in memory of her husband, Houghton P. Metcalf/photo Erik Gould. © ADAGP, Paris and DACS, London 1999.

34. Salvador Dalí: *Little Cinders*, 1927. Oil on panel. 64 × 48 cm. Museo Nacional Centro de Arte Reina Sofia, Madrid. © Salvador Dali-Foundation Gaia-Salvador Dali/DACS 1999.

35. Fernand Léger: *The City*, 1919. Oil on canvas. 230.5 × 297.8 cm. Philadelphia Museum of Art. A. E. Gallatin Collection. © ADAGP, Paris and DACS, London 1999.

36. James Wallace Black: *Boston from the Air*, 1860. Albumen print. Courtesy of the Boston Public Library, Print Department.

37. Gustave Caillebotte: *Paris Street; Rainy Day*, 1876–7. Oil on canvas. 212.2 × 276.2 cm. Charles H. and Mary F. Worcester Collection, 1964.336/photo © 1997 The Art Institute of Chicago. All rights reserved.

38. Pierre Bonnard: *Morning in Paris*, 1911. Oil on canvas. 76 × 121 cm. State Hermitage Museum, St Petersburg/photo Scala, Florence. © ADAGP, Paris and DACS, London 1999.

39. Charles Marville: *Tearing Down the Avenue de l'Opéra*, c.1877. Albumen print. Musée Carnavalet, Paris/Photothèque des Musées de la Ville de Paris.

40. Joseph Stella: *New York Interpreted (The Voice of the City)*, 1920–2. Oil and tempera on canvas. Side panels, 223 × 137 cm; centre panel, 251 × 137 cm. The Newark Museum, Newark, NJ/photo Art Resource, New York.

41. Edward J. Steichen: *The Flatiron*, 1905. Brown pigment gum-bichromate over gelatin-silver print from 1904 negative. 49.9 × 38.9 cm. The Metropolitan Museum of Art, New York. Alfred Stieglitz Collection, 1933 (33.43.44).

42. Aristarkh Lentulof: *Moscow*, 1913. Oil and metal foil on canvas. 97 × 129 cm. Tretyakov Gallery, Moscow/photo Scala, Florence.

43. Charles Sheeler: *Church Street El*, 1920. Oil on canvas. 40.6 × 48.5 cm. © The Cleveland Museum of Art, 1998. Mr and Mrs William H. Marlatt Fund 1977.43.

44. Édouard Manet, *Portrait of Émile Zola*, 1868. Oil on canvas. 146.5 × 114 cm. Musée d'Orsay, © Paris. © Réunion des Musées Nationaux/ photo H. Lewandowski.

45. Eugène Delacroix: *The Triumph of Apollo*, 1850–1. Oil on canvas. 800 × 750 cm. Musée du Louvre, (Salle d'Apollon), Paris. © Réunion des Musées Nationaux.

46. Charles Nègre: *Chimney-sweeps Walking*, 1851. Salted paper print from a paper negative.

15.2 × 19.8 cm. National Gallery of Canada, Ottawa.

47. Andrew J. Russell: *Hanging Rock, Foot of Echo Canyon, Utah*, 1867–8. Albumen print from a collodion glass negative. The Yale Collection of Western Americana, Beinecke Rare Book and Manuscript Library, Yale University, New Haven, CT.

48. Édouard Manet: *The Balcony*, 1868–9. Oil on canvas. 170 × 125 cm. Musée d'Orsay, Paris. © Réunion des Musées Nationaux/photo H. Lewandowski.

49. Mary Cassatt: *Little Girl in a Blue Armchair*, 1878. Oil on canvas. 89.5 × 129.8 cm. Collection of Mr and Mrs Paul Mellon © 1998 Board of Trustees, National Gallery of Art, Washington, DC.

50. Henri de Toulouse-Lautrec: *At the Moulin Rouge: The Dance*, 1890. Oil on canvas. 115.6 × 149.8 cm. Philadelphia Museum of Art, Henry P. McIlhenny Collection in memory of Frances P. McIlhenny.

51. Paul Cézanne: *The Artist's Father*, 1866. Oil on canvas. 198.5 × 119.3 cm. Collection of Mr and Mrs Paul Mellon © 1998 Board of Trustees, National Gallery of Art, Washington, DC.

52. Anders Zorn: *Self-Portrait*, 1896. Oil on canvas. 117 × 94 cm. Nationalmuseum, Stockholm/© photo Statens Konstmuseer

53. Unknown photographer: *A London Slum*, 1889. Gelatin-silver print. Getty Images, Ltd, London.

54. Jacob A. Riis: *Flashlight Photograph of One of Four Peddlers who Slept in a Cellar*, c.1890. Gelatin-silver print. The Jacob A. Riis Collection #203, Museum of the City of New York.

55. Evelyn George Carey: *View of the Internal Viaduct Near One of the Cantilever Towers, Forth Bridge, Scotland*, c.1888. Gelatin-silver print from a collodion negative. 48. 3 × 40 cm. Collection Centre Canadien d'Architecture/ Canadian Center for Architecture, Montreal.

56. Margaret Bourke-White: *High Level Bridge, Cleveland*, 1929. Gelatin-silver print. Margaret Bourke-White Collection, Department of Special Collections, Syracuse University Library/The Estate of Margaret Bourke-White.

57. Claude Monet: *Weeping Willow*, 1919. Oil on canvas. 99.7 × 120 cm. Kimbell Art Museum, Fort Worth, Tx/photo Michael Bodycomb.

58. John Dudley Johnston: *Liverpool an Impression*, 1908. Gum-bichromate print. The Royal Photographic Society, Bath.

59. Sandor Galimberti: *View of a Street in Nagybánya*, 1907. Oil on canvas. 64 × 75 cm.

The Museum of Somogy County, Rippl-Rónai Museum, Kaposvár, Hungary/photo Gőzsy Gáborné.

60. Konrad Krzyźanoswki: *The Landscape from Finland*, 1908. Oil on canvas. 110 × 125 cm. National Museum of Poland, Cracow.

61. Per Krohg: *Female Nude*, 1919. Oil on canvas. 81.5 × 60 cm. © Nasjonalgalleriet, Oslo/photo J. Lathion. © ADAGP, Paris and DACS, London 1999.

62. Moriz Melzer: *Bridge–City*, 1921–3. Oil on canvas. 131 × 98.3 cm. Stadtmuseum Berlin/photo Hans -Joachim Bartsch, Berlin.

63. Nils von Dardel: *The Trans-Siberian Express*, 1918. Oil on canvas. 95 × 150 cm. Private Collection/photo Tord Lund, Moderna Museet, Stockholm/Statens Konstmuseer © BUS.

64. Wyndham Lewis: *The Crowd*, 1914-15. Oil and pencil on canvas. 79 × 60 cm. Tate Gallery, London. Estate of Mrs G. W. Wyndham Lewis. By permission.

65. George Grosz: *The Street*, 1915. Oil on canvas. 45.5 × 35.5 cm. Staatsgalerie, Stuttgart. © DACS 1999.

66. Gösta Adrian-Nilsson: *The City by the Sea*, 1919. Oil on canvas. 31 × 33 cm. Moderna Museet Stockholm/photo Statens Konstmuseer. © DACS 1999.

67. Stanislaw Wyspiański: *Głowka Helenki*, 1900. Pastel on cardboard. 34 × 25 cm. National Museum of Poland, Cracow.

68. Ferdinand Hodler: *The Night*, 1890. Oil on canvas. 116 × 299 cm. Kunstmuseum Berne/ photo Peter Lauri.

69. Stanley Spencer: *Christ's Entry into Jerusalem*, c.1920. Oil on canvas. 47 × 57 cm. City Art Gallery/Leeds Museums and Galleries/photo Bridgeman Art Library. © Estate of Stanley Spencer 1999. All rights reserved, DACS.

70. Pierre Puvis de Chavannes: *The Shepherd's Song*, 1891. Oil on canvas. 104.5 × 109.9 cm. The Metropolitan Museum of Art, New York, Rogers Fund, 1906.

71. Gustave Moreau: *The Chimeras*, 1884. Oil on canvas. 236 × 137 cm. Musée Gustave-Moreau, Paris. © Réunion des Musées Nationaux/photo R. G. Ojeda.

72. Witold Wojtkiewicz: *Baśń Zimowa*, 1908. Oil on canvas. 80 × 70 cm. National Museum of Poland, Poznan.

73. Hans von Marées: *Golden Age II*, 1880–3. Oil on canvas. 185.5 × 149.5 cm. Neue Pinakothek, Munich/photo Kunstdia-archiv Artothek, Peissenberg.

74. Edvard Munch: *The Scream*, 1893. Tempera and oil pastel on card board. 91 × 73.5 cm. © Nasjonalgalleriet, Oslo/photo J. Lathion.

© The Munch Museum/The Munch-Ellingsen Group/DACS 1999.

75. Paul Gauguin: *Ancestors of Tehamana*, 1893. Oil on canvas. 76.3 × 54.3 cm. Gift of Mr and Mrs Charles Deering McCormick, 1980.613/photo © 1997 The Art Institue of Chicago. All rights reserved.

76. Paul Cézanne: *An Old Woman with a Rosary*, 1896. Oil on canvas. 80.6 × 65.5 cm. © The National Gallery, London (NG 6195).

77. Hans Christian Anderson: *Wandschirm*, 1873–4: *Germany* (left) and *France* (right). Collage on linen, 2 of 8 panels shown here, each panel, 153 × 62.5 cm. H. C. Andersen House/Odense Bys Museer.

78. George Grosz and John Heartfield: *Life and Activity in Universal City at 12.05 Midday*, 1920. Photomontage. Akademie der Künste, Berlin (John Heartfield Archiv). © DACS 1999.

79. Paul Citroën: *Metropolis*, 1923. Collage of photographs, prints, and postcards. 76.1 × 58.4 cm. Courtesy of Study and Documentation Centre for Photography, Leiden University, The Netherlands. © DACS 1999.

80. Stuart Davis: *Lucky Strike*, 1921. Oil on canvas. 84.5 × 45.7 cm. The Museum of Modern Art, New York. Gift of the American Tobacco Company, Inc./photo © 1999 The Museum of Modern Art, New York. © Estate of Stuart Davis/DACS, London/VAGA, New York 1999.

81. Victor Brauner: *Composition*, *c*.1929. Oil on canvas. 53.5 × 64.5 cm. National Museum of Art, Bucharest/photo Art Services International, Alexandra, VA. © ADAGP, Paris and DACS, London 1999.

82. Édouard Manet: *Olympia*, 1863. Oil on canvas. 130.5 × 190 cm. Musée d'Orsay, Paris/© Réunion des Musées Nationaux/photo H. Lewandowski.

83. Édouard Manet: *The Mocking of Christ*, 1865. Oil on canvas. 190.8 × 148.3 cm. Gift of James Deering, 1925.703/photo © The Art Institute of Chicago. All rights reserved.

84. Edvard Munch: *Ashes*, 1894. Oil and tempera on canvas. 120.7 × 141 cm. © Nasjonalgalleriet, Oslo/photo J. Lathion. © The Munch Museum/The Munch-Ellingsen Group/DACS 1999.

85. Magnus Enckell: *The Awakening*, 1894. Oil on canvas. 113 × 86 cm. The Finnish National Gallery/Atenuem/The Antell Collection, Helsinki/photo The Central Art Archives.

86. Pablo Picasso: *Family of Saltimbanques*, 1905. Oil on canvas. 212.8 × 229.6 cm. Chester Dale Collection © 1998 Board of Trustees, National Gallery of Art, Washington. © Succession Picasso/DACS 1999.

87. Pierre-Auguste Renoir: *The Promenade*, 1870. Oil on canvas.81.3 × 65 cm. The J. Paul Getty Museum, Los Angeles, CA.

88. Paul Gauguin: *Where Do We Come From? What Are We? Where Are We Going?*, 1897. Oil on canvas. 139.1 × 374.6 cm. Courtesy Museum of Fine Arts, Boston, Tompkins Collection.

89. Jean Frédéric Bazille: *Summer Scene*, 1869. Oil on canvas. 160 × 160.7 cm. Courtesy of the Fogg Art Museum, Harvard University Art Museums, Gift of Mr and Mrs F. Meynier de Salinelles.

90. Max Liebermann: *In the Bathhouse*, 1875–8. Oil on canvas. 181 × 225.1 cm. Dallas Museum of Art, Foundation for the Arts Collection, Mrs John B. O'Hara Fund. © DACS 1999.

91. Thomas Eakins: *Swimming*, 1885. Oil on canvas. 69.5 × 92.4 cm. © Amon Carter Museum, Fort Worth, Tx (1990.19.1).

92. Gustave Caillebotte: *Man at his Bath*, 1884. Oil on canvas. 170 × 125 cm. Private Collection (on extended loan to The National Gallery, London).

93. Paul Gauguin: *Manau tupapau (Spirit of the Dead Watching)*, 1892. Oil on burlap mounted on canvas. 72.4 × 92.4 cm. Albright-Knox Art Gallery, Buffalo, NY, A. Conger Goodyear Collection, 1965.

94. Marcel Duchamp: *The Bride Stripped Bare by her Bachelors, Even* or *The Large Glass*, 1915–23. Front view. Oil and lead wire on glass. 277.5 × 175.6 cm. Philadelphia Museum of Art, Bequest of Katherine S. Dreier. © ADAGP, Paris and DACS, London 1999.

95. Hannah Höch: *The Sweet One (Die Süsse)*, *c*.1926, from 'From an Ethnographic Museum' series. Photomontage with watercolour. 30 × 15.5 cm. Museum Folkwang Essen. © DACS 1999.

96. Georges-Pierre Seurat: *A Summer Sunday on the Island of the Grande Jatte, 1884*, 1884–6. Oil on canvas. 207 × 308 cm. Helen Birch Bartlett Memorial Collection, 1926.224/photo © 1997 The Art Institute of Chicago. All rights reserved.

97. Georges-Pierre Seurat: *Bathers at Asnières*, 1883-4. Oil on canvas. 201 × 300 cm. © The National Gallery, London (NG 3908).

98. Lukian Popov: *Mobilized*, 1904. Oil on canvas. The Russian Museum, St Petersburg.

99. Adolph Menzel: *Supper at the Ball*, 1878. Oil on canvas. 71 × 90 cm. National Gallery, Berlin/photo Staatliche Museen Preussicher Kulterbesitz.

100. Ilya Repin: *Religious Procession in the Province of Kursk*, 1880–3. Oil on canvas. 175 × 280 cm. Tretyakov Gallery, Moscow/photo Scala, Florence.

101. Henri Matisse: *The Conversation*, 1909.

State Hermitage Museum, St Petersburg/
photo Bridgeman Art Library, London. ©
Succession H. Matisse/DACS 1999.

102. Fernand Léger: *Soldiers Playing at Cards*,
1917. Oil on canvas. 129 × 193 cm. Rijksmuseum
Kröller-Müller, Otterlo. © ADAGP, Paris
and DACS, London 1999.

103. Kasimir Malevich: *Portrait of the Artist
Ivan Vasilievich Klyun (1873–1942) as a Builder*,
1911. Oil on canvas. 111 × 70 cm. State Russian
Museum, St Petersburg/photo Bridgeman Art
Library, London.

104. Raoul Hausmann: *Tatlin at Home*, 1920.
Collage of pasted papers and gouache. 41 × 28
cm. Moderna Museet, Stockholm/Statens
Konstmuseer. © ADAGP, Paris and DACS,
London 1999.

105. Arthur G. Dove: *Grandmother*, 1925.
Collage of shingles, needlepoint, page from
the Concordance, pressed flowers, and ferns.
50.8 × 54 cm. The Museum of Modern Art,
New York, Gift of Philip L. Goodwin (by
exchange)/photo © 1999 The Museum of
Modern Art, New York. The Estate of Arthur
Dove (Terry Dintenfass Inc, New York).

106. Katherine Dreier: *Psychological Abstract
Portrait of Ted Shawn*, 1929. Oil on canvas.
76.2 × 63.5 cm. Munson-Williams-Proctor
Institute Museum of Art, Utica, New York,
96.29.

107. Lucia Moholy: *Florence Henri*, 1926–7.
Gelatin-silver print. 37 × 27.8 cm. Julien Levy
Collection, gift of Jean and Julien Levy,
1975.1141. Art Institute, Chicago.

108. Margrethe Mather: *Semi-Nude (Billy
Justema in Man's Summer Kimono)*, c.1923.
Gelatin-silver print. 8.8 × 11.5 cm. Center for
Creative Photography, University of Arizona,
Tucson, AZ.

109. Vanessa Bell: *Studland Beach*, c.1912.
Oil on canvas. 76.2 × 101.6 cm. Tate Gallery,
London. © 1961 Estate of Vanessa Bell.

110. Rudolph Thygesen: *Barbarians*, 1914. Oil
on canvas. 199 × 139.5 cm. © Nasjonalgalleriet,
Oslo/photo J. Lathion. © DACS 1999.

111. Camille Pissarro: *The Apple Pickers*,
1884–6. Oil on canvas. 127 × 127 cm. Ohara
Museum of Art, Kurashiki, Japan.

112. Nikolai Yaroshenko: *The Stoker*, 1878. Oil
on canvas. 124 × 89 cm. Tretyakov Gallery/
photo Novosti (London).

113. Abrham Arkhipov: *Laundresses*, 1901. Oil
on canvas. 97 × 65 cm. State Russian Museum,
St Petersburg/photo Novosti (London).

114. Károly Ferency: *Boys on the Danube*, 1890.
Oil on canvas. 119 × 149 cm. Hungarian
National Gallery, Budapest/photo Tibor
Mester.

115. Édouard Manet: *A Bar at the Folies-
Bergère*, 1882. Oil on canvas. 96 × 130 cm. The
Courtauld Gallery, Courtauld Institute of Art,
London, Gift of Samuel Courtauld, 1934.

116. Claude Monet: *On the Bank of the Seine at
Bennecourt*, 1868. Oil on canvas. 81.5 × 100.7
cm. Mr and Mrs Potter Palmer Collection,
1922.427/photo © 1997 The Art Institute of
Chicago. All rights reserved.

117. Eugène Atget: *La Marne at Varenne*,
1925–7. Albumen-silver print. 18 × 24 cm. The
Museum of Modern Art, New York. Abott-
Levy Collection. Partial gift of Shirley C.
Burden. Copy print © 1998 The Museum of
Modern Art, New York.

118. Paul Cézanne: *Houses near Auvers-sur-
Oise*, 1873–4. Oil on canvas. 39.4 × 53.3 cm.
Courtesy of the Fogg Museum, Harvard
University Art Museums, Bequest of Annie
Swan Coburn.

119. Camille Pissarro: *The Hermitage at
Pontoise*, c.1867. Oil on canvas. 91 × 150.5
cm. Wallraf-Richartz Museum, Cologne.

120. Édouard Vuillard: *Large Interior with
Six Figures*, 1897. Oil on canvas. 88 × 193 cm.
Kunsthaus, Zurich. © 1999 by Kunsthaus
Zurich. © All rights reserved. © ADAGP,
Paris and DACS, London 1999.

121. August Strindberg: *The Wave VIII*, 1892.
Oil on cardboard. 99 × 69 cm. Nordiska
Museet, Stockholm/photo Birgit Brånvall.

122. Laura Gilpin: *Basket of Peaches*, 1912.
Autochrome. 7.6 × 13 cm. © 1979 Amon
Carter Museum, Fort Worth, Tx, Gift of
the Estate of Laura Gilpin (P1979.146.50).

123. Lazar El Lissitzky: *Proun 12 E*, 1923.
Oil on canvas. 57.2 × 42.5 cm. Courtesy of
the Busch Reisinger Museum. Harvard
University Art Museums Association Fund.
© DACS 1999.

124. Kasimir Malevich: *Suprematist
Composition: White on White*, 1918. Oil on
canvas. 79.4 × 79.4 cm. The Museum of
Modern Art, New York/photo © 1999
The Museum of Modern Art, New York/
photo Bridgeman Art Library, London.

125. Mikhail Matiushin: *Movement in
Space*, 1917–18. State Russian Museum,
St Petersburg.

126. Hans Mattis-Teutsch: *Compositiion
in Yellow* from 'Flowers of the Soul' series,
1916–24. Oil on canvas. 80 × 90 cm. National
Museum of Art, Bucharest.

127. Bertram Brooker: *Sounds Assembling*, 1928.
Oil on canvas. 112.3 × 91.7 cm. Collection of the
Winnipeg Art Gallery/photo Ernest Mayer,
Winnipeg Art Gallery. Courtesy Phyllis
Brooker Smith.

128. Jan Matejko: *The Battle of Grunewald*, 1878. Oil on canvas. 426 × 987 cm. National Museum of Poland, Warsaw.

129. Wasilly Kandinsky: *White Cross*, January–June 1922. Oil on canvas. 100.5 × 110.6 cm. Peggy Guggenheim Collection, Venice/photo Robert E. Mates. © ADAGP, Paris and DACS, London 1999.

130. Leon Wyczołkowski: *U Wrót Chałubińskiego*, 1905. Pastel on cardboard. 80 × 110 cm. National Museum of Poland, Cracow.

131. Sándor Bortnyik: *Geometric Composition*, 1922. Paper and watercolour. 36.3 × 25.5 cm. Hungarian National Gallery, Budapest/photo Tibor Mester.

132. John Covert: *Time*, 1919. Oil and carpet tacks on canvas. 61 × 61 cm. Yale University Art Gallery, New Haven, CT. Gift of Collection Société Anonyme.

133. Georgia O'Keeffe: *Blue and Green Music*, 1919. Oil on canvas. 58.4 × 48.3 cm. Alfred Stieglitz Collection, Gift of Georgia O'Keeffe, 1969.835/photo © 1997 The Art Institute of Chicago. All rights reserved. © ARS, New York and DACS, London 1999.

134. Tom Thomson: *In the Northland*, 1915. Oil on canvas. 101.7 × 114.5 cm. The Montreal Museum of Fine Arts, Gift of the Friends of the Montreal Museum of Fine Arts/photo the Montreal Museum of Fine Arts. © ARS, New York and DACS, London 1999.

135. Lawren Harris: *From the North Shore, Lake Superior*, 1923. Oil on canvas. 121.9 × 152.4 cm. London Regional Art & Historical Museums, Ontario. Courtesy Mrs Margaret Knox.

136. Tivardar Csontvary Kosztka: *Ruins of the Greek Theatre at Taormina*, 1904–5. Oil on canvas. 302 × 570 cm. Hungarian National Gallery, Budapest/photo Tibor Mester.

137. Akseli Gallen-Kallela: *Lemminkainen's Mother*, 1897. Tempera on canvas. 85.5 × 108.5 cm. The Finnish National Gallery/Ateneum/The Antell Collection, Heksinki/photo The Central Art Archives. © Mrs Aivi Gallen-Kallela.

138. Imogen Cunningham: *Triangles*, 1928. Gelatin-silver print. Photograph by Imogen Cunningham © All Rights Reserved by The Imogen Cunningham Trust, Berkeley, CA.

139. Kasimir Malevich: *Girls in a Field*, 1928–30. Oil on canvas. 106 × 125 cm. State Russian Museum, St Petersburg/photo Bridgeman Art Library, London.

140. Walker Evans: *Brooklyn Bridge, New York*, 1929. Gelatin-silver print. 22.2 × 14 cm. The Museum of Modern Art, New York. Mr and Mrs John Spencer Fund. Copy print © 1999 The Museum of Modern Art, New York. Courtesy the Estate of Walker Evans (The Metropolitan Museum of Art, New York).

The Publisher and Author apologize for any errors or omissions in the above list. If contacted they will be pleased to rectify these at the earliest opportunity.

Bibliographic Essay

General

The bibliography devoted to modernism is so complex and large that it is not possible to cover it all in a short essay. The following is a guide for the beginner and includes works written in English and accessible in most large libraries. It is not intended for the specialist and includes few works that are outside what might be called the traditional history of art—those devoted directly to the histories of painting, photography, and printmaking. Students who are fascinated by the theoretical literature and to studies of modernist culture itself must look elsewhere.

Most large histories of visual modernism tend to divide the nineteenth and the twentieth centuries. Certain of them, following Alfred Barr's *Museum of Modern Art*, annex the final twenty years of the nineteenth to the twentieth century. Hamilton's text is the most distinguished of the general studies of modernism and the most accurate, clear-headed, and descriptive. Thus, it is the one essential book. Its most recent edition also contains the best—and largest—bibliography for use by the new student. Rosenblum's book is the most inclusive, international survey of nineteenth century art, with an excellent bibliography, and his co-authored and compiled text on the nineteenth century is the most up-to-date in terms of recent methodological developments, and also has a fascinating bibliography.

Hamilton, George Heard, *Painting and Sculpture in Europe, 1880–1945* (New Haven and London, 1993).

Rosenblum, Robert, *Nineteenth Century Art* (New York, 1984).

Rosenblum, Robert and **Eisenman, Stephen**, et al., *Nineteenth Century Art: A Critical History* (New York, 1994).

The twentieth century has faired less well in the area of general surveys, but Rosenblum's graceful and intelligent study remains useful. The work of Rubin at the Museum of Modern Art has defined the various avenues in twentieth century art history with particular clarity and accuracy. Two of his texts deserve special mention.

Rosenblum, Robert, *Cubism and Twentieth Century Art* (Englewood Cliffs, NJ, 1976).

Rubin, William, *Dada and Surrealism* (place, 1968).

Rubin, William, *Primitivism and Twentieth Century Art* (place, 1984).

Studies of artistic cosmopolitanism are not as common as one would like. The Centre Pompidou has been active in a series of exhibitions that measure the culture and artistic boundaries of Paris, by negotiating binary studies. These are, unfortunately, only available in French. There are also several studies of foreign artists in Paris.

The national histories of modern art are legion, and mostly unremarkable except in a descriptive sense. The best-studied traditions outside France and the United States can be found in the literature devoted to German, Austrian, and British art. Careful synthetic studies of Russian, Polish, Swiss, Danish, Norwegian, and other European traditions await publication in accessible English-language works. However, Italian modernism has been well studied in English with works by Norma Broude, Anne Coffin Hanson, Susan Barnes Robinson, and others. A single systematic study of foreigners in Paris has not been written.

Centre Pompidou, *Paris/Moscow* (1979), *Paris/Berlin* (1978), and *Paris/New York* (1977).

Weinberg, Barbara, *The Lure of Paris* (New York, 1991).

In England, nineteenth century studies of French modernism have been particularly sophisticated with major contributions by John House of the Courtauld Institute and both Richard and Belinda Thomson, writing separately. Christopher Green has also been a

highly productive scholar in twentieth-century European art.

Art museums have been major centres of scholarly research and publication in the area of modernist art, and projects for major museums by Charles Stuckey, John House, Douglas Druick, Paul Hayes Tucker, Judi Freeman, Gary Tinterow, Charles Moffett, Patrice Marandel, Joseph Rishel, Henri Loyrette, Françoise Cachin, Kirk Varnedoe, Joachim Pissarro, and others have become standard works.

Twentieth century modernism has been firmly divided from that of the nineteenth century in academic teaching and research, and most large academic departments have divided modernism chronologically simply to accommodate the large numbers of students in courses on modern art. This has not created conditions of collaboration and exchange and has lead to excessive specialization in graduate training.

Feminist Studies and the Study of Modernism

There is little doubt that the feminist critique of culture has been the most powerful methodological force in the humanities for the past generation. Now, one can no longer seriously read formerly crucial books and articles on the history of art written by male art historians about male artists for a male audience. So many canonical texts, and the canonical artists they worship, can clearly and convincingly be identified as sexist. The feminist project has been particularly important in its relationship to modernism and visual representation. It is not possible to think about modern art without reading the feminist critiques of its imagery, marketing, connoisseurship, criticism, and scholarship by historians like Linda Nochlin, Griselda Pollock, Norma Broude, Hollis Clayson, Eunice Lipton, Abigail Solomon-Godeau, Anne Higgonet, Nancy Mathews, Molly Nesbitt, Carol Duncan, Rosalind Krauss and, increasingly, the work of male feminists like Stephen Eisenman, Kenneth Silver, and John House.

Not surprisingly, a good deal of this critical literature springs directly from modernism itself. It is, in fact, impossible to write the history of modern art, collecting, curating, or art scholarship without women. Though women have often fought for their place at the table, once taken that place has been firmly maintained, and an increasing number of women have been invited to join the ranks. In certain cases, the gatherings were confined to women, but the majority of women fought to gain positions of gender equality with the men who dominated discourse and, hence, power in all fields of human activity except the home. In certain ways, women now dominate the visual arts numerically, but their struggle to be in senior positions of power in universities, museums, commercial galleries, and professional organizations continues apace.

The study of women as artists and as direct contributors to the modernist enterprise, is dominated by women scholars, particularly the bibliographies devoted to the careers of Mary Cassatt, Berthe Morisot, Sonia Delaunay, Florine Stettheimer, Georgia O'Keeffe, and Vanessa Bell, men apparently feeling unequipped for the task. These studies, and the small, but fascinating general literature on women artists, have been significant additions to the bibliography of modernism. Indeed, the comparative rarity of successful professional women artists, even in modern art, has meant that, when their careers are documented and understood, they take on an importance that is, perhaps, greater than certain of their male colleagues.

A bibliography of feminist contributions to modernists studies would be enormously long. From the intense and driven writings of Pollock to the critically nuanced essays of Nochlin, the tone of feminists studies is as diverse as its contributors. There is, however, no doubt that the central text of feminist scholarship is Pollock's collection of challenging essays, *Vision and Difference*. The current work of feminist art historians serves both as a critique of the phallo-centric world of traditional art history and as a propagator of concepts of the 'gaze' and the 'other', many of which have their roots in anthropology and other social sciences rather than in the history of art per se. Broude and Gerrard's anthology offers a diverse general reader on the subject.

Broude, Norma and **Gerrard, Mary D.**, *The Expanding Discourse, Feminism and Art History* (New York, 1992).

Nochlin, Linda, *The Politics of Vision* (New York, 1989).

Pollock, Griselda, *Vision and Difference: Femininity, Feminism and Histories of Art* (London and New York, 1988).

Pollock, Griselda, *Avant-Garde Gambits 1888–1893: Gender and the Colour of Art History* (New York and London, 1993).

Part I Realism to Surrealism

The most reliable style histories are the somewhat overlapping books written for the Pelican

History of Art by Novotny and Hamilton. The many books on the various styles of movements treated separately are too legion—and generally too mediocre—to mention individually. Exceptions are Nochlin's brilliant and broadly inclusive book on Realism, and Cork's two volume masterpiece of detailed documentation. These two books are the best of two types of historiography—one that takes an international modern movement in all its breadth and diversity and the other that documents the complexities within a single, localized movement. Books of the latter type tend to be better, because their aims are more clearly described and the material relating to them narrower and easier to access. One wishes for more and better books in the manner of Nochlin's study. Yet most general books of this type are commissioned by large publishers from scholars who are forced to produce them in very short order, more to make money than seriously to rethink and research their contents. Oddly enough, there is not a good book on international impressionism, although several country-by-country surveys exist.

Cork, Richard, *Vorticism and Abstract Art in the First Machine Age* (Berkeley, 1976).

Hamilton, George Heard, *Painting and Sculpture in Europe 1880–1945* (New Haven and London, 1993).

Nochlin, Linda, *Realism* (London and New York, 1970).

Novotny, Fritz, *Painting and Sculpture in Europe 1770–1880* (Baltimore, 1960).

Two theoretical books worth reading are Poggioli's classic text and Drucker's more recent and critically laden one. In general the theoretical literature devoted to modernism concerns itself with contemporary art and does not make concerted use of historical analyses, even of theoretical texts. In general, the style art history perfected in the nineteenth century persists in all types of art history, no matter the methodological or theoretical interests of the individual scholar.

Drucker, Joanna, *Theorizing Modernity: Visual Culture and the Critical Tradition* (New York, 1994).

Poggioli, Renato, *The Theory of the Avant-Garde* (New York, 1971).

Part II The Conditions for Modern Art
Chapter 1. Urban Capitalism

The study of the development of the modern city and its socio-economic systems is vast and fascinating. A good many of its central conclusions have been simply annexed by historians

of representational form. This idea that the city itself is the condition of modernism has its roots in the writings of Victor Hugo. Whilst he was living in exile he wrote an essay on Paris for the International Exhibition of 1867 which is perhaps the most powerful single expression of urban-modern linkage. The best early book is du Camp's, and modern studies are legion, but the most widely accessible texts are those by Pinkney, Schorske, and Oisen.

du Camp, Maxime, *Paris, ses Organes et ses Fonctions* (Paris, 1869, repr. 1975).

Oisen, Donald J., *The City as a Work of Art: Paris, London, Vienna* (New York and London, 1986).

Pinkney, David, *Napoleon III and the Reconstruction of Paris* (Princeton, 1972).

Schorske, Carl, *Fin de Siecle Vienna: Politics and Culture* (New York, 1979).

There are major studies of most modern Euro-global cities in print, and Eastern European cities have fared particularly well with monographs on modern Prague, Budapest, and Bucharest leading the way. Unfortunately most of these texts are not available in general art libraries in Britain and the United States largely because they are published in Eastern Europe and are not distributed widely in the West. One of the most delightful and informative of these is a multi-authored bilingual guide to *Cubist Prague* (published by Ceska Pojistovna, Prague). Lukacs wonderful book on Budapest is more widely accessible, but it is comparatively weak in its analysis of the visual arts. I am also fond of a book written by Boyer that interprets the modern city as a sort of collage.

Boyer, M. Christine, *The City of Collective Memory: Its Historical Imagery and Architectural Entertainments* (Cambridge, 1996).

Lukacs, John, *Budapest 1900: A Historical Portrait of a City and its Culture* (New York, 1988).

Chapter 2. Modernity, Representation and the Accessible Image

The essay most frequently read by advanced students of modernism as an urban phenomenon is the now canonical text by Benjamin. This has now been supplanted by a larger sampling in English, and by Gilloch's analysis of all the urban writings.

Benjamin, Walter, 'Paris—The Capital of the Nineteenth Century' *New Left Review* 48 (March–April 1968), 77–88.

Benjamin, Walter, *Selected Writings*

(Cambridge, Mass., 1996).

Gilloch, Graeme, *Myth and Metropolis: Walter Benjamin and the City* (Cambridge, 1996).

Writings on reproduction, photography, print distribution, museums, temporary exhibitions and commercial galleries are also numerous and uncollected. There is no core text that deals with capitalist image exploitation. The graphic traffic is best studied in the separate histories of the reproductive graphic arts, photography, and lithography. All of the following books have important bibliographies.

Jussim, Estelle, *Visual Communication and the Graphic Arts: Photographic Technologies in the Nineteenth Century* (New York, 1983).

Henisch, Heinz K. and Henisch, Bridget A., *The Photographic Experience 1839–1914: Images and Attitudes* (Pennsylvania, 1994).

Rosenblum, Naomie, *A World of Photography* (New York, 1984).

Twyman, Michael, *Lithography 1800–1850* (Oxford, 1970).

Weber, Wilhelm, *A History of Lithography* (London, 1966).

There is also an excellent new series called *Documenting the Image* published by Gordon and Breach, Amsterdam. The aim of the series is to create a viable history of the image rather than of art. Hamber's recent book is particularly relevant to my arguments, and the second volume in the series is also useful.

Hamber, Anthony J., *'A Higher Branch of the Art': Photographing the Fine Arts in England 1839–1880* (Amsterdam, 1996).

Roberts, Helene E., *Art History Through the Camera's Lens* (Amsterdam, 1995).

The art museum has been most profitably studied as part of the larger history of museums in Euro-global culture. Aside from Bazin's descriptive summary, there is no reliable general history of the art museum in modern capitalist cultures. The majority of 'great' museums have commissioned some form of institutional history, mostly dealing with the heroism of early collectors, directors, curators, or trustees. For America these have been summarized in Burt's *Palaces for the People*. However, many of the best specialized studies of collectors, directors and the like, have appeared since the publication of this book. Students who want to delve into the mass of this material should consult museum publications produced by the major American and European art museums. All of these are sepa-

rated from the history of art itself, thus further marginalizing museum scholarship from that produced in the academy and for independent publishing houses. Perhaps the best compendium of sources available on the early history of museums and exhibitions is Holt's anthology.

Bazin, Germain, *The Museum Age* (New York, 1967).

Burt, Nathaniel, *Palaces for the People: A Social History of the American Art Museum* (Boston, 1971).

Holt, Elizabeth Gilmore, *The Triumph of Art for the Public: The Merging Role of Exhibitions and Critics* (New York, 1979).

Other valuable studies of museums include:

Alexander, Edward P., *Museums in Motion: An Introduction to the History and Functions of Museums* (Nashville, 1979).

Alexander, Edward P., *Museum Masters: Their Museums and Their Influence* (Nashville, 1983).

Duncan, Carol, *Civilizing Rituals: Inside Public Art Museums* (London and New York, 1995).

Henderson, Amy and Coupler, Adrienne L. (eds), *Exhibiting Dilemmas: Issues of Representation at the Smithsonian* (Washington and London, 1997).

Kaplan, Flora E. S. (ed.), *Museums and the Making of 'Ourselves': The Role of Objects in National Identity* (London and New York, 1994).

Root, Deborah, *Cannibal Culture: Art, Appropriation, and the Commodification of Difference* (Boulder, Col., and Oxford, 1996).

Weil, Stephen E., *A Cabinet of Curiosities: Inquiries into Museums and their Prospects* (Washington and London, 1995).

Part III the Artist's Response
Chapter 3. Representation, Vision and 'Reality': The Art of Seeing
Chapter 4. Image/ Modernism and the Graphic Traffic

There is no text that has organized the history of modernism into the two strands proposed here, and, for that reason, a bibliographical essay for these two chapters will be extremely long or non-existent. The reader is urged to consult the notes to these sections. The literature on symbolism and its imageries has been richer than that associated with collage, photo-collage, and Surrealism. Frechette and Rannou have compiled a thorough bibliography of art historical and critical texts published between 1984 and 1994 for the Montreal Museum of Fine Arts 1995

exhibition catalogue. The general reader might wish to consult Dorra's brilliantly composed anthology of Symbolist art theories, and the summary of the best writing on the iconology of collage by Poggi.

Claire, Jean and **Cogeval, Guy**, *Lost Paradise: Symbolist Europe* (Montreal, 1995), 533–52.

Dorra, Henri, *Symbolist Art Theories: A Critical Anthology* (Berkeley, 1994).

Poggi, Christine, *In Defiance of Painting: Cubism, Futurism and the Invention of Collage* (New Haven, 1992).

Part IV Iconology
Chapter 5. Sexuality and the Body

The subjects of modern pictures have been dissected with real passion by the last two generations of art historians on both sides of the Atlantic. The most passionate type of analysis decodes body imagery and is so prevalent that one can only summarize the recent trends. That a good deal of this literature is faddish and loaded with dated jargon goes without saying, but there is little doubt that millennial anxieties about gender and its discourses has produced the most sustained discussion of the body in art since the Renaissance.

Brooks, Peter, *Body Works: Objects of Desire in Modern Narrative* (Cambridge, 1993), an interdisciplinary text produced by an eminent literary critic.

Feher, Michel and **Nadaff, Ramona** and **Tazi, Nadia** (eds), *Fragments for a History of the Human Body* (2 vols, New York, 1989).

Herdt, Gilbert (ed.), *Third Sex, Third Gender: Beyond Sexual Dimorphism in Culture and History* (New York, 1994).

Nead, Lynda, *The Female Nude: Art, Obscenity, and Sexuality* (London, 1992).

Chapter 6. Social Class and Class Consciousness

The social history of art has been as important as the sexual or gender history. Following the lead of Marxist scholars like Arnold Hauser and Walter Benjamin, students of the social history of modern art have become immensely subtle in their decoding of the bourgeois drama of modernism, with its anxieties and unconscious manipulations of categories of social class. There is no doubt that Timothy J. Clark is the most important of these figures. While teaching at Harvard and Berkeley he trained an entire generation of social historians of canonical modern art. His most important book, *The Painter of Modern Life*, has produced a veritable fountain of responses, particularly from feminist historians who view Clark's preoccupation with class as sexist. Yet,

many scholars have followed Clark's lead and considered class as primary in the sexually charged imagery of such modernists as Manet, Degas, and Seurat. The most often read of these texts is by Clark's student, Hollis Clayson. All of this material has been analysed and summarized in the notes and bibliography of Eisenmann's edited social history of modernism.

Clark, Timothy J., *The Painter of Modern Life: Paris in the Art of Manet and his Followers* (New York and London, 1984).

Clayson, Hollis, *Painted Love: Prostitution in French Art of the Impressionist Era* (New Haven, 1991).

Eisenman, Stephen (ed.), *Nineteenth Century Art: A Critical History* (New York and London, 1994).

The second major force in the publishing and graduate teaching of the social history of art is Robert L. Herbert, whose students have conquered vast territories in both the nineteenth and twentieth centuries. The recent texts of Kenneth Silver, Judy Freeman, James D. Herbert, Molly Nesbit, and many others have conjoined issues related to gender and social class in readings of twentieth-century art that are highly nuanced and remarkably free from 'vulgar' Marxism. Following their lead, it has now become completely standard, even in museum displays of masterpieces, to place them in their socio-political contexts in both wall labels and accompanying publications. This is particularly true of the study of Fauvism.

Freeman et al., *The Fauve Landscape* (New York, 1990).

Herbert, James D., *Fauve Painting: The Making of a Cultural Landscape* (New Haven, 1992).

The social history of art has been equally active in Britain and the United States during the past generation, and class-based image analysis is so pervasive that no single text can serve to summarize it. A particularly thorough and detailed example is a study of British landscape painting by Hemingway, and its 'continuation' in the work of Thomson.

Hemingway, Andrew, *Landscape Imagery and Urban Culture in Early Nineteenth Century Britain* (Cambridge, 1992).

Thomson, Richard, *Monet to Matisse: Landscape Painting in France 1874–1914* (Edinburgh, 1994).

There has been abundant literature in the history of photography that exploits the tech-

niques of the Marxist or class-based social history of art. Nesbit has written a fascinating and sophisticated book on Eugene Atget. Readers might well consult her extensive interdisciplinary bibliography. Also McCaulay's books are models of exhaustive research and socio-historical methods applied to the mass production of photographic imagery.

McCaulay, Anne, *A. A. E. Disderi and the Carte de Visite Portrait* (New Haven, 1985).

McCaulay, Anne, *Industrial Madness: Commercial Photography in Paris 1848–1871* (New Haven, 1994).

Nesbit, Molly, *Atget's Seven Albums* (New Haven, 1994).

Much of this literature stresses the bourgeois conventions of modernist imagery, regardless of the class represented in the work of art. The smaller literature on the representation of social classes as part of the larger portrait of modern society is confined to the analysis of urban leisure workers and, to a lesser extent, to peasants and rural workers. There is also a large and critically unsophisticated literature on the representation of the rich—either aristocrats or bourgeois. These books tend to be compendia of images and short biographies. The most intelligent and bibliographically complex of these is by Lucie-Smith.

Brettell, Richard and Brettell, Caroline, *Painters and Peasants in the Nineteenth Century* (Geneva, 1983).

Lucie-Smith, Edward, *How the Rich Lived: The Painter as Witness 1870–1914* (New York and London, 1976).

Chapter 7. Anti-Iconography: Art Without 'Subject'

The study of anti-iconography is in its infancy. The theory of independent pictorial meanings is tied to the concept of a plastic art without necessary connection to the verbal equivalent of the visual world. Perhaps the most important figure in this study is Richard Shiff, director of the Center for the Study of Modernism at the University of Texas at Austin. His dissertation on Cézanne was enlarged and published, and his work has continued to defy stereotypes and to insist on an integrated study of medium, technique, and imagery, thus stressing the move away from a verbally based iconography. He has also written two recent investigations of pictorial method.

Shiff, Richard, *Cézanne and the End of Impressionism* (Chicago, 1984).

Shiff, Richard, 'Cézanne's Physicality: The Politics of Touch' in Kemal, Salim and Gaskell, Ivan (eds), *The Language of Art*

History (Cambridge, 1991).

Shiff, Richard, 'Corot and the Painter's Mark: Natural, Personal, Pictorial' *Apollo* (May 1998), 3–8.

A good deal of this anti-iconography stems from landscape painting, whose vast literature is predominantly nineteenth century. The idea that the landscape provided the painter with infinite compositions that simply needed to be transcribed takes away from the painter the realm of verbal meanings. The various searches for meaning in modern landscape have been summarized in my own synopsis of nineteenth-century French landscape theory in Champa's anthology. His own fascinating text in this book makes links between landscape painting and music, links that deprive the landscapes studied of social and cultural meanings. It is no accident that Champa's thought has developed in this manner, as his early writings were concerned with colour-field abstraction in America. So far, a book that explores the connections between subjectless landscape, still-life and genre paintings of the nineteenth century and theories of abstraction in the twentieth century has yet to be written.

Champa, Kermit, *The Rise of Landscape Painting in France, Corot to Monet* (New York, 1991). See especially pp. 15–22 for my own essay.

Chapter 8. Nationalism and Internationalism in Modern Art

A single comparative study of nationalism and the representational arts has not been written. Rather, nationally based historians in virtually every modern European and American country have written independent studies that deal with individual national schools or aesthetic trends. Such studies tend to decry or de-emphasize foreign contributions to national aesthetic systems, and in certain cases, the study of international movements like Impressionism and Symbolism have been divided in a country-by-country manner. Perhaps the most virulent and defensive of these literatures involves the study of American art, which has, for that very reason, sought too often to study works produced by American artists in a cultural vacuum called 'America'. Examples of this are so numerous that they can scarcely be listed, but a couple of texts come to mind. Miller's book on this subject is a particularly subtle example, based on the work of such American scholars as Novak, whose text is cited by virtually every student of American art. Novak also bases a good many

of her conclusions on the extensive study of British and English landscape imagery, most of which concentrate on English landscape painting of the eighteenth and early nineteenth centuries.

Miller, Angela, *The Empire of the Eye: Landscape Representation and American Cultural Politics* (Ithaca and London, 1993).

Novak, Barbara, *Nature and Culture: American Landscape Paintings 1825–75* (Oxford and New York, 1980).

A comparative study of the national landscapes of England and the United States in the nineteenth century can be found in Daniel's book. The study of nationalism in French painting has also largely been confined to landscape painting and this is summarized in the anthology by Brettell et al. and House's book. Hill's text covers nationalism in Canada.

Brettell, Richard et al., *A Day in the Country: Impressionism and the French Landscape* (New York, 1984).

Daniel, Stephen, *Fields of Vision: Landscape Imagery and National Identity in England and the United States* (Princeton, 1993).

Hill, Charles S., *The Group of Seven: Art for a Nation* (Ottawa, 1995).

House, John, *Landscapes of France: Impressionism and its Rivals* (London, 1995).

Timeline compiled by Julie Lawrence Cochran.

Art

1851 George **Sigl**, Vienna, develops mechanical press for **lithography**
Courbet, *Young Ladies from the Village*
Holman Hunt, *Valentine Rescuing Sylvia from Proteus* [**2**]
Leutze, *Washington Crossing the Delaware*

1852 **van Klenze** completes Hermitage, St Petersburg
Daumier's lithograph, *The Orchestra During the Performance of a Tragedy*

1853 Russian critic Nikolai **Chernyshevsky**'s essay, *The Aesthetic Relations of Art to Reality*
Bonheur, *The Horse Fair*
Delacroix, *Alfred Bruyas*

1854 **Delacroix**, *Christ on the Sea of Galilee*
Holman Hunt, *The Light of the World*
Rossetti, *Found*

1855 **Courbet** exhibits paintings including *The Studio of the Painter* [**3**], in his Pavilion of Realism
International Exposition, Paris
Church, *Andes of Ecuador*
Degas, *Portrait of the Duchess Morbilli*

1856 **Tretiakov** acquires his first Russian paintings
Ingres, *Madame Moitessier Seated* and *La Source*
Millais, *The Blind Girl*

1857 Church, *Niagara*
Millet, *The Gleaners*
Rejlander, *The Two Ways of Life* [**10**]
Whistler, *Self-Portrait*

1858 **National Gallery of Scotland** opens
Millet, *Angélus*
Church, *Heart of the Andes*
Moran, *Ruins of the Nile*
Deaths: Hiroshige

1859 **Manet**'s *Absinthe Drinker* rejected by the Salon
Manet registers as copyist at the Louvre
Courbet meets Baudelaire, Boudin, and Monet in Honfleur

1860 **Renoir** registers as copyist at the Louvre
Monet drafted and sent to Algeria
Carpeaux, *Hugolino*

Events

1851 Coup d'état, France
Paxton's **Crystal Palace**, London
New York Times founded
Ruskin, *Stones of Venice*
Liszt, *Grandes Études de Paganini*
Verdi, *Rigoletto*

1852 Proclamation of **French Empire**, Louis-Napoleon becomes **Napoleon III**
Vast urban renewal in Paris
Baudelaire's translation of *The Raven* published in *L'Artiste*
Roget's Thesaurus

1853 **Crimean War** begins
Commodore Perry visits Tokyo, thus opening up Japan
Dickens, *Bleak House*
Verdi, *Il Trovatore*

1854 England and France side with Turkey against Russia in Crimean War
Orange Free State founded by Boers
Le Figaro published in Paris
Baudelaire's translations of Poe's short stories published in *Le Pays*
Smetana, *Triomphe* symphony

1855 Opening of railway to Lyon and Mediterranean
Turgenev, *Russian Life in the Interior*
Longfellow, *Hiawatha*
Whitman, *Leaves of Grass*
Berlioz, *Les Troyens*
Chopin, *Seven Polish Songs*

1856 Peace Congress in Paris
Burton and Speke discover **Lakes Tanganyika** and **Victoria**
France and Britain attack China, taking Tientsin and Peking
Rebuilt ***Bolshoi*** theatre opens, Moscow
Flaubert, *Madame Bovary*

1857 **Italian National Association** founded by **Garibaldi**
Cuneiform script deciphered by Rawlinson and others
Bjornson's first tales of rural life in Sweden
Deaths: Musset; Glinka

1858 Suez Canal Company founded
Bernadette's visions at **Lourdes**
Laying of **trans-Atlantic cable** begins
French begin conquest of Viet-Nam
Frankfurter Zeitung begins publication
Viollet-le-Duc, *Dictionnaire raisonné de l'architecture française* (medieval and gothic)
Bulfinch, *Age of Chivalry*

1859 War of Italian Unification
Boulevard Saint-Michel completed, Paris
Charles Blanc (ed.), *Gazette des Beaux-Arts*
Darwin, *The Origin of Species*
Dickens, *A Tale of Two Cities*
Fitzgerald's translation of *The Rubáiyát of Omar Kayyám*

1860 **Free trade treaty** between France and Britain
Lincoln elected **US president**
Garnier Opera House begun, Paris
Wagner concerts in Paris
Turgenev, *First Love*
Collins, *Woman in White*
Ostrovsky, *The Storm*

1861	

1861 Delacroix finishes frescos in St Sulpice
Manet has 2 paintings accepted at the Salon
Inness, *Delaware Water Gap*
Doré's illustrations for Dante's *Inferno*

1862 Renoir admitted to École des Beaux-Arts
Founding of and exhibition by **Société des
 Aqua-Fortistes**, Paris
Manet exhibits etchings discussed by Baudelaire
Astruc founds *Le Salon*
National Museum of Warsaw opened
Daumier, *Third Class Carriage*
Frith, *The Railway Station* [**5**]
Whistler, *Symphony in White*

1863 Baudelaire's, *Peintre de la vie moderne*
Monet, Renoir, Sisley and **Bazille** in Chantilly
Galerie Martinet exhibits works by **David, Courbet,
 Rousseau, Diaz, Corot,** and **Manet**
13 students withdraw from Academy of Arts, St
 Petersburg, and set up **St Petersburg Artists'
 Co-operative (Artel)**
Manet, *Déjeuner sur l'herbe* and *Olympia* [**82**]
Deaths: Delacroix

1864 **Delacroix retrospective** and estate sales
Finnish Artists' Association founded
Fantin-Latour, *Hommage à Delacroix*
Rodin, *Man with the Broken Nose*
Corot, *Souvenir de Mortefontaine*
Cameron, *Portrait of Ellen Terry*
Deaths: Flandrin

1865 First book published using **chromolithography**
 to reproduce works of art
Manet, *Olympia* and *The Mocking of Christ* [**83**]
 at Paris Salon
Reopening of **Luxembourg Museum**, Paris
Courbet paints Proudhon on his deathbed
Homer, *Pitching Horseshoes*
Nadar, *Portrait of George Sand*

1866 Zola writes 'Mon Salon' dedicated to Cézanne
Metropolitan Museum of Art, New York, founded
Bierstadt, *Storm in the Rockies*
Cézanne, *The Artist's Father* [**51**]

1867 **Proudhon**'s *Le Principe de l'art et sa destination
 sociale*
Ingres's retrospective, École des Beaux-Arts
Pissarro, *The Hermitage at Pontoise* [**118**]
Deaths: Rousseau; Ingres

1868 **Cézanne** and **Degas** apply to copy at the Louvre
Gauguin enlists in the Navy
Manet, Renoir and **Pissarro** at Salon
Bibliothèque National, Paris, opens
Spanish Royal Museum renamed **The Prado**
Manet, *Portrait of Émile Zola* [**44**] and *The Balcony*
 [**48**]
Deaths: Wyspianski; St Gaudens

1861 Start of **American Civil War**
Russia abolishes serfdom
Baudelaire, *Richard Wagner*
Brahms, *Piano Concerto* No. 1
Mussorgsky, *Intermezzo in modo classico*
Rimsky-Korsakov, *Symphony* No. 1

1862 French annexation of Cochin-China
French forces invade Mexico
Otto von **Bismarck** become president of German
 Diet
Wielpolski becomes chief of civilian government,
 Kingdom of Poland
World's Fair, London
Viollet-le-Duc's essay criticizes the Academy,
 École des Beaux-Arts and recommends reforms
Hugo, *Les Misérables*

1863 Russo-Prussian Convention against Polish
 insurrection
Lincoln's *Gettysburg Address*
King of Sweden–Norway tries to create united
 Scandinavian kingdom
German Federation declares war on Denmark
Nadar launches his hot-air balloon, Champs de
 Mars
Lamartine, *Mémoires politiques*
Renan, *Vie de Jesus*

1864 **Pasteur** develops germ theory of disease
First *Geneva Convention* on medical and general
 treatment of prisoners-of-war
Larousse vol. 1
 of *Grand Dictionnaire Universel*
Verne, *Journey to the Centre of the Earth*
Grieg, *Symphony*

1865 President **Lincoln assassinated**
13th Amendment abolishes slavery in US
Tolstoy, *War and Peace*
Carroll, *Alice's Adventures in Wonderland*
Wagner, *Tristan and Isolde*
Grieg, *Violin Sonata* No. 1
Dvořák, *Bells of Zlonice*

1866 **Nobel** invents **dynamite**
Swinburne, *Poems and Ballads*
Dostoevsky, *Crime and Punishment*
Rimsky-Korsakov, *Overture on Russian Themes*
Offenbach, *La Vie Parisienne*

1867 **Canada** granted dominion status
Russia sells **Alaska** to US
Coronation of **Emperor Franz-Joseph I**, Hungary
Universal Exposition, Paris
Zola, *Thérèse Raquin*
Ibsen, *Peer Gynt*
Mussorgsky, *Night on the Bare Mountain*
Deaths: Baudelaire

1868 Impeachment of US **President Johnson**, **Grant**
 elected president
Serbian **Prince Michael III** assassinated
Grape phylloxera devastates European vineyards,
 replacement stock sent from New York
Dostoevsky, *The Idiot*
Alcott, *Little Women*
J. Strauss, *Tales from the Vienna Woods*
Deaths: Rossini

1869

1869 Bazille, *Summer Scene* [**89**]
Carpeaux, *La Danse*
Monet and **Renoir**, *La Grenouillère*
Deaths: Thoré (William Burger); La Caze, collector
and benefactor of the Louvre

1869 First **transcontinental railway** in US completed
Medelijeff's Periodic Law of the elements
De Lesseps completes **Suez Canal**
Twain, *Innocents Abroad*
Petipa, *Don Quixote* ballet

1870

1870 **Bazille** killed in Franco-Prussian War
Boston Museum of Fine Arts founded
Association of Travelling Art Exhibits (**The
Wanderers**) formed, Moscow
Burne-Jones, *The Wheel of Fortune* [**11**]
Renoir, *The Promenade* [**87**]

1870 France declares war on Prussia
Verne, *Twenty Thousand Leagues under the Sea*
Kivi, *Seitsemän veljestä (Seven Brothers)*, first
Finnish novel
Wagner, *Die Walküre*
Deaths: Dickens; Dumas; Mérimée

1871 **Courbet** becomes president of **Commune Art
Commission** and is imprisoned for his role in
the destruction of the Vendôme Column
First travelling exhibition of **The Wanderers**

1871 **Franco-Prussian Armistice**
French government troops fail to remove guns
from the Commune; Versaillais enter Paris;
Fall of Commune
Proclamation of **German Reich**
Rimbaud, *Bâteau ivre*
Eliot, *Middlemarch*
Verdi, *Aida* debuts in Egypt to celebrate Suez Canal
opening

1872 **Ontario Society of Artists** founded
Homer, *Snap the Whip*

1872 **Grant** re-elected President of US
Yellowstone National Park, US, established
Brooklyn Bridge opened
Schliemann's excavations of Troy
Carroll, *Through the Looking Glass*
Tchaikovsky, *Symphony* No. 2

1873 New **Salon des Refusés** in Paris
Joint auction sale by Monet, Renoir, Sisley, and
Morisot
Anderson, *Wandschirm* [**77**]
Cézanne, *Small Houses at Auvers* [**119**]
Monet, *The Luncheon (Argenteuil)* [**6**]

1873 Death of **Napoleon III**
End of German occupation of France
World Exposition, Vienna
Foundation stone of **Sacré Coeur** laid, Paris
Academy of Sciences and Letters established,
Cracow, Poland
Tolstoy, *Anna Karenina*

1874 First Exhibition of **Société Anonyme des Artistes,
Peintres, Sculpteurs, et Graveurs**, at Nadar's
Blvd des Capucines, Paris
Degas, *Place de la Concorde* [**9**]

1874 **Disraeli** becomes Prime Minister of Britain
Iceland Centenary
Garnier Opera House opens
Hardy, *Far from the Madding Crowd*
Alarcón, *Three-Cornered Hat*
Verdi, *Requiem*
Saint-Saëns, *Danse Macabre*
Offenbach, *Orpheus in the Underworld*

1875

1875 **Art Students League** founded, New York
Impressionists hold auction at Drouot
Degas, Monet, Pissarro, Renoir, and Sisley exhibit
in London
Eakins, *The Gross Clinic* [**4**]
Liebermann, *In the Bathhouse* [**90**]
Deaths: Corot; Millet; Carpeaux

1875 Dissolution of **French National Assembly**
Berlin's population reaches 1 million
James, *The Passionate Pilgrim and Other Tales*
Gilbert & Sullivan, *Trial by Jury*
Bizet, *Carmen*
Deaths: Bizet

1876 Second **Impressionist** Exhibition
Manet, *Portrait of Mallarmé*
Rodin, *Age of Bronze*
Whistler, *Peacock Room*

1876 **Bell** invents **telephone**
Russia abolishes separate court system and
introduces Russian to Polish courts
Wagner Festival debuts at new **Bayreuth Opera
House**
Manet illustrates Mallarmé's *L'Après-midi d'un
faune*
Twain, *Adventures of Tom Sawyer*
Deaths: Sand

1877 Third **Impressionist** Exhibition includes
Caillebotte's *Paris Street: Rainy Day* [**37**];
Monet's *Gare St-Lazare*; **Renoir**'s *Ball at the
Moulin de la Galette* [**7**]
Whistler, *Nocturne in Blue and Gold*
Deaths: Courbet

1877 **Edison** invents **phonograph**
Republican victory in French legislative elections
Ibsen, *Pillars of Society*
Mozart Festivals held in Salzburg
Tchaikovsky, *Swan Lake* ballet premieres at Bolshoi

Art	**Events**

1878

1878 Duret publishes *Les Peintres Impressionistes*
Whistler plans law suit against **Ruskin**
Cassatt, *Little Girl in a Blue Armchair* [**49**]
Matjeko, *Battle of Grunewald* [**128**]
Menzel, *Supper at the Ball* [**99**]
Yaroshenko, *The Stoker* [**112**]
1879 Fourth **Impressionist** Exhibition
Charpentier forms 'La Vie Moderne' for one man
show
Deaths: Daumier; Viollet-le-Duc

1878 Congress of Berlin
Austria occupies Bosnia and Herzegovina
World Exposition, Paris
Greece declares war on Turkey
Gilbert & Sullivan, *HMS Pinafore*
Hardy, *Return of the Native*
1879 Edison invents **electric light bulb**
Alta Mira cave paintings discovered
Ibsen, *A Doll's House* premieres in Copenhagen
Dostoevsky, *The Brothers Karamazov*
Strindberg, *The Red Room*
Tchaikovsky, *Piano Concerto* No. 2

1880

1880 Fifth **Impressionist** Exhibition
National Gallery of Canada and **Royal Canadian
Academy** founded
Böcklin, *Island of the Dead*
Repin, *Religious Procession* [**100**]
Ryder, *The Flying Dutchman*
von Marées, *Golden Age II* [**73**]
1881 Sixth **Impressionist** Exhibition
Société des Artistes founded
Icelandic Realists periodical *Veranda*
Nordic art exhibition, Gothenburg
Cézanne, *Mill on the Couleuvre* [**14**]

1880 France grants full amnesty for exiles of Commune
Rhodes founds **DeBeers** Mining Corporation
Zola, *Nana* and new art criticism
Harris, *Uncle Remus*

1881 French Protectorate over Tunisia
Tsar Alexander II assassinated
National Theatre, Prague, opens
C. Rossetti, *A Pageant and Other Poems*
Offenbach, *Tales of Hoffmann*
Deaths: Disraeli; Dostoevsky

1882 Seventh **Impressionist** Exhibition
Courbet retrospective, École des Beaux-Arts
Artists' Association of Finland holds first exhibition
in protest at Fine Arts Association
Danish Royal Academy of Fine Arts reforms after
protests by progressive artists
Manet, *A Bar at the Folies-Bergères* [**115**]
1883 Durand-Ruel Impressionist exhibitions London,
Berlin, Rotterdam, and Boston
Monet, Renoir, and Sisley one-man shows at Paris
gallery
Renoir and **Monet** visit south of France
Exhibition of **Japanese** prints, Petit's
Nordic art exhibition, Copenhagen
Huysman's *L'Art moderne*
Deaths: Manet; Gonzales

1882 Union Générale crash in France
Italy joins **Austro-German Alliance**
Marti, *Ismaelillo* poems
Maupassant, *Mademoiselle Fifi*
Wilde, *Vera, or the Nihilists*
Wagner, *Parsifal*
Deaths: Trollope; Emerson; Longfellow
1883 British flee Sudan after defeat by forces of Mahdi
Orient Express train introduced
Gaudi begins **Sagrada Familia**, Barcelona
Metropolitan Opera opens, New York
Nietzche, *Also Sprach Zarathustra*
Stevenson, *Treasure Island*
Deaths: Wagner

1884 Manet exhibition at École des Beaux-Arts and
Studio sale
Société des Vingt founded, Brussels
First exhibition of **Les XX**, Brussels
National Gallery of Iceland founded
Seurat, *Bathers at Asnières* [**97**] rejected by
Salon, shown with 'Groupe des Artistes
Indépendants'
Caillebotte, *Man at his Bath* [**92**]
Moreau, *Chimeras* [**71**]
Pissarro, *Apple Pickers* [**111**]
Rodin, *Burghers of Calais*
Sargent, *Madame X*
Seurat, *La Grande Jatte* [**96**]

1884 Mergenthaler invents **Linotype** machine,
Baltimore, US
Reform in **Denmark's Royal Academy**
Art Workers Guild founded, Britain
Nellie Melba debuts as Gilda in *Rigoletto*, Brussels
Hungarian State Opera House opens
Twain, *Huckleberry Finn*
Chekhov, *The Shooting Party*
Ibsen, *Wild Duck*
Debussy, *Enfant prodigue*
Massenet, *Manon*

1885

1885 Delacroix retrospective, École des Beaux-Arts
Durand-Ruel Group exhibit in Brussels
80 **Swedish artists** hold 2 independent exhibitions
Madsen's *Japansk Maler-Kunst* arouses interest in
Japonism in Scandinavian arts and crafts
Great official 'Salon' in Helsinki
Gonzales Exhibition at La Vie Moderne
Eakins, *Swimming* [**91**]
Signac, *The Modistes* [**17**]

1885 First **internal combustion engine**
Indian National Congress founded
Belgium takes Congo
Revue Wagnerienne founded, Paris
Richardson's Marshall Field's department store,
Chicago
Zola, *Germinal*
Maupassant, *Bel-Ami*
Massenet, *Le Cid*
Dvořàk, *Hymn of the Czech Peasants*
Deaths: Hugo

Art	**Events**

1886

1886 Eighth and last **Impressionist** Exhibition **Klimt**, Vienna City Theatre murals **Toronto Art Students' League** founded Second **Salon des Indépendants**	**1886** Foundation of **Polish League** **Trans-Canadian** Railway completed Introduction of **Home Rule** bill for Ireland Peace of Bucharest between Serbia and Bulgaria **Statue of Liberty** erected in New York Harbor Zola, *Oeuvre* Stevenson, *The Strange Case of Dr Jekyll and Mr Hyde* Saint-Saëns, *Carnival of the Animals*
1887 Gauguin sails for Martinique **Art Museum of the Ateneum** opens, Helsinki Muybridge, *Animal Locomotion* Renoir, *The Bathers*	**1887** War between Italy and Abyssinia Portugal takes Macao from China **Queen Victoria's Golden Jubilee**, Britain **Théâtre Libre** founded, Paris Conan Doyle, *A Study in Scarlet* Verdi, *Otello* Bruckner, *Symphony* No. 8 Deaths: Borodin
1888 Durand-Ruel opens New York Gallery First **Arts and Crafts** exhibition, London Exhibition French art, Copenhagen **Gauguin** visits **van Gogh** in Arles; **Sargent** visits **Monet** in Giverny Bierstadt, *The Last of the Buffalo* Ensor, *Entry of Christ into Brussels* **Gauguin**, *Vision after the Sermon* [18] **van Gogh**, *The Night Café* [15] Sérusier, *The Talisman*	**1888** **Institut Pasteur** founded **Wilhelm II** becomes Emperor of Germany Mallarmé translates poems of Poe Kipling, *Plain Tales* and *Soldiers Three* Debussy, *Ariettes Oubliées* Gilbert & Sullivan, *Yeoman of the Guard* Paderewski, *Piano Concerto* Rimsky-Korsakov, *Sheherazade*
1889 **Gauguin** organizes exhibit 'Paintings of the Impressionist and Synthetist Group', Café Volpini Large **Monet** exhibit, Petit's **Munch** studies in Paris **Monet** begins '**Haystack**' series Impressionist exhibition at Kustforeninen, Copenhagen	**1889** **World Exposition**, Paris **Eiffel Tower** completed Crown Prince **Archduke Rudolf of Austria** commits suicide at Mayerling Yeats, *The Wanderings of Oisin and Other Poems* Kipling, *The Man Who Would Be King* R. Strauss, *Don Juan*
1890 **Monet** collects funds to buy **Manet's** *Olympia*, which is then hung in the Palais de Luxembourg Exhibition of over 900 **Ukiyo-e prints** at École des Beaux-Arts **Sargent** begins murals, Boston Public Library **Ferenczy**, *Boys on the Danube* [114] **Holder**, *The Night* [68] **Toulouse-Lautrec**, *At the Moulin Rouge* [50] Deaths: van Gogh	**1890** First **Workers' May Day**, Poland **Kaiser Wilhelm II** dismisses Bismarck Wilde, *Picture of Dorian Gray* Riis, *How the Other Half Lives* Petipa and Tchaikovsky, *Sleeping Beauty* ballet debuts, St Petersburg Borodin, *Prince Igor* Deaths: Franck; Richard Francis Burton (explorer and writer)
1891 First Independent exhibition of **Finnish** artists **Gauguin** sails for Tahiti **Monet's** 'Haystacks' series, Durand-Ruel First **Nabis** exhibition, Le Barc de Boutteville France buys **Whistler's** *Study in Grey and Black* **Puvis de Chavannes**, *Shepherd's Song* [70] Deaths: Seurat; Jongkind; Choquet	**1891** **Triple Alliance** (Italy, Germany, Austria) renewed Construction of **Trans-Siberian Railway** **Carnegie Hall**, New York, built Hardy, *Tess of the d'Urbervilles* Whitman's final collection of poems Rachmaninoff, *Piano Concerto* No. 1 Deaths: Delibes; Rimbaud; Alarcón
1892 First exhibition of **Rose + Croix** group, Paris **Pissarro** and **Renoir** one-man shows, Durand-Ruel; **Morisot** at Boussof & Valadon The **Secession** exhibitions, Berlin and Munich **Swedish Artists' Association's** first exhibitions, Stockholm and Copenhagen **Topkapi Saray Palace**, Istanbul made a museum **Gauguin**, *Manau Tupapau* [93]	**1892** Founding of **Polish Socialist Party** New York's **Ellis Island** immigration station opened **Cholera** epidemic in France Stendhal, *Souvenirs d'égotisme* Tchaikovsky, *The Nutcracker* ballet debuts, St Petersburg Sibelius, *En Saga* and *Kullervo* Deaths: Whitman; Tennyson; Renan
1893 **Cassatt's** World's Columbian Exposition murals **Vollard** opens gallery, Paris Free exhibition in Copenhagen includes works by **Gauguin** and **van Gogh** **Toulouse-Lautrec's** posters for Moulin Rouge, Paris **Bonnard's** lithographs for *La Revue Blanche* **Sisley** one-man exhibition, Boussof & Valadon	**1893** **World's Columbian Exposition**, Chicago French protectorate over Laos Rossetti, *Verses* Shaw, *Mrs Warren's Profession* Wilde, *A Woman of No Importance* Puccini, *Manon Lescaut* Dvořák, *Symphony* No. 9, *From the New World*

1890

| Art | Events |

Art

Enckell, *The Awakening* [85]
Gauguin, *Ancestors of Tehamana* [75]
Munch, *The Scream* [74]

1894 Large **Pissarro** show Durand-Ruel
Redon exhibition, Haagse Kunstring
Swedish Artists' exhibit, Secessionist show,
Munich
Caillebotte bequest to nation and retrospective,
Durand-Ruel
Berenson publishes *Venetian Painters of the
Renaissance*
Malczewski, *Melancholia* [12]
Meier-Graefe, *Edvard Munch*
Munch. *Ashes* [84]
Deaths: Caillebotte

1895 **Munch** and **Gallen-Kallela** joint exhibition, Berlin
Cézanne exhibition, Vollard's gallery
Deaths: Morisot

1896 **Munch**'s scenery for Ibsen's *Peer Gynt*, Paris
Morisot retrospective, Durand-Ruel
Galerie Art Nouveau opens, Paris
Degas exhibits photographs
Cézanne, *Old Woman with Rosary* [76]
Zorn, *Self-Portrait* [52]
Deaths: W. Morris

1897 **Tate Gallery**, London, opens
Sezession group, Vienna, founded
Rennie MacIntosh begins **Glasgow School of Art**
Sisley one-man show, Petit's
Kollwitz begins *Weavers' Revolt* etchings
Gauguin, *Where Do We Come From? What Are We?
Where Are We Going?* [88]
Rousseau, *The Sleeping Gypsy*

1898 **Larsson** decorates Stockholm Opera House
Guimard's Art Nouveau Castel Bérenger built
Rodin, *Balzac*
Deaths: Boudin; Beardsley; Moreau; Burne-Jones;
Puvis de Chavannes

1899 **Monet** begins painting his **water-lily** pond
Signac's *From Delacroix to Neo-Impressionism*
Sisley exhibitions at Berheim-Jeune, Paris, and
Durand-Ruel, New York
Choquet estate sale
Ensor, *Portrait of the Artist Surrounded by Masks*
Vuillard, *Misia and Vallotton* [19]
Deaths: Sisley

1900 **Hunt** begins façade of Metropolitan Museum of Art
Finnish Pavilion at World's Fair designed by
Gesellius, Lindgren & Saarinen with frescos by
Gallen-Kallela
Art Nouveau Pavilion at World's Fair
Wyspianski, *Glowka Helenski* [67]
Deaths: Church

Events

Riegl, *Stifragen*
Deaths: Gounod; Tchaikovsky; Maupassant

1894 **Armenian** massacres in Turkey
Mahatma **Ghandi** organizes Natal Indian Congress
Sino-Japanese War begins
Tsar Alexander III dies, succeeded by Nicholas II
Edison invents **motion picture**
Lumière Brothers make first films
Kipling, *The Jungle Book*
Gorky, *Goremkya Pavel*
Debussy, *Prélude à l'Après-midi d'un faune*

1895 **Cuban War** of Independence from Spain
Keil Canal opened
Roentgen discovers **X-ray**
First public presentation of projected film, Berlin
Wells, *Time Machine*
Mahler, *Symphony* No. 2, *Resurrection*
Deaths: Engels; Pasteur; Dumas fils

1896 **Olympic Games** re-established, Athens
Becquerel discovers **radioactivity**
Housman, *A Shropshire Lad*
W. Morris, Kelmscott *Chaucer*
Puccini, *La Bohème*
Strauss, *Also sprach Zarathustra*

1897 **Gold** strike in **Klondike**
Greece and Turkey at war
Chekhov, *Uncle Vanya*
Bram Stoker, *Dracula*
Wells, *Invisible Man*
Rostand, *Cyrano de Bergerac*
Dukas, *The Sorcerer's Apprentice*
Deaths: Daudet; Brahms

1898 Anti-Polish emergency in Prussian-annexed Poland
Social Democratic Party founded in Russia
Spanish-American War, Spain cedes Cuba to US
The **Curies** discover **radium**, radioactivity
Paris Métro opens
Moscow Art Theatre founded; **Stockholm Royal
Opera House** opens
Wells, *War of the Worlds*
Ravel, *Shéhérazade*
Deaths: Mallarmé; Carroll; Fontane

1899 **Second Boer War**
Invention of **aspirin**
US–Phillippine War begins
A. J. **Evans** begins excavations of **Minoan** culture,
Crete
Kipling, *White Man's Burden*
Shaw, *Caesar and Cleopatra*
Elgar, *Enigma Variations*
Deaths: J. Strauss

1900 **World Exposition**, Paris
DuBois organizes **First Pan-African Congress**,
London
Reed discovers mosquitoes carry yellow fever
Freud's *The Interpretation of Dreams*
Australia given **Commonwealth** status
Baum, *The Wonderful Wizard of Oz*
Potter, *The Tale of Peter Rabbit*
Puccini, *Tosca*
Deaths: Ruskin; Wilde

1894
1895
1896
1897
1898
1899
1900

Art	Events
1901 **1901** **Picasso**'s 'Blue Period' Gallé directs newly founded **School of Nancy** **Muybridge**'s photographic series *The Human Body in Motion* **Arkhipov**, *Laundresses* [113] **Strindberg**, *The Wave VIII* [121] Deaths: Toulouse-Lautrec; Boecklin	**1901** **Queen Victoria** dies US **President McKinley** assassinated **Marconi** transmits first transatlantic telegraph message Polish school children strike against Germanization of schools Chekhov, *Three Sisters* Elgar, *Pomp and Circumstance Marches* No. 1 and No. 2
1902 **Meier-Graefe**'s book on **Manet** **Duret**'s *Histoire d'Édouard Manet et son oeuvre* Stieglitz's **Photo-Secession** group **Redon**, *Decorative Panel* [16] Deaths: Bierstadt; Twachtman	**1902** **Boer War** ends *The Times* begins weekly Literary Supplement Méliès, *Un Voyage dans la Lune*, **first feature-length silent film** Conrad, *Heart of Darkness* Gorky, *The Lower Depths* Deaths: Zola
1903 Large memorial exhibition of works by **Gauguin**, Salon d'Automne **Stieglitz** founds *Camera Works* magazine **Kandinsky**, *The Blue Rider* **Mehoffer**, *Strange Garden* [13] **Steichen**, *J. P. Morgan and Eleanora Duse* Deaths: Pissarro; Gauguin; Whistler	**1903** **Wright Brothers**' first flight **Lenin** establishes Bolshevik wing of Russian Social-Democratic Workers Party **Cuba** becomes American protectorate under Treaty of 1903 **Panama** wins independence from Colombia **Bjornson** wins Nobel Prize for Literature New York Lyric, Hudson, and New Amsterdam theatres open Ibàñez, *The Shadow of the Cathedral* Shaw, *Man and Superman*
1904 **Cassatt** made Chevalier de la Légion d'Honneur **Wright** begins Larkin Building **McKim** begins Pennsylvania Station, New York **Kosztka**, *Ruins of the Greek Theatre at Taormina* [136] **Matisse**, *Luxe, Calme et Volupté* **Popov**, *Mobilized* [98] Deaths: Fantin-Latour; Muybridge; Bartholdi	**1904** **Russo-Japanese War** **Entente Cordiale** formed by Britain and France Rubel invents **offset Lithography**, New York **T. Roosevelt** elected to full term as President of US Abbey Theatre opens, Dublin Reymont's *The Peasants* begins publication Puccini, *Madame Butterfly* Cohan, *Give My Regards to Broadway* Deaths: Chekhov; Dvořák
1905 **1905** **Picasso**'s 'Rose Period' Vauxcelles creates the name '**Les Fauves**' First **Die Brücke** exhibitions **Picasso**, *Family of Saltimbanques* [86] **Steichen**, *The Flatiron Building* [41] **Vlaminck**, *Bougival* [20]	**1905** **Einstein**'s Special Theory of **Relativity** **Sinn Fein** political party in Ireland **Norway**'s independence from Sweden Revolution in Russia Forster, *Where Angels Fear to Tread* Lehár, *The Merry Widow* Deaths: Verne
1906 **Salon Russe** first important presentation of Symbolist art of Moscow in the West **Wright** begins Unity Temple **Matisse**, *Joie de Vivre* **Ritter**, *Study of Foreign Art* Deaths: Cézanne	**1906** **Reign of Terror** in Russia **San Francisco earthquake** Nexo, *Pele the Conqueror* Prokofiev, *Ten Pieces for Piano* Deaths: Ibsen
1907 **Charpentier** collection sold Moreau-Nélaton collection in Musée des Arts Décoratifs **Braque** and **Picasso** paint at L'Estaque **Cézanne retrospective** Salon d'Automne **Galimberti**, *View of a Street in Nagybanya* [59] **Picasso**, *Demoiselles d'Avignon*	**1907** **Triple Entente** (Great Britain, France, and Russia) formed to balance Triple Alliance **Famine** in Russia Nobel Prize for Literature to Kipling Méliès film *20,000 Leagues Under the Sea* Synge, *The Playboy of the Western World* Deaths: Grieg; Huysmans
1908 **Ashcan School** of Realist painting forms with works by '**The Eight**' The Salon shows painting in 'little cubes' by **Picasso** and **Braque** **Kandinsky**, *Murneau* **Klimt**, *The Kiss* **Krzyzanowski**, *The Landscape from Finland* [60] **Matisse**, *Harmony in Red* **Wojtkiewicz**, *Basn Zimowa* [72]	**1908** General Motors founded; US produces 63,500 cars; **Ford** creates **Model T** Worst-ever **earthquake** in Europe (Sicily) kills 75,000 Ibáñez, *Blood and Sand* Forster, *A Room with a View* Deaths: Rimsky-Korsakov

Art	Events

1909

1909 Vauxcelles coins the term **Cubism**
Marinetti publishes the **Futurist Manifesto**
Matisse, *Conversation* [101]
Monet, *Waterlilies*, at Durand-Ruel
Picasso, *Portrait of Ambroise Vollard*
[24]

1909 **Peary** and **Henson** travel to North Pole
Blériot flies the English Channel
Lagerlöf becomes first woman to win Nobel Prize
for Literature
Strauss, *Elektra*
Deaths: Swinburne; Meredith; Albéniz

1910

1910 **Kandinsky** paints abstract watercolours
Exhibition of Independent Artists in US
Technical Manifesto of the Futurist Painters
published
Canadian Art Exhibition, Walker Art Gallery,
Liverpool
First modern art exhibition, Romania
Russian artists join 'Suprematism'
Boccioni, *The City Rises* [25]
Deaths: Homer; Nadar; Marc

1910 **Union of South Africa** founded
Death of **King George V**, succeeded by **Edward VII**,
Britain
Eliot, *The Love Song of J. Alfred Prufrock*
Premiers of Diaghilev, *Shéhérazade* (with Nijinsky)
and *The Firebird*; Puccini, *La Fanciulla del West*
(with Caruso); Massenet, *Don Quichotte* (with
Chaliapin)
Deaths: Tolstoy; Twain; Björnson

1911 The **Blaue Reiter** group form and hold first
exhibition
van der Rohe's Perls house, Berlin
Wright's Taliesin
Duchamp, *Nude Descending a Staircase No. 1*
Picasso, *Still Life with Chair Caning*
Malevich, *Portrait of Ivan Klyun* [103]
Matisse, *The Red Studio* [21]
Marc, *Blue Horses*

1911 **Sun Yat Sen** provisional president, establishes
Chinese Republic
Italy declares war on Turkey
Premier **Stolypin** assassinated in Kiev
Machu Picchu discovered by American Hiram
Bingham
Brooke's poems
R. Strauss, *Der Rosenkavalier*
Deaths: Mahler; Nielsen

1912 **National Gallery of Canada** opens
Epstein's tomb of Oscar Wilde, Paris
First major **Blaue Reiter exhibition** and publication
of the *Blaue Reiter* almanac
Balla, *Speeding Automobile*
Bell, *Studland Beach* [109]
Delaunay, *Circular Forms* [26]
Duchamp, *Nude Descending a Staircase No. 2* and
The King and Queen Surrounded by Swift Nudes
Gilpin, *Basket of Peaches* [122]
Kupka, *Vertical Planes III* [27]

1912 **Balkan Wars**
Titanic sinks on maiden voyage
Wilson becomes US President
Last Emperor of China **Henry p'u Yi** abdicates
Hauptman wins Nobel Prize for Literature
Mann, *Death in Venice*
Guazzoni's silent film epic, *Quo Vadis*
Berg, *Five Altenberg Songs*
Schoenberg, *Pierrot Lunaire*
Deaths: Strindberg; Massenet; Stoker

1913 The **Armory Show**, New York, first major exhibition
of 20th-century art
Goncharova solo exhibition, Moscow
Kandinsky's *A Question of Form*
Picasso's first assemblages and object sculptures
Boccioni, *Unity of Forms in Space*
Duchamp, *Bicycle Wheel*
Kirchner, *Nude Woman Combing her Hair* [22]
Lentulof, *Moscow* [42]

1913 Second Balkan War begins
300th anniversary of **Romanov** dynasty
Bohr develops model of structure of the **atom**
Proust, *À la recherche du temps perdu*
Lawrence, *Sons and Lovers*
Ives, *Holiday Symphony* and *The Fourth of July*
Apollinaire, *Alcools*

1914 **Tatlin**'s public viewing of Synthetic-Static
compositions
Bomberg, *Mud Bath* [28]
Duchamp, *Stoppages-Etalon*
Lewis, *The Crowd* [64]
Thygesen, *Barbarians* [110]

1914 **Panama Canal** opens
Archduke Ferdinand assassinated at Sarajevo
triggering **First World War**
Joyce, *Dubliners*
Shaw, *Pygmalion*
Prokofiev, *Sarcasms*

1915

1915 **Rodin**'s *Les Cathédrales de France* essay
Inauguration of **Suprematism**
Duchamp, *The Large Glass* [94]
Grosz, *The Street* [65]
Malevich, *Suprematist Composition: Black
Trapezium, Red Square* [29]
Thomson, *In the Northland* [134]
Weber, *Rush Hour, New York*

1915 Italy joins Allies in War
Lusitania sunk by German U-boat off Ireland
Germans use poison gas on British, **Ypres**
Gallipoli expedition, the Dardanelles
German and Russian armies fight for Kingdom of
Poland
Brooke, *1914 and Other Poems*
Madox Ford, *The Good Soldier*

1916 Foundation of **Dada** movement
Mattis-Teutsch, *Composition in Yellow* [126]
Matisse, *The Piano Lesson.*
O'Keeffe, *Blue Lines*
Picabia, *Universal Prostitution* [32]
Deaths: Eakins; Chase

1916 Battle of the **Somme**
Irish Volunteers and Irish Citizen Army in failed
Easter Rising, Dublin
Einstein's General Theory of **Relativity**
Holst, *The Planets*
Deaths: Rasputin

1917

1920

Art

1917 **Dada** exhibition, Galerie Corray, Zurich (renamed Galerie Dada)
De Stijl group forms, advocating basic forms in art
Popova's *Painterly Architectonics* series
Léger, *Soldiers Playing at Cards* [**102**]
Matiushin, *Movement in Space* [**125**]
Mondrian, *Composition no. 3* [**31**]
Deaths: Degas; Thomson; Ryder

1918 **Monet** offers his *Nymphéas* to France in honour of end of war
Auctions of **Degas**'s Old Master and contemporary collections
Shchukin and **Morozov** collections nationalized
Dardel, *Trans-Siberian Express* [**63**]
Malevich, *Suprematist Composition: White on White* [**124**]
Rouault, *The Crucifixion*
Deaths: Klimt; Hodler

1919 **Bauhaus** founded by Walter **Gropius**
Malevich teaches in **Popular Art School** founded by Chagall, later transformed into **UNISOVA**
Witkiewicz, *The New Forms in Painting and Misunderstandings which Result*
Breton, *Litterature* magazine
Adrian-Nilsson, *The City by the Sea* [**66**]
Covert, *Time* [**132**]
Johnston, *Liverpool an Impression* [**58**]
Krohg, *Female Nude* [**61**]
Léger *The City* [**35**]
Monet, *Weeping Willow* [**57**]
O'Keeffe, *Blue and Green Music* [**133**]

1920 **Group of Seven** first exhibition, Toronto
Mattis-Teusch first solo exhibition, Bucharest
Mondrian's essay 'Neo-Plasticism'
Ozenfant and **Le Corbusier** magazine, *L'Espirit Nouveau*
Gabo and **Pevsner**, *The Realist Manifesto* on Constructivism
Doesburg, *Pure Painting* [**30**]
Hausmann, *Tatlin at Home* [**104**]
Sheeler, *Church Street El* [**43**]
Spencer, *Christ's Entry into Jerusalem* [**69**]
Stella, *The Voice of the City of New York Interpreted* [**40**]
El Lissitsky, *Almanac #1*

1921 **Louvre** re-opens after evacuation during war
Philips Gallery opens, Washington DC
Hausmann, Moholy-Nagy, and Arp, *Manifesto of Elemental Art*
Doesburg's Dada essay 'Anti-philosophy'
Man Ray and **Duchamp**, *New York Dada Magazine*
Davis, *Lucky Strike* [**80**]
Melzer, *Bridge–City* [**62**]

1922 First **Constructivist** magazine, *Contimporanul* (Contemporary Man)
Bell's essay, *Since Cézanne*
Grosz designs costumes for Goll's play *Methusalem or the Eternal Bourgeois*
Bortnyik, *Geometric Composition* [**131**]
Kandinsky, *White Cross* [**129**]

1923 **Bauhaus** exhibition, Weimar
Le Corbusier's Villa, La Roche, Paris
Kurt **Schwitter**'s first *Merzbau*

Events

1917 **Russian Revolution**
US declares war on Germany
Millay, *Renascence and Other Poems*
O'Neill, *The Long Voyage Home*
Prokofiev, *Symphony* No. 1
Ravel, *Le Tombeau de Couperin*
Deaths: 'Buffalo Bill'

1918 Revolution in Germany forces abdication of Kaiser Wilhelm II
11 November Armistice, end of First World War
Formation of **Yugoslavia**
Influenza pandemic
Iceland gains independence from Denmark
Tarkington, *The Magnificent Ambersons* (Pulitzer Prize)

1919 **Treaty of Versailles** signed at Paris Peace Conference
Founding of **League of Nations**
Permanent **Court of World Justice** established
Prohibition begins in US with 18th Amendment
Mussolini establishes Fascist society
Kafka, *The Trial*
Maugham, *The Moon and Sixpence*
Gide, *La Symphonie pastorale*
Charles **Chaplin**, Mary **Pickford**, Douglas **Fairbanks**, and D. S. **Griffiths** establish **United Artists**

1920 **Women's Suffrage** approved in US
Treaty of Riga closes Soviet-Polish War after Battle of Warsaw
Lithuanian and **Estonian** independence
Kemal defeats Greeks and forms **Turkish Republic**
Romanian Composers' Society established, Bucharest
Lawrence, *Women in Love*
Shaw, *Heartbreak House*
Wharton, *Age of Innocence* (Pulitzer Prize)

1921 **Irish Civil War**
Ahmad Shah deposed, Shah Reza Pahlevi takes power in Iran
Maugham, *Rain*
Čapek, *R. U. R*
Rudolph Valentino stars in *The Sheikh*; Greta Garbo stars in *Gösta Berling's Saga*
Prokofiev, *The Love for Three Oranges*
Deaths: Caruso; Saint-Saëns

1922 **Mussolini** becomes Premier, **Fascists** seize Italian government
Polish President **Narutowicz** assassinated
Sun Yat-Sen reorganizes Kuomintang Party on Bolshevik model
Tomb of **King Tut** excavated by Carter
Joyce, *Ulysses*
Eliot, *The Waste Land*
Duke Ellington forms his jazz band

1923 **Hitler** imprisoned after failed coup
France and Belgium occupy the Ruhr due to unpaid German reparations

		Art			Events

Art | Events

		Art		**Events**

		Harris, *From the North Shore Lake Superior* [135]		Yeats, Nobel Prize for Literature
		Lissitzky, *Proun 12 E* [123]		Borges, *Fervor de Buenos Aires*
		Mather, *Semi-Nude (Billy Justema)* [108]		Vaughan Williams, *English Folk Song Suite*
		Picasso, *Bird Cage* [23]		Deaths: Hašek; Bernhardt
		Deaths: Eiffel		
1924	1924	**Breton**, *Manifesto of Surrealism*	1924	Hitler's ***Mein Kampf*** published
		First exhibition of '**Contimporanul**' group, Bucharest		Forster, *A Passage to India*
		Degas retrospective, Petit's		Gershwin, *Rhapsody in Blue*
		Brancusi, *The Beginning of the World*		Deaths: Lenin; Conrad; Kafka; Puccini
		Citroen, *Metropolis* [79]		
		Deaths: Sullivan; Bakst		
1925	1925	Exposition International des Arts Décoratifs et Industriels Modernes, Paris	1925	Scopes Trial in Tennessee challenges '**Creationism**'
		Introduction of **Art Deco** style		Scott Fitzgerald, *The Great Gatsby*
		First **Surrealist** exhibition, Paris		**Eisenstein**'s film, *Potemkin*
		Breuer develops tubular steel chair		**Chaplin**'s film, *The Gold Rush*
		Atget, *The Marne at Varenne* [117]		Balanchine is chief choreographer of Ballets Russes
		Dove, *Grandmother* [105]		Deaths: Satie; Reymont
		Deaths: Sargent		
	1926	**van der Rohe**'s Liebknecht-Luxembourg Monument, Berlin	1926	Pilsudski coup d'état in Poland
		Gropius's Toerten Housing Development, Dessau		Goddard launches liquid-propelled **rocket**
		Man Ray and **Duchamp**'s film, *Anemic Cinema*		**Hirohito** becomes emperor of Japan
		Giacometti, *The Spoon-Woman*		Hemingway, *The Sun Also Rises*
		Höch, *The Sweet One* [95]		Bernanos, *Sous le Soleil de Satan*
		Moholy, *Florence Henri* [107]		Faulkner, *Soldier's Pay*
		Ozenfant, *The Jug* [33]		Lang's film, *Metropolis*
		Deaths: Monet; Cassatt; Gaudi; Moran		Deaths: Rilke; Valentino
	1927	**Brancusi** exhibition, Chicago organized by Duchamp	1927	**Lindbergh** flies solo non-stop New York to Paris
		Le Corbusier's Villa Stein, Garches		**Pavlov**'s *Conditioned Reflexes*
		Dali, *Little Cinders* [34]		Fossils of '**Peking Man**' found
		Deaths: Atget; Guillaumin; Gris		Woolf, *To The Lighthouse*
				Hammerstein II and Kern's musical, *Showboat*
	1928	International **Abstraction** exhibition, Berlin	1928	Alexander **Fleming** discovers **penicillin**
		Museum of Modern Art, New York, opens		Stalinist reign of terror begins
		Brooker, *Sounds Assembling* [127]		Huxley, *Point Counter Point*
		Chagall, *Bride and Groom with Eiffel Tower*		Lawrence, *Lady Chatterley's Lover*
		Cunningham, *Triangles* [138]		Nabokov, *King, Queen, Knave*
		Demuth, *I Saw the Figure 5 in Gold*		Deaths: Hardy; Ibáñez
		Malevich, *Girls in a Field* [139]		
	1929	**van der Rohe** designs German Pavilion for Barcelona's World's Fair	1929	US Stock Market crash and **Great Depression**
		Bourke-White, *High Level Bridge, Cleveland* [56]		**Nehru**'s Indian Congress party demands full independence from Britain
		Brauner, *Composition* [81]		***Graf Zeppelin*** makes round the world trip
		Drier, *Psychological Abstract Portrait of Ted Shawn* [106]		**Columbia Broadcasting System** founded
		Evans, *Brooklyn Bridge* [140]		Remarque, *All Quiet on the Western Front*
				Hemingway, *A Farewell to Arms*

Index

The Oxford History of Art is an important new series of books that explore art within its social and cultural context using the most up-to-date scholarship. They are superbly illustrated and written by leading art historians in their field.

'Oxford University Press has succeeded in reinventing the survey … I think they'll be wonderful for students and they'll also appeal greatly to members of the public … these authors are extremely sensitive to works of art. The books are very very lavishly illustrated, and the illustrations are terribly carefully juxtaposed.'
Professor Marcia Pointon, Manchester University speaking on *Kaleidoscope*, BBC Radio 4.

'Fully and often surprisingly illustrated, carefully annotated and captioned, each combines a historical overview with a nicely opinionated individual approach.'
Independent on Sunday

'[A] highly collectable series … beautifully illustrated … written by the best new generation of authors, whose lively texts offer clear syntheses of current knowledge and new thinking.'
Christies International Magazine

'The new series of art histories launched by the Oxford University Press … tries to balance innovatory intellectual pizzazz with solid informativeness and lucidity of presentation. On the latter points all five introductory volumes score extremely well. The design is beautifully clear, the text jargon-free, and never less than readable.'
The Guardian

'These five books succeed admirably in combining academic strength with wider popular appeal. Very well designed, with an attractive, clear layout and carefully-chosen illustrations, the books are accessible, informative and authoritative.'
The Good Book Guide

'A welcome introduction to art history for the twenty-first century. The series promises to offer the best of the past and the future, mixing older and younger authors, and balancing traditional and innovative topics.'
Professor Robert Rosenblum, New York University

Oxford
History of
Art

Art in Europe 1700–1830
Matthew Craske

In a period of unprecedented change — rapid urbanization, economic growth, political revolution — artists were in the business of finding new ways of making art, new ways of selling art, and new ways of talking about art.

Matthew Craske creates a totally new and vivid picture of eighteenth- and early nineteenth-century art in Europe. He engages with crucial thematic issues such as changes in 'taste' and 'manner' and the impact of enlightenment notions of progress. The result is a refreshingly holistic survey which sets the art of the period firmly in its social history.

'excellent introduction … His capacity to deal with a mass of material genuinely European in scope is outstanding overall. His admirably thought-out bibliography is a model.'
Apollo Magazine

'Craske's text is illuminating and informative, the images a cross-section of the well known and the intriguing … good value.'
Royal Academy Magazine

'The refreshing good sense of this, combined with Craske's conceptual fluency and amazingly broad reach … establishes this volume at the head of its field immediately.'
The Guardian

Oxford History of Art

Titles in the Oxford History of Art series are up-to-date, fully-illustrated introductions to a wide variety of subjects written by leading experts in their field. They will appear regularly, building into an interlocking and comprehensive series. Published titles are in bold.